phac

THE CAMERA AS HISTORIAN

OBJECTS/HISTORIES Critical Perspectives on Art, Material Culture, and Representation

A series edited by Nicholas Thomas Published with the assistance of the Getty Foundation.

JUN 2012

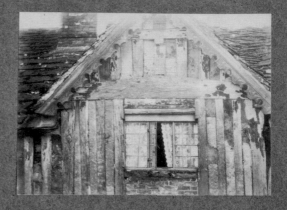

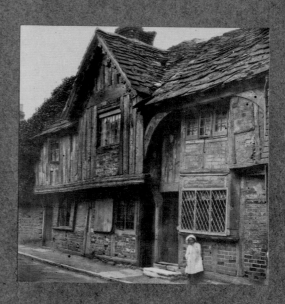

Old timber houses, Tarring. Photographed by P. M. Johnston and E. F. Salmon, n.d.
Photographic Survey of Sussex *(courtesy of Sussex Archaeological Society).*

The Camera as Historian

AMATEUR PHOTOGRAPHERS AND

HISTORICAL IMAGINATION, 1885–1918

ELIZABETH EDWARDS

DUKE UNIVERSITY PRESS *Durham & London* 2012

© 2012 Duke University Press
All rights reserved
Printed in China by Four Colour Print Group on acid-free paper ∞
Designed by Jennifer Hill
Typeset in Garamond Premier Pro and Futura by Tseng Information Systems, Inc.
Library of Congress Cataloging-in-Publication Data appear
on the last printed page of this book.

For Simon and Issy and for Pete

Across the moor that bounds our village, the proud towers of Windsor (never so proud as now!) soar above the tree-tops, and in the immediate foreground the eye falls on the old house which includes some parts of the original mansion in which King John slept the night before he signed Magna Charta. Almost within stone's throw of this house lies the quiet mead on which he met the grim company of Barons who were to wring from an unwilling monarch some of the most cherished liberties of our race. And, if these beautiful prospects do not suffice to stimulate the mind to carry itself back to the remote and stirring past, a turn of the head will lead the gaze to an old grey stone on the river's bank which bears these words: "The ancient stone above the inscription is raised upon this pedestal exactly over the spot where it formerly stood, inscribed 'God preserve ye City of London.' 1285." . . . these dates and scenes waft you back in imagination, it needs some very powerful agency — such as the prosaic-looking camera at your side — to recall you. For nothing is so soothing to the tired mind as to turn back the hand of time a few centuries, and live a while amongst the silent ghosts of the dusty, shadowy past.

— *British Journal of Photography*, 23 March 1900, 181.

CONTENTS

I have written this book from inside photography, so to speak. Bill Jay, at the beginning of his book *Cyanide and Spirits*, which he called an "inside-out view of history," wrote, "Visit an appropriate library and select any volume of a 19 century [*sic*] photographic periodical. Before opening it, try and erase from your mind all your preconceptions and past knowledge of the history of photography, create a blank but sensitive surface, like a sheet of unexposed film. In that state read the volume cover to cover."[1]

I cannot pretend to have read the volumes cover to cover or to have been quite as blank a sheet of film as I should have been, because I came to the volumes with certain research questions, looking for answers. But I have tracked through those volumes debates about the nature of photography and its role in the historical imagination of contemporaries, particularly concerns about the way in which photography could be harnessed as a form of collective cultural and historical memory for the benefit of the future. This book is an exploration, an historical ethnography, of those ideas, as they were articulated through the photographic survey movement of the late nineteenth century and the early twentieth. This loose configuration of intent provides a useful prism for thinking about these ideas, because it constitutes a self-conscious engagement with those questions and an attempt to find answers for them. I have tried to understand what participation meant for the men and women who devoted photographic energies to the survey movement in terms that might have been meaningful for them. In the broader

picture, the production of survey photographs is also an example of the way the struggle of discourse is played out, in part, in the realm of the visual.[2] But it is a body of photographic production that has been largely ignored by historians and anthropologists of photography.

Jay also adds, "I guarantee that you will reach a startling conclusion." I am not sure I have achieved that startling conclusion. But I hope to demonstrate the complexity and ambiguity that emerged around photography, ideas of evidence, and history in the popular imagination. Jay describes the early photography that was revealed by his method of study as a "vibrant, living organism, squirming and struggling in blind faith, darting in unexpected directions, battering against (and usually being defeated by) new possibilities." The directions taken and battles fought in relation to photography might have shifted in some cases, while others appear to have lingered for decades, but crucially, even by the late nineteenth century and the early twentieth, the dynamism, fluidity, and ambiguity of the desires that clustered around the practice of photography had not.

My interest in the relation between photography and popular British history arose from my spending some twenty years as a visual and historical anthropologist working with nineteenth-century and early twentieth-century colonial and anthropological images. A dominant model of analysis for such images was that photographs of "the Other" were active in the construction and definition of "self" — a position more theoretically assumed than ethnographically demonstrated in many cases. So, if this model were valid, it raised the question, how did self represent self to self? How did "domestic" or "internal" "ethnographic" photography constitute an expression of identity and history? How was an enhanced sense of popular historical topography, locality, and nation performed photographically? What was its role in shaping subjects and contexts that allowed certain things to be said and done? I found the record and survey movement an illuminating prism through which to explore these questions, for the movement coexisted with, and indeed was part of, the moment of high imperialism, the massive expansion of photographic practice, and a period of intense historical imagination — in books, magazines, museums, pageants, and spectacles, to name but a few expressions of that imagination.

So this book is an historical ethnography of a given moment in the cultural history of photography and how that moment relates to a broader historical imagination. My "fieldwork" has been in those contemporary journals that Jay recommended, and in the scattered visual and textual archives left by the photographic surveys. When I started this work, the "history of photography" knew about four of these surveys in Britain, although there were local knowledges, occasional fragmentary traces, and folk memories of others. I have located and followed up seventy-three surveys and have worked intensively on seventeen. I am certain there were more, so small, so unsuccessful, or so ephemeral, that they left no recognisable trace. The photographs the surveys left behind, and I have looked at about 55,000 of them, were sometimes scattered, fragmented, and unrecognisable. The images had rarely received any attention beyond that of local historians, and even then their attention was sporadic and their usage often simply illustrative. Many of the photographs are not particularly good by any standard, technical or aesthetic. Some are downright dreadful. Some are truly glorious. Yet they are the centre of this story and this analysis, for they, as their producers hoped they would, carry the weight of history.

ACKNOWLEDGMENTS

Major research projects are never entirely one's own. They are dependent on, and blessed by, the unstinting support, generosity, and goodwill of others. First and foremost, this research would not have been possible without the generous support of the British Academy, De Montfort University, the University of the Arts London, and a grant towards image publication costs from the Marc Fitch Fund. I am more than grateful to all of them. Many individuals have also helped me along the way, generously sharing knowledge and expertise, facilitating my research, or giving moral support: Sal Anderson, Martin Barnes, Chris Bennett, Kaushik Bhaumik, Linda Clover, Annelies Cousserier, Katherine Dunhill, Linda Eerme, Chris Gosden, Gill Grant, Bernard Heathcote, Anita Herle, Giles Guthrie, Clare Harris, Colin Harris, David Harris, Janice Hart, Anita Herle, Patti Langton, Wiebke Leister, Ian Leith, Bryan Liddy, Gregg Mittman, Malcolm Osman, John Pickles, Roslyn Poignant, Annabella Pollen, Michael Pritchard, William Raban, Russell Roberts, Simon Schaffer, Patrick Sutherland, Jennifer Tucker, Eve Waring, Kelley Wilder, and Val Williams. Thank you.

This project has been a massive archival trawl. I am extremely grateful to the following institutions who facilitated my research and gave me access to their collections: Birkenhead Reference Library; Birmingham City Archives and Local Studies Library, Bodleian Library, Oxford; Bradford Central Library Local Studies; Brighton History Centre; Bristol Museum and Art Gallery; the British Museum; Brotherton Library, University of Leeds;

Cambridge Antiquarian Society; Cambridgeshire Local Studies Library; Croydon Public Library Local Studies and Archives; English Heritage (National Monuments Record); Essex County Record Office; Exeter City Library (West Country Studies); Gloucestershire Archives, Herefordshire County Record Office; Greater Manchester Record Office; Hereford Public Library Reference Section, Huddersfield Library, Local Studies; King's Lynn Public Library; Lambeth Borough Library; Leeds City Library, Local Studies; the Record Office of Leicestershire and Rutland; the Leicester Literary and Philosophical Society; Maidstone Museum; Manchester City Libraries (Local Studies Unit); National Media Museum, Bradford; National Portrait Gallery, London; Norfolk County Record Office; Norwich Local Studies Libraries; Nottingham City Library (Local Studies); Nottinghamshire Archives; Oxfordshire Studies Centre; the Royal Anthropological Institute, London; Sheffield City Archives; Sheffield City Libraries (Local Studies); the Society of Antiquaries, London; Somerset County Record Office; Somerset Local Studies, Taunton; Suffolk County Archives, Ipswich; Surrey History Centre, Woking; Sussex Archaeological Society; Thoresby Society, Leeds; Victoria and Albert Museum; West Yorkshire Archives Service, Leeds; Worcestershire County Record Office; and Yorkshire Archaeological Society.

I would also like to thank all the other county record offices and archives, and local studies libraries and museums who answered my endless enquiries, even if we drew a blank in the end. Survey material is strangely elusive and, in some cases, seems to have disappeared without a trace. I am grateful too to the many institutions who have allowed me to publish their photographs here. All were wonderfully supportive, reducing fees massively or even, in some cases, waiving them entirely. In a photo-heavy book, where images are part of the evidence and argument, not merely expendable decoration, this has been very much appreciated. Also I must thank all those who came to seminars at ANU (Canberra), Cambridge, Concordia, University College London, the Institute of Historical Research, Warwick, Bristol, Durham, East Anglia, Kent, Leicester, and Queens (Ontario), and members of Peter Mandler's nineteenth-century history workshop group at Cambridge, and colleagues at the Max Planck Institut für Wissenschaftsgeschichte, Berlin, where I was a visiting scholar, for their productive comments and discussion as I tried out my ideas and material across different disciplines.

And finally to the lasts but by no means leasts: I should like to thank Ken Wissoker, Leigh Barnwell, Neal McTighe, Jeffrey Canaday, and the team at Duke University Press for their constant support and good counsel throughout the publication process. Joan Schwartz who always keeps me on my toes. Chris Pinney, who, in a kind act of friendship, gave me a copy of *The Camera as Historian* that he had found in a second-hand book shop. It appears to have belonged to Hugh Topley, the son of one of the authors, and who also donated a few photographs to the Surrey survey. The book is a great treasure. Liz Hallam, who has read, encouraged, and provided sanity checks throughout as we finished books together, even if we did eat too much cake. Pete James, whose knowledge on the origins of the survey movement, Harrison, Stone, the Warwickshire survey, and the history of photography more generally, is second to none, has been more generous and supportive over the years than can be imagined; I literally could not have done this without him. My parents, who first made me interested in histori-

cal landscapes. Some of my earliest memories are of outings to castles, parish churches, and old houses. And finally, my family, who have lived with the surveys for eight years. With their interests in architectural history, geography, and landscape, at least they have found the subject matter more engaging than some of my other projects, but this is little compensation for what they've had to put up with.

PUBLICATION ACKNOWLEDGMENTS

Although they are much revised and rearranged here, parts of this book have, inevitably, been tried out elsewhere. Parts of chapter 2 were originally published as "Straightforward and Ordered: Amateur Photographic Surveys and Scientific Aspiration 1885–1914," (*Photography and Culture* 1, no. 2 [2007]: 185–210). Those parts of chapter 3 on aesthetic and stylistic practices originally appeared in "Unblushing Realism and the Threat of the Pictorial" (*History of Photography* 33, no. 1 [2009]: 3–17), and those on materiality, photography, and the material performance of the past, in *History and Theory* 48, no. 4 (2009): 130–50. Parts of chapter 5 on connections with anthropology originally appeared in my essay "Salvage Ethnography at Home: Photographing the English," in *Photography, Anthropology and History: Expanding the Frame*, ed. C. Morton and E. Edwards (Ashgate, 2009).

Direct photograph of Beddington Lock.

Architect's drawing of same.

[*Facing p.* 2.

FIG. 1.—Photographic contrasted with graphic record.

1. The Beddington Lock: drawn and photographed. *The Camera as Historian (author's collection).*

"Sacred Monuments of the Nation's Growth and Hope"

Amateur Photography and Imagining the Past

In 1916, at the midway point of the Great War, three members of the Photographic Survey and Record of Surrey published a small book, *The Camera as Historian*. This book set out detailed practices, from fieldwork to the creation of institutional structures, for the use of photography in recording traces of the past. In its first few pages, the book compares a drawing of a wrought-iron lock from Beddington Manor House, Surrey, to a photograph of the same object. The drawing was made for the antiquarian and architectural draftsman A. C. Pugin in 1828 for his book *Examples of Gothic Architecture*. This comparison placed photography in a long tradition of historical and antiquarian observation and record, while asserting the primacy of the medium over others. *The Camera as Historian*'s authors quoted Pugin's introduction to his book: "Fidelity must constitute the chief value of the work." They then drew attention to the incorrect rendering of the central panel—the improper proportions of the dragon figures—immediately questioning the fidelity of drawing when compared with photography. (See figure 1.) The authors continued, "This illustration is given as epitomising the case for those who urge that the claim of photographic record to superiority over all other forms of graphic record is incontestable."[1] A range of assumptions and aspirations is entangled in this statement, assumptions that define a specific discourse on the nature of photography, evidence, authenticity, and historical potential.

This book explores claims about photography and its utility in relation to popular historical imagination as

that imagination was articulated through the photographic survey movement in England between 1885 and 1918. The study can be read as an ethnography of aspects of the culture of English amateur photography at a specific historical moment, but, more importantly, it is a prism through which to examine the relationships between historical imagination and photography more broadly. While there are of course many other bodies of photographic material that could be approached as filters and articulations of historical imagination, in that they address the relations between past, present, and future, the photographic survey movement is particularly useful because it produced images made specifically to articulate a series of values though which the past could be expressed. Saturated with the temporal character intrinsic to historical imagination, the photographs from the surveys were the product of a self-conscious act of memorialisation.

THE RECORDING IMPULSE

The idea of amateur photographic survey was first fully articulated in 1889 when W. Jerome Harrison, a geologist, science schoolmaster, and keen amateur photographer from the Midlands, read a paper at the Birmingham Photographic Society, in which he laid out the idea of a systematic photographic survey that would form an archival base for the future. With 1,000 copies of his paper circulated to photographic societies and reprinted in full in the photographic press, Harrison defined the parameters in which the energies of amateur photographers and the evidential qualities of photography might be harnessed to make a permanent and publicly accessible record of England's visible past. Such a record should comprise the antiquities, ancient buildings, and customs of

Britain, and the practices, and current conditions that map human experience, in order to constitute a "True Pictorial History of the Present Day."[2]

In Britain, as elsewhere, the moment of recognition, cohesion, and aspiration resonated through amateur photographic circles and through the public perception of the utility and evidential importance of photographs over the next thirty years, and indeed beyond. In and of itself, the presentation of Harrison's paper was an unremarkable event, giving rise to many photographic acts that would too, in isolation, be entirely unremarkable. Yet, taken together, they raise some fundamental questions about the relationship between photography and the past, questions about photography as evidence, the public utility of photographs, and popular historical imagination at a key period of expansion and change.

The amateur photographic survey movement emerged from the confluence of two major but complex social shifts: first, a response to the sense of an ever-accelerating change in the social landscape and the physical environment, and, second, the massive expansion of photography as a pastime. As has been discussed by a multitude of commentators, the period was characterised by a sense of the losses and gains of industrialisation, increasing social mobility, urban and suburban growth, and the expansion and solidification of imperial and national identities. These are, of course, huge subjects that can only be adequately explored elsewhere. By the late nineteenth century, the effects of various interlocking dynamics were so complex, fragmented, amorphous, localised, and contradictory that generalisations obscure as much as they reveal. Consequently, there is a need to shift analysis from a homogenising, macroscopic perspective to the complex nego-

tiations of the microscopic, and from identifying core trends of a single period to exploring the ways in which those dynamics are experienced at the periphery, located away from the centres of overt political, economic, or cultural power. It is here that larger trends are at work in a multitude of ways, without necessarily assuming a complete dependence of the periphery on the centre, because that periphery is also a space of complex patterns of agency.[3] This is just such a study. A number of interrelated paths could therefore lead out from this study, for it is part of a vast, multidisciplinary complex: perceptions of change and modernity, class relations, the expanding democratic base, national identity, centre-provincial relations, the preservation movement, colonial experience, imperialism, the impact of mass education, and literatures of cultural nostalgia. While all will have their walk-on parts, and all of them form part of the broader context in which the photographic surveys were undertaken, they are not the focus of this book. My account is of a periphery shaped and articulated through the photographic practice of amateurs, how they saw the value in what they did and what they aspired to. Implicit throughout this study is the question, to what extent is it possible to posit a history that is played out at the level of the image. How might we get a "sense of the ways in which the particular activities [of amateur practice and photographic survey] combined into a way of thinking and living"?[4] I leave it to others to pursue the broader strands and to integrate photography and photographs, often remarkable in their absence, into accounts of those broader strands. Much of the theoretical writing about photography must also be assumed here. Its influence is clear in this book's line of argument, but although it has quietly informed my thinking this writing does not

need a reiteration. The focus instead is on how a photographic movement emerged from a certain set of social and cultural conditions. The movement as it emerged in Britain in the late nineteenth century embraced, or was at least connected to, the thinking and photographic practices of many thousands of amateur photographers, and indeed some professionals, and self-consciously articulated the relationship between photography and a future historical engagement.

Part of the nineteenth-century impulse to map, control, and render a wide range of phenomena visible as spectacle, the photographic surveys were born of the productive interaction of epistemological frames and technological possibility. The application of photography in these contexts also linked the eye to broader scientific systems of knowledge, and extended them in revelatory ways. As an advocate of survey photography stated:

> If we do but consider the nature of photography we may be led to perceive that, in very truth, the language of photography is a part at least of the language of the universe. It is the language of geometry and astronomy, and of physics and chemistry. The language of all pervading radial activities under such conditions that we can see and gradually learn to read the records.
>
> Our personal vision is very limited, both as regards sensitiveness and the periodicity of the incident vibrations which are directly perceptible by us, but photography knows no such narrow limitations, and can and does help us to see pictures where the eye could perceive nothing.[5]

The function of the survey movement and its photographs must also be understood as part of

[Facing p. 30.
FIG. 2.—International Institute of Photographic Documents, Brussels.

2. The International
Institute of Photo-
graphic Documents,
Brussels, as illus-
trated. *The Camera
as Historian (author's
collection).*

a larger culture of the spectacle of mass produc-
tion and hypervisibility, a culture manifested in
a vast array of productions, for instance, rail-
ways, in department stores, or in advertising,
and which saturated the nineteenth-century
visual consciousness. The images of historical
topographies produced by the amateur photog-
raphers of the survey movement were in some
respects self-conscious responses to this all-
embracing visuality and its potential. Qualities
of vision and experiences of sight were there-
fore integral to the way in which topographies
of all sorts were absorbed and understood.[6]

Photographic survey and the evidential
potential of photography were not, of course,
new ideas. They had been present from the in-
vention of the medium, as François Arago, in
announcing the daguerreotype to the Chamber
of Deputies in Paris in 1839, noted how the tech-
nology could be used to record and aid the study
of ancient Egyptian hieroglyphs.[7] Countries
in Europe and beyond saw a steady stream of
photographic recording and surveying projects.

In France in 1851, La Mission Héliographique,
the first state-sponsored photographic project
to record the built cultural heritage, was estab-
lished. In Britain in 1855, in the spirit of ama-
teurism that is a focus of this book, Reverend
F. A. S. Marshall extolled the virtues of photo-
graphs as architectural records: "Everything
that can be subject to visual observation is ren-
dered permanent, so that whatever is noticed
now may be noticed by all the world forever."[8]
In a similar vein in the 1870s and 1880s the So-
ciety for Photographing the Relics of Old Lon-
don produced a series of photographic port-
folios of old buildings for subscribers, while a
number of photographic surveying activities
were connected to programmes of city im-
provement and redevelopment. Preeminent
examples of such surveying activities are those
of Charles Marville in Paris in the 1850s, those
of Thomas Annan in Glasgow in the 1860s, and
those by Robert White Thrupp and James Bur-
goyne in Birmingham in the 1870s.[9] But dur-
ing the second half of the nineteenth century,
there was a massive expansion in the number
and scale of such projects. There were projects,
for instance, to map the heavens, the weather,
the races of the British Empire, the antiquities
of India, and the archaeological sites of Great
Britain. Scientific "atlases" were produced to
map pathologies, microbes, and so forth.[10]
There were also archives of utopian visual ambi-
tion, notably that of the Institut International
de Photographie in Brussels, to "photograph
everything that existed" and create a universal
encyclopaedia of images of Borgesian scale and
dilemma.[11] (See figure 2.)

Photographic surveys of the kind explored
in this book took place under the broad ethos
of the *Heimatschutz* movement in Germany,
and in Switzerland, France, Belgium, Scandi-

navia, Italy, and East Prussia (now Poland) for instance.[12] While these projects differed from one another structurally, in patterns of funding, participation, and archiving, they emerge nonetheless from the same epistemological frames of encyclopaedic desire, positivist confidence, preservational impulse, and a concern with narratives of the past, present, and future that are entangled with similar discourses of photographic reliability and public utility.

The survey movement emerged from a massive expansion of photography, itself part of a wider socioeconomic shift towards increased leisure, mobility, disposable income, and greater educational opportunity. With the advent of dry-plate negative technologies and smaller, more manoeuvrable cameras, the hobby of photography was no longer the preserve of a wealthy elite. While earlier "democratisations" of photography in the middle of the nineteenth century could only be relative, given the expenses of photographic equipment and supplies, by the late nineteenth century there was a genuine increase in access to photographic technologies. Photography was certainly still beyond the financial reach of most working-class people, but by 1905 some 10 percent of the population of Great Britain (approximately 4 million people) had direct access to camera technology and engaged in making photographs, with an associated plethora of "how to" manuals and magazines aimed at amateurs, including children.[13] There was a range of publications aimed at different interests, different levels of expertise and different pockets. The inexpensive *Photographic Answers* sold for one penny and included a collotype reproduction, while *Photographic Quarterly* cost 2 shillings an issue, and the widely circulated *Amateur Photographer* cost 2 pence a week in 1902. Other

people had access to photography and its publications through clubs and educational establishments. Photography was taught extensively in technical colleges and through a range of social and educational networks such as mechanics institutes and photography sections of clubs and societies, activities that required a supporting literature. As many commentators have shown, however, at one level this broadening of the photographic base tied photographers more firmly to a system of industrial capital through the consumer expansion of modernity and the manufacture of photographic goods, especially camera kits, plates, and papers.[14] But on the other hand, such developments freed the amateur photographer from the need for a detailed knowledge of chemistry and optics. The amount of time and the knowledge necessary to undertake photographic activity had shifted radically.

This activity has also to be understood within patterns of photographic connectivity as the medium and its ever-expanding presence became a defining feature of everyday life. As one commentator said: "Photography has its uses in connection with every phase of life and every industry; it is at one time the most useful and the most popular art and science that has ever been placed in the hands of man, and is destined to become a necessity in every walk of life, and every art, science, manufacture or trade."[15] In this context, the connection between the recording potential of the medium and the direct popular engagement with the visual remains of the past grew as "preservation became an ever more powerful and widespread impulse in British public life."[16] There is, then, in cultural terms, a sense in which the idea of mass photographic survey and record had a certain inevitability to it.

The presence of photography has now saturated the consciousness of the past for over 150 years, becoming one of the "new connectors in temporal perspectives" noted by Paul Ricoeur. The medium accelerates the "primacy of the visual," which has marked memory construction since antiquity.[17] It is hard to imagine a sense of the past without photography, so integrated is it in the relations between past, present, and future. This process, a culture of what Scott McQuire has termed "photomnemonics," has meant that "the impact of the camera cannot be limited to filling gaps in historical content. On the contrary, the profound technological mutation of the archive necessitates questioning the very concept of history, and exposing the collusion between representation and the time it has long presupposed."[18] Scholars from Siegfried Kracauer to Jacques Le Goff and Raphael Samuel have posited that the advent of photography was the turning point in historical consciousness, just as the relationship between the past and future held in photographs became a formative strand in the writing of theorists in the mid-twentieth century, in particular, Walter Benjamin and Kracauer. Photography "revolutionizes memory: it multiplies and democratizes it, gives it a precision and a truth never before attained in visual memory, and makes it possible to preserve the memory of time and of chronological evolution."[19]

The central theme of this book is, as I have noted, the relationship between photography and historical imagination, especially the ways in which the latter is articulated and negotiated through the former, and through the agency of amateur photographers. Historical consciousness, questions of memory, practice, and the study of the ways in which people at given historical moments negotiate, understand, and act upon their perceptions of the past, both collectively and individually, encircle the questions raised here. I can only touch on those questions — and they have been extensively explored elsewhere.[20] I prefer, in any case, the term "historical imagination" because the uses of photography explored in this book were concerned not only with a sense of the past as a naturalised cultural ambience, but with self-conscious and imaginative acts of inscription in response to the material traces of the past. Furthermore, my use of the term "history" is framed not only by the interests of an academic or disciplinary understanding of what history might be, but more particularly by an anthropological response to photographers' own use of the word and categorisation of their activities. Debates over and descriptions of the production of what were referred to as "history pictures" constitute a set of clearly articulated strategies and mechanisms through which people situated themselves in time and space and negotiated the translation of this situated sense into photographs and archives.[21]

Central to the concept of photographic survey was the specific relationship between visual practices, the temporal and the historical dynamics of place, a relationship in which photography was a transformative technology. This was not simply a collapse into the ontological "pastness" of photography in the shape argued, for instance, by Roland Barthes, its essential *noeme*, "that which has been."[22] The new technologies of vision that emerged in the nineteenth century made time palpable in many ways, "as a weight, as a source of anxiety, and as an acutely pressing problem of representation."[23] Modern life, with its emphasis on relentless progress, brought about dramatic

changes in the experience and understanding of time. These changes demanded not only an enhanced awareness of time but an "attempt to repossess [the past] through its multifarious representations."[24]

Questions of time were written into debates about photography itself—for example, the instantaneous inscription that recorded the moment imperceptible to eye reshaped the concept of photography in relation to time. Not only did photographs temporalise the spatial in an abstract sense, they defined a place through its past. Photography also connected and translated the local into the national through the massing of data and the extrapolation of meaning, linking generalised theories of cultural and national origin. Thus photographs made in the present could be conceived of as being "of" the past in a self-conscious temporal slippage between observation and the consumption of the image. Not only were photographic fragments of time themselves negotiated, but in the temporal dynamics of their subject matter there is a coming together of the temporal interjections of photography with cultural perceptions of deep time, "the thick layers through which one could penetrate in order to get in touch with the past." Whether the layers were "languages, customs, rocks or fossils, biological species, levels of civilization psychic consciousness or subconsciousness—all there to be tunnelled."[25]

The promise of photographs was to grasp time and rematerialise it.[26] Photographs extended the reach of the temporal beyond relations between the present and the past to the future as well, creating an archival grid through which the past might be accessible in an imagined future: "The epistemological structure allow[ed] for the knowledge or representation of time mobilized through a series of binary oppositions—continuity versus discontinuity, rationalization versus contingency, structure versus event, determinism versus chance, storage versus legibility."[27] Such concerns resonate through photographic record and survey. In this way, time, as an indissoluble relation between historical past, present, and future visibilities, saturates the discourse of the amateur surveys and formed one of the epistemological bases for the endeavours of amateur photographers, endeavours in which the very act of photography and the experience of taking a photograph implies duration: "The camera, with its great recording eye, will not alone pictorially depict the passing events of the day, but retain the appearance of the fast crumbling landmarks and monuments of the past; it will duplicate the features of the present generation, as well as permanently renew the old fading portraits and yellowing parchments, thus preserving them for the students and searchers of the future."[28]

The visual was, as I have suggested, integral to this complex and interwoven process. As Lynda Nead has pointed out: "The rhythms of social life and visual representation in the years around 1900 were diverse and multi-temporal; self-conscious modernity went hand in hand with heritage and conservation."[29] The emergence of recording and surveying as dynamic forces in amateur photography in the 1890s is no coincidence; indeed, the self-definition of the movement as "a movement" suggests the consciousness of a collective dynamic. Not only did this movement emerge through the expansion and democratisation of photography, but it was part of a much wider social matrix of preservation that can be linked to shifting practices of memorialisation, historical appreciation, and identity formation. Yet at the same time, the movement was premised on the valourisation of visual knowledge and the particu-

lar power of photographic constitutions of that visual knowledge.

The primacy of the visual rather than the verbal in nineteenth-century senses of the past has been widely discussed. Many forms of nineteenth-century history making come under this rubric—from municipal museums and lantern slides to books of popular history and travel. Rosemary Mitchell has pointed out that while "early nineteenth-century expansion in historical consciousness was fuelled by illustrated books and print media, the late-nineteenth century [expansion] was fuelled by photography."[30] While this was certainly so, the extent to which contemporary visual apprehensions of the past were "cultivated in the landscape more often than in the library" and were "shaped by a direct encounter with material objects" should be acknowledged, because responses to the material objects of the past framed these photographic practices.[31]

The period was saturated with images of historical reference that linked image, text, and material encounter. These images occur, for instance, in tourist guides, in local and national displays in exhibitions, and in photographers' windows. Other examples can be found in the wealth of topographic work by photographers such as William Howitt, who produced photographic books of ruined castles and abbeys in the 1860s and 1870s, the mass circulation of the photographs of Francis Frith, and the work of the Scottish topographical photographer George Washington Wilson. (See figure 3.)

Travel literature in particular offered the middle classes "in search of historical and aesthetic erudition" histories of places and buildings such as cathedrals and abbeys. Such literature "sharpened the sense of place and orientation of native and stranger alike by creating elementary visual maps that structured perceptions of entire landscapes as well as of their individual features, whether medieval or modern."[32] In the culture of the historical past, the visual was as significant as the textual, a relationship that can be linked to romantic and picturesque histories of the early nineteenth century, with their visual and reconstructive narratives on the one hand, and a democratisation of historical sensitivity on the other.[33]

This stress on the material trace created an historical topography that was both a focus of the historical imagination and amenable to the act of photography. However, this raises the question of the discursive location, constitution, and recognition of such historical topographies as "histories" and "identities." What kind of narrative—national, local, or collective—might those topographies stand for? Pierre Nora has pointed out that history, the nation, and national development have constituted the oldest of our collective traditions, "our quintessential *milieu de mémoire*," but this process of national self-imagining is one that, as Steve Attridge has argued, "primarily reveals the act of imagining itself, rather than any innate properties of nation."[34]

The values associated with customs and antiquities are, of course, intimately linked to the construction of a sense of the past—the legitimation of cultural ideologies, social values, and social practices. This process employed a notion of precedence, and thus historical sense, that is embodied in the material environment and the practices enmeshed within it. In the course of the nineteenth century, this sense of the past worked with more formal and conscious elaborations of history in a way that was both multiple and complex and symptomatic of the widening gap between academic history and a popular interest in the articulation of a collective historical consciousness.[35]

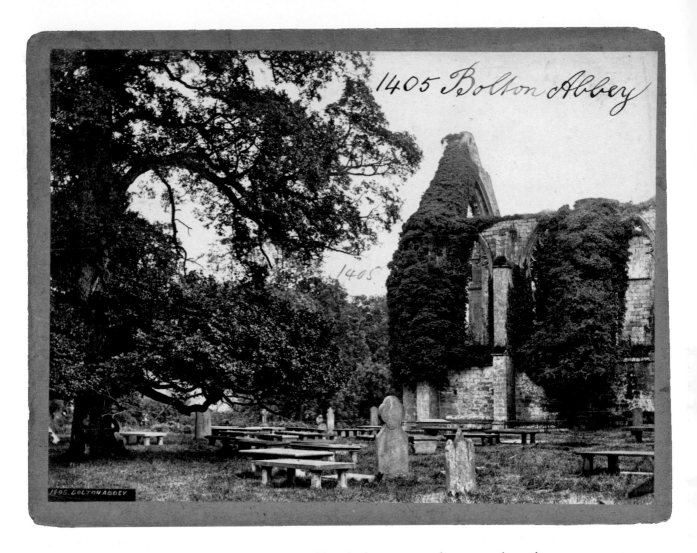

3. Bolton Abbey, Yorkshire. Photograph: Francis Frith, c. 1860. Albumen print *(photo © Victoria and Albert Museum, London).*

LOCAL AND NATIONAL NARRATIVES

The late nineteenth century and the early twentieth were, as many commentators have noted, a period of complex and ambiguous discourses of nation, especially in an imperial context.[36] While many of the surveys elsewhere in Europe were overtly related to nationalist discourses and the definition of the nation-state, the concept of photographic survey was somewhat differently inflected in Britain because of the country's relative political stability and particular political milieu. Krishan Kumar has argued that "a moment of Englishness," manifested itself in the late nineteenth century through a clear concern for and a consciousness of the nature of Englishness but stopped short of "full-blooded" nationalism.[37]

Nonetheless, the movement was part of that much broader cultural matrix in which both a pride in history and a sense of the loss of Britain's tangible past was entangled with shifting national identity in the age of rapid social and economic change. It was a moment such as that identified by Pierre Nora as an "acceleration of history" that "crystallizes and secretes itself . . . at a particular historical moment, a turning point where consciousness of a break with the

past is bound up with the sense that memory has been torn."[38] This turning point was articulated through an intensified sense of the past and its preservation, that, in Britain. was manifested through a range of activities, for example, societies to collect folklore, dialect speech, and "bygones" for museums; Cecil Sharp collected English folk songs and had them added to the school curriculum. There were societies and movements concerned nationally and locally not only with architectural preservation but with the preservation of rural landscapes, ancient townscapes, footpaths, and open spaces, a concern for preservation exemplified by successive acts of Parliament to protect ancient monuments and by the foundation of the National Trust.[39]

While there was a related mobilisation at national and local levels to undertake a "salvage ethnography" of the English and the peoples of Celtic "margins" within a narrative of cultural origin, this movement was not as heavily inflected with a political-national discourse as it was elsewhere in Europe. The sense of centrality, born of imperial confidence and self-definition, enjoyed by the British at this period permeates constructions of national and local identities. These constructions presented complex and differentiated ways through which national identities could be expressed, from coronations to Delhi Durbars, from landscapes to music.[40] At the same time English identity was being negotiated through modernist anxieties inflected with ideas of authenticity, history, race, and culture. The position might best be summarised in Ian Baucom's words: "The struggle for English identity becomes . . . a dual struggle of defining the national past and preserving this invented past from the contaminations of Empire."[41]

There is a sense in which the very concept of the surveys is a self-conscious engagement with these wider cultural processes. The activities of amateur survey photographers became small acts of agency in the construction and legitimation of narratives of history, narratives that become visual in certain arenas and at certain moments. What is significant overall, however, is how little overt articulation of national or imperial values is found in the discourse of the survey movement, suggesting the need to both qualify and complicate this strand in any analysis of the movement. There are appeals to "nation." As the journal *Amateur Photographer* said in 1897 in regard to survey photography: "The enormous service photography will thus render to the nation cannot be exaggerated."[42] But these national appeals were not necessarily framed in terms of the glorification of the nation-state as a geopolitical entity, but in terms of a sense of community, a group of people inhabiting a common space. A sense of nation was founded in the "civics" of place, association, and community rather than in the political sense of the nation-state or in an ethnic or racial delineation. Resonances of the "ethnic" basis of identity can be read in specific narratives of the surveys, in their valorisation of specific historical periods for having dense signifiers of community and of nation. But there is little overt sense of the diversity of a colonial and imperial nation. Rather, there exists an unarticulated sense that England's past and its preservation could be positioned as the enduring core of national identity in opposition to the racial and cultural instabilities and potential contaminations of empire.[43]

Questions of national identity almost become a form of the "political unconscious," to use Jameson's famous phrase, a set of values and assumptions that makes certain forms thinkable and that shapes all survey and record ac-

tivities yet remains largely unspoken. But that shaping nonetheless raises questions that are central to the concerns of this book, namely the location of photography in the making of localities and identities across a wide range of social groupings and dynamics, across historical and cultural specifics, and, especially, in the performance of visual imaginings of local and national identities in constituting a field of historical consciousness within those relations.

The vision of national narrative that informed the idea of the survey movement was at one level profoundly inward looking. The consistency of the tropes across individual surveys—the parish church, the rural village and manor house, ancient cottages, the traditional practices of agriculture and ritual observance, time immemorial etched in the stone and wood of buildings, settlements organically embedded in the earth of the nation—are part of national, cultural narratives and establish clear patterns of value as "the authority of antiquity was one thread of a common nationality, and was visibly available in the architectural ruin, the physical trace of historical event in the countryside." Historical processes and marks of time became naturalised within the broader idea of "nation."[44] Thus the efforts of amateur photographers involved in record and survey work, whether those efforts were focussed on "single monuments or framing stretches of scenery," which, as geographer Stephen Daniels observes, provide "visible shape; they picture the nation. . . . As exemplars of moral order and aesthetic harmony, particular landscapes achieve the status of national icons."[45] (See figure 4.) Understandings of landscape, place, and nation entwine to constitute "an essential vehicle and [a] mould for nation-building because they symbolize the history and roots of a nation and thereby engage the people in a relationship with

their past which can help them make sense of their present."[46]

The significance of landscape and topography thus clearly constitutes a key yet ambiguous metanarrative for the entangled relations of photography and historical imagination. Duncan Bell has described the temporally and spatially discursive realm, the kind that marks the survey movement, as a "mythscape," the space in which the myths of an historical imagination are constantly forged, transmitted, and reconstructed. This model offers a productive way of thinking about the survey photographs because it accounts not only for patterns of ideological instrumentality in relation to photographs, but also for social agency, the modes and media through which historical imagination is articulated, and the practices of individuals involved, in ways that can precisely account for the tensions that characterise the aesthetic, material, and social practices of the survey movement.[47]

In addition and related to Bell's concept of mythscape, the historical topography of the survey movement is constituted in many ways through what Michael Billig has described as "banal nationalism"—a series of unconscious, ideological habits of identity that saturate the everyday. National identity "is not a flag which is being consciously waved with fervent passion; it is the flag hanging unnoticed on a public building."[48] The survey photographs engaged with the background space of the everyday, the forgotten and unnoticed reminders that were embodied in the everyday topography of the ancient buildings and traces of the past that were to be found layered in the midst of a town. Such a recognition charged those reminders with a sense of identity by encoding the familiar and bringing them to consciousness.[49] This sensibility to the visible, and to a visualised history in the midst of everyday modernity, becomes

4. Ilmington Manor. Photographed by E. C. Middleton, 1892. Warwickshire Photographic Survey *(courtesy of Birmingham Library and Archive Services).*

profoundly important in the dissemination of survey photographs.

Yet there is an uneasy relationship between national and local narratives. An analytical stress on determinist and instrumental uses of photography in the construction of the nation has elided or collapsed the complex microlevels of historical desire within amateur photographic practice. While many of these photographs focus on modest traces of the past, they also record objects and scenes that could be variously absorbed, explained, and made valuable through national discourses in the ways that Stephen Daniels, for instance, has defined them. The ways in which survey photographs elevated their subject matter—the village cottage, the small parish church, or the ancient market cross—focusing attention in certain ways, creating, and translating significance, gave "even the most humble, the most modest vestige the potential dignity of the memorable."[50] However, survey photography was not automatically absorbed into national discourses. Despite the potent analytical lure of nationalist discourse, an exploration of the historical imagination and desires articulated through the surveys charts a photographic response that embraced both aesthetic and evidential performances of place on a periphery that, although clearly and strongly informed by

such narratives, cannot necessarily be reduced to them. These narratives imbricated each other in the sense that localities had distinctive histories that "existed at wholly different spatial levels from the society of the nation."[51] Within the overt pattern of the visualised nation, there was a profound and indeed fiercely guarded sense of the local. Thus, on the one hand, the photographic survey movement is not a project that can be reduced to discourses of national identity alone, yet on the other hand "the preservation of memory in the modern era and the project of nation building remain fundamental."[52] In the way that the photographs endowed "the singular with significance while at the same time never needed to relinquish that singularity," the surveys were locked into a complex discursive system of vacillation between providing a visualised national narrative and a local one, a fluid historical discourse that reached out to empire but also in towards the small relics of the local village.[53] (See figure 5.)

SURVEY PHOTOGRAPHS AND MEMORY PRACTICE

What the national and local, whatever their relationship, have in common is the temporally inflected discourse of place and its relationship with memory. The surveys would appear to ex-

5. Broom village, Warwickshire. Photographed by A. Longmire, c. 1890. Warwickshire Photographic Survey *(courtesy of Birmingham Library and Archive Services)*.

emplify precisely a history premised on place, a history as it was envisaged by Le Goff, one that was "based on the study of 'places'" in the collective memory: "Topographical places, such as archives, libraries, and museums; monumental places, such as cemeteries or architectural edifices; symbolic places, such as commemorative ceremonies, pilgrimages, anniversaries or emblems; functional places, such as manuals [*The Camera As Historian*, for example] autobiographies, or associations."[54] As Barbara Bender has argued, landscapes as cultural objects, including the built environment, are time materialised, marked by a sense of time passing both historically and mythically, and are profoundly imbricated with social and political relations, but relations that must at the same time be understood as "recognis[ing] the untidiness and contradictoriness of human encounters with time and landscape."[55] Such a position demands some consideration of the relationship of the concept of photographic survey to ideas of collective memory practice, for all societies have the desire, in some form or another, to mark the shape of their lives, experiences, and their pasts.

The memorialising and narrativising practice, as constituted through the discourse of survey, perhaps owes more to James Fentress's and Chris Wickham's concept of "social memory" and Bell's mythscape (which was formulated in part to address problems of the concept of "collective memory"). In those conceptualisations, memory is held by a specific group in which individuals "remember." This is in contrast to Maurice Halbwach's definition of memory that privileges the collective over the individual memorializing action, for Halbwach's definition does not fully allow for the tensions between individual, local, and national per-

ceptions of how the memorializing functions of photography should be developed and controlled.[56] In particular, my analysis would appear to accord with Bell's emphasis on the dynamics of the individual and agency in collective memory practices as "a socially-framed property of individual minds."[57] Nevertheless, while a sense of "the collective" and memory practices strongly informs the ethos of survey, it is in its archival manifestations that this sense is most clearly and effectively articulated. Formulated as a memory bank, photography was conceived precisely to counter the fragmentation of memory processes that beset the historical record, even if, as we shall see, it failed in its universalising and all-encompassing agendas.[58]

From the start, the surveys were conceived as a form of externalised collective memory, in its real and metaphorical roles—a "holding" of the past in which photography, properly executed, monitored, and archived, could become a memory bank of the material traces of the past and thus of identities. The relationship between, on the one hand, visual knowledge as a memory form and, on the other, the archive as prosthetic memory links the debates that dominate this study of the survey movement. These debates encompass those on the quality of observation, scientific and mechanical objectivity, material practice, those on style and aesthetics, and those on the social production of the bodies of amateur survey photographers themselves. Photography, with its reproductive and repetitive qualities, is a form of externalised memory par excellence, fulfilling the inscriptional and performative qualities of memory, and thus of the cultural milieu. As Barthes stated, "What the Photograph reproduces to infinity has occurred only once: the Photograph mechanically repeats what could never be repeated existen-

tially. Through it we know most intensely those things we have consciousness of knowing."[59]

There is a strong sense of what one might describe as a neo-Lamarckian sentiment that informs the photographic surveys and, in particular, their dissemination.[60] Latent memories, manifested through "traditions" or marked in the stones of old buildings, become conscious through the apprehension of the photographic image as people engage with their past. This position is repeatedly made clear in debates about photography, survey, and historical imagination. For instance, the *Eastern Daily Press* commented in regard to the Norfolk survey that the photographs would be "refreshing [the viewer's] memory about things that he has wholly or half-forgotten, and would rejoice to be reminded of," while *The Camera As Historian* opined that in "human memory, . . . albeit quite unconsciously, recollection and imagination will blend when an effort is made to construct a mental picture of the past. A pictorial record in such cases will serve the double purpose of checking vagaries of memory by reference to actual facts, and of recalling to mind, through the powers of suggestion, details that otherwise would be irreclaimable."[61] Likewise in a series of essays entitled "The Whole Duty of a Photographer" in the *British Journal of Photography* in 1889, the use of the camera advocated for recording all aspects of life. The role of the archive as an externalized collective memory also became apparent. Memory was to be managed by the institutional structures of photography. Photographs, as stated in one of the essays, "ought to be inserted in great albums, sacred from the polluting touch of the silver print, kept at the Royal Photographic Society of the future. Such a society would have one of its highest and most trusted officials as 'keeper of albums' on whom would devolve the responsibility of choosing photographs and seeing them mounted and fully labeled with every precaution for their preservation."[62]

In this perception of the externalised memory, photographs could construct, externalise, and maintain historical imagination as a monument against forgetfulness, while at the same time providing the mechanisms through which memory might be internalised. It should be noted that the emergence of the amateur surveys was contemporaneous with new ideas on the nature of memory. While I am not necessarily suggesting any direct causal link, memory practices were increasingly being theorised as "social practices of the present," in, for instance, the work of Henri Bergson, while at the same time notions of memory were being externalised through practices, as Nora suggests, of the archive and the museum. The surveys and their resultant archives constituted precisely the complex cultural interaction and negotiation that Wulf Kansteiner has identified as constitutive of collective memory. These new ideas comprise the intellectual and cultural conditions that frame representations of the past (in this case, photographic style), visual and discursive objects (represented as photographic content and the material photographs themselves), the ingenuity of memory makers (in this case, photographers) and the various interests of memory consumers (viewers).[63] These performed not only the relations between individual and collective, but were part of the wider discourses and processes through which identity was forged.

The stress laid by those involved in survey photography on exhibitions, lantern slide shows, and, especially, on public access through the depositing of archives in local libraries and

museums, emphasizes the way in which the photographs were intended to function, as the reproducibility of photographs and the repeated engagement with them performed the repetition that constitutes memory and that memory would in turn reproduce itself. While there are well-aired theoretical problems with the concept of "collective" or "social" memory, in terms of practices there was a fully articulated and self-conscious belief in the efficacy of photographs as survey advocates anticipated uses and responses. As one commentator claimed: "They [photographers] wished to quicken the intellects of those who had not now an opportunity of seeing in all their freshness scenes which were passing before their eyes; and they wished not to live for this generation alone, but for the generation which would follow, so that they might see the habits and customs of their ancestors, and it might be that they also would still hand down a fruitful record of the times which were to come."[64]

In order to achieve such objectives, however, the amateurs involved in photographic record and survey were invested in a specific view of photography that might translate the fluidity of historical imagination into "fact." Their endeavours embraced a concept of photography as evidence that was premised on the potential of a direct, causal, apparently unmediated and mimetic relationship between the photograph and the photographed object as subjects were to be treated "in the best and most realistic way — by means of absolutely 'unfaked' photographs" that could stand as "accurate transcripts of landscapes, buildings, etc."[65] Thus, for the surveys to be effectual, they had to be understood as a form of unmediated representation in which the faith in history was a faith in its representation as the photographs became "the appearance of *history itself*." As Sir Benjamin

Stone, initiator of the National Photographic Record Association (NPRA) and champion of all things connected to photographic records, claimed: "The only kind of photography that would be tolerated in the near future, would be that class that expressed the truth, the whole truth and nothing but the truth."[66]

These photographic values can also be linked to a sense of scientific methodology in history that intensified the processes through which a "true" memory might be critically established. The camera itself was, as John Tagg has pointed out, in effect, "the Historian," as both "History" and "Photography" were developed epistemologically in the nineteenth century "under the sign of the Real."[67] Stephen Bann has argued that photography, with its promise of "reproduction without representation," became the logical extension of nineteenth-century objective history with its "truth to sources" and concerns with questions of authenticity and authentification in a positivist "new history," but also in a sense in which "correct representations" could "arrest the decay of the present and vivify the resurrection of the past," both positions to which photography appeared so admirably suited.[68] Such a view was, of course, part of nineteenth-century engagement with the "reality effect" of photographs as empirical facts, an engagement in which "photographs . . . had a mission, a moral purpose, which was to relate to the truth."[69] While this overall positivist, hyperempirical view pertained to, and was part of, broader cultures of representational realism in art and literature, this was not a naïve acceptance of "the truth" or the "reality" of photographs but, as many commentators have noted, a series of negotiations through which "a photograph [could] come to stand as *evidence* . . . rest[ing] not on a natural or existential fact, but on a social, semiotic process."[70]

"Evidential force" as Barthes argues, was vested in the relationship between the specificity of photography as a medium and the social expectations that clustered around it. The value given to "evidential force" was the outcome of complex and even contradictory sets of values and negotiations through which the photographs produced by the record and survey photographers could come to have historical weight. Such values and social expectations as an "ideology, a way of seeing, a system of historically contingent connotations" in which claims on the future efficacy of photography were premised on "protocols and hierarchies of evidence."[71]

However, as the complex ebbs and flows of debates around photographic efficacy and procedural correctness in survey and record photography show, the efforts of amateur photographers were not driven by "a solid self-satisfied vision of a misguided objectivity and faith in representation but [were] a highly self-conscious attempt to explore or create a new reality, its massive self-consciousness implied a radical doubt, its strategies of truth-telling, a profound self-consciousness."[72] In social and cultural terms the survey constituted a very genuine quest for knowledge that, whatever the theoretical problematics, stood in opposition to a critique that realism was "incapable of delivering analytical knowledge."[73]

The survey movement, with interpenetration of scienticity on the one hand and a saturation with the subjective on the other, cannot be accommodated within a neatly dichotomised model of memory and history, or *milieux* and *lieux de mémoire*, such as that postulated by Nora in his seminal work on history, memory, and modernity. Rather, the movement exists fluidly between the two poles. Here the historical process is not a transferral from the head and the heart to the archive, as it is in Nora's somewhat elegiac argument, but an investment of the head and the heart in the inscriptions *of* the archive. Both the historical process and the archive remain replete with the emotional loading of the tangible past and its imaginings. The survey photographs were also inflected with a sense of sentiment and affect, but, as I shall discuss further in Chapter 3, the objective language of survey was at the same time threatened with the destabilization of sentiment. Yet in order to sustain their objectives to both record and to engage a popular historical sensibility, the photographic surveys merged the instrumental realism of the mechanical inscription and the sentimental realism of the photographic inscription of the affect of place.[74]

For all the claims for photography, truth, and the immutable archive, the surveys were redolent with the subjectivities that informed the very act of historical imagining. The survey photographers' optimistic empirical and positivistic view of photographic potential was also fully recognised as a fragile authority, threatened at every turn by the excess of photographic inscription and the inadequate control of the photographer's imagination and that imagination's problematic translation into the archive.[75] Indeed, the survey project can be characterised as a continual and dialogic tension between historical objectivity and subjectivity. Frank Ankersmit has argued that "all of historical writing," and in this I would include photographic inscription in the contexts we are considering it here, is "situated in the space enclosed by [the] complementary movements of the discovery (loss) and recovery of the past (love) that together constitute the realm of historical experience."[76] Precisely such a tension informs and defines the historical desires of the survey movement.

While firmly embedded in the discursive

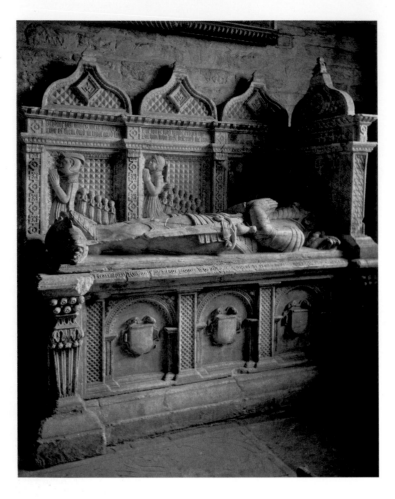

6. The Whalley Monument, Screveton Church. Photographed by Charles Ferneley, 1899. Photographic Survey of Nottinghamshire *(courtesy of Nottinghamshire Archives, DD/1915/1/411).*

discourse of the authenticity and historical resonance of objects. It was this sense of age-value which informed Harrison when, with Ruskinian overtones, he called for amateurs to become involved in survey photography: "The carved stones [can be] seen to have been the unassisted productions of the working mason, as the carved chests were of the working carpenter. They were the last products of the art-feeling which formerly prevailed amongst our common craftsmen; and their cessation marks very distinctly the period at which an apathy to everything artistic settled down upon the English people."[78] Furthermore, the accumulation of survey photographs in archives and the public role of those photographs, the material qualities of which I shall turn to later, would appear to accord with Riegl's claim that the cult of historical value and commemoration gave documentary significance to exact copies, especially photographs.[79] (See figure 6.) It was this entanglement of exactness and emotion, tied to the authenticity of the object and the authenticity of photographic inscription, that enabled photographs to stand for a collective past.

In the context of the massive expansion of prosthetic memory and monumentalising practice on the one hand, and the context of the circulation of visualisations of the past on the other, there was an unquestioned, extensive, and popular engagement with and sensitivity to the past and to the idea of history in this period, a sensitivity stimulated by a sense of the disjunction of modernity—what Scott McQuire has termed "the crisis of memory" and the "new desires" of an emergent historical method.[80] However, this contention needs some attention, for it has also been argued that, conversely, there was a falling away of interest in history in the late nineteenth century, despite the anxieties of disappearance and the rup-

practices of mechanical realism of the camera and aspirations to scientific objectivity in the historical statement, the survey photographers' notion of "historical value" was also shaped by that "love," a sentimental attachment to the past and its sites, and, thus, to patterns of identity. These attachments were articulated through a form of what Alois Riegl has described as "age-value" which, in its mass appeal, "manifests itself . . . through visual perception and appeals directly to our emotions."[77] This age-value is demonstrated not only through the choice, or "recovery," of much of the subject matter—ancient churches, village stocks, and half-timbered cottages—but also in the

ture in modernity. Because of this rupture, it has been suggested, the sense, and indeed the relevance, of a past receded in the face of the everyday demands of rapid industrialisation, imperial expansion, and social and technological change, while aspects of "the present" and the invention of "tradition" were increasingly pressed into discourses of longevity for the service of national, imperial, and hegemonic needs.[81] However, more recently, alternative readings of the role and impact of history in the late nineteenth century and the early twentieth have begun to emerge, suggesting practical and experienced manifestations of time and its rematerialisation. These manifestations, it is argued, were realised not through the formal institutions of historical practice that had emerged in the nineteenth century, but through a massive expansion in historical activity at a popular level, for instance, in the

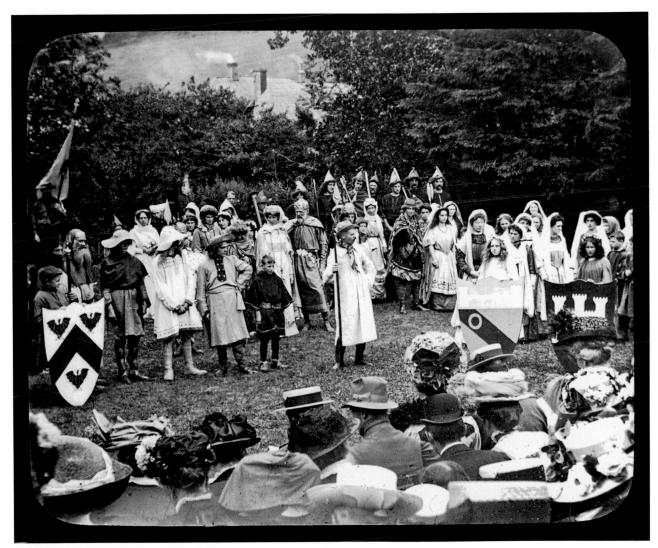

7. Piddletrenthide Pageant in the vicarage garden — singing songs in Dorset dialect.
Unknown photographer, 1910. Dorset Survey. Lantern Slide *(courtesy of Dorset County Museum)*.

formal establishment of history in the school curriculum in the Education Act of 1902, the emergence of the notion of "national heritage" and a huge number of popular illustrated history books, pertaining both to national and local history, aimed at all ages and all classes.

Paul Readman, in particular, has argued that the importance of a more diffuse and heterogeneous sense of the historical "manifested itself in a wide variety of ways," with resonances over the whole social spectrum.[82] Some of these resonances drew on extant forms of historical imagination, such as the novel, revivals and refigurings of folk customs, notably May Day and the persistence of "Merrie England." Other resonances emerged out of centenaries, anniversary celebrations, and locally focused historical pageants.[83] (See figure 7.)

History books were also published in increasing numbers and had a very substantial circulation through private and public free libraries.[84] Furthermore, the growing social base of internal tourism spawned a plethora of illustrated guidebooks and historical accounts of everything from national monuments like the Tower of London, the great cathedral, and abbeys. The Bell's Guides series provides representative examples of this genre of guidebooks to parish churches and much-photographed local beauty spots, such as Tintern Abbey and Wye Valley.[85] Guidebooks and local publications also often gave accounts of the histories of important local families, local customs and byways for the curious visitor. The consumption of the historical, and especially those books illustrated with photographs in half-tone reproductions, was expanding on a massive scale that constituted a "popular historical consciousness [that] made its cultural presence felt independently of elite control," for as Paul Readman argues "there is no doubting the existence of a strong

antiquarian sensibility in the 1890s and 1900s. Indeed there is considerable evidence that antiquarianism . . . was enjoying healthy and vigorous growth in these years."[86]

The survey movement emerged from just such an expanding and popular sense of the historical as described by Readman, which built up layers of historical consciousness and imagination. Participation in the survey movement was one expression of this historical consciousness. The surveys were premised on the burgeoning of a different kind of history. This history was not necessarily premised on the grand narratives of state and the aristocracy, but was a history of the everyday, the marks of identity and the cultural practice of banal nationalism scattered across the urban and rural landscape. Historical sites became constituted as both monuments and as memory-texts that could be both excavated and projected photographically, and through which amateur photographers could mark, in some small way, their own agency in the broader cultural processes of history and modernity. (See figure 8.)

NOSTALGIC IMPULSES

Any discussion of historical imagination and historical enthusiasm, especially as they overlap with amateur photography in the period, must bring one to a consideration of photographic survey as a "nostalgic impulse"—a phrase I have been carefully avoiding up until this point. In much writing to date, the survey movement has been characterised as conservative, reactionary, bourgeois, nostalgic, and ultimately antimodern and anxious to protect the specific sociopolitical practices and sentimental appropriations of a picturesque vision of history.[87] As John Taylor has argued, amateur photographers "resurrected the past in

terms of aesthetic pleasure, deciding that it was 'quaint.' The pre-industrial dream created a past that was available for consumption. The relation of this dream to the past was nostalgia, or the desire for an impossible union."[88] A similar analytical position also informs related concepts of the patriotic picturesque as developed by Jens Jäger and by Malcolm Andrews in his formulation of the metropolitan picturesque. The patriotic picturesque has also been linked to a Foucauldian model of surveillance and archival order, almost a sense of an "internal colonial gaze."[89] Furthermore, the historiographical dominance of Sir Benjamin Stone—a Conservative member of Parliament with a patrician approach and both intellectually conservative in his aspirations for photography—in the analysis of the survey movement, has tended to uphold this view.

This position might also be understood in relation to broader readings of the preservationist movement and cultural institutions in the nineteenth century. These readings characterised these cultural institutions of the late nineteenth century as instruments of social order that imposed a hegemonic view of history. An alternate reading has emerged from Martin Weiner's characterisation of English culture of the period as backward-looking, antiindustrialist, and based on a ruralist nostalgia for a "green and pleasant" land, an antiindustrialist mindset that, Wiener argues, had disastrous economic consequences. This ruralist vision was inflected with tropes of Merrie England, a pastoral idyll of social harmony and contentment focused on the squire, the manor house, the cottage, and the peasant, and bound in a rustic innocence.[90]

However, while these strands are undoubtedly part of the discourse, manifested in the vast numbers of survey photographs of half-timbered cottages, ancient church lych-gates,

8. "Historical" Family Album, c. 1900. Inserting family histories into national histories (author's collection).

and ivy-clad alms-houses of ancient foundation, the survey movement was much more complex and ambiguous, socially and ideologically. The movement was concerned with dynamic futures as much as imagined pasts that engaged with, and constituted, a simultaneous response to both the exhilaration and the anxiety inherent in the transformation of the visual landscape of modernity. The surveys have to be understood as a complex temporal response. The anxieties played out through the practices of photography were not merely about a loss of the past, but about a loss of a future that might

have embraced and been moulded by its past. The melancholia at work here is not merely due, therefore, to a lost past in the face of modernity, but a fear for a future unaware of its past. It is a melancholia emerging from the tensions of a historical desire torn between discovery and recovery, loss and love. In such a state the photograph "excites a double desire of history: on one hand the careful sifting and assembling of detailed and objective records: and, on the other, for the restoration of history as a 'lived reality.'"[91] In this set of complex relationships, the evidential rhetorics of the survey movement were an attempt to control and align the intersection and interdependence of disparate ideas of history and historical value, but also to align disparate concepts of photography and its purpose. In this, various disciplinary practices of observation, photographic practice, evidence production, and material performances that guaranteed the archive for the future, and the moral values of preservation, social utility, sentiment, and photographic practices, were mapped onto one another in the construction of complex historical narratives.

In this context, however, as Jeanette Edwards has pointed out, "nostalgia is inadequate to explain the quotidian ways in which the past is put to work in affirming or denying local identity."[92] The photographic practices of the survey movement emerged from an intense belief in the ability of the photograph to perform a sense of the past's dynamic presence within the contemporary. (See figure 9.) Consequently, perhaps, it would be more helpful to think about nostalgic impulses of survey photographers as having more in common with Nadia Seremetakis's definition of nostalgia. Going back to the original Greek, she suggests nostalgia is a dynamic desire or longing in the context of estrangement that carries sensory impli-cations and the possibility of a transformative impact of the past as an unreconciled historical experience.[93] Photography and the potential of the archive were, for survey photographers, part of the possibility of reconciliation.

In this reading, therefore, survey activities cannot necessarily be reduced to a fin de siècle retreat into a conservative and reactionary nostalgia in the face of an energetically expanding and encroaching modernity, nor to the replication of class interest as a mode of historical-social control. Certainly, there are elements of these formations at play, sometimes powerfully so, in survey photography, especially in the discourses around its dissemination. However, it is too easy to drift into a simplistic and obscuring instrumentalism without asking why things mattered in certain ways at certain times. For, overall, the agendas of survey photographers were more complex and more quietly radical than they might have appeared on the surface. As Jeremy Burchardt has argued more generally, "Few of the leading figures within preservationism would have accepted a description of their aims as a retreat into the past. On the contrary, most of the leading preservationists regarded their activities as being very much about improving the future rather than sanctifying the past. Preservationism did indeed draw on the values it perceived in the past to criticise the present, but it did so with the aim of fostering a better future."[94]

Many of those involved in the survey movement, and importantly the facilitators of the movement, including editors of the photographic press, librarians, museum curators, and the new professionals of local government, had liberal views, and while the conservative vision of the social order, nostalgia, and the reactionary is undoubtedly a strand of the survey discourse in a more nuanced reading the surveys

were not so much simply upholding social order. They were also, in their way, contributing to a script for a refigured space in the context of the broader discursive order. Such a reading can contribute to ways that might complicate our thinking about the production and visualisation of history.[95]

Despite the conservative appearance of the survey movement and its desire to articulate the intense historical connection between the present and the past, the dynamics of the movement—from the making of photographs to their dissemination—were increasingly complicated by agendas that, although they were politically imbricate, privileged democratic access to history through the accessible and easily apprehended medium of photography. At the heart of the survey movement was not simply a fear of the rapid disappearance of markers of identity but rather a fear for a future that would have no sense of its past. Hugh Blakiston, *The Times* journalist and secretary of the newly founded National Trust lamented: "Unhappy indeed is the people which has no past."[96] Thus the "love" is not merely or simply a nostalgia for the recovered past, but the potential for inscriptions of the past to resonate in the future.

Finally, too, the reductionist assumptions that the survey and record movement was a retreat into reactionary conservatism have tended

9. Corfe Castle. Photographed by Thomas Perkins, c. 1895. Dorset Survey *(courtesy of Dorset County Museum)*.

to deny the movement its own unfolding dynamic within a rapidly changing social environment.[97] The photographs in their subject matter indicate patterns of what for the participants defined who they were and defined what they perceived as valuable for the future. If one positions the survey movement as both looking back and looking forward, the impulses that drove it—the relations between the past and the future, between nationalism and localism, between nostalgia and anticipated memory, between the different roles that photography itself might fulfil—the complexities and ambiguities of these patterns become increasingly clear. The surveys constituted a social space in which these narrative tensions could be negotiated, but this space was marked as much by complexity and diversity as by homogeneity.

Amateur photographers were real people, with real experiences, ideas, hopes, and fears at a given historical moment. And while survey photographers might offer the historian or anthropologist a prism through which to view specific analytical questions, survey photographers are not merely abstract discourses, ciphers, or passive vehicles of ideology. These photographers, men and women, are largely invisible in the history of photography, yet by 1890 they made up the majority of those engaged with the medium. Their efforts fill family albums and local archives. Occasionally, these photographers flit across the consciousness of the photographic world, exhibiting a photograph at one of the Royal Photographic Society salons, or are listed as provincial exhibitors or prize-winners in the photographic press, but most are not recognised. Yet, as hobbyists, they took their medium seriously. They wanted to contribute to history and photography. The surveys, whatever their theoretical or sociopolitical shortcomings, offered survey photog-

raphers a way of contributing to the historical record, and linked them to a body of clearly defined values that negotiated a definition not only of what photography was, but of what history might be. This book is an exploration of their particular negotiation of what a visual or photographic history might be, how its lasting value might be secured, and its implications for us, as interpreters at the intersection of photography and historical imagination.

APPROACHING THE ETHNOGRAPHY

While photographic practice and photographs taken by amateur photographers are the focus of this book, my concern is with the photographs, not so much as representations, nor as a site of a theoretical contemplation on history, but as part of what James Helva has called a "photography complex," in which photography becomes a heading under which "a range of agencies animate and inanimate, visible and invisible," is clustered, and from which emerge a series of images.[98] Such a complex is constituted by the cultural and social processes through which certain kinds of photographs were made. It addresses how certain kinds of photographs became thinkable and meaningful at a given historical moment, and how photographs are given shape through the relationships between human and nonhuman actants. The network, as Bruno Latour has described such configurations, constituted the conditions of making, communicating, and preserving photographs, conditions which included, for instance, cameras, chemicals, plates, archives, mounting cards, libraries and their librarians, maps, ancient buildings, photographers, bicycles, file cabinets, lantern slides and viewers.[99] All these things, human and nonhuman, are essential and irreducible elements in understanding the

survey movement and its members. For photography and photographs are "neither [a] reflection nor [a] representation of the real, but a kind of metonymic sign of the photography complex in operation."[100] This "photography complex" was utilised to "produce" history, not only in the minds of the amateur photographers but through the whole system of values in which the production of the photographs, their archiving, and dissemination was embedded. What were the processes through which a popular relationship with the past became articulated through a series of records of the physical and experienced traces of the past to be projected into the future?

One of the methodological challenges of this study has been to get beneath the survey movement's own rhetoric, especially that generated by Stone, and subsequent characterisations of the survey movement from this rhetorical position. For rhetorical it was. The reality of the survey movement was very much more complex and ambiguous in the ways in which it was experienced by amateur photographers and others interested in photography, antiquities, local and national histories. These participants were keen to experience the very ordinary human pleasure and self-satisfaction in a hobby perceived as useful and to contribute in some way to the social good. We cannot know individual motivations in detail, they leave little or no trace, but this loosely bound group of photographers, linked by common values and aspirations gives us a way to explore the relationship between photography and the kinds of questions I have outlined above.

While the original results of these endeavours were perhaps less extensive and more uneven than enthusiasts of photographic survey and "history pictures" might have liked, the scale of survey photographers' ambition and vision has

to be recognized as integral to the discourse. Yet its study and its archival base are fraught with methodological problems. The original ambitions for the photographs have dissipated over the years, resulting in a confused, fragmented, and dispersed archive that tells us much about shifting evaluations of photographs as historical evidence and their institutionalisation, but that archive does not necessarily tell us as much about the survey movement and its photographers. Thus, while it has been difficult, on occasion, to be certain of one's understanding and interpretation, a fear that haunts all historians, anthropological or otherwise, the patterns of archive and commentary that have emerged from the various archives and contemporary sources are consistent enough to be the basis for overall conclusions about the way historical topographies were evaluated and visualised.

My research has revealed some seventy-three surveys based in English counties, cities, and towns (for a full list, see the appendix). There are probably more surveys that have eluded me to date, especially the short-lived failures that never even resulted in a one-line notice in the photographic press. If such references exist at all, they are probably hidden in local papers in provincial towns. Although largely independent and diverse in many ways, all these surveys aligned themselves self-consciously to common objectives and series of values and beliefs, values articulated largely in the photographic, national, and local press, about the historical potential of record photography to provide an archive for the benefit of future generations. Of the seventy-three surveys I have identified, I have examined seventeen in detail, for over fifty of them appear to have left little recognisable mark—all one knows is that they happened at some level or other. The seventeen were, in effect, self-selecting, because they

left some form of a coherent archival trail or were reported in the photographic press of the period. Some of these had only paper trails, and almost no photographs could be located (such as those taken for surveys in Essex and Yorkshire); others had photographs but no paper trail and only very limited press references (surveys, for instance, in Kent, Sussex, and Gloucestershire); some, such as those undertaken in Exeter, Surrey, Manchester, and Norwich, had both a paper trail and extant photographs and offered an embarrassment of riches, both empirically and discursively. Some of the surveys I followed up, such as the one planned in Sheffield, do not appear to have progressed beyond the stage of good intentions and inspiring rhetoric, but they nonetheless left behind revealing debates in the local press. These seventeen surveys yielded an image data-set of about 55,000 prints, although there were possibly more because not all the photographs could necessarily be located or identified as specifically belonging to a survey project.

This archival trail also revealed just over 1,000 active amateur photographers, and I have managed to glean at least some basic biographical data for about 80 percent of them. We know roughly and variously who they were, where they lived, and what they did for a living, and we have some idea of their networks. In addition, there were a few hundred supporters and facilitators engaged with survey and record projects. Simple arithmetic will point to the possible number of photographs that were made under the rubric of "survey photography" and the number of people involved, even if we have lost archival sight of many of them.

I have restricted my study to England, not only for the sake of sanity, in terms of the mass of material, but also because it is interesting to look at the way England itself, and its ideas of history topography and locality, were articulated during a period when, in terms of national rhetoric, there was so much imperial glory and such a stress on the "Great" in Great Britain. There were also surveys in Scotland, notably Edinburgh and Dundee; in Wales, notably Glamorganshire; and in Ireland under the auspices of the Royal Irish Academy in Dublin, all of which largely follow the patterns and ethos I discuss here, but which also might complicate colonial readings of the survey.[101]

This book covers the period from 1885, the year of the first stirrings of the amateur photographic survey movement, to 1918, the end of the Great War. This periodisation might seem a little eccentric. Why not stop conventionally at 1914, the start of the Great War? The reason is straightforward: the values of photographic survey resonated through the discourses of nation during the war, and though taking photographs became increasingly difficult, the desire to record and archive was, if anything, enhanced and more urgent. It is only in the period immediately after the First World War that the surveys became more inflected with nostalgia and a sense of loss and reparation.[102] This was a fundamental shift in the dynamics that had informed late nineteenth- and early twentieth-century surveys. Furthermore, in 1916, at the midpoint of the Great War, *The Camera as Historian* emerged as the great ex post facto statement of survey practice. (See figure 10.)

The Camera as Historian, the presence and voice of which runs throughout this book, and which gives this book its title, was a *vade mecum* for photographic survey. The book began life as a lantern slide lecture of the same title about the work of the Surrey survey in about 1907.[103] In its 260 pages, the book covered everything

from a review of amateur survey work to date, to institutional structures and fieldwork practices, to debates on photographic style, printing, and storage techniques, providing what the reviewer from *The Architectural Review* described as "the fullest possible detail" and what the *British Journal of Photography* described as "painstaking thoroughness."[104] Dedicated to Sir Benjamin Stone, whose portrait adorned the frontispiece, and written by Harry Gower, Stanley Jast, and William Topley, who were all involved with the Surrey survey as either photographers or facilitators, *The Camera as Historian* was the culminating, utopian statement of the values and aspirations that had defined this amateur movement since Harrison's first delineation of the potential of survey.[105] The book provides a rich sense of the mindset and aspirations of those involved with photographic survey, and was widely disseminated, especially in public libraries, even if some of its potential impact was lost, appearing as it did, almost at the moment of cultural disappearance in the mud of Flanders.

The range and kind of materials from which I have drawn this study also require some methodological comment. Methodologies concerned with critical, forensic, and semiotic readings of photographs tend to have their roots either in a traditional art-historical address of single images or in psychology and visual communication. Such analyses tend to focus on the end product of the social and cultural process of photography. In this kind of study, the "social" and "cultural" provide "context" and thus explication for the generation for "image meanings" rather than bringing those processes themselves into the centre of the analysis. Furthermore, with such a mass of disparate images—of churches, cottages, manor houses, whipping posts, ancient trackways, shepherd's smocks, cattle, beehives, cathedrals, castles, the practice of folk customs, rood screens, dog-gates, funeral monuments, city streets, children's games—clearly an analysis of individual images is not only impracticable, but promises to obscure as much as it reveals. (See figures 11 a–c.)

The photographs in this book were selected for their being typical of a specific kind of survey image, for being relevant to the point under discussion. In a sense, they are interchangeable—there are many such photographs similar in style and content. Consequently, although I do, on occasion, address single images, my focus is "the photography complex"—the processes through which the photographs could emerge.

In his study of nineteenth-century novels, Franco Moretti has asked how we understand

10. *The Camera as Historian* (1916) (author's collection).

11a. "Sussex flail for Threshing." Photographed by A. Corder, 1905. Photographic Survey of Sussex *(courtesy of Sussex Archaeological Society)*

11b. Rood Screen, Lockington. Photographed by George Henton, 1903. Photographic Survey of Leicestershire *(reproduced with permission of the Record Office for Leicestershire, Leicester, and Rutland).*

11c. Detail of door jamb, Old Palace Croydon. Photographed by J. Hobson, 1905. Photographic Survey and Record of Surrey *(licensed from the collections of Croydon Local Studies Library and Archives Service).*

the dispersed fields beyond the canon. He argues that studies of the nineteenth-century novel have focused on about 200 works representing about 1 percent of the novel output of the period.[106] The same goes for photographs, for despite the expanding base of research, there remain many bodies of photographs underrepresented in writing on photography.[107] How do we account for the massive and bewildering array of photographs like those I have just noted? Heterogeneity is both the problem and the answer. Moretti argues that what is of significance are the shapes, forms, relations, and structures of this body of material. The recognition of pattern is also a vital methodological tool because as Matthew Engleke has commented, "One way in which anthropologists become convinced of getting it right . . . is through the recognition of patterns in the social life they observe."[108] Consequently, rather than being the sum of individual cases, such masses of photographs have to be understood as a collective system that expresses complex and linked values. What actually holds these photographs together as a coherent statement? Is it inten-

tion? Style? Materiality? Community? Function? Archive? We need to excavate an archive for "its regularities, for its logic of recall, for its densities and distributions, for its consistencies of misinformation, omission and mistake, along the archival grain."[109]

Overdichotomising contextual models that cluster around questions of cultural hegemony, memory practice, and modernity is problematic. As Christopher Pinney has argued, photographs cannot necessarily be reduced to "a 'truth' that simplistically reflects a set of cultural and political dispositions held by the makers of those images."[110] Nor should photographs be subjected to a sense of context that can become overpowering, which is always a danger in social-constructivist approaches to photography. As Frank Ankersmit has warned, "The gravitational pull of context" is such that context can drain the object or the subject, the thing itself, of content and its statement will be left with little to say.[111] While these dominant strands of analysis are important to consider and inform this study, I have tried to keep amateur photographers, their ideas, and their

images at the ethnographic centre of this study, in order to understand how the idea of photographic survey worked in terms of the experiences of photographers, rather than how the survey works in our experience as interpreters. My approach is deliberately eclectic, absorbing approaches to a greater or lesser degree from anthropology, history, the history of photography, art history, and the history of science. But ultimately, I would argue that my methodologies make this an exercise in ethnography and anthropology rather than in cultural and social history or the history of photography, although of course this book can also be read in those terms.

The photographic press is central in this study and should, alongside the archive itself, be understood as a primary source. As Jennifer Tucker has demonstrated, the photographic press created the sphere of debate through which values were made and unmade, and patterns of influence maintained. Furthermore, the photographic press produced a hybrid literature that was read across a wide social spectrum and that contained contributions from a wide range of interests.[112] The photographic press has been a rich resource, allowing me to track the broader picture of the survey movement, its contexts and collective mindsets, to pattern its ebbs and flows, its evangelisms and doubts, its experiments in fostering participation, its debates about photographic style and the translation of modes of observation, and the dissemination and the shifting foci of power within the movement. But the photographic press also provides an overview of the way in which the concept and practice of survey and record photography "sits" with other photographic concerns of the period.

Crucial for a consideration of the relationship between photography and popular historical imagination in this period is the way in which the debates about photography and survey, and thus about questions of history, memory, and knowledge production, enter the general press. Though *The Camera as Historian*, selling at 6 shillings, had a restricted audience, the photographic survey movement was reported in the local and national presses, in specialist architectural and antiquarian presses, and was at least acknowledged in publications as diverse as the *Church Family Newspaper*, which carried a lengthy interview with NPRA secretary George Scamell, and the socialist newspaper *The Clarion*, which carried, for example, an appeal from Ernest Goodman for volunteers to work on recording the disappearing buildings of London.[113] Thus, throughout the period, knowledge of the objectives of the movement, and more particularly, consciousness of the overt links between photography and historical imagination resonated over a very wide social range, even for people with no ostensible interest in either photography or the historical past or the opportunity to engage actively in such interests.

Despite the ambition and universalising and encyclopaedic claims for the overall survey project by advocates, such as Harrison and Stone, the survey's products, and perhaps the experience of the survey was, for many involved, fragmented and serendipitous. I have taken these points of instability or fracture as the foci for my discussion because they are where one can perhaps excavate the rhetoric of Stone, Harrison, and that of the more enthusiastic and extravagant press debates. Such an excavation not only uncovers the ambiguities in the ideology of the survey movement and in the practice of amateur photography. The excavation also illuminates a debate about what photography itself is, what it was "for," and for

whom. The chapters of this book are, therefore, overlapping, for there is no neat linear progression to be laid out; rather, a series of themes — of the social efficacy of photography, of memory practice, of modernity, of sociability, of individual and collective endeavour — run through all the chapters here. The points of fracture inherent in the ambiguities of the amateur survey movement as it attempted to realise its objectives constitute different vertical incisions into these major themes.

"A Credit to Yourself and Your Country"

Amateur Photographers and the Survey and Record Movement

In June 1885, W. Jerome Harrison read a paper at a meeting of the Birmingham Photographic Society. In it he presented systematic photographic surveys by amateur photographers as a fitting focus for a local photographic society. He stated unequivocally that "much useful work . . . may be done . . . by securing accurate representations of old buildings," for that work would thereby furnish "a record for posterity" whose accuracy "could not be disputed" and whose "interest in the future would be great." This record could be realised through the endeavours of amateur photographers, the "multitude of new hands."[1]

Increasingly, amateur photography was not, in the context in which I am discussing it here, simply a technical or aesthetic practice or a discursive ideological practice. Amateur photography was based in a series of values articulated through social practices, networks, and complexes that constituted, in a Latourian sense, a mesh of connections between human photographers and non-human "objects": objects that ranged from the interactions of photographers and the materiality of the camera itself to landscapes and ancient churches. As such, the identity of the survey movement can be said to be forged from two connected strands. First was the realisation of the concept of systematic practice through the mechanical character of the camera. Second was the harnessing of new ways of managing attention and thus observation and knowledge production, which could be focused within the expanding field of photographic engagement as represented through the networks of amateur practice such as camera clubs.[2]

PHOTOGRAPHY AND THE
IMPULSE TO RECORD

Between 1885 and 1889, the first proposals for systematic survey through the endeavours of amateur photographers began to emerge, informed by a carefully formulated discourse of memory practice, social duty, and technical potential. The first suggestion for an amateur photographic survey came perhaps from the Boston Camera Club in the United States, which announced in a letter to *Amateur Photographer* in April 1885 its intention "to make negatives and lantern slides of from 75 to 100 leading objects of interest in and about its city," the results of which were circulated for the consumption of British photographic societies and were shown at Liverpool, among other places.[3] By the late 1880s, laudatory notices in the photographic press of intended surveys began to emerge. Surveys of "The Hundred of the Wirral" by the Birkenhead Photographic Society in June 1888 and a survey of the city of Sheffield in 1889 were reported; and others, organised by counties, cities, or towns, were soon founded across the country, aligning themselves, sometimes retrospectively, with the principles of Harrison's vision of "useful work."

There were similarly shaped proposals in a number of disciplines, for example, in archaeology, architecture, anthropology, and botany. One of the very earliest was in connection to geological fieldwork in a paper read at the Liverpool Amateur Photographic Association in 1886 by Osmond Jeffs, in which he noted that "an entirely new field is open" to the "large body of active workers who [were] anxious to employ their cameras in some new field of utility, namely the formation of a collection of photographic views illustrating the geological views of each county."[4] As Harrison

had, Jeffs outlined a scheme to harness the energies, observational skills, and techniques of amateur photographers to produce a collection of photographs of geological features, and in words and sentiments similar to Harrison's, he argued that such endeavours opened "an entirely new field" to the amateur photographer "who was willing to exercise his abilities for the advancement of science."[5]

Harrison himself had first become interested in survey as a scientist, and in an immediacy of visual knowledge that would bring the learner "face to face with the facts of nature."[6] The recording of historical topography was, for Harrison, just one facet of an imaging capability that was, literally, universal. Linked to the emerging wave theory of light, a theory of which Harrison would have been aware, but also linked to earlier ideas about light, was the concept that images travelled from earth into space, recording the planet's history in great detail—a kind of giant celestial photographic negative. Harrison noted enthusiastically this universal scope of photographic inscription in a statement redolent of an historical imagination:[7]

It is a wonderful thought, that every action which has ever occurred on this sun-lit Earth of ours—or indeed, for that matter, anywhere within the illuminated universe—is recorded by the action of light, and is at this moment visible somewhere in space, if any eye could be there placed to receive the waves of light . . . speeding away from our orb, which would now be visible only as a star . . . [so that] we should pass in review the lives of our parents and ancestors, History would unfold itself to us. We should only have to continue the journey long enough to see Waterloo and Tra-

falgar fought out before our eyes; we should learn the truth as to the vaunted beauty of Mary Queen of Scots; and the exact landing place of Julius Caesar on the shores of Britain would no longer be a mystery. If we had the curiosity to ascertain by ocular demonstration, the truth of Darwinian theory, a still more extended flight would disclose the missing links—if such existed—by which man passed from an arboreal fruit-eating ape-like creature to a reasoning omnivore.[8]

The visual, and the photographic in particular, became not merely a voyeuristic "world as spectacle," which some commentators have claimed was the basis of Harrison's statement, but also the means through which historical excavation could take place, through which truth claims could be tested, and through which understanding would emerge. These processes were based on ideas of scientific endeavour and scientific objectivity that saturated the discourse of the surveys. In general, these expansive visions for photography were taken up by the photographic press, who reported a wide range of photographic practices and engagements to appeal to an increasingly wide range of amateur practitioners. Survey and record photography became one of the press's enthusiasms, as its reporting and discussion assumed both formative and reactive roles.

Although the ambitions and values of the surveys were less overtly expansive, they can be seen as applying scientific ideas to localised endeavours of objectivity, mechanical reliability, and archival longevity. The surveys formed a cohesive historical statement, in that "such photographic records [would] before long become the one thing needful in connection with every country, society, or body having interest in its history, or other body having any inter-

est in its history being handed down to posterity, [would] be apparent to all."[9] In 1889 Harrison produced the first extended statement of the systematic organisation and management of photographic survey endeavours in a paper read at a joint meeting of the Birmingham Photographic Society and the Vesey Club, a local natural history society at nearby Sutton Coldfield. Widely reported and circulated, the statement also broadened the debate about the desirability of survey, the nature and purpose of the archive, and, by implication, the nature and purpose of photography itself. In his paper, Harrison outlined not only the case for and scope of survey in relation to local Warwickshire history, but a plan for the structure of the survey's own committee, a plan for raising subscriptions, and for relations with land and property owners. Harrison also expounded on photographic subject matter and the practices of photographers. In May 1890, the Photographic Survey of Warwickshire was founded as the council of Birmingham Photographic Society resolved to establish "a section of the BPS . . . with separate subscription and controlled by separate officers for the carrying out of a photographic survey of the county of Warwickshire."[10] The structure, principles, and objectives of the Warwickshire survey, with its extensive coverage in the photographic press, became central to the survey movement in its early years as the concept of photographic survey and the role of amateur photographers as inscribers of history moved centre stage.

Encouraged by the response to the Warwickshire survey, Harrison lost no time in expanding this vision to the national field a couple years later in 1892, with his call for a National Photographic Survey and Record. In it he reiterated the structures, principles, and material practices he set out for Warwickshire in 1889.

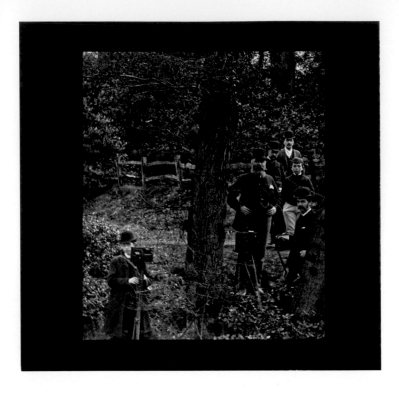

12. "Mr Fowler and Mr Godfrey" on an excursion of the Warwickshire Photographic Survey, 1894. Lantern Slide *(courtesy of Birmingham Library and Archive Services).*

organised in cities, towns, counties, and workplaces, although this list is far from complete, and almost weekly the pages of the photographic press report the foundation of new clubs and societies. These organisations range from the great photographic societies that emulated learned societies to less socially exclusive and formal, and to camera clubs such as those based in workplaces, YMCAS, and mechanics institutes. (See figure 12.) There were national societies, such as the Royal Photographic Society of Great Britain and the Amateur Photographers' Society of Great Britain, and a plethora of album clubs and postal camera clubs exchanging prints for aesthetic critique (although some specified "advanced workers only"). Some postal camera clubs exchanged lantern slides according to subject interest, including an interest in "record" slides.[12] The idea of photographic survey was embedded in the sociability of this extensive network, which itself marked the social shifts in camera use.

There were well-known surveys, coming out of major camera clubs, with national and even international connections, such as the Birmingham Photographic Society, the Warwickshire Photographic Survey and the Manchester Survey undertaken by the Manchester Amateur Photographic Society between 1893 and 1900. The concept and practice of photographic survey was, however, embraced at all levels of amateur photographic engagement and of its social and scientific networks. For example, the survey in Barnstaple, Devon (1892), was initiated by the Barnstaple and North Devon Photographic Society. The survey in Chiswick was started by the West London Photographic Society (1893), and Darwen, in the north of England had a survey by 1895, organised as part of the Darwen Photographic Society. Others, such as the surveys in Dorset (1894) and Somerset

He also positioned the endeavours of amateur photographers as "a new power," and outlined survey efforts that were linked to photographic applications in geology, astronomy, and hydrography, while at the same time historically linking those efforts to the Domesday Book. He reiterated the importance of photographic survey: "The desirability of mapping or depicting scenes and places of which our senses take cognisance has long been patent." Consequently, Harrison urged, survey photographers were "to fix the fleeting features of the epoch in which we live and hand down to posterity the 'outward and visible' state of things as they existed."[11]

The core of the project, however, lay in amateur photographic practice, so it is unsurprising that many projects were founded by photographic societies and camera clubs. These burgeoned at the end of the nineteenth century. The *British Journal Photographic Almanac* for 1900 lists some 190 societies across England

(1892), were started by photographic sections of natural history and archaeological societies, or in the case of the Nottingham survey (1893), the camera section of the Mechanics Institute was the founder. There was another flurry of foundations after 1900: the hugely influential Photographic Survey and Record of Surrey (1903), as well as, for instance, organizations in Hull (circa 1901), Brentford (circa 1904), Kent (1904), Huddersfield (circa 1908), Essex (1906), Exeter (1911), and Norwich and Norfolk (1913) (see the appendix). In terms of organisational structure, some surveys were simply run as part of the general activities of the organising societies, such as the survey of Somerset, a model that seldom seems to have been successful, lacking the sense of focus and community that became the hallmark of much survey aspiration. Other projects were organised by special committees within originating bodies (this was Harrison's model for Warwickshire), but operating with a greater or lesser degree of independence, and with their own rules, membership fees, and committee structures—other examples of this structure are found at Norwich and Leicester. I have identified at least seventy-three examples of English surveys that had varying degrees of longevity, both intentionally and unintentionally. There were time-limited projects set up for specifically defined goals, such as those projects at Rotherham and Woolwich, which were disbanded at the perceived end of the project. Others lasted for many decades, with varying degrees of intensity, such as those at Surrey, Warwickshire, and Worcestershire, whose activities lasted well into the twentieth century, and which have enjoyed a number of resurrections.

The pace, rhetoric, and public perception of photographic survey changed radically in 1897, with the foundation of the National Photo-graphic Record Association (NPRA) by the ebullient Birmingham industrialist and Member of Parliament for Birmingham East Sir Benjamin Stone.[13] Stone, an avid, if not obsessive, amateur photographer and collector, had been closely involved with the Warwickshire survey, supporting Harrison's plans through the Birmingham Photographic Society, of which he was president. Significantly, the NPRA was founded in the year of Queen Victoria's Diamond Jubilee—a festival of intense nationalist and imperialist sentiment—and was seen as part of a fitting tribute to Her Majesty. However, the NPRA's national aspirations remained dependent on the endeavours of precisely the same amateurs in local photographic societies and camera clubs who were the backbone of the local surveys and who were asked to submit photographs to the NPRA from those local surveys. As the secretary of the NPRA wrote to the nascent Cambridgeshire Survey, "We are anxious to have Local Sect[ions] throughout the country and have already received offers of help in various parts."[14] It was made clear from the outset that the NPRA did not intend to usurp local activities but move the recording and archiving activities of amateur photographers onto the national stage, creating a central resource that was to be deposited in the British Museum. The plans for the revived Leicestershire survey in 1901 made the plan for this dual archiving clear: "When completed [the NPRA] is intended to publish this information for the benefit of all, and to deposit one copy of the photographs taken at the British Museum and another at a central place in Leicestershire, probably the Museum in Leicester."[15]

The subscription to the NPRA was one guinea a year, or the donation of six platinum prints, whereas, for example, the Warwickshire Photographic Survey subscription was two shillings

and sixpence (half a crown), as it was for Surrey group. Participation in the later Exeter survey was free to all. In return for this "subscription" the NPRA would mount and deposit in the British Museum all acceptable photographs sent to it. It would also supply mounts at wholesale prices and help at meetings, lectures, and exhibitions.[16] Considerable political and social weight was put behind the establishment of the NPRA as Stone, using his authority as a member of Parliament, lobbied the trustees of the British Museum to accept this national memory bank in a way that Harrison perhaps could not: "The Trustees are in full agreement with you that such a records survey collection, if carefully and systematically brought together, cannot fail to be of the greatest value and interest both to the present and to future generations."[17]

The inaugural meeting of the NPRA in the Midland Grand Hotel, St. Pancras, London, demonstrated Stone's ambitions for the association. The meeting was attended by representatives of learned societies and other men of influence who provided a suitable, collective figurehead with high-profile connections in, variously, the Royal Society, the Royal Photographic Society, and the Society of Antiquaries. The latter, influenced by Harrison and the Warwickshire Survey, had attempted to initiate their own photographic survey of antiquities in 1893–94.[18] Under Stone's direction, rules were drawn up for the production of photographs for the NPRA. These followed earlier guidelines, especially Harrison's rules for the Warwickshire Survey and "others" — probably the Societies of Antiquaries' scheme, 8,000 copies of which were circulated. Furthermore, Stone came to the meeting with a commitment from the trustees of the British Museum to provide a home for the archive of what Stone

perceived to be national identity, the importance of which was reiterated by the presence at the inaugural meeting of Sir Edward Maunde Thompson, principal librarian (that is, director) of the British Museum. The act of archiving at the British Museum was integral to the NPRA's claims to authority and was reiterated continually in the reporting of the NPRA's activities. Indeed, there could be no more fitting place for the archive, the British Museum being the symbol of national identity. that the NPRA claimed, "A national photographic record and survey collection should be added to the enormous store of national objects in the great building in Bloomsbury."[19] This was backed up by an energetic press campaign, with the apparently avuncular Stone as its champion, which not only disseminated the survey ethos but made very public a specific view of what photography could and should be.

The concepts of photographic truth and the value of photographs to posterity that Stone espoused had certainly also been part of Harrison's vision for survey, but with his new status and contacts as a member of Parliament, Stone moved the concept of photographic survey onto the national stage, effectively marginalising Harrison, whose efforts he had initially facilitated.[20] Harrison had also fallen foul of the photographic establishment, notably the Royal Photographic Society, having been revealed as the author of pseudonymous articles, "English Notes," under the name of Talbot Archer in the U.S. photographic journal *Anthony's Photographic Bulletin*. In these articles, the photographic establishment had been attacked as fossilised and unimaginative, especially for its opposition to Harrison's plans for survey.[21] Nevertheless, Harrison remained active on the international scene, notably presenting a paper calling for the establishment of the Interna-

tional Bureau for Photographic Survey at the World's Columbian Exposition in Chicago in 1893.[22] Harrison worked with Leon Vidal, who was actively engaged in survey and documentation archives in France and in the development of educational and scientific photography. Despite reiterating his scheme for county surveys at the meeting of the British Association for the Advancement of Science (BAAS) in York in 1906, possibly an indication of his frustration with the content and achievement of the NPRA up until then, he effectively withdrew from the further local developments in the photographic survey movement.[23]

This left Stone to develop his more dogmatic and less scientifically based idea for "history photographs." Stone, through his close association with the Warwickshire Survey and with the NPRA, was held up in the photographic press instead of Harrison as the most successful exemplar of survey endeavour. It was Stone and the NPRA that became the point of reference for survey activity—for instance, the revived Leicestershire Survey of 1901–1902 used the NPRA's rules and mounts, and the NPRA's influence is clear even for those such as the Surrey Survey, which reformulated and expanded that vision. Stone spoke at the inaugural meetings of survey projects and dispensed encouragement in letters to branch secretaries. He spoke at the foundation of the Surrey Survey for instance, while the NPRA secretary George Scamell gave lectures on the virtues of photographic survey at the Photographic Convention in Newcastle in 1900 and circulated a lantern slide lecture to be read at photographic societies and clubs, such as happened at Leicester in 1898, at Redhill and District Camera Club in 1899, and at Croyden Camera Club in 1902, whether or not they actually initiated a survey. Combined with his personal influence and status, locally,

nationally, and increasingly internationally, Stone became associated with survey in the public imagination. He was nicknamed "Sir Snapshot" and "Knight of the Camera" in the contemporary popular press and indeed has become synonymous with survey in the canons of the history of photography.

This position has tended to overshadow, in historiographical terms, significant local surveys that constituted themselves as independent survey and record societies, although this model was limited—Surrey and Exeter were the most successful. Although they drew their membership from the same networks of photographic societies and clubs and archaeological and antiquarian societies, they were nonetheless structured and configured in ways that addressed the complexities of survey activity. They saw their role as avoiding the contested practices of photography which had, as they saw it, hampered and distracted survey endeavours elsewhere. But this was not strictly true; one can point to the general success of the Warwickshire Survey, firmly embedded as a subgroup within the Birmingham Photographic Society. The foundation of a separate survey society, however, was seen as a way of negotiating the conflicts of interest and rivalries, and the different tastes and aims of local societies. In many ways, this structure owed more to Harrison's vision of record and survey than to Stone's. The problem of negotiating and cohering a disparate body of interests around photographic practice, which was both inclusive but cutting across specific interest groups, is made clear by *The Camera as Historian*: "A special Survey Society, having no aims or interests conflicting with those of its component parts, is free from certain jealousies which might conceivably arise if any one society, whether Learned or Photographic, sought, by claiming the aid of others,

to place itself in a position of quasi-seniority."[24] Tensions of this sort appear to have truncated the surveys in Sheffield, Somerset, and Leicestershire. In the case of the Leicestershire survey, there was a tension between the Leicester Photographic Society, which had originally initiated the county survey in 1898, and the more socially prestigious Leicester Literary and Philosophical Society that overrode this endeavour with their own project in 1901, adding insult to injury by demanding a £5 subscription to something the Photographic Society felt was their project. Consequently, the Photographic Society withdrew from the survey project, claiming, "The objects of the Joint Survey Committee [are] foreign to that of our own Society," and leaving the Literary and Philosophical Society without the range of technical skills required for the survey.[25] In Sheffield, the attempts by museum curator Elijah Howarth to start a photographic survey in 1889 foundered after public displays of acrimony played out for all to see in the pages of the local press. As Mr. Maleham, secretary of Sheffield Camera Club, wrote: "Mr Howarth admitted that he did not have any practical knowledge of photography, and therefore was certainly in no . . . position to lay down and adhere to, hard and fast lines for a photographic survey."[26]

What is clear is that whatever the local and national politics of such endeavours, they spread across a marked variety of locations, from major metropolitan, industrial cities, such as Manchester, which embraced a broad social and political mix, to the rapidly modernising towns and cities, such as Exeter and suburbanising spaces such as Essex and Surrey. More conservative counties, such as Dorset, also founded surveys. The more successful surveys tended to be based in larger urban spaces, such as Birmingham, Manchester, and Leeds (even

if their photographic remit was geographically broader) or, after 1900, in the suburbanising southeast of England. There are a number of reasons for this. The one constantly reiterated by commentators is that the nostalgic metropolitan longing for the rural, edenic, and idyllic space of authenticity and undisturbed social order was articulated through the aesthetics of the picturesque.[27] This is indeed one of the formative elements of the survey movement, and there is a sense in which increasing urban mobility projected metropolitan aesthetics and sentiments onto rural spaces. But there are, I think, other reasons for the differential success rate of the various surveys. The demographics of urban spaces were able to deliver the critical number of people with interests in, variously, photography, history, architecture, and archaeology, people whose networks could cohere as a body of amateur practitioners and realise survey objectives. Considerable support for the surveys came from an expanding lower middle class and from upwardly mobile, skilled artisans who tended to be urban based—that "multitude of new hands." Rural communities were not only more dispersed geographically, which attenuated social networks, they lacked the critical massing of those new hands on whom survey depended. In the counties, the shape of social networks still revolved largely around traditional patterns of upper-middle and middle-class sociability, with a smaller new technical middle class and a much more limited working-class mobility (the rural mass of agricultural labourers were among the poorest and most dispossessed sectors of British society at the time).

The Dorset survey demonstrates this very clearly. With the exception of a few local, professional photographers, all the survey's contributors belong to the traditional upper-

middle and gentry classes—rural clergymen, local solicitors, and doctors. One of the reasons given for the ultimate failure of the Somerset survey is the absence and inadequacy of concentrations of photographic skill. It would appear that ideas for a Devonshire survey organised by the Devonshire Association, which preceded the urban-based association in Exeter by some fourteen years, never really got off the ground for similar reasons. The 600 "sets of photographs" that were expected never seem to have materialised and the survey disappeared from the record.[28] These examples, and there are others, demonstrate the fundamental social hybridity of the movement and the way in which the movement emerged from and represented different strands of interest—photographic, archaeological, historical, architectural, and even natural historical. The attempt to homogenise, discursively, rhetorically, and practically, these disparate, and sometimes hierarchical, amateur practices as they clustered around the production of photographic images, which constitute the points of fracture in the survey movement, limited its achievement.

At one level, the movement emerged not only as a "real" community of photographers acting together, but as an imagined community, as Benedict Anderson has famously described such social and cultural configurations. The movement comprised groups of people not necessarily communicating directly with one another, but bound by common values, modes of imagining, and technical practices, groups articulated as "print communities" through the photographic press.[29] What unites the various survey projects is their cohesive sense of purpose, attempts at institutional rigour, and an engagement with the historical imagination, represented through the density of an historically constituted topography. But at the same time, the surveys were linked to very clearly differentiated identities, especially those clustering around ideas of historical space. Consequently, it would be a mistake to see the movement as homogenous or to over-reify it. The movement is characterised by unevenness and by points of fracture, photographically, intellectually, and socially, which offer a reading of the movement different from the high-profile rhetorics of the movement itself.

What gave this disparate group its identity were the attempts at structural and institutional rigour in the inscription of the traces of the past in the present and the production of photographs. The aims, objectives, and organisational structures that emerged in Harrison's delineation of amateur survey photography remained core to the concept and realisation of photographic survey in the period from 1885 to 1918. As late as 1913, J. Bowker stated at the inauguration of the King's Lynn survey:

> The idea is to collect & to preserve photographs of historic places, things passing events, natural history subjects &. . .— particularly photos of such subjects as are liable to change or improvement—so that, in years to come, posterity may have a faithful record of what has existed in the past— not only in single collection instead of, as formerly, in various places and numerous publications: but a record made by the Camera and hence exact in every detail as distinct from the inaccurate representations (sometimes flagrantly so) made by the old processes.[30]

Rather it was the intellectual, social, and technical context in which the survey operated that shifted. Harrison's suggestions, and indeed Stone's, came out of the applications of photog-

raphy itself. It was photographic practice rather than antiquarian or archaeological practice that was at the centre of the endeavour and its conceptualisation, and it was, at least at the beginning, largely photographic concerns that were addressed. However, addressing photographic concerns was not unproblematic, because such projects demanded not merely photographic skill but a variety of historical and observational skills. In many ways, the debates over photographic survey, over its realisability and efficacy, were debates about the quality of observation, statement, and knowledge production. So while photography was at the core of these endeavours from the beginning, the constitution and organisation of photographic surveys were seldom purely photographic. For instance, in initiating the Norfolk survey in 1913, secretaries of local learned societies were invited to a special meeting at the public library, meetings "at which the proposed Norfolk Photographic Survey will be explained and the co-operation of local societies invited." And no less than 33 of the 113 members of the Surrey survey in its first year were there as representatives of local learned societies, and a similar pattern structured the revived Leicestershire survey of 1901 (see the appendix).[31]

By the early years of the twentieth century, the structural basis of the survey movement was beginning to shift on its axis. Mindful of the problems in realising the public utility of the surveys, members of the survey movement cultivated formal relationships with the civic structures of rational leisure and public education, and with infrastructures of modern knowledge production, namely museums and free libraries. Although surveys continued to be established on the original model through photographic societies and clubs and photographic sections, for instance, the links with public libraries, mu-

seums, and local authorities became stronger and the emphasis, broadly speaking, shifted from the photographic itself, to broader agendas that were constituted through the photographic.

There had been, of course, a link between the survey movement and libraries from the outset. For instance, the short-lived Staffordshire survey was founded in 1892 directly by the local free library, while the Warwickshire survey was deposited in Birmingham City's reference library from its foundation and had used the city's art gallery for its exhibitions since 1892, a relationship that grew closer in the early years of the twentieth century. Kent (founded in 1904 under the auspices of the South East Association of Scientific Societies, which had also encouraged the Sussex survey on the model provided by Surrey), Norfolk and Norwich (founded in 1913), and King's Lynn (1913) all had close working relationships with local libraries and museums, which were seen as an increasing force as the power base moved from the photographic societies themselves.[32]

Thus, despite the expansive rhetoric and claims to universality of the NPRA, Surrey set the new standard for survey activity in the period immediately before the First World War, eclipsing both Warwickshire and the NPRA. Surrey's importance demonstrated the shifting social base of survey activity towards a more clearly articulated scientific model, one with increasingly strong and direct links to public utility. As early as 1906, this was indeed the NPRA's own assessment of the situation. The drop in the number of contributors to the NPRA was presented as a natural consequence of the success of local surveys: "This we cannot regret [the NPRA claimed] so long as records are being made and deposited for public use."[33] Stone himself conceded, "In a majority of cases

they [local collections] are more readily accessible than one of the large dimensions which the national collection must inevitably assume, and further, the stimulating effect on photographers to carry on the work to completion is bound to be greater when the fruits of their predecessors' labours are at hand to be seen and studied."[34] While the NPRA had clearly never intended to eclipse local endeavours, its dominant rhetorical position could not be sustained in an ever-broadening photographic agenda. When the NPRA was disbanded in 1910 and attempts were made to bring extant societies and sections under the rubric of the National Federation of Photographic Survey and Record Societies, the members of the Surrey Survey were the principal movers, wresting control from a moribund NPRA and challenging Stone's conservative vision for photography to create a newly figured liberal programme of public improvement and participation overtly clustered around the values of the free library and the increasingly democratic reach of photography itself. One observer remarked of the founding meeting of the federation that "a noteworthy feature was the attendance of librarians and others who, though not themselves photographers, declared their keen interest in making record photographs."[35]

The federation's goal was to collate and disseminate photographs, to advise photographers, and, above all, to maintain the social relations and connectivity of the survey community. The taking and collecting of photographs themselves were left to local amateurs. This was an attempt to impose a system and conformity on survey practice. As *Amateur Photographer*, a constant supporter of survey and record photography, commented, "The proposed Federation is, therefore, a move in the right direction, as it will possibly enable information as to the best methods of survey work in this country to be collated and dealt with in a more systematic way" (see the appendix).[36]

The idea of a national federation was not new. The concept had been part of the debate about the best way to organise survey activity and to cohere the values of photographers from the earliest years of the movement. However, the founding of the federation in 1910 could be seen as a vindication of Harrison's hitherto marginalised vision, for as his paper from 1892 stated, a federated national survey had always been his intention. If the federation never made the impact to which it aspired, nonetheless it did much to raise the profile of photographic survey and appears to have been the impetus behind the final production of *The Camera as Historian*, which became the statement of ideal practice and aspiration for the survey movement, just at the moment when the ethos of photography, national and local identities, and the historical imagination were undergoing radical realignment under the pressures of the First World War.

ASSOCIATIONS, NETWORKS, AND PHOTOGRAPHY

While Reverend Thomas Perkins of the Dorset survey stressed the collective in claiming that to be of "the greatest use, individuals should be associated together in bodies . . . so that complete collections may be formed," the survey movement was made up of individuals with their own ideas of what photography could or should do, and what might constitute the historical.[37] Remarkably little work has been done on the experience of amateur photographers, outside those who are seen as making "significant" contributions to the canons of the history of photography. The occasional excursion is

made into the work of amateur photographers whose appeal and challenge is often that they were and sometimes remain anonymous. However, it is crucial to understand in detail what kinds of people were involved in the movement and what their claims to local and national history might have been.

Faced only with an archive and a series of ideologically loaded analyses, the commentator might be tempted to see the surveys as simply an exercise in nationalistic collective memory, nostalgic or otherwise.[38] From this perspective, the ways the surveys were actually experienced by people, both producers and consumers, in sets of embodied social relations that produced photographs is easy to overlook. As an imagined community, the survey movement emerged from and was sustained by very real sets of relationships between individuals, social groups, and bodies of knowledge. An idea of photographic survey produced and realised through the sociability of amateur photographers was fundamental to the identity of the movement. These relationships—the idea that "all photographers are brothers"—were manifested in the photographic societies in particular, which were crucial in the conception and realisation of photographic survey.[39] They determined the making and circulation of the photographs, for as one commentator in *British Journal of Photography* said: "We commend photographic record to every photographic society, however small. It should form an incentive to co-operation among the members of which many a society sadly stands in need."[40] Photographic societies linked survey endeavour to local and broader patterns of patronage and association, and thus to channels of influence in which, perhaps, differences and rivalries were dealt with through a network of voluntary organisations in which people could come together despite differences of opinion and ideology.[41]

The majority of contributors to the surveys were what could be loosely described as middle class or white collar workers. (See figure 13.) By the late nineteenth century, the middle class comprised an increasing social mix and range of professions that made up local clusters of power and influence on town councils and in the structures of modernity, such as hospital and charity boards, forming a heterogeneous group. This group made up a "dense web of economic networks and social relationships which bound together different geographical and occupational groupings . . . in ever more complex and reciprocal ways." A series of linkages developed in civil society at complex levels of social, political, and business organisation that constituted middle-class consciousness.[42] This is reflected in the patterns of association found in camera clubs, which brought together photography as a hobby with relationships that made greater social mobility as possibility. As such an increasing number of people constituted the social networks out of which the survey movement emerged.

The two most substantial groups in the middle-class network were, however, the older upper-middle class of the minor gentry, made up of those in the "noble" professions of law, medicine, and the church, and the newer and expanding middle class comprising both new professionals and the metropolitan class, a group made up of local government officers, librarians, engineers, architects, and upwardly mobile tradesman and skilled artisans. The new middle class was entering a photographic environment expanded and liberated from gentleman experimenters and commercial trade photographers. This is not to say that these two

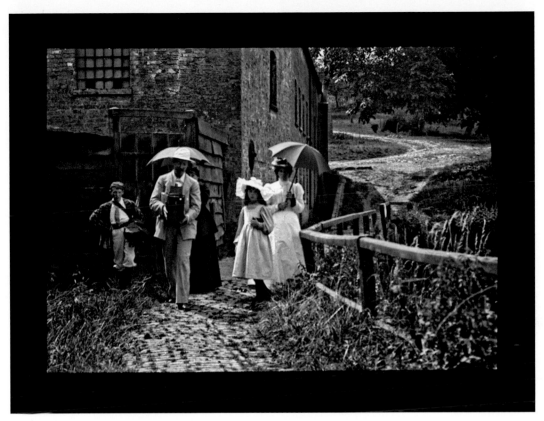

13. The Baynton family on a photographic outing on the River Avon, 1900. Lantern Slide
(courtesy of Birmingham Library and Archive Services).

pillars of the photographic community did not contribute to the surveys; they did, but they were far outnumbered by those from the new middle classes. However, while the surveys remained, in the broadest sense, largely a middle-class concern, it would be a mistake to reduce the movement to this, for unlike folklore and folk song collection in this period, for instance, the surveys were not simply "a metropolitan clique with networks into rural hierarchies."[43]

While skilled artisans, such as William Ellis, a Nottingham lace gasser, or Frank Parkinson, a Spalding bricklayer, constituted only a small number of participants in the survey movement, a large proportion of the survey photog-

raphers, possibly as high as 40 percent, would appear to be fairly low-status white-collar workers or trade workers such as drapers' assistants.[44] "Clerk" in particular was an occupational category that covered a massive range in the nineteenth century and the early twentieth, a category that, like elementary school teacher, offered social mobility, especially between the upper working and lower middle classes.[45] Contributors to the surveys reflect the range of the occupation of clerks. On the one hand, for instance, James Marchant, clerk to the Duke of Bedford, contributed to the NPRA and demonstrates the full range of established middle class networks. He was a fellow of the

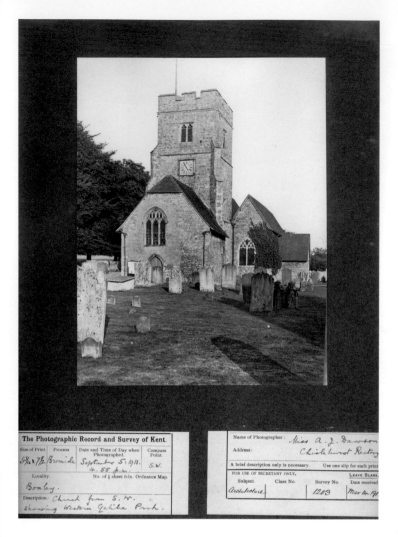

The Photographic Record and Survey of Kent.

Size of Print	Process	Date and Time of Day when Photographed.	Compass Point.
5½₁₆ x 7½₂	Bromide	September 5; 1911. 4. 55 p.m.	S.W.

Locality. Boxley.

Description: Church from S.W. showing Western Galilee Porch.

Name of Photographer :	Miss A. J. Dawson
Address :	Chislehurst Rectory

A brief description only is necessary. | Use one slip for each print

FOR USE OF SECRETARY ONLY. | | | LEAVE BLANK.

Subject	Class No.	Survey No.	Date received
Architecture		1203	Mar the 191

14. Boxley Church. Photographed by Miss A. J. Dawson, 1911. Photographic Survey of Kent *(courtesy of Maidstone Museum and Bentlif Art Gallery).*

tographers. For instance, Mary Hobson made substantial contributions to the Surrey survey with her father Dr. J. Hobson, while Elizabeth Peake, in Norwich, whose husband was chairman of the Norwich and District Photographic Society, was active in the Norfolk survey, and in the Norwich Ladies' Camera Club. Other women appear to have been independent hobbyists, such as Miss A. J. Dawson, a clergyman's daughter from Chislehurst in Kent (see figure 14); Iris Niblett from Ledbury in Herefordshire, who won a survey competition held by *Amateur Photographer* magazine in 1906; and Mary Hare of Exeter who made superb platinum and carbon prints for the Exeter Pictorial Record Society.[46] Some women were professional photographers, such as Mrs. G. Swain of Norwich or Marianne Wall, a studio portraitist from Southport in Lancashire, at a time when an increasing number of women were entering the photographic business as practioners. The most notable female contributor, especially to the NPRA, was Catherine Weed Barnes Ward, who not only edited *Photogram* magazine with her husband, Henry Snowden Ward, but was a member of the committee of the NPRA and was responsible for drafting its rules and regulations. American by birth, she did much to further the cause of photography as a suitable profession for women on both sides of the Atlantic.[47] A fine topographical photographer, she contributed a substantial series of photographs of medieval church fonts to the NPRA, intentionally limiting her scope in the interests of thoroughness and system. She later contributed photographs of prehistoric and medieval antiquities to the Photographic Survey of Kent. This active involvement of women can be seen as part of the gradually expanding role, in both scale and social demographic, of women in civil society, as they took up active hobbies and were

Royal Photographic Society, was on its committee in 1901, was on the NPRA committee, and served as president of the North Middlesex Photographic Society. On the other hand, Frank Wood, of the Surrey survey, was a clerk in the local gas company and the son of a solicitor's clerk, while one of his sisters was a school teacher and the other a dressmaker.

Women were also active in the surveys. At least 13 percent of the photographers were female, but other women have probably gone unidentified, obscured beneath mere initials in the survey records. Many of those women identified had kin connections with other survey pho-

increasingly involved with the networks attendant on these activities. They served on committees, they exhibited their work and gave lectures. Alice Geldart, for example, was on the committees of both the Norfolk survey and the Norwich and Norfolk Naturalists Society.[48]

It is impossible in most cases to excavate individual reasons for involvement in the survey movement. Participation was, of course, determined by access to a certain level of photographic technology, leisure, and mobility, but participation was also determined by scientific interest and photographic enthusiasm. The structures of feeling, as Raymond Williams has called them, "the particular living result of all the elements" of cultural experience, were possessed in multiple ways by different members of the same community.[49] Some contributors, it would seem, were not particularly interested in photography. For them, photography was merely a means to an end, the recording of things that interested them. This is especially so of the "antiquarian" photographers like George C. Druce of the Surrey survey and member of Surrey Archaeological Society, whose photographs clearly follow his antiquarian interests in medieval churches, on which he published extensively. (See figure 15.) George Embrey, of the Gloucester Survey and member of the Bristol and Gloucester Archaeological Society, also photographed churches.[50] Robert Brereton made a detailed study of Somerset church towers, the negatives for which he bequeathed to the NPRA. For others, the technology and aesthetics of photography were the primary interest and survey was an incidental, though worthwhile, adjunct. This characterisation would seem to apply to many of the early contributors to the Warwickshire survey, such as A. Leeson, Harold Baker, William Greatbatch, and E. Middleton, who

15. Benchend, Nutfield Church. Photographed by G. C. Druce, 1904. Photographic Survey and Record of Surrey *(reproduced by permission of Surrey History Centre. Copyright of Surrey History Centre, 7828/2/111/17).*

16. Long Compton, Warwickshire. Photographed by Harold Baker, c. 1890 *(courtesy of Birmingham Library and Archive Services).*

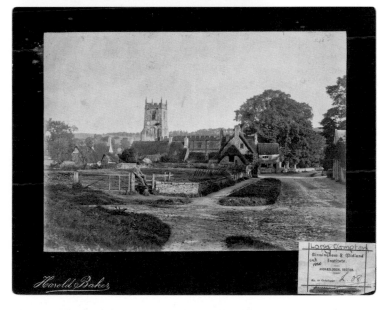

had demonstrably wider photographic interests that resonate through their survey contributions (see figure 16). Yet few photographers would seem to have aspired to the upper echelons of photographic production of the period.

Of some 1,000 active survey photographers, well over a third can be identified as having been connected to photographic societies and clubs, but only thirty-seven of them were connected to the Royal Photographic Society. Those thirty-seven fell into two clear groups. They were either higher-class individuals, such as lawyer Basil Lawrence, who was also on the NPRA committee, and Reverend C. J. Moncrieff Smyth, a keen amateur who was, as Lawrence was, a member of London's prestigious Camera Club. Such major institutions constituted the normal patterns of network for those of their social class. The second group involved with the Royal Photographic Society was the professional photographers who were also part of the survey movement. These included professionals such as Albert Coe (Norfolk), Warwick Brooke Manchester), Charles Ferneley (Nottinghamshire) and Frank Wratten (Surrey).[51] For them, the Royal Photographic Society was effectively a trade organisation bestowing both status and a form of aesthetic authority on their craft.

It is also worth noting the number of amateurs who would appear to be interested in photography, in part at least, because of their interest in, or professional experience with, technical instruments, optics, or chemistry. These make up a considerable proportion of lower middle-class and trade participants, such as James Stanley of Croydon, a retired watchmaker who contributed to the Surrey survey; James Brothwick, a chemist's assistant who participated in the Woolwich survey; and Weaver Baker of Exeter, who was the manager of Boot's Cash Chemists in the city. But one cannot and should not develop crude class models, for what characterises the surveys, however disparate they might seem, is a common purpose, the inscription of historical imagination, and a belief in the efficacy of photographs in the future,

which drew on values that had considerable resonance across the entire social scale.[52] These were ordinary men and women participating in a larger debate about what photography was "for"—a debate about its social, cultural, aesthetic, and even political purposes. For them, photography had an "object," a focus, a reason, an application beyond simple picture making.[53] Furthermore, although many clubs and societies, including survey societies such as those in Warwickshire and Worcestershire, were affiliated with national bodies, institutions like the Royal Photographic Society were perhaps not as central to photographic culture as many have assumed, and the relations that constitute the imagined community of photographers were not necessarily as hierarchical and pyramidal in terms of practices and stylistic agendas as many have imagined.

It is highly likely that in some cases the patterns of association and participation were aspirational in relation to social mobility, civic engagement, or intellectual ambition, although this is now impossible to excavate historically. However, as Megan Price has demonstrated in her study of the relations between academic and amateur claims to knowledge in the making of British prehistory, the social processes of historymaking were integrally connected to intellectual networks and the sense of personal achievement and satisfaction brought by membership in local societies.[54] These processes have tended to be read as an embourgeoisement of values and tastes, as tools of a gentrified bourgeois modernity, especially in the case of photography. In this reading, photography is understood as "an index and [a] means of social integration," because of the intensity of photographic and aesthetic practice.[55] While this is almost certainly so, the negative inflection of such a theoretical model denies the rights of other

sections of society to the benefits of democratisation; it denies them, through a form of false consciousness, the validity of their own photographic power to inscribe history. For however problematic and mediated, these "benefits" could also support personal enablement and self-improvement and give the satisfaction of social and cultural networks premised on mutual interest and curiosity. Consequently, as Paul Readman has argued in regard to preservation and the countryside movement, a discourse closely related to that of photographic survey, interpreting these movements as simply pyramidal with a top-down dynamic "is of limited utility." For while there were indeed desires for individual social improvement, and in all likelihood for social advancement, such readings can also obscure the extent to which values were held in common in social and cultural environments that placed increasing emphasis on a feeling of the collective ownership of place and history.[56]

But these patterns of association and networks of influence were wider than the surveys alone, for it was these patterns which linked survey to other discourses, discourses that defined survey photography as an intellectual and social endeavour. By the same measure, it would be a mistake to limit the influence of the photographic survey movement to those photographs produced directly within its rubrics. The movement intersected with a huge range of historical interests that were filtered through photography. For instance, the Architectural Detail Club was, as its name suggests, devoted to the production and exchange of photographs of architectural detail.[57] In another example, the Old Cambridge Photographic Club, which took photographs of engravings of old Cambridge scenes and buildings, ran in parallel with the activities of the Cambridgeshire Survey.[58]

Some journals ran networks that, although not specifically aligned with the survey movement, nonetheless reproduced its values and overlapped with its objectives. For instance, *Amateur Photographer* ran a correspondence club, the Record League, "for the interchange of prints and information between all those who [had] an interest in photographic record work," while *Photogram* offered the realisation of an "imagined community" through its Photographers' Guild, which aimed "to provide the advantages of a photographic society for isolated workers all over the world."[59]

Thus amateurs involved in survey were part of a larger series of what Luckhurst and McDonagh have characterised as "transactions" between the scientific, social, and cultural "to emphasise what is carried over, conducted between and passed across" in a wide range of linked endeavours and constituencies that generated cultural knowledge.[60] The most active nodal sites of social connection were local societies of all sorts. A good number of amateur photographers active in the survey movement belonged to other associations, holding joint memberships with local historic, antiquarian, and natural historic societies, or memberships of multiple camera clubs. They range from the upper-middle class and professional members of the Society of Antiquaries, through the networks of local elites (such as literary and philosophical societies and also antiquarian societies, such as in Leicester and Somerset), to more modest networks, such as mechanics institutes (although by late nineteenth century these had an increasingly middle-class membership) and local polytechnics. In instances of more local networks, Mr. Hellyer of the Surrey survey belonged to Battersea Field Club, where he expressed a particular interest in botany, while he also belonged to the Belmont Camera Club.

Mr. Hogg, a local gas company employee, belonged both to the Waddon Camera Club and the Gas Camera Club at his workplace, and the apparently quite wealthy Mrs. Padwick of Horsham belonged to the Sussex survey, the Sussex Archaeological Society, and the Hove Camera Club. Membership in multiple networks and groups, often cutting across class, gender and subject interest, was therefore typical of those in the survey movement at all levels, and extended patterns of sociability and association over a wide social spectrum.[61]

The survey movement looked to the networks of science at national and local levels to give the movement authority and legitimacy, and, for instance, some of its supporters, such as W. J. Harrison and J. H. Baldock of the Surrey survey, contributed to both the photographic surveys and the BAAS geological collections, which constituted so key a scientific relationship for survey photographers. However, this interest was seldom reciprocated. There was little connection, in terms of a network, between the survey movement and what one might describe as the related learned societies concerned with ethnographic cultural description, those of folklore and anthropology. Even relations with local antiquarian and archaeological societies appear to have been uneasy at times. For instance, the Anthropological Institute was represented on the committee of the Surrey survey by the Cambridge anthropologist A. C. Haddon, who had strong interests in folklore and cultural evolution; however, when he resigned, the institute chose not to replace him, although it did maintain its membership in the survey for some years.[62] Only a handful of photographers appear to have been connected to the national learned societies. For instance, Godfrey Bingley,[63] a Leeds amateur geologist, antiquarian, and instigator of the Yorkshire

survey, and G. Cluich (Surrey) were members of the Geological Society, and Edward Lovett (Surrey) was a member of the Folklore Society, as was Haddon.[64] The exception and largest overlap was, perhaps unsurprisingly, between the survey movement and the Society of Antiquaries in London, because of the survey's focus on archaeological and antiquarian interests. However membership was, for the most part, determined socially and was concentrated on the upper echelons of survey participation. However, by this date, membership of the Society of Antiquaries comprised not only the traditional county elites and clergy, such as Edward Beloe, King's Lynn solicitor (North Norfolk), but men such as Birmingham paint manufacturer and pictorialist architectural photographer William Archer Clark, who contributed to the Warwickshire survey, and London cardboard box manufacturer Henry W. Fincham who donated prints to the NPRA.[65] This is a notably smaller group than those affiliated with local archaeological and antiquaries societies, or with natural history societies that make up at least a third, probably more, of the 1,000 active photographers I have studied.

These relationships are important because they suggest the ways in which networks of association and influence were entangled with the moral values of "straightforwardness," "record," and "duty," and with the reproduction of scientific and civic values and aspirations, which were bound up in photographic practice, preservation, and archiving. These relationships produced clusters of photographic practice that subscribed to and could be defined by specific beliefs about the nature of photography, its applications, and its social efficacy. Indeed, Harrison's call for survey emerged from just such a transactional social network — an invitation for Birmingham Photographic Society members to

read "scientific papers" at the Vesey Club. Such networks, "based on a highly localised web of dependent personal relationships" were constituted through a matrix of institutions and cultural forms that characterised public culture.[66]

Networks of influence and patterns of patronage were also crucial to the way the survey movement developed. Local photographic societies, which formed the base of survey activity, especially in its first fifteen years or so, did not, on the whole, have the social prestige to garner the elite support that many other endeavours of preservationist intent did. While there were indeed some exceptions, presidents of photographic societies and camera clubs were often local gentry. For instance, in Norfolk, Sir Eustace Gurney encouraged survey activity through the presentation of a silver cup to the photographic society "for the Record Class," even before the survey itself was formally initiated.[67] In other cases, professional men, local members of Parliament or local members of the aristocracy, were the presidents of photographic and survey societies. Viscount Middleton, who had antiquarian interests, proved to be an active president for the Surrey survey, for instance. But overall, survey committees were made up of "practical men" (and occasionally women) rather than social figureheads.

One can see that Stone used networks of patronage in the development of the NPRA. The committee of the NPRA included not only important and influential figures from the photographic world, such as A. Horsely Hinton and Henry Snowden Ward, but aristocratic patronage in the Earls of Crawford and Rosse, both of whom had photographic and scientific interests.[68] Equally important for objectives of the NPRA were influential connections in archaeology and architectural history. These included St John Hope, the eminent medievalist from the Society of Antiquaries; Philip Norman, who was instrumental in William Morris' Society for the Protection of Ancient Buildings (SPAB); and H. Wheatley, the noted antiquarian of London and editor of Pepys' diaries. There were also members of the law, and the chemist professor Raphael Meldola represented the scientific interests of the Royal Society.[69] But despite Stone's ambitions for elite patronage and his attempts to harness his parliamentary influence—he had planned to ask Queen Victoria to be patron, but there is no evidence that this was ever attempted—the NPRA failed overall to attract the same level of elite patronage as did, for instance, the National Trust or the SPAB, for whom the membership "as many artists & men of letters as possible" was highly desirable; while a long list of "nonentities would be of no use at all."[70]

These networks and communities, "imagined" or "real," of photographic imagination or of historical experience, manifested the discursive connections that made certain kinds of photographs imaginable at a given historical moment and forged the survey movement's social and cultural dynamic. Friedrich Kittler has characterised these communities as "discourse networks" in which "the network of technologies and institutions allow[s] a given culture to select, store and process relevant data," precisely, in practical terms, the aspiration of amateur photographers involved in survey.[71]

SELECTIVE TRADITIONS?

The questions of the social makeup of the survey movement raise then the question of "whose history?" and patterns of agency. As the *British Journal of Photography* said in their critique of Harrison's plan, "It is difficult enough, in all conscience, for them [photographers] to

know where to begin; but where should they leave off? Where is the line drawn between that which is worthy of recording by means of photographs, and that which is not; and above all, who is to draw it? If the picturesque, the antiquated, and the interesting is to be preserved on paper for the historian of remote centuries, why not the unlovely and unpicturesque, since both equally go to the making of history?"[72] As with any inscriptive practice, the photographic surveys, it can be argued, constituted what Raymond Williams famously called "selective tradition," legitimating certain forms of historical knowledge and preserved aspects of cultural heritage that accorded with the dominant values and interests of an historical moment. The survey movement emerged from a whole body of activities in which "certain things [were] selected for value and emphasis."[73] Williams continues, "Traditional culture of a society will always tend to correspond to its *contemporary* system of interests and values: for it is not an absolute body of work but a continual selection and interpretation."[74] The creation of these photographic documents would appear to accord with this model of selective tradition as a social dynamic as we see in it "reversals and re-discoveries, returns to work apparently abandoned as dead" that are dependent on institutional practices to keep them "alive or at least accessible."[75] An understanding of this shifting dynamic of selective tradition, which follows social dynamics, is crucial to an understanding of the survey movement. While there was a strong metaphorical and symbolic element in play in survey photography, there was also a clear sense that it was filling spaces in the larger national narrative, spaces that were overlooked or reduced to stereotype, hence the preference for photographs of the everyday pasts implicit

in parish churches, cottages, and farmhouses over photographs of cathedrals and palaces.[76]

These patterns of chosen subject matter reveal a broad sense of the ways in which historical topographies were constructed and, thus, seen, patterns in which "elements of the past [were] selected as belonging to a place and which rejected" as identities are composed from "a myriad of elements in social lives which become 'congealed' as 'identity.'"[77] The dominant focus was the medieval parish church, overviews, details of architectural features, furnishings, fonts, tombs, and a wide variety of ancient curios related to churches. The village space, with historical and ancient houses and cottages, forms another key cluster, as do the associated ancient trees, byways, stocks, market crosses, tollbooths, bridges, and civic regalia. (See figure 17.) Folk customs, which, largely because of scholars' selective reading of Stone's archive, have been disproportionately emphasised in writing about the survey movement, are unexpectedly thin. This is especially remarkable because the survey discourse was entangled with the discourses of survival and preservation in which antiquarian concerns often meant folklore and folk custom.

While the surveys were essentially an urban movement, and took urban values into rural spaces, they cannot simply be reduced to a ruralist response, translating landscape through historical and photographic picturesque tropes. As Jeanette Edwards has argued, this process is not simply a matter of what people find interesting from the past, but the "way in which [the] past is mobilised in the formation and composition of local identities and senses of belonging."[78] How are places constituted through the different ways in which people belong to them? The meanings of places and relationships to them

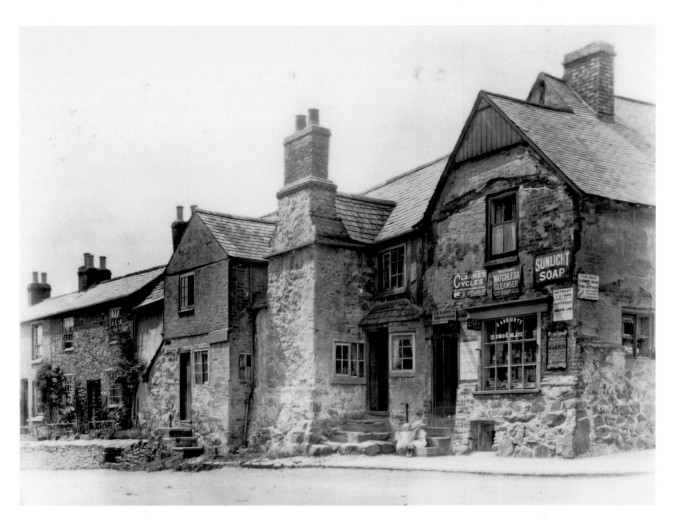

are forged through diverse attachments and connections, including links to persons, pasts, and other places in a variety of shifting configurations, and are expressed through a series of identifications and denials. These tropes became "devotional sites" or "mythscapes" as foci of the historical imagination.

This "selective tradition" also raises the question of what constituted the "old" and the "historical" in the historical imagination of amateur photographers. What were the temporal inflections that clustered around the "collective biographical objects" through which stories could be told? "Old" constituted a key value and was repeated endlessly both in the discourse and in the descriptive terms used for the content of survey photographs, as it was in J. Tibbett's photograph of "Old Houses, Gloucester," for the Gloucester survey.[79] These values of the old and the historical were reiterated tirelessly in the photographic press in their talk of "ancient houses," "the oldest house in Sussex," "priceless heritage of ancient architecture," a "relic of ancient London," and so on. The past, as represented in survey photographs, was conceived of largely as a medieval, Tudor, and, to an extent, Stuart past. The coverage of subjects from the eighteenth century is less extensive and often

17. Cross Green, Rothley. Photographed by George Henton, c. 1903. Photographic Survey of Leicestershire *(reproduced with permission of the Record Office for Leicestershire, Leicester, and Rutland).*

restricted the great houses or literary landscapes, landscapes such as George Scamell's delineation of the topography of London for the NPRA. Though romantic medievalism, the "mediaevalism and the Middle Ages to which these . . . scenes waft you back in imagination," cast the Middle Ages and the Tudor period of Merrie England as the dominant tropes of nineteenth-century historical imagination, by the beginning of the twentieth century, the Stuart period was, in the popular accounts of historians such as G. E. Trevelyan, increasingly seen as the period from which peace, prosperity, and the independence of the English character

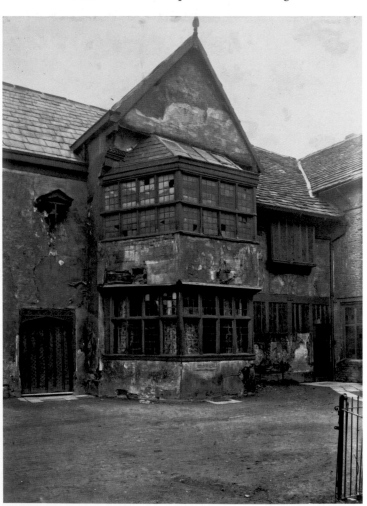

18. Ordsall Hall, Salford. Photographed by James Shaw, c. 1892. Photographic Survey of Manchester and Salford *(courtesy of the Manchester Room at City Library, Local Studies)*.

emerged.[80] For survey photographers, "old" and "significant" related almost exclusively to these key periods. For instance, having traced the history of Warwickshire from the prehistoric period, Harrison established "The Civil War in Warwickshire" as the historical cut-off point in his 1889 scheme. Even allowing for the individual predilections of photographers, this pattern of historical significance and subsequent archival density points to the cultural investment in certain historical moments and their formations, a cultural investment demonstrated by contemporary ideas of relevance and appropriateness that were performed through the choice of photographic subjects. (See figure 18.)

The Middle Ages were focused on in particular through the antiquity of the parish church. The parish church represented the core of local and community identities, as the material traces of the past, manifested in old masonry, woodwork, and funerary monuments, stood for the heart of the village community, and were valourised, on the one hand, by historians such as Frederic Seebohm as key to concepts of cultural continuity, survival, and change and, on the other, by the popular, picturesque historical imagination of writers such as P. H. Ditchfield. Significantly, guides on architectural history for amateur photographers, such as that by Thomas Perkins, focused largely on medieval heritage, with detailed drawings of window types and mouldings, while less attention was given to later periods. The sociability of amateur photographers themselves was expressed through a self-conscious reference to a medieval community in the shape of the Photographers' Guild, run by *Photogram* magazine, whose agenda was to encourage survey and similar activities among amateur photographers. There were of course practical reasons for this overall focus,

too. Medieval and earlier modern remains were most threatened in urban spaces as old street plans and half-timbered buildings were destroyed in the rationalisation aimed at producing the modern functioning city. Warwick Brooke's photograph of "Deakin's Entire" in central Manchester, a sixteenth-century half-timbered building surrounded by the technologies of modern infrastructure, demonstrates such a concern and its visualisation.[81] (See figure 19.) But the photograph also reflects concepts of the old in the popular historical imagination.

Yet the temporal sensitivities of the survey movement cannot be reduced to a sentimental or nostalgic fantasy of Merrie England. The concept of record was also applied to the lived experience of the present. As the local Norwich paper stated in connection to their local survey, in a way that linked the past to current modernities: "Most of us have only the vaguest imagining of what went on in a textile factory in Norwich in the eighteenth and early nineteenth centuries. Our posterity will be under no similar disability for there are interior views relating to most of the leading products of the present generation, including mustard, boots and shoes, electrical dynamos and medicated wine."[82]

Thus, the past was apprehended through a

19. "Deakin's Entire," Market Square, Manchester. Photographed by Warwick Brook, c. 1890. Photographic Survey of Manchester and Salford (courtesy of the Manchester Room at City Library, Local Studies).

20. New Street Birmingham. Photographed by T. Clarke, c. 1890.
Warwickshire Photographic Survey *(courtesy of Birmingham Library and Archive Services).*

"distinctive modernity" that embraced the veneration of the traditional, the ancient, and "the modern impulse to conquer them" as part of the demonstration of that very modernity.[83] Harrison's initial outlining of the scope of survey was also to be a record "of the state of present things," a record that was to include "impressions of the appearance of our streets, and the busy crowds by which they are traversed."[84] (See figure 20.) Even the historical work was not, as Ernest Goodman of the London Survey commented, "to be merely an antiquarian catalogue of what had existed, but a living record of what still remained at the time of the survey,"[85] a position reiterated by *The Camera as Historian*: "Photographic Survey work is by no

means merely concerned with the somewhat melancholy task . . . of reporting scenes and objects of beauty and interest which have vanished, or which are vanishing; records of existing things are themselves undoubtedly a factor of no small importance in the preservation of that which is pictured by the camera. If politics be that portion of history which is happening under our eyes, then may we not claim for the camera a political as well as a historical *rôle*."[86] Such an agenda was clearly not simply a conservative nostalgic ruralism or hegemonic consolidation, but linked photographic survey to the self-conscious and systematic promodern values of the town planner. These technologies were, however, understood and presented

as instrumental in the changing of historical landscape and people's relationship to it, just as there was a recognition that the survey's delineation of the values of historical topographies was premised in the very modern technology of the camera.[87] Thus the surveys were constituted through a complex temporal interpenetration of past and present, through the nature of photography itself and photographers self-consciously engaged with the layered temporalities inherent in the survey enterprise.

SCIENTIFIC ASPIRATION AND MORAL DUTY

The record and survey movement was constituted through a series of various and shifting interests belonging to an equally diverse group of people. Despite its uneven history, what characterised the movement was a belief in the veracity, effect, and authority of photographic inscription. All these endeavours, whatever their institutional structures, formulated a systematic photographic survey with clear rules and objectives, a survey premised on the production of a specific kind of visual practice that would produce knowledge in certain ways. The rules are important because they were the means through which actions complied with a set of assumptions and values that reveal the concerns and aspirations of the survey movement.[88] The rules effectively supported views of both photographic "truth" and posterity, emphasising a mechanical and positivistic understanding of photography as the unedited translation of informed and accurate observation. While questions of subject matter and technique were framed, in many cases, through the overall objectives of the survey movement, the activities of amateur photographers were directed and contained through a series of discursive practices that constituted ideas of "the systematic," "the straightforward," and "the accurate."

The words "system," "systematic," "uniform," "structure," "consistency," and "regularity" were used repeatedly in discussions of photographic survey and record activities, and anxieties about the idea of the systematic, and to what extent a practicable concept of "system" could be realised, was the focus of extended debate. For Harrison, trained as a scientist, it was clear that these values had to be the modus operandi of photographic survey. He advocated "systematic photography" as a "handmaid of all the sciences."[89] Conversely, it was well recognised by those involved in the survey movement that the lack of "system," whether through inadequate practices of observation or technical application, allowed a series of points of fracture within the objectives of the survey. Indeed, Samuel Coulthurst, writing in 1897 of his experiences working with the Manchester survey, specifically pointed to that survey's launching "without any attempt at organization and system" as the root of its difficulties.[90]

For exponents of photographic survey, the object of the system was to frame the visual statements of history as a clear and straightforward translation, and to establish their authority and efficacy within clear parameters. An exhibition of Warwickshire survey photographs in Birmingham in 1892 was presented, for instance, as "prepared on a truly scientific and systematic basis."[91] What was not in question was the camera's ability, as a mechanical device, to deliver "truthful" or "straightforward" images through the untrammelled purity of the negative and the suppression of the aesthetic and subjective desires of photographers.[92] While this was not a naïve acceptance of the truth of photography, it was premised on a belief that photography could, if properly regulated, deliver pure "fact"

without and beyond stylistic convention and constitute a form of objective statement, or even a scientific history.[93] Subjects were treated "in the best and most realistic way — by means of absolutely 'unfaked' photographs."[94] Survey photographers shared a concern with the scientific historicism of the nineteenth century and the concept of "truth to sources."[95] Indeed, exponents of survey photography argued that the representation of modern history would eventually become purely pictorial: "It is quite possible that the chief part of elementary education of another generation would be thus imparted."[96]

What were in question were the methodological requirements of selection, observation, translation and inscription, and the role of both competing and complementary knowledges of, for instance, photography, history, architecture, and archaeology. The surveys can be seen as part of the development of the methods of the earlier antiquarian traditions of eighteenth century and the early nineteenth, with their strong empirical base and their emphasis on field observation and technique. By the late nineteenth century, these empirical techniques became refigured around ideas of the systematic and the standardisation of observation and representation, values drawn, as I have suggested, from the emergent "scientific" disciplines of archaeology and anthropology and their methods.[97] It should be noted that Robin Kelsey has described the aesthetics of photographic production intended for record purposes as "archive style," production in which individual pictorial aspirations were contained and negotiated within clear, centralised archival structures such as the United States Geological Survey.[98] While there might be surface resemblances with these surveys within the overall concept of "survey," in the case of the surveys considered here, photographers were not working within predetermined institutional frames, despite their regulatory ideals. In an ethos of collaborative volunteerism, institutional frames remained largely rhetorical as different sets of historiographical and photographic desires were accommodated by the desire for archival accumulation. Thus while survey photographs are saturated with both the regulatory ideal and with slippages around and across the ideal, they effectively constituted a synthetic archive in which the individual was accommodated within the collective through successive and uneven privilegings and suppressions that cannot be reduced to sets of grids and equivalences or to an unproblematic instrumentality.

The concept of the systematic promised to control the fragmented, dispersed, ambiguous, and potentially incoherent visualising practices of photography and the subjectivities of photographers. The definition of an historically useful photograph had to be carefully balanced between the quality of observation and its visual expression on the one hand, and the "unsystematic" photographs that might contain historical information on the other. (See figure 21.) Thus the articulation of the system "must be framed with the utmost care to avoid, on one hand vagueness, and on the other the inferential exclusion of useful matter."[99] "System," as it was understood by those involved, created a distinction between the information that was "useful," and which itself constructed the system, and the unusable beyond, a distinction that became increasingly complex with growing attempts to bring everything under visual control.

The idea of the systematic therefore provided a plan for the production of reliable photographs of objects and landscapes of historical interest that could focus the attention of the

Moreton Valence. Church

21. Morton Valance Church. Photographed by George Embrey, 1903. Photographic Survey of Gloucestershire. Quarter-plate silver bromide prints *(courtesy of Gloucestershire Archives, SR44.36297.150).*

photographers and thus give discursive coherence to the photographs. In formulating their instructions, and as a point of discursive reference, those involved in the photographic surveys used the language of science, a language that clustered around ideas of "empirical reliability . . . procedural correctness . . . [and] emotional detachment."[100] However, the very claims implicit in the word "survey" were seen as problematic, especially when linked to ideas of system. This was not only a technical objection that what was popularly called "survey photography" in the press bore no relation to the scientific and mathematical applications of photography and what was perceived as the absolute legibility of the images in land surveying, photogrammetry (such as that being developed by Albrecht Meydenbauer in Germany), and cartography. Many articles in the photographic press about these forms of photography use the word "survey" almost confrontationally, as if to reclaim the term for the mathematically precise.[101] The presumption of the encyclopaedic and the exhaustive in the word "survey" was also challenged from the beginning and was connected to concerns about the possibility of the systematic. As a commentator in the *British Journal of Photography* argued in this connection:

> The term "survey" in such a connexion, is clearly a misnomer. . . . Pictures may be taken at random by individuals, and by photographic societies on Saturday afternoon excursions. The Birmingham [Photographic] Society has gone about the work of the local survey in a thorough if scarcely systematic way, and photography is certainly the gainer by the 1000 or more admirable views it has secured. What value posterity, or even contemporary society, will place

of the work, is hard to tell . . . it would be absurd to regard the scheme of a concerted "photo-survey."[102]

This concern raises the question of thoroughness in opposition to system. It suggests that the production of photographs and photographers could be well managed and focused, yet elude the more rigorous concept of system. What is unclear is how this distinction might be made and where the system might be located—in photographers' intentions, in the image, in the managed bodies of photographers moving through space observing, or in the archive? Some commentators sought to remove the problem altogether. It was suggested instead that "records" might be a more accurate, attainable aim for this photographic work, especially if the photographs were "unconnected at the time they are secured by any definite plan."[103] This view called for a set of serendipitously created documents, which was, in fact, the way many photographs arrived in survey archives, especially the archive of Stone's NPRA. The preface of *The Camera as Historian* addresses this debate, preferring to use the word "record," and "leaving the latter [the word "survey"] to its more limited and technical meaning." Significantly, Surrey styled itself the "Photographic Survey and Record of Surrey."[104] Through the slippages and overlappings between system, notions of straightforwardness and thoroughness, photographs could become authoritative, especially within the massing and juxtaposing practices of the archive, without photographers' making overt claims to scientific method.

In relation to the scientific aspirations of photographers, the BAAS was of particular relevance as one of the nodal sites of the social networks I discussed previously. Not only did

the values of science resonate through Harrison's rendering of the survey's objectives, but the structures of scientific knowledge production, exchange, and sociability were emulated. Over the years the BAAS had become an interface between an increasingly professionalized science and amateur enthusiasts and had also been a forum through which the emergent professional-scientific class could harness the energies and skills of amateurs, especially photographers, and direct amateur practices of observation and visualisation.[105]

In particular, the surveys adopted a model for the collection of scientific data and knowledge production that was prominent in the eighteenth- and nineteenth-century models; that is, the engagement of local amateurs, and thus local knowledge, to contribute material to interpreting centres of learned societies and universities for analysis.[106] Such a method had already been used, especially in extensive and dispersed fields of observation such as meteorology and astronomy.[107] Not only had this practice been a key BAAS methodology, connecting amateur and emerging professionals over a range of scientific disciplines, it transformed local knowledges into national inventory through centralised structures of scientific validation. In a similar way, the endeavours of individual amateur photographers isolated phenomena, perhaps trivial in themselves, that were, "worked into a collection scattered across a large territory [in which] the individual became valuable." Here, as in the enormity and range of "the historical," in survey endeavours "observation networks and the 'concert of data' mirrored the complexity and scale of the phenomena."[108] Yet in the photographic survey movement there was a vital difference. Despite a broad centralised discourse, the desire to collect and establish a systematic practice was not disseminated only by scientists mobilizing amateur observers, but rather by amateurs themselves who absorbed and refigured the values, language, and practices of science over a disciplinarily dispersed yet ideologically interconnected field. This decentring of the hierarchies of observation, collection, and interpretation in the photographic survey movement was precisely what marginalised it from recognised scientific practices.

However, in practice most local photographic societies, and a good many natural history and archaeological societies, were only involved in the BAAS when its annual meeting was hosted in their town. For instance, the Leicester Photographic Society was involved in almost a year of planning for its small part in the BAAS Leicester meeting of 1907. And in many ways it was the broad ethos of the photographic survey that brought increasing numbers of photographers into contact with BAAS values. Harrison was closely involved with the geological survey and provided the most direct link between the BAAS and the survey movement. However, a number of active survey photographers were members of the BAAS; Frank Allen and Charles Bothamley, for instance, instigated the Somerset survey. Many others were members of the corresponding societies with links to the BAAS, such as Nobarts, Baldock, and Hobson of the Croydon Natural History and Microscopical Society and the Photographic Survey of Surrey. Furthermore, the photographic debates in the BAAS were extensively reported in the photographic press, and were available to all, thus extending the intellectual transactions. This created complex and extensive networks of association and influence of the kind I have noted, through which values constituted within science could be filtered and reproduced with the photographic survey.

More broadly, the photographic world also looked to the methods of the BAAS as a mode of inclusion, exchange, and sociability. For instance, the annual photographic conventions, the first of which was held in Derby in 1886, were closely modelled on the BAAS. A number of those involved in surveys, such as Reverend Perkins (Dorset), Harold Baker (Warwickshire), Charles Bothamley (Somerset), George Scamell, and Mrs. Gandy (NPRA), regularly attended these conventions, at which lectures and exhibitions of local survey endeavours were common features during the 1890s and 1900s. The conventions included special interest groups, organised excursions, displays of work, and a different regional focus each year, in a forum specifically intended to increase the social networks of photographers, affording "opportunities for personal intercourse and exchange of ideas amongst those interested in the art from all parts of the United Kingdom."[109]

In terms of photographic method and aspiration, the scheme initiated by the Geology section of BAAS (Section C) to register and collect geological photographs became an important point of reference for the survey movement.[110] This was the scheme that had first been outlined by Jeffs in 1886. Taken up by the BAAS in 1889, the project was especially successful, lasting for over fifteen years and instituting rigorous standards of observation and representation: "In order to secure uniformity of action and as guide to those willing to assist, a Circular of Instructions was issued, embodying those points which were thought to be most desirable in effecting the objects of the Committee. The details were drawn up after very careful consideration and consultation with practical photographers, and were so framed as to be applicable to most of the conditions to be met with in photographing the different classes of objects

having geological interest worthy of permanent record."[111] A critical engagement with the kind of evidence afforded by photographs was discussed in the annual reports of Section C, and clear shifts in the assessment of photographs can be discerned, shaping the collection as it became increasingly concerned with the collection of "typical phenomena." As was commented at the BAAS meeting in Edinburgh: "a greater proportion [of photographs] are of high scientific interest and illustrate features of real geological importance." This was necessary, otherwise "the collection would cease to represent typical geological features of the United Kingdom, and become simply a collection of landscape photographs."[112] The historical survey projects shared just such a concern. What was the borderline between the straightforward and the informational? What was, on the one hand, the topographical view and, on the other, pictorial imaginings? How, in other words, were survey photographs to avoid being collections of views that "may be taken at random by individuals, and by photographic societies on Saturday afternoon excursions"?[113]

The survey committees and societies tried to mitigate these problems through a series of rules and recommendations. Ideas of the systematic were discussed both locally and in the photographic press (for examples, see the appendix). The organisational structures of the various projects give us an insight into the ways in which they aspired to produce and manage visual knowledge. While the BAAS Geology project had a methodological impact in the development of a system, the rhetorical framing, observation, and recording were most clearly linked to Section H, Anthropology (which included archaeology in this period), which not only instigated its own photographic scheme in 1898, a scheme modelled on that of the geolo-

gists "to collect, preserve and undertake the systematic registration of photographs on anthropological interest."[114] Section H's ethnographic survey of the British Isles was announced in 1893. Although, unlike the BAAS ethnographic survey, the photographic survey movement was not concerned, explicitly, at any rate, with race, there was nonetheless a marked overlap in objectives and underlying epistemological structures between the BAAS survey and the various photographic survey projects.

Crucially for the surveys, it was through the BAAS that anthropology and archaeology performed sets of techniques, styles, methods, and theories in relation to the human past and human development, through which practices could claim to be systematic. One sees this interpenetration in the organisation of the surveys. Some, such as Surrey, adopted a structure akin to that of the BAAS, with committees (in reality, seldom more than two or three people) to oversee photographic production in certain fields. These committees were meant to produce lists of desiderata, guide observation, and police duplication, although there is little evidence of the efficacy of this strategy, for both lacunae and duplications abound. For example, Surrey, in a structure copied by Norfolk, had subject committees on antiquities, archaeology, ethnography, and passing events, emulating the structure of BAAS sections. These committees attempted to guide the activities of photographers, whereas earlier Warwickshire had lists drawn up by local antiquarians or from a "good county history," from which should be drawn up a "list of all the places and objects in its pages" to guide photographers. Likewise, the Birkenhead Photographic Society had "books, with maps and interesting objects for various sections for each member of the society carrying out the survey" drawn up by its instigator,

Mr. John Hargreaves, who was also a member of the Historical Society of Lancashire and Cheshire.[115] The list produced by Cambridgeshire (see the appendix), which was drawn up by A. C. Haddon, had a remarkable resemblance, at least in terms of tangible and visible culture, to that produced for the ethnographic survey.

Yet for all the debate on the straightforward and the systematic, many of the rules of the survey projects were concerned with organisation, management, and social relations. Rules concerning what and how to photograph were discursively, rather than prescriptively, produced. Thus there was relatively little detailed instruction about what to photograph, or more importantly, in practical terms, precisely how to produce a photograph. While some photographers chose to specialise in order to produce a systematic series of photographs of their chosen subject matter, for instance, Catherine Weed Barnes Ward photographed fonts, Mr. G. Woodfall of Leyton in Essex (who was involved with *Photogram*'s "Photographers Guild") photographed windmills for the NPRA, and Harrison set himself a project on the Roman roads of Warwickshire, more broadly the untidy mass of photographs were produced and assumed value through a combination of procedural correctness and the mechanical guarantee of the camera.[116] (See figure 22.)

The debates and practices clustering around ideas of the systematic and the use of concepts drawn from scientific domains formed the epistemological parameters of the idea of photographic survey for its amateur participants, and were translated into practical concerns about appropriate "practices of looking." This might be connected to a kind of "procedural correctness," for these practices were not merely discursive and organisational but materially

22. Gloucestershire Fonts. Photographed by Mrs. Catherine Weed Barnes Ward, 1903.
Mounted together for the NPRA *(courtesy of V. and A. Images, Victoria and Albert Museum, London).*

performed through detailed attention to the photographic practices through which visual knowledge could be produced. The anxiety was that photographers might not have had the necessary range of knowledge to translate these ideas into the visual practices required for such an endeavour. From the beginning, there had been disquiet over the kind of knowledge being produced through such an exercise. As Reverend Thomas Perkins of the Dorset survey, himself a noted antiquarian, said:

> It often happens, as we look through a collection of photographs of cathedrals, castles, and churches, that we feel something is wanting, technically perfect as far as exposure, development, and printing though the pictures may be. When we inquire what it is, we shall, in most cases, find that what is wanting is knowledge and study of architecture on the part of the photographer. Many of those who carry their cameras and lenses with them to some noted building do not know what are its really important features, and so pass them by; or do not know from what points the builder intended his work to be looked at, and, consequently do not choose the best positions for their cameras.[117]

Thus considerable attention was given to fostering a critical historical sensitivity in photog-

raphy, "training [the photographer's] eye for the salient and important parts."[118] This was also part of an overt appreciation of the educational value of taking survey photographs, but the necessary focus here is the way in which the attention of amateur photographers was managed in order to realise the objectives of survey projects. Although many antiquarians, such as R. W. Dugdale of the Gloucester survey, whose photographs were published to illustrate articles in the *Transactions of the Bristol and Gloucestershire Archaeological Society*, were, by the late nineteenth century, skilled photographers (it was almost one of the tools of the trade), there was still a sense that survey enthusiasts were reliant on the kinds of photographic skills to be found in the photographic societies and camera clubs to realise their objectives in relation to permanence. Indeed, one of the reasons given for the lack of success of the Somerset survey organised by the Somerset Archaeological and Natural History Society was the lack of established photographic societies in their region, although there were many amateurs.[119]

These claims to knowledge and the different skills that might constitute those of photographic survey are entangled with contested and differently weighted claims to knowledge, authority, and an emerging disciplinarity of modernity. Contributors were drawn to the survey movement from a variety of perspectives. This is demonstrated by a series of comments in the minutes of the Somerset Archaeological and Natural History Society in regard to their photographic survey. It was suggested that photographers could be co-opted to help with the survey, but it was decided that "any addition to their number must be from members of the Society, but that others might be associated in an Honorary capacity." This should

perhaps be read in the light of a minute from the previous year, stating that it was necessary for members to use "proper discretion as to the eligibility of candidates whom they may bring forward. Quantity is desirable, quality is essential to the well-being of such a Society." In ways that relate to the debate about the authority of different historical voices in relation to the selective tradition, the implication is that photographers would not make, in terms of the social and intellectual status of the society, suitable or authoritative historical statements and could not have the "disciplinary eye" necessary to make qualitative observations of the "correct" order.

This position had an impact on all aspects of survey activity. However, these claims to knowledge were not uncontested. There were continual tensions between the status of photographic knowledge and disciplinary knowledge, whether that of archaeology or architectural history. Such tensions were also related to claims to local knowledge as opposed to centralised, disciplinary knowledge that had been at the core of the established relations between amateurs and professionals, that centre and periphery in the production of scientific knowledge. It is possible that many survey endeavours were never fully realised precisely because of such difficulties, as in the case of the Sheffield survey.

Underlying the concern and the need for systematic collective action was the characterisation of photographic survey as a form of moral duty linked to rational leisure. Questions of morality saturated the discourse of the survey movement, as *Photogram* magazine described "record photography," as "one of the most useful and most unselfish tasks ever set before photographers."[120] Photographic survey as useful work for amateurs was part of

the broader Victorian concern with "useful" leisure and "rational recreation" that informed the regulation of public spaces, education, and cultural institutions in the nineteenth century. As spaces of social improvement, such pursuits stimulated and restored the mind rather than "merely debilitating the body" and offered the opportunity to contribute to a regeneration of the community more generally.[121] These values are repeatedly found in contemporary discussions of survey photography. Quoting Harrison in 1906, *Photogram* magazine stated that the photographer would "find interest and useful employment combining the pleasure of mild research and specialised effort, with the pleasure of giving to his locality or his county . . . valuable and lasting results which [would] always be associated with his name." Furthermore, photography could "be enhanced by the serious study of some subject relevant to survey, not necessarily a profound knowledge was required but a competency."[122] This individual endeavour and improvement was linked to a collective improvement: "The growing desire among the English photographic societies to make themselves of real service to the community." And as Reverend Perkins writing in *Photographic Quarterly* said, "Not only is systematic work useful to himself [the photographer] from an educational point of view, but the results of such work will be valuable to others."[123] Harrison urged members of the Birmingham Photographic Society that it was "the plain and direct duty of the Society to organise and to carry out" a survey and "the highest ambition of its members to carry out [that survey] successfully." *The Camera as Historian* opined, "By a little systematic regulation his work can be made to produce not merely personal and ephemeral gratification, but results of great present and almost incalculable future

value."[124] These activities were positioned as the successor to the great British antiquarian tradition. As Stone put it, somewhat romantically, and apparently to great applause at a meeting of the Birmingham Photographic Society in 1899, "To take such records is a duty—and it is not a great one—to secure that which is worth preserving for the future generations. I cannot coin words to urge you to record the present, as did Stow and Dugdale, and doing so you will become a credit to yourself and your country."[125]

These were effectively calls to embrace specific forms of controlled and measured memorialising practice through camera technology. These values inflected the making and production of the photographs, the organisation of the surveys through the practices of civil society, and the regulation of observation itself, part of more general disciplinary procedures in the nineteenth century to produce efficient, well-regulated, and productive individuals.[126]

The values inherent in the organization of the survey are important because they give the amateur the moral responsibility to produce the archive of the future. But this responsibility is not simply an atomisation of memorialising practice to the individual, but a series of individualised endeavours within a collective community. This position is especially so in the face of the repeated resistance of governmental bodies to undertake such work. Captain Abney, addressing a meeting of the NPRA in 1898, only a year after its founding, stated, "Now the importance of this work is generally recognised, perhaps the Government might be induced to render some aid, if not take up the work entirely."[127] But the government never did provide aid.[128] The diminished personal responsibility in memorialising practice that Nora has associated with the rise of the archival and of "history" cannot be found in the values the move-

ment espoused. Rather Nora's claim in relation to more recent historiographical trends that "every social group ... [must] redefine its identity through the revitalization of its own history" does accord with the movement's motivations.[129] However, the discourse of the survey movement both demonstrates and complicates this view, in that the personal endeavours of the amateur photographer emerged from a personal responsibility to record history and create that archive.

TAKING PHOTOGRAPHS: OBSERVATION AND MOBILITY

Photographers actively translated everyday experiences into an historical topography, which they then translated into photographs, while at the same time endeavouring to operate within the discursive and epistemological parameters of the survey ethos. For it is at this point of production that the epistemological frames of the survey movement came together with the embodied experiences of photographers. Photographic survey was part of a broader concept of rational leisure and the production of scientific visual practices to produce objective observation. Because of this connection, one of the major challenges of the survey movement was to regulate not only the observational and visual practices of photographers but to regulate their practices on the ground, because a key point of fracture in survey discourse is located in the bodies of amateur photographers themselves.

The primary method adopted to encourage systematic coverage and observation of photographers anchored to topography itself was through the six-inch Ordnance Survey (os) map. By the 1880s a sheet was available for every county and thus the early dissemination of these maps was simultaneous with the emer-

gence of photographic survey. These maps ("*the* map for the work of photo-survey"), with their precise delineation of fields, tracks, boundaries, and buildings, delivered a systematic rendering of space that could be traversed with directed attention, which itself would translate into systematic and straightforward photographs.[130] Thus the mathematicisation of landscape through the os maps appealed to the sense of system and order to which the surveys aspired. The significance of maps can be related to the methods employed by other survey endeavours, notably the use of county archaeological maps that were being produced in the 1890s by the Society of Antiquaries. By 1897, maps of Kent, Hertfordshire, Cumberland, and Westmorland had already been produced and had influenced the methods of photographic survey.[131]

The os maps also linked observations of the historical landscape to a systematic grid. As Matthew Edney has argued in his brilliant analysis of mapping in Imperial India, "In the popular mind ... mapping continued to be imbued with all of the scientism and empiricism of the Enlightenment understanding of science: the world can be mapped exactly, the world can be *known*. In this context, the map's graticule of meridians and parallels signifies the map's scientific, rational, ordered, and systematic foundations. It signifies the map's naturalness, the map *is* the world."[132] By the nineteenth century, maps had become rational, realistic devices representing things as they actually appeared. The idea of mapping was central to the whole concept of survey.[133] Maps stood for an objective landscape through their basis in trigonometry, photogrammetry, and the mathematical translation of landscape. The map was a perfect panopticon through which the archive could gather all.[134] It is significant therefore that maps, mapping, and the discourse of sur-

vey became cohering tropes of this systematic photographic desire. Nevertheless, as the survey movement had been, the OS was conscious of the fragility of things that were to be accounted for before they disappeared. Historical topographies were increasingly, since the mid-nineteenth century, marked on OS maps. This marking was part of the process by which local historical topographies became inscribed as national heritage: the placing of specific historical locations in wider frameworks of geographical space and on larger historical topographies.

Although the recording of antiquities on the OS maps was not fully formalised until the work of O. G. S. Crawford in the 1930s, maps were nonetheless saturated with the marks of historical continuity, in the criss-cross of roads and footpaths, enclosure boundaries, field systems, the relationships of settlements and place names.[135] The purpose of the OS map for survey organisers was to ensure a full and systematic coverage, to ensure that photographers were not merely indulging an aesthetic response to picturesque forms of history and subjects that might appeal to dominant contemporary aesthetic practices. Thus, survey workers were encouraged to base their visual mapping on the OS maps of the area. While most of the surveys referred to OS maps to impose a system on historical space, some, such as the Warwickshire survey, Birkenhead's 1889 survey of the Wirral, the Essex survey, the Nottinghamshire survey, and the Dorset and Surrey surveys attempted a systematic coverage of the historical landscape by organising recording work by cutting the map into either a quarter sheet or six-inch sections, a "convenient size for carrying in the pocket or camera case."[136] These sections were then given to photographers who were expected to cover all items of historical interest within the grid.

Maps created a system, literally, on the ground, that, in theory at least, prevented photographers' cherry-picking only the picturesque and ensured thorough coverage. Maps were used to avoid duplication and focus photographers' attentions appropriately, in order to produce work that was "less haphazard and less overlapping."[137] This was the system first adopted in Warwickshire, where Harrison had emphasized the importance of "a large scale and accurate map." As such the OS six-inch scale map was ideal for survey because the "orientation of buildings is clearly shown."[138] Nottinghamshire followed a similar system based on what was intended to be a parish-by-parish survey using the OS map. The system, however, did not guarantee success, for "only one parish [had] been completed, that is Stapleford. Of the chief points of interest in most of the other sixteen villages, only one or two pictures [had] been taken."[139] (See figure 23.) George Scamell, in his work for the NPRA, also used a map system, a system indicating points of interest by dots. He subsequently, so to speak, "did the dots," and, as he reported, "had nearly exhausted Hertfordshire."[140] However, this kind of approach was also resisted, precisely because it imposed on the individual vision and subjectivities of the photographer. James Wilcock of the Manchester Survey commented, "To take an ordinance map and cut it into slips, giving a piece to each member to mark his circuit would be rather arbitrary in a voluntary work of this kind."[141]

But the maps also ordered the photographers in other ways—through the production of the body of the photographer moving through an historical landscape. While maps ostensibly manifested a control over practices and style, they were also an attempt to manage the way photographers moved through the landscape

with their cameras, focusing their attention on specific points of historical topography rather than allowing them to engage in "aimless snap-shotting." Despite the intention to control the body of the photographer and the production of photographs, the act of photography over-laid the map with imaginative force as the "striations and inscriptions of memory actions, places, emotions, love [and] fear . . . [were] celebrated and worried over the surface of the map." Yet at the same time, the experience translated the mathematicisation of the map into the subjectively experienced texture of his-torical imagination, undermining the system of the map and survey aspiration. Individual frag-ments of knowledge made through the taking of fragments and actualising them through the photograph ran both with and against the grain of maps.[142]

The survey movement was premised on the physical mobility of photographers. Historical topographies, marks of the past, became a form of narrative experienced through that move-ment.[143] Indeed, "various methods of locomo-tion, sailing and steam ships, and railway rolling stock" were among the subjects listed as suit-able for record-making.[144] While railways and horse-drawn vehicles had always carried pho-tographers around, "the camera and the cycle [were] becoming fast and inseparable friends" for the amateur photographer.[145] Many camera clubs had cycling sections, just as many cycling clubs had photographic sections, as did the Worcester Tricycle Club. This trend can be di-rectly linked to the expansion and democratic dynamic of survey photography. George Sca-mell, the secretary of the NPRA, was featured in articles in the photographic press about cycling for photographers. Linking survey and cycling directly, he demonstrated in photographs ways of carrying equipment on a bicycle, and by 1907

Amateur Photographer, the journal that did so much to forward the cause of photographic survey, ran a summer feature entitled "Cycle and Camera" by a pseudonymous A. Wheel-man.[146] The railway, linked to increased leisure for a wide social range, massively enhanced the mobility of photographers. Indeed, much of the NPRA material would appear to be the result of photographic enthusiasts moving around the country in their leisure time. For instance, Godfrey Bingley of Leeds, a major contributor to both the NPRA and the BAAS geological col-lection, submitted photographs from locations as distant as Northumberland, Oxford, Devon,

23. Stapleford Cross, "Supposed to be the remnant of an old Saxon Cross." Photographed by T. Wright, 1898. Photographic Survey of Nottinghamshire *(courtesy of Notting-hamshire Archives, DD/1915/1/436)*.

and Somerset. He also donated material to the surveys of those areas he visited, such as Exeter, specifically printing material from his collection for donation.[147] There were even attempts to get reduced rail fares for photographers, a privilege apparently enjoyed by other amateur and hobby groups.[148] The combined impact of the railway and the cycle in shaping survey production is no better demonstrated than by George Scamell's coverage of Norfolk churches in 1904. The sites of his photography, such as the churches of Worsted, Runton, and Beeston Regis, are within cycling distance from the village stations on the branch railway lines from Norwich to North Walsham, and Sheringham.

However, the most significant engagement with historical topography remained that experienced by the walking photographer carrying his or her own camera equipment. For as Michel de Certeau pointed out, "stories" begin "on the ground with footsteps." This movement through the landscape constitutes what Peter Hansen has described, in regard to mountaineering, as a performative modernity, in which the relations between the past and modernity are experienced performatively through the embodied actions, gestures, and symbols of photography itself as "a style of tactile apprehension and kinaesthetic appropriation."[149] This is not, therefore, merely a visualisation of Baudelaire's and Walter Benjamin's "flâneur" moving disconnectedly through spaces, gazing voyeuristically, without focus, upon the fragmented spectacle and bricolage of modernity. Nor is it simply an opening up of the landscape to the viewer's gaze. As Jonathan Crary has argued, the disciplinary practices of modernity created new practices of attention that shaped perception and were integral to modernity itself, and that style and use, such as walking, are ways of processing symbolic values.

Here the specific subjective gaze of historical imagination was expressed and experienced haptically, through moving in the landscape, weaving places together, and dealing with the technology of photography, through which historical imagination and affect is realised, and in which the rhythm of movement "implies the relation of a time with space."[150] As Michel-Rolph Trouillot has argued, "History begins with bodies and artefacts, living brains, fossils, texts and buildings. . . . The bigger the material mass, the more easily it entraps us. . . . [Bodies, artefacts, and buildings] bring history closer while they make us feel small. A castle, a fort, a battlefield, a church, all these things bigger than we that we infuse with the reality the past lives, seem to speak with an immensity of which we know little except that we are part of it. Too solid to be unmarked, too conspicuous to be candid, they embody the ambiguities of history."[151] (See figure 24.)

Walking, it can be argued, created "maximal presence" a spatial acting-out of place. The experiences of landscape, "on the plane of the present are 'common places' in the sense that everyone can visit them, that they lie open for examination, that they can be walked. But they are not 'commonplaces'—they are not empty but full, not shallow but deep, not dead but alive. They are the repositories of time—or perhaps even better. The places where history can get hold of you."[152] As an eminent, contemporary nineteenth-century historian said: "It is possible for us, while taking our walks, to bring before ourselves a sympathetic picture of the life and efforts of our ancestors, who worked at the problems which we ourselves have to try and carry on a little further."[153] Thus we see Harrison in his paper encouraging the photographic Survey of Warwickshire in 1889, suggesting that photographers first visit places

without their cameras, in order to experience the sense of place and history that would be translated into photographs.[154] This conflation of place and imagination is exemplified in a passage in the diary of three amateur photographers, William Greatbatch, Bernard Moore and Percy Deakin, who undertook an excursion for the Warwickshire survey over the Easter weekend of 1896. As they cycled and walked through the landscape, their survey endeavours are repeatedly and almost overwhelmingly punctuated by embodied experience of that space and its relation to historical imagination and the picturesque. At Edge Hill, the site of a Civil War battle in 1642, they paused and "imagined the Royalists charging down the hill side & rounding the little woods and copses."[155]

But there are different kinds of walking that can be related to the values of observation, efficiency, and procedural correctness. *The Camera as Historian* also advocates walking but links it firmly to a system, rather than poetics — walking is a "methodical laying out of the work beforehand." The book continues, "Thoroughness of work is best attained by *walking* our ground unencumbered by photographic impedimenta and noting on the map the views to be taken ... This done the photographic outing is directed without loss of time to actual work and the result will be found a better series of records that could be obtained by casual unpremeditated, and therefore less promiscuous plate exposure."[156] This process constitutes a space through a finite number of stable, iso-

24. "The Great Gateway into the Second Ward," Corfe Castle. Photographed by Cornish Browne, 1910 *(courtesy of Dorset County Museum).*

of embodiment and forms of sociability" by directing participants through the historical landscape, marking spots of selective significance.[159] Thus the experience and practice of making photographs was grounded in shared circumstances through which topographies of significance were apprehended. This is exemplified in the description of a photographic excursion to Colchester, Essex, that was also seen as an opportunity to take survey photographs:

> The party ascended Balkerne Hill, Dr Laver explaining the various points of interest associated with the building of the old Roman Wall. . . . At the Balkan Gate—which was viewed with special interest . . . [one of] the only two Roman archways of the kind remaining in England. Having viewed the old Roman Guard room, the company proceeded to St Mary's steps, where they inspected the remains of one of the towers built in the wall for defensive purposes by the Romans.[160]

25. Ancient road. "A portion of Ermyn St over the Mickleham Downs." Photographed by N. F. Robarts, c. 1905. Surrey Survey *(reproduced by permission of Surrey History Centre. Copyright of Surrey History Centre, 7828/2/94/28).*

latable, yet interconnected elements—church, cottage, ancient trackway—that are brought together through embodied activity.[157] (See figure 25.)

Clearly, photographers worked in all sorts of configurations, moving through the landscape alone, in pairs, in informal groups (such as that of Greatbatch, Moore, and Deakin), or in formal groups, such as at Woolwich or at specific meetings (for instance at Barnstaple where a notice in the local paper announced an "outdoor meeting for the purpose of proceeding with the photographic survey of the town").[158] Organised excursions—or "photographic rambles," as they were often referred to—in particular marked the "relationship between practices of walking, the experience

This activity was also linked to an intensity of vision and attention; it was part of the enskillment and formation of knowledge that connects social and educational capital to the constitution of place.[161] The party in Colchester, for instance, were promised privileged sight of the historical. They would, the announcement of the excursion for the Essex survey stated, "be able to see and photograph some of the nooks and corners which are usually missed by casual visitors. It [was] hoped this will be the inauguration of a systematic survey of the town as well as an incentive to those able to assist in the work of our general Survey and Record."[162] Survey photography becomes framed not simply by the distanced gaze, but the experiential. This frame is made clear in an account of

an excursion of the Woolwich survey in May 1903, a damp and muddy excursion: "The party consisted [of] seven members & one visitor. Cameras were brought into action on entering Crown Wood, which was systematically photographed as far as the Railway bridge, when rain which had been somewhat fitful during the earlier part of the afternoon, settled into a pronounced drizzle & put a stop to further photographic work. The party then retraced its steps through the thick clayey mud which the rain had caused, to Shooters Hill where they dispersed."[163]

The embodied attention of survey photographers produced an historical topography delineated by keen observation and determined by a self-conscious collective. The mobility of the photographer is clear not only in rural contexts but also in the urban. The trained eye, historically sensitised, aware of the potential for photographic inscription and engagement with concepts of local civic pride and historical consciousness, brought to the streets an active historical imagination that could recognise and record historical significance wherever it might be found, in ways that conflate Nora's *milieux de mémoire* and *lieux de mémoire*. The photographs of Manchester streets, made for the Manchester survey by Samuel Coulthurst, are such an example. He advocated making record photographs of everyday street life with a hand-held or detective camera as the photographer walked to work, observing what was around him. Even when photographing buildings, Coulthurst moved through space with a small quarter plate camera, seeing and photographing from all angles, creating not only a completeness of record but also multiple layers of experience of things and people as he moved through the city.[164]

Similar is a series of photographs by T. K. Gordon, the building surveyor for Nottingham Corporation, for the Nottinghamshire Survey. The photographs in the series are arranged to create little narratives interweaving town space and people, the comings and goings of everyday urban life, in which there is a strong sense of Gordon himself as part of the space of the street.[165] (See figure 26.) In both Coulthurst's and Gordon's series, the photographs are mounted together on cards in the archive, maintaining this sense of engagement, creating a narrative of space. These photographs exemplify the way in which place is actively constituted through walking. Making the photographs required the performance of "a distinctive relationship with place, the interaction of the walker and the meaningful environment," the creation of an historical topography through experience and mobility, the creation of multiple points of significant observation from which knowledge is accumulated.[166]

The hand-held camera, producing instantaneous pictures, had a moral dimension, which became increasingly emphasized in the surveys. It shifted the social, embodied dynamic of photography, the relationship between observer and observed, photographer and subject. It carried an assumption of directness and spontaneity of observation, and thus local knowledge, in that the photographer was "better able to judge the correct moment for exposure by watching the object than [by] looking in the very small screen of the finder." The hand-held camera dictated that "the operator should be free to attend to his subject [and] not the camera."[167] That is, the instantaneous photograph stood for a direct, unmediated translation of vision itself, and thus the immediacy of the historical. The photographs then represented moments of stillness in the movement of the photographer through the

26. Nottingham streets. Photographed by T. K. Gordon, c. 1895. Photographic Survey of Nottinghamshire *(courtesy of Nottinghamshire Archives, DD/1915/1/716).*

landscape, not only because of the nature of the photograph itself, but because the moment of *observation* on which the surveys were premised was made from a stationary position.[168] Thus one can argue that the photographs emerge from rhythms of movement and stillness, focussed by the body of the photographer.

FAILURE OR LIMITED SUCCESS?

Whatever the individual and local experience of survey, by the late nineteenth century the idea of "the amateur" suffered a general loss of intellectual status as a producer of knowledge. Although the photographic and antiquarian societies that constituted the operational and imaginative base of the survey movement continued to be productive, especially in their production of local knowledge, the disciplinary structures of professional knowledge gradually defined the boundaries of archaeology, anthropology, and architectural history more firmly. The shift of the power base from these societies to the public face of these disciplines, through the free library and museum system, thus holds an ambiguous position in this loss of status, for both power bases gave public access to filtered forms of new disciplinary knowledge, while also encouraging the reproduction and dissemination of this knowledge through the autodidactic practices of rational leisure, of which practices the surveys themselves were part.

While survey and record photography's fluid amateur status, premised on rational leisure, moral duty, and civic utility, a status on which the movement prided itself, produced laudable rhetoric, it was less adept at producing photographs. Survey committees and the photographic press constantly complained that photographers were not sufficiently willing to undertake collective work: "There are so many users of the camera who do not care to be bound by any rules and prefer working according to their own idea rather than in a systematic way." This individualism was seen as selfishness in the face of social duty. As E. C. Middleton, an active survey photographer from Birmingham, stated: "Loyalty to the cause is a most essential feature to [the survey's] success, and selfishness must be placed entirely on one side . . . much work will have to be done not as a matter of choice but as a matter of duty." But as Coulthurst of the Manchester Survey commented, "The general run of photographers is too selfish to undertake to photograph anything that is specially wanted."[169] As Katherine Anderson has noted in her study of the networks of observation in nineteenth-century meteorology, those networks became "a critical site of the encounter of differing visions of the value and purpose of science."[170] In the context of the survey movement, the network became a site through which amateur photographic values were negotiated, and this did not always deliver satisfactory photographs, as far as survey enthusiasts were concerned.

Too often the success or failure of survey and record projects rested on the energies and enthusiasm of a small group of people; as was noted of the Photographic Survey of Gloucestershire, "not much progress has been made . . . a leader, such as Warwickshire has been fortunate enough to find in Sir Benjamin Stone, is not yet forthcoming."[171] Alfred Naylor of the Leeds Photographic Society wrote to George Scamell, "I laid your scheme . . . before our members in due course. So far they have not shown any active interest in the matter."[172] Coulthurst laments, "That I was dragged into the Photographic Survey of Manchester and Salford I cannot deny many times I have regretted it." However, mindful of social duty, he continues:

"I resolved to stick to my guns and see through to the end what others had deserted." In a similar vein, reporting on Warwickshire's progress in 1892, "Mr J. H. Pickard announced that he had received letters from several amateurs and professional photographers offering to assist the council. He also stated that, although at the outset photographic societies in other towns in the county had promised their assistance, no photographs whatever had been received from them, and the whole work had been done by members of Birmingham Photographic Society." Even the successful Surrey survey lamented, "If one per cent of the people of Surrey took about one percent as much practical interest in the Society's work as is done by a handful of enthusiasts . . . our rate of progress would be increased tenfold." Stone commented, "The public had not begun to understand what was being done. The labours of those who were now making record photographs would be better appreciated by future generations than they were by those now living."[173] Consequently, Coulthurst noted, "Some schemes by important societies have been abandoned, whilst others, after hanging fire for years, have been finished off in a fashion, and closed to get them out of the way, as it were."[174]

Furthermore, despite the discourse of system, survey coverage remained serendipitous and largely subjective. While nineteenth-century science, even by the end of the century, was sufficiently fluid to allow for a range of interests and communities within it, the surveys had the continuing problem of the impossibility of disentangling systematic observation and the practice of recording historical topography from more romantic or sentimental experiences of that topography. Thus the idea of survey was caught in a "field of practices open to the va-

garies of fluctuating commitment and opportunistic rather than organized photographing."[175] This structural character of the surveys—of largely "undisciplined" knowledge, of amateurism, of subjectivity, and of an underlying aestheticism—effectively ensured the movement's marginality in a modernity increasingly mindful of its disciplinary boundaries. The management and structuring of knowledge meant that amateurs were increasingly distanced, not so much from access to knowledge, but from active participation in the specific processes of desire, production, and validation through a constellation of discourses and their inclusions and exclusions in precisely the way Foucault has described the production of knowledge.[176] Thus the problems of the surveys were not necessarily found only in the photographs themselves but in how the survey's networks of production were perceived.

The photographic record and survey movement never fulfilled its encyclopaedic ambitions as promoted by Harrison, Stone, and even the Surrey survey in its more enthusiastic statements. Not only were there problems with status and network, but the work itself, as the *British Journal of Photography* had pointed out at the very beginning of the movement, was unrealistic. There was the fundamental problem of the nature of "completeness" inherent in an encyclopaedic aspiration, even within the discourses of system. The physical world of historical possibility would always exceed and threaten to "overwhelm the photographer who is bent on saving it all from disappearance."[177] A critique of Harrison's scheme for photographic survey, published in 1889, argued, "It would be absurd to regard the scheme of a concerted 'photo-survey' by the Societies of the United Kingdom as other than impracticable, un-

wieldy, of doubtful utility, of problematic longevity in its execution, and of debatable practical value when (if ever) finished."[178]

The rational and systematic rhetorics of survey and record, based in empirical observation and photographic mechanics, were "ultimately revealed to be unrationalizable," in that photographic attention could never be sufficiently focussed and controlled.[179] Not only did the excessive inscription inherent in survey photographs — random inclusions of hats, umbrellas, heating stoves, drain pipes, church chairs, and modern advertising — all intrude into the space of historical imagination, but the unfocussed qualities of photographers' intentions inter-

vened at every stage. (See figure 27.) Attention as a perceptual, mental, and thus photographic organiser could not be entirely isolated, for it "demanded organization, selection, [and] isolation" of what was an embodied, what was experienced as a united visual field. Attention always contained within itself the conditions of its own disintegration — it was haunted by the possibility of its own excess."[180]

Some survey and record projects were dismal failures. Somerset mustered only thirty-two photographs in five years, whereas the highly organised and focussed Surrey society photographed and collected about 14,000 photographs over fifteen years. Nottingham pro-

27. "Mangotsfield — Effigies." Photographed by F. F. Tucket, c. 1895. Photographic Survey of Gloucestershire *(courtesy of Gloucestershire Archives, SR44.36297.11).*

duced about 900 photographs, but it is not clear if the collection is complete. Kent and Sussex made between 3,000 and 4,000 each, while the Warwickshire and Norfolk archives are also very substantial. The NPRA itself acquired only 5,800 photographs in thirteen years of existence, which, given the scale of the organisation's ambitions, can only be seen as a failure. Indeed in the latter years of the NPRA the contributors were most often George Scamell, Godfrey Bingley, and Stone himself. Some surveys, such as that of Sheffield, do not appear to have progressed beyond the stage of good intentions and inspiring rhetoric. However, it is difficult to assess precise numbers in many cases because of the vicissitudes visited on survey deposits over the years.

Furthermore, despite the ethos of social duty and volunteerism and the increasing engagement from local government, in many cases the infrastructure to deliver those desires remained hopelessly inadequate, and financial support for basics such as mounting, labelling, and boxes remained largely elusive. Likewise, many schemes to ensure a constant and systematic flow of images into the survey and record archives were entirely impracticable and often organisationally, and indeed financially, vastly overambitious. For instance, there were constant appeals for old negatives that could be printed or old prints that could be copied for the archive. But given the amount of material available under such a rubric, the quantity of work undertaken was minute. Another example of ambitious acquisition was a request to the city engineer's department of Norwich: "Before he issues instructions for the demolition of any building or object of interest in the city, a photograph of such object or building should be taken by his department, and a print by permanent process presented to the collec-

tion of the Photographic Survey." The suggestion was met with a stony silence from the engineer's department.[181]

Even local curators and librarians could on occasion be reticent. This seems to have been more marked in museums than libraries, possibly part of a marginalisation of photographs in museums which continues to this day. Despite his enthusiastic response to photography in general and the fact that Kent survey photographs were going into his museum, J. H. Allchin of Maidstone Museum stated clearly, "The survey is quite a private association, and has nothing to do with the Museum," while Henry Roberts of Brighton Museum, which was involved with the Sussex survey through the Sussex Archaeological Association, "inquired if curators had not already enough to do." Roberts is reported as observing, "A photographic survey in Sussex had been resuscitated, but he had religiously abstained from having anything to do with it beyond arranging and cataloguing the documents which members brought in."[182]

There was also the work of local commercial photographers, producers of topographical images for the "views trade." Although there was a constituency in survey photography that saw their images as too generalised and popularist, indeed Stone himself had taken up photography precisely because of the inadequacies, in his view, of such photographs, appeals for donations were met with only half-hearted support.[183] Despite the appeal of the larger social good, these photographers wanted to sell photographs, not give them to libraries. There were, of course, exceptions to this rule: Sidney Pitcher of the Gloucester survey, for instance, had strong antiquarian interests and the Belfast photographer Robert Welch gave large numbers of photographs to the NPRA. Welch, however, was unusual in that he had clear scientific

aspirations as an active member of the Belfast Field Club and as an active collaborator with Cambridge anthropologist A. C. Haddon, who had interests in Irish ethnography and worked for the BAAS ethnographic survey. Commercial and professional photographers were undoubtedly involved with local surveys, but their contributions on the whole were slight, and their involvement appears to have emerged from the sociality of photographic networks, from their membership of local photographic societies, rather than through any particular sense of social duty or preservationist desire.

In addition to these problems, there was perhaps also a disquiet with Sir Benjamin Stone's high-profile pronouncements on photography, what photography should be, what photographs should achieve, and for whom they were intended. Although their objections were never fully articulated, one gets a sense that the photographic establishment and the habitués of the salon were irritated by Stone's declarations and were sceptical of the claims of the survey movement. But Stone was also seen as imposing impracticable demands on amateur photographers regarding the appropriate historical forms to be recorded, and regarding the technology photographers used and their aesthetic competence. Despite the fact that Stone is repeatedly acknowledged as the champion of photographic survey, this unease can be seen resonating through rather fulsome yet tongue-in-cheek and gently sceptical descriptions of the survey project. Stone is repeatedly referred to as "ebullient," "ubiquitous," and "vocal." For instance, in 1904, *Photography* magazine opined,

"Sir Benjamin is occupied in carrying out a new Pilgrim's Progress, being engaged in following in the footsteps of John Bunyan, the travelling tinker; or, as he has been more euphemistically designated, the itinerant whitesmith. Well, it's a big job to secure photographs of everything with a Bunyanistic reminiscence attached to it, if ever Sir Ben wants a task that will test his patience and ubiquity I would suggest he takes a photograph of every bed in which Queen Elizabeth is said to have slept. It would certainly be an easier task to photograph the beds of the period in which she did *not* sleep (if any such there be) . . . I fear that Sir Ben has not fully realised the enormity of his self-imposed task if he thinks he can secure negatives of every place in which Bunyan was imprisoned, to say nothing of all the pots, kettles, and frying pans he repaired."[184]

The same journal was openly hostile when Stone's photographs of English antiquities and folk customs were shown and awarded medals at the St. Louis Exposition of 1903: "A jury that awards seventy-eight medals among ninety-eight competitors, that classes the work of Sir Wm Abney on the same place as that . . . of Sir Benjamin Stone . . . is worthy only of a comic opera."[185] One even gets the sense that the British Museum was not entirely welcoming of Stone's donation or his idea of "significance," as Sidney Colvin, keeper of prints and drawings at the British Museum, reported to the trustees: "He feels bound . . . to observe that the series of portraits [of members of Parliament] formed no part of the gift as originally announced. . . . [This] causes him some apprehension as to the prospective look of the collection."[186]

Finally there is the question of the limited numbers involved in photographic survey. It is, of course, difficult to assess the impact of such a movement retrospectively. Even if the 1,000 or so photographers from the seventeen

surveys researched for this book were multiplied by the seventy-three known English surveys, there would only be about 4,500 photographers. Although it probably constituted at that date the largest ever mass mobilisation of amateur photographers for a single purpose in Great Britain, the overall numbers remain small in relation to the huge number of hobby photographers, the estimated 4 million active in photography in some way, either owning camera technologies or with access to darkrooms through clubs, societies, and educational establishments. Furthermore, it has been argued that the impact of the preservationist movement has been overestimated and that it was a movement coming from a tiny minority of aesthetes and romantics addressing an equally select audience.[187] Yet the survey movement cannot necessarily be dismissed as marginal. As Readman has pointed out, it is important not to confuse numerical limitation with limitation of impact, for such an interpretation fails to account for networks of influence and the fact that the cultural range and absorption of shared cultural values of survey photographers' activities were part of a larger cultural movement that "had considerable resonance across the entire social scale."[188] The endeavours and values of survey were entangled with, and quietly informed, a range of cultural practices, both within the practice of amateur photographers and more broadly.

The coverage in the photographic press clearly shows that the survey movement had an impact in debates not only about history and preservation, but on the perception of what photography was for and what it could be expected to deliver in the public sphere. The values of survey and record photography and the possibility of useful work with the camera inspired amateur photographers. The range of influences and kind of historical and topographical awareness that the survey movement wished to foster and the wider public impact of the photographs themselves cannot be measured simply through numbers of survey members and exhibitions, because these numbers constitute a whole system of values around responses to the past and perceptions of the future. Above all, the survey movement found an active role for amateur photographers within this public space, a role that allowed them to contribute to the practices of history, photography, and archive production. Thus, the relatively small membership and limited success of many of the photographic surveys should not necessarily be called failures or, more significantly, unimportant. As one commentator noted in regard to the development of the NPRA collection at the British Museum: "The industrious amateur will do well to aid in the glorious work, covering himself with immortality in the Valhalla of Bloomsbury."[189]

The inscriptive potential of photography, which was central to the survey movement's beliefs and practices, was entangled with debates about the nature of evidence and the role of the visual in recording, preserving, and even understanding physical traces of the past, be they geological, archaeological, or architectural. That potential was also part of key debates about the nature and purpose of photography itself and the social expectations that clustered around photography as survey photographers grappled with the difficulties of establishing incontrovertible meaning through their medium, in a series of debates similar to scientists and others concerned with the evidential potential of photography: "If record photography is to be really useful now and in the future — it must have a clearer definition of what a record photograph is, or should be."[1] For survey photographers, photographs had to constitute an evidence that was both legible and convincing, addressing, reproducing, and performing subject matter. Furthermore, in order to realise the general objectives of the photographic survey movement, this body of historical evidence would have to survive without physical, and thus informational, loss into the future. (See figure 28.)

Those involved with the photographic surveys strove to institute a realisable "truth" through the control of material, aesthetic and taxonomic practices in order to produce the desired evidential quality of historical record photographs. Saturating these practices were the moral values of science, community, and duty. Historical imagination and historical desire were articulated through the

Unblushing Realism

*Practices of Evidence,
Style, and Archive*

Somerset Archæological & Natural History Society.
Photographic Record.

Subject (A) Bishop Lydeard Church Tower – 1898
(B) Lydeard St-Lawrence Church Tower – 1898

Exhibited by D. F. J. Allen Date of Photograph 1898

28. Bishop's Lydard and Lydard St. Lawrence, Somerset. Photographed by F. J. Allen, 1898. Photographic Record of Somerset *(courtesy of Somerset Archaeological and Natural History Society).*

values of photography itself, going to the heart of amateur photographic practice and to the aspirations of those involved. The material practices of photography provide a key medium through which debates about the nature and purpose of photography in recording and preserving the past were articulated, whether in relation to photographic style or the prosaic details of mounting cards. These practices constitute the analytical basis of a kind of "material hermeneutic" that brings the consideration of the material back into the centre of historical understanding and interpretation, for it is the material that shapes existences and experiences. In the context of survey photography, "instruments," the camera, negatives, printing papers, mounts, boxes, and labels, mediate experiences and articulate desires to the extent that they "co-constitute the reality studied by scholars."[2] The contemporary debates around questions of observation, instrumentation, chemical processes, and archival ordering reveal anxieties about the future and the historical legacy, and

about the containment of photographic meaning through a combination of stylistic and archival control. The technical and material aspects of photography and its objectivity were thus integral to articulating, enhancing, and maintaining those values.

The survey and record movement advocated photographs as truthful and unmediated records privileging the mechanical inscription of their subject matter. The intention was, of course, to provide "evidence" of the past, producing documents that would be legible over time and ensure the visibility of a valued past. While this is far from a naïvely uncritical position, the surveys were premised on a positivistic reading of the inscriptive traces of photography, a privileging of unmediated inscription in which subjects were to be treated "in the best and most realistic way by means of absolutely 'unfaked' photographs. It is impossible . . . [f]or the best written description to convey to the imagination so accurate an impression of a scene or an object as that given by a photograph. The one is interpreted according to the mental capacity of the reader; the other is the same to every eye."[3]

For survey enthusiasts, "pure image" could elicit "pure vision" and pure, or at least proper, "understanding."[4] While this position was undoubtedly partly rhetorical, adherents of survey and record photography required both a photographic style and processes of production that grounded the images firmly in the mechanical and authoritative certainties of photography. This style and these processes in turn stood for the scientific qualities of observation and the inscription of "empirical reliability . . . procedural correctness . . . [and] emotional detachment."[5] This was what made photographs worthy and reliable documents that could be bequeathed to the future with confidence. Nonetheless, the

projection of this material into the future, with its intellectual, physical, and informational longevity assured, was insecurely grounded, and the production of that evidence was understood as profoundly and self-consciously mediated through the material practices of photography. The moral economy was threatened at every turn with the dissipation of the survey objectives, through the ambiguities of photographic inscription and the desires of amateur photographers themselves.

ENTROPIC ANXIETIES

The survey movement, with its concern for the future, was beset by the fear of the loss of the evidence that those concerned understood as valuable, and which ultimately stood for the loss of history and of culture itself. This was not only the fear of the loss of the physical historical environment but a concern over the stability of the archive itself and the tensions between "the conjunction of rigorous regulation and the simultaneous acknowledgement of inevitable excess and diversity."[6] The fear of loss, however, was constituted over multiple registers. A complex entropic anxiety permeates all levels of the photographic surveys, not only in the language of cultural disappearance but in survey contributors' concerns over stylistic instabilities and fragile material practices. Such entropic fears encompassed anxieties about the loss of information through inappropriate photographic styles, the mutability of photographic meaning, unstable photographic processes, disorder in the archive, and even the dissipation of the energies of photographers. Record and survey photography was based on an efficiency of purpose that could be disrupted by the failure to control the disordered

and excessive inscription of the photograph, an inscription that needed not only systematic production through the organization of photographers but through the rigorous organization of photographs themselves.

Such concerns were, however, part of a larger culture of entropic anxiety. Thomas Richards has argued, in the context of the imperial archive, that concepts of "information loss" had become more forceful with advances in physics, especially in the development of thermodynamics, notably the Second Law of Thermodynamics, which is concerned with the distribution and loss of heat, energy, and power.[7] It posited the inherently unstable and disordered nature of the universe. Just as the broad application of Darwinian biological theory resonated through the surveys, thermodynamics represented a similar revolution in theoretical physics, one which again caught the public imagination as the language of physics came to be used over a number of fields, including social and moral criticism.[8] As both Stephen Brush and Greg Myers have demonstrated in their different ways, not only were these ideas inflected with social theory and moral criticism, especially in their popular explications, such as the work of the nineteenth-century Scottish physicist Balfour Stewart. These ideas were absorbed into the public imagination as the language of physics came to be used over a number of fields.[9] Applied to mathematics, statistics, and then the macroeconomics of the waste and conservation of capital, the concept and device of "entropy" became "the important epistemological index of the century."[10] By the late nineteenth century, entropy had become a theory of information management of metaphorical force, as what had become one of the first "information societies" struggled to cope

with the possibility of too much knowledge, knowledge that might explode and dissipate at any moment.[11] The laws of thermodynamics, applied more generally, threatened to degrade and dissipate concepts of a graspable universal history, such as the universal history advocated by Harrison. Attention was thus given to ways of organising information "so as to cope with chance events and evade disorganisation," and it was around this intention that archival organisation became reoriented.[12]

Survey photography and its archiving can be seen as precisely such a battle against entropic forces, against the frailty of the human memory, against the forces of disordered modernity, and against cultural and material disappearance. These concerns were articulated by *The Camera as Historian* as it lamented:

> One of the outstanding characteristics of our time—as contrasted with the past—is its tendency towards the elimination of waste of power—the economical direction of human activities so as to increase their productivity and effectiveness—the utilization of what have heretofore been regarded as "waste products." To the engineer it is abhorrent that any energy be allowed to run to waste.
>
> But in the domain of photography the amount of "horse-power running to waste" is appalling—and all for lack of a little system and co-ordination. Shall this be allowed to continue? Shall the product of countless cameras be in the future, as in the past (and in large measure today), a mass of comparative lumber, losing its interest even for its owners, and of no public usefulness whatever? This is a question of urgency. Every year of inaction means an increase of this wastage.[13]

Related to those contemporary ideas of a sense of duty and rational leisure, a repeated theme was the idea that the energies of photographers and their photographic materials should not be wasted on "worthless images" in general and the ephemeral glories of pictorialism in particular, but be channelled to survey and record as the historical exercise of lasting value.[14] Reverend Perkins, anticipating the remarks in *The Camera as Historian*, asserted that "energy wasted on aimless plate exposing should be channelled into a more useful purpose," that photographers should find "a more profitable field for their photographic energies."[15] Similarly *Amateur Photographer*, reporting the annual meeting of the NPRA, stated that "very small a proportion of photographers who practice what is called pictorial photography can hope to achieve anything above the ordinary, but that these might on every camera excursion secure at least a few 'Record' prints of an interesting and instructive kind."[16]

If the pictorial impulse was conceptualised as an entropic danger to be resisted, at the other end of amateur practice, the enthusiastic "snapshotter" likewise represented wasted energy that could be constructively harnessed to the survey purpose: "Mere aimless wandering about and casual snapshotting is not only poorly productive in itself, but tends to beget a slipshod attitude towards the work which it should be the aim of Survey organisers to combat."[17] Alfred Watkins, the noted antiquarian, historian, and photographer from Hereford, addressing the survey section of the Photographers Guild in 1897, stressed "the importance of having a definite aim of photography instead of muddling away plates in an objectless manner."[18] J. Bridges-Lee similarly claimed, in an article from 1902: "There are many amateurs who do a vast amount of almost aimless

and useless snapshotting to obtain pictures of which a very small proportion will have any abiding interest for themselves or enduring usefulness to anybody."[19] Indeed, some commentators went as far as to accuse amateur photographers of selfishness, in that photographers were content to make photographs merely for their own pleasure, not to share the for the collective good and for the benefit of others in the future. As Edwin Middleton, writing in *The Practical Photographer*, claimed, "The real value of a clever worker who merely works to please himself, selfishly picking a good subject here and another there, and producing excellent photographs, will not compare with the second or third rate man — as a photographer — who conscientiously enters into the work, loyally sticks to the cause, works systematically with a definite aim, and gradually produces his complete work, individually inferior prints perhaps, but collectively of far greater value."[20] The attitude of the "clever worker" might hamper the open exchange networks of social and cultural intercourse on which the "scientific community" of survey depended, and risked working against that fraternity of scientific or "systematic" endeavour and sociability, within which the successful realisation of survey aims might have been achieved.[21]

The ephemeral nature of the mass of photographic production was also seen as symptomatic of the problem. As Harrison stated in proposing photographic survey in an address at the Chicago World's Fair in 1893: "It is certainly lamentable to consider how many thousands of valuable negatives are wasted annually for want of any method for their preservation and publication."[22] It was not merely a matter of preserving those photographs made by photographers for survey and record collections, but the ephemeral and transitory quality of the

potential archive, a point to which I shall return later. In addressing the Museums Association Meeting in Maidstone in 1909, collector and art historian Sir Martin Conway discussed the desirability of museums collecting photographs of all kinds: art, natural history, railways, "types." In relation to records, and echoing the comment of Bridges-Lee on "useless snapshotting," he stated that "the output of photographs at the present day is enormous and for the most part prints made in any one year have become scattered and for the most part destroyed in the course of the following decade. The result is that records of priceless value are being lost as rapidly as they are being made."[23]

There was also a sense that the whole project of photographic survey was entropic: that the loss of information could not be contained, for the project itself was essentially flawed. This had been the basis of the *British Journal of Photography*'s criticism of Harrison's original scheme for photographic survey in 1892: "The term 'survey' in such a connexion, is clearly a misnomer, as Mr Harrison does his best to prove by his suggestions that such pictures may be taken at random by individuals, and by photographic societies on Saturday afternoon excursions."[24] The continuing concern about the essentially unavoidable fragmentary and serendipitous nature of the project was expressed repeatedly. One of the main causes of scepticism about the validity of the survey ideal did not merely pertain to the quality of observation or the scale of the project overall but to the impossibility of true permanence as the endemic entropic character of photographs made them unrealisable.[25]

These concerns can be understood as linking directly to those about entropy and the concern of the authors of *The Camera as Historian* on the appalling waste perceived to be inherent in photographic effort. There is an almost Baudril-

lardian sense of the disordered mass of photographic images emerging in a dynamic modernity that might swamp those photographs of value, obscuring the "reality" and "authority" of the historically significant, and allowing "the past" to seep away into oblivion, in a mass of undifferentiated simulacra. In a thermodynamic view, decline, here the mutable mass of photographs, was inextricably linked to uncertainty.[26]

Yet despite these concerns and anxieties, the fear of loss also constituted a form of hope and a sense of the future. The role of the survey photographs was to be, as is so often the case in making photographs, a dynamic focus for an anticipated future and for anticipated acts of memory as people engaged with their histories. Entropic anxieties were focused not on a simple negative of loss and disappearance, whether of culture or of photographs themselves. Rather, the concerns clustered around the risk that the positive and dynamic future envisaged for the photographs could not be realised because of the inadequacies of the present, whether stylistic, technological, or archival.

THE PICTORIAL AND THE VEXED QUESTION OF STYLE

One of the main entropic threats to the correct and systematic translation of observation, and thus to the creation of credible and legitimated evidence, was that of photographic style and the treatment of the subject. The photograph as historical record was understood to depend on the quality of visual statement and the shifting relations between historical precision and imprecision: "At issue was not only accuracy but morality as well, the all-too-human scientists, must, as a matter of duty, restrain themselves from imposing their hopes,

expectations, generalizations, aesthetics, even [their] ordinary language," onto their subject matter.[27] As Stephanie Moser and Sam Smiles have pointed out in relation to archaeological imaging, "Formal and stylistic observances act as filters of meaning, delimiting what can be achieved pictorially: technical constraints can determine the amount and quality of detail; stylistic mannerisms will inflect the recording of data."[28] All these elements shape the production of photographs for survey.

The future value of the photographs was premised on the unmediated inscription of the camera image. (See figure 29.) This translated into concerns about how a subject was photographed. Evidential value merged with photographic style to create a moral economy of observation, photographic production, and an archival system that valued a "straightforward" approach in which "every subject should be so photographed as to bring out the special points of interest as an historical record."[29] There was a fluid and problematic relation between ideas of "record," "document," and "topographic" photographs in ways that both conflated and blurred the critical boundaries that emerged around such terms. However, as James Elkins has argued, informational photographs, such as those anticipated and desired by survey photographers, were not "inexpressive" but were replete with the expressive performance of knowledge according to specific codes.[30] The moral qualities of straightforwardness and directness were central to the ideas of unmediated record and informed observation, and they were premised on a sense of duty and the moral values of objectivity constituted through diligence and self-restraint.[31]

Pictorialism was the dominant photographic aesthetic of the late nineteenth century and the early twentieth. Concerned with establish-

ing photography as an expressive art medium and aligning its aesthetic potential with the conventions of academy painting, the specific principles of pictorialism had first been established in the 1860s by Henry Peach Robinson in his book of 1869, *The Pictorial Effect in Photography*.[32] While the approaches and qualities pictorialism should take were subject to heated and acrimonious debate over the years, by the late nineteenth century a broadly constituted pictorialism formed the core values of the photographic press, photographic societies, and photographic exhibitions, at all levels, from international exhibitions to local camera clubs.[33] Closely related, although not exclusively so, to the picturesque in terms of its subject matter — often landscapes, rural idylls, and allegories of life and work — the pictorial was a pursuit of the beautiful through individual vision, articulated photographically through hand control over colour, tone, detail, and the making of "pictures."

Pictorialism developed, in part, in the context of an increasingly extensive commercial practice that was seen as debasing the values of the medium. The artistic aspirations of amateur photographers were, as a number of commentators have demonstrated, closely related to class, namely in the difference between the educated and aesthetically attuned gentleman and the artisanal mechanical operator.[34] These class tensions might be understood as mirroring earlier ones in the creation of historical knowledge, tensions between gentleman antiquarians and artisanal draughtsman.[35] Advocates for photography as an art form wished to demonstrate that photographers could transcend the mechanical nature of the medium to create images of beauty, a transcendence and a moral value through which photographers might compete with painters and engravers.

29. "Square iron bar 2½ inches thick, fixed in the window sill of the Parlour of the White Hart Inn in the Corn Market, to chain arrested persons to." Wimborne, Dorset. Photographed by J. Kenrick (of the Surrey survey), c. 1900. Silver print from quarter-plate negative donated to Dorset survey *(courtesy of Dorset County Museum)*.

Although by the first decades of the twentieth century early modernist photography began to emerge in the upper echelons of photographic refinement and was seen in exhibitions and publications (a response to what was perceived as the exhausted sterility of the pictorialism), pictorialism nonetheless continued to be the dominant aesthetic of photographic societies and camera clubs from the Royal Photographic Society to local camera clubs.[36]

However, despite their disparate agendas, there were points of connection between the different approaches to photography. Some strands of pictorialism, especially in its less impressionistic forms, were, for instance, not dissimilar to those of the survey movement. Both record photography and pictorialism advocated truth to nature, quality of observation, and the quality of the photographic print. For instance, in a way reminiscent of strictures on obser-

vational accuracy and scientific seeing, Frank Meadow Sutcliffe, writing under the pseudonym Pursuivant Elect in *The Linked Ring Papers*, stated that photographic "truth," however it was construed, was dependent on quality of vision: "By keen Eyesight, I do not mean an Eyesight for little Details but for Accuracy and Knowledge of how to express what was seen."[37] Likewise, there was in the work of P. H. Emerson and Frederick Evans a strong sense of the integrity and purity of the negative to represent either the naturalistic forms of human vision or a straightforwardness in the observation of subjects.[38] This echoes Ruskin's claim that in order to perceive the "pure facts of nature" the spectator must attempt to clarify his or her vision by reducing the element of "self" interposed between the viewer and the object."[39] While formulated in the aesthetics of nature, this is in many ways very similar to the concept of vision that informed the survey movement and constituted yet another transactional nodal point. Indeed, despite the survey movement's general unease with self-conscious aesthetic statements, their views on architectural preservation and restoration would appear to have been absorbed from Ruskin and Morris.[40]

Whatever their overlaps, however, these photographic values were differently premised. It was not merely the case that these were photographic practices with widely different intentions and applications. The surveys presented themselves as an accumulation of fact through the precision of mechanical optics, while pictorial photographers subscribed to the affectiveness of human visual experience premised on the vision of the artist. The photographic practices therefore stood for very different social and moral values. (See figure 30.)

What is crucially different between the pictorial aesthetic and that of survey was the position of the individual. Pictorialism was premised on the aesthetic sensibility of the individual who had the education, temperament, and aesthetic ability to realise the picture-making potential of photography. The aptitude for pictorial photography was therefore vested not in the camera as a mechanical instrument but in the camera used for the articulation of those qualities. Pictorialist art photography was premised on the translation of individual vision and observation not through a scientific grid but through and for the realisation of individual aesthetic expression and satisfaction.[41] As Henry Snowden Ward, editor of *Photogram* magazine, keen supporter of survey photography and member of the NPRA committee told the Photographic Convention in Canterbury in 1909, pictorial ability was "the power to see beyond the obvious," and while "photography may be a matter of teaching; art is a matter of education."[42]

Conversely, the emphasis of the surveys was on the collective and the values of social improvement through engagement with historical roots. Although the names of photographers are recorded for almost all survey photographs, this must be understood not as a privileging of the author, but as a documenting of observation and the making of a statement in quasiscientific terms. This again points to the scientistic values that underpinned the surveys. One of the defining moral characteristics of the nineteenth century scientific community was, as Lorraine Daston argues, the emergence of a notion of objectivity that she terms "aperspectival." This notion embraced "detachment, impartiality, disinterestedness, even self-effacement. . . . [and was] enlisted to make shared public knowledge" in which the individual subjective position was necessarily forgotten "in order to attain 'the true standard.'"[43] Such values informed the sense of

Little Coggeshall Church
Essex.
Geo Scamell

30. Little Coggeshall Church, Essex. Photographed by George Scamell, 1909.
NPRA Collection *(photo © Victoria and Albert Museum, London).*

collective and social duty in survey photographers' suppression of the subjective and its aesthetic manifestations: "Unlike the practitioners of 'pictorial photography' the photographers devoted to record work can hope to make no bubble reputation, nor be flattered by reproductions, usually unlike the originals, of their work in the amateur papers."[44] Instead, photographers working in record and survey photography were expected to "throw overboard all cherished ideas of composition and be content to proceed in an unblushingly realistic and matter-of-fact way." There was a sense that individual vision and interventionist photographic practices could be distracting in the case of survey photographs. As the *British Journal of Photography* suggested in 1908, "Many prints miss being satisfactory records solely because their producers have failed to divest themselves of their pictorial pre-possessions."[45] Indeed, the images that resulted from survey activity were often referred to not as "pictures," or even "photographs," but as "records," as if to stress their mechanical and inscriptive nature, documenting status and implied future importance over any aesthetic considerations.[46]

Critics such as pictorial photographer Frank Meadow Sutcliffe, who took famous photographs of Whitby fishing people and was a well-known commentator and judge at photographic exhibitions, deplored the lack of aesthetic control in record photographs, in their composition and their tonal qualities. He castigated the NPRA, and by implication other surveys, for

31. Bearsted village. Photographed by W. Wilson, 1904. Photographic Survey of Kent. Silver bromide print *(courtesy of Maidstone Museum and Bentlif Art Gallery).*

nothing left to the imagination; as is sometimes the case in our pictorial efforts."[50] Dr. J. H. Baldock, of the Surrey survey, a medical doctor, an active member of the Croydon Natural History Society, and a keen microscopist, engaged in a public debate on fuzzigraphs in the pages of the *British Journal of Photography* in 1898. He stated that photographs must be "accurate presentations of what is seen, and not distorted views."[51] More than anything, fuzziness interfered with the quality of attention required to engage with the informational aspects of the photograph: "Looking at a 'fuzzy' picture, we are continually attempting to focus it sharply, and failing, the result being a distraction to the main object of the picture."[52]

As if to stress the moral duty of photographers, critics presented pictorialism as a form of temptation that might distort, whether intentionally or not, "visual facts." (See figure 31.) As *The Camera as Historian* stated in regard to landscape and scenery: "The pictorial aspect of this branch of photography will naturally tempt the worker to stray from the paths of record pure and simple. A photograph of a beautiful scene, simple as such, has its value in a record collection, but for systematic work aesthetic gratification should not be allowed to overshadow other considerations."[53] Photographs contained, in the manipulation of negative and print, the possibility of moral destabilisation. Stone claimed: "[Photographs] had in them elements of decay and evidences of untruthfulness."[54] Good record photography, as did good science, depended therefore on the suppression of individual, subjective, and aesthetic responses in favour of the collective endeavour, articulated through the uniformity of style and production.

taking anything that chance threw their way. He argued that some photographs were so bad that they would kill, rather than inspire, sensitive members of future generations or permanently wreck their sensibilities.[47] On the other hand, writers interested in evidential values railed against "fuzzigraphs," which they saw as a betrayal of what photography could offer.[48] In the words of the *Amateur Photographer* in 1900, "The more we see clearly [in a photograph], the less is left to the imagination."[49] Even if "excess of detail" could itself be distracting, as the secretary of the Norfolk survey claimed, "good technical straightforward prints were required, &

However, these choices were not necessarily seen as choices, but as being, to some extent,

temperamentally determined. For instance, differences in temperaments of photographers are hinted at by F. J. Mortimer, editor of *Amateur Photographer* and a noted pictorialist photographer, at the Photographic Convention in Canterbury: "The whole district around the city teems with material for the camera. The pictorial worker may have his fill of subjects that can be turned to artistic account, while the more technical worker will find subjects galore for the 'survey and record' type."[55] Likewise, the *British Journal of Photography* commented, "Fortunately the work does not call for any special qualification beyond the ability to take a good photograph . . . therefore it may be possible to enlist the services of many photographers who possess neither the inclination (not the temperament alleged to be necessary) to pictorial work."[56] And *Amateur Photographer* declared, after the announcement of the Sheffield survey in 1889, "By all means let those who *can* emulate the artist, make pictures, but inability need be no barrier [to making record photographs] to others not so gifted."[57] However, members of the Surrey survey saw this perceived differential as being to the advantage of their project: "Otherwise much valuable material would be unavailable. Nay it is often the case that the processes by which pictorial excellence are secured in photographic work (partial suppression of detail, double printed, atmospheric effect and the like) are detrimental, if not fatal, to the production of a useful record photograph. It is not suggested that technical excellence is unimportant in a record; but a moderate degree of excellence suffices, and other qualities are called for which often do not accord with the methods of the pictorial worker."[58]

The tensions that clustered around the virtues of photography and its functions were on occasion played out publicly for a general audience. For instance, the Norwich newspaper the *Eastern Daily Press* published the full text of Stanley Jast's lecture in Norwich to launch the Norwich and Norfolk survey in January 1913. Jast's suggestion that survey photography was a "department of human activity in which the comparatively unskilled worker could do so much of real and increasing value to posterity" received a robust response, with entropic inflections, from Edward Peake of the local photographic society: "Good technique will tell in this as in every other art, and that if simple record is to make up the mass of the survey, these photographs, from their straightness and simplicity ought to be of fine technical quality . . . otherwise the contributions to the survey will be paying for more photographic waste."[59]

Such tensions and concerns also emerge in the wider field. For instance, the *British Journal of Photography*, commenting on the photographic section of the Dresden International Photographic Exhibition in 1909, which included a substantial section of record photographs from all over Europe within scientific displays, thought that there were too many survey photographs, out of proportion to the technical, aesthetic, and even scientific interest of the material displayed: "Frankly the exhibits in many cases are 'just photographs,' and often of not a very high order of merit; but they have great interest for the public, are regarded as of educational value, and in some instances, notably that of Austria, do possess really great pictorial merit."[60] Conversely, Stone reported at the annual general meeting of the NPRA that year that "The English Pictorial exhibit [at Dresden] was a representative of a large number of well-known exhibitors, but so overweighted with meaningless pictures as to lose all attraction. In consequence of this . . . the room is al-

most always empty, while the scientific section is much appreciated. The record exhibits being peculiar to England attract much attention."[61]

THE CULTURE OF CLUBS: MIXED MESSAGES

The problem for many in photographic societies and camera clubs, however, was that such a position, privileging the straightforward over the pictorial, might have been read as tantamount to admitting a lack of photographic talent or aesthetic and intellectual ambition, to being a "second or third rate man" as Middleton said. *Amateur Photographer* wondered if "artistic workers (i.e., those who practice the aesthetic side) ever condescend to the taking of record photographs." Likewise, *Photographic Quarterly* stated, "It must be said that to some minds, especially those who go in for "picture making," surveying work, to illustrate, say, the architecture or the life of the people in some particular district, would prove too dry and narrow, as presenting comparatively little opportunity for independence."[62] At the Birmingham Photographic Society's exhibitions, judges were specifically reminded that survey photographers were not to be judged according the same standards and criteria as other classes in the exhibition. This point was also made by a commentator on a set of Rotherham survey photographs exhibited in Bradford: "Whilst not being admissible as pictorial work, [the photographs contained] an evidence of the thoroughness with which they were performing their task."[63] Photographic societies were therefore in an ambiguous position, on the one hand wishing to support the socially important work of survey, on the other finding that work aesthetically unchallenging.

The culture of the photographic societies

themselves was largely focused on technical accomplishment, aesthetic aspiration, and development of the medium. There was a massive system of dissemination of ideas and images through the photographic societies, and examples of what was perceived as best aesthetic practice were widely available. (See figure 32.) For instance, noted photographers, often working in pictorial style, lent prints for exhibition in the larger provincial cities such as Manchester and Leeds, often under the auspices of the Royal Photographic Society, and for the exhibitions of the regional photographic federations that were established in the late nineteenth century and the early twentieth. In addition, lantern slides of photographs from the London exhibitions were circulated by the Royal Photographic Society, *Amateur Photographer*, and *Photographic News*, or through publications such as *Photograms of the Year*. Norwich and District Photographic Society, for instance, scheduled a meeting every year specially to discuss the contents of *Photograms of the Year*, for "much may be learnt from a careful perusal of its pages."[64] The minutes of the Leeds Photographic Society recall a meeting in October 1889: "The evening was spent reading portions of Dr Emerson's new book, with letters criticising the same, and afterwards a discussion of the subject took place."[65] The way photographic history has been written—focusing on key figures; specific groupings, such as the Linked Ring Brotherhood or the Photo-Secessionists; or major exhibitions—has not only suppressed the recognition of other strands of practice, it has tended to overlook the way work was disseminated to create a community of photographic values.[66] Amateurs were actually sitting in local libraries, working men's institutes, and club rooms in provincial towns and cities such as Huddersfield, King's Lynn, or Exeter,

discussing, for instance, Fred Holland Day or Alfred Stieglitz, and their own relationship to those photographers as the model of significant photographic work, both aesthetic and technical.

For this reason, despite the extensive rhetoric around survey and record photography, especially Stone's very public declarations of what photography should be, record photography could only be marginal to the endeavours of a photographic society. These tensions are implied when in 1902 the Leicester Photographic Society disassociated themselves from the local survey committee established by the Literary and Philosophical Society, commenting that the "objects" of the latter were, "foreign to that of our own society."[67] Likewise, in reference to record work at the Norwich and District Photographic Society in 1913, "Mr Peake ... expressed the hope that the members would when possible treat their subjects pictorially" as this was "after all the object of the club."[68] *The Camera as Historian* effectively admits this object, "The Photographic Society or Club, as such, takes as the chief aim improvement in the technique of its members; it usually, for obvious reasons, makes pictorial excellence in photographic work its goal."[69] If the pictorial threatened to pollute the mechanical and objective recording of history in the surveys, so record photography threatened to deflect photographers from the development of artistic sensibility as a refined and civilising influence and the progress of photography as a higher art form.[70]

However, despite this view, photographers were not necessarily disempowered, "mere servants of the camera."[71] They needed a sensitivity to and engagement with the historical, which could be translated into evidence through carefully conditioned seeing and an equally careful

32. Members of Birmingham Photographic Society in their club room, 1902. Lantern Slide *(courtesy of Birmingham Library and Archive Services).*

self-conscious attention to style and technology in order to perform facts within "spheres of appropriateness."[72] A carefully orchestrated realism embraced both the mechanical and inscriptive powers of the camera and a disciplined eye. Individual pleasure and satisfaction could be achieved through the sense of communal worth and social duty. But there was also personal satisfaction in fulfilling the rigorous demands of good survey photography that accorded with the vision for its purpose. In the words of Rev. H. J. Palmer, an Anglican clergyman from Ashton under Lyne, and instigator of the Manchester survey through the city's Amateur Photographic Society in 1889: "Is there any pleasure in the world to surpass the sight of a perfect negative, growing and gathering in its beauty and perfection under your hand, and owing its existence, first and last, to your own thought and care and skill?"[73]

The suppression of the aesthetic impulse was further complicated because the subject matter of the surveys—from ancient churches to cottages—inflected as they were with a sense

of the past and of disappearance, were those that were seen as lending themselves to a picturesque interpretation. For despite its self-declared scientism, survey photography was in many ways premised largely on a picturesque concept of history and an associated Rieglian "age-value," with its emphasis on the visible and resonant apprehension of the past.[74] Although survey photographers rejected the more extreme ivy-clad walls and ruinous buildings of the picturesque in favour of the clearly delineated archaeological and historical legibility of the unrestored authentic historical object, they nonetheless valourised age-value for its understanding of historical significance. This becomes crucial in the tensions between pictorial and record modes. For it was precisely the emotional appeal of age-value that simultaneously made something photographable for record but that had to be methodologically suppressed in the scientism of that record.

Thus, although in photographic terms the picturesque is more encompassing than the stylistic parameters of pictorialism, there is nonetheless a substantial discursive overlap, especially in terms of the affective tone. This discursive overlap did not necessarily constitute a stylistic dichotomy, but a succession of privilegings and suppressions required to make record photographs. (See figure 33.) Despite the rhetoric of surveys, there was continual slippage between the particular discourse of survey photography and that of the pictorial in both their stylistic qualities and the language used in them.[75] This nuance of language is demonstrated through exhibition captions for photographs of "peasantry" that occurred in the early years of survey activity. The Nottinghamshire survey, in a flyer calling for entries to an exhibition of survey photographs in 1897, stated firmly that "prints may not bear any name, title or motto."[76] This suggests that they were mindful of the power of titles to configure meaning, and of the destabilising force of information that might distract from the survey project, a project which demanded only the descriptive. In contrast, the influence of the strong pictorialist tradition of the Birmingham Photographic Society is clearly apparent in the Warwickshire survey section of their exhibition in 1893. This section included in its class for photographs of "Warwickshire Peasantry," photographs with narrative titles and including pictorial genre pieces such as that of E. C. Middleton for instance, and two photographs by E. Jacques entitled *Preparing for Dinner* and *An Item of News*.[77] (See figure 34.)

An ambiguous relationship with photographic style and the production of "appropriate" forms of evidence is clear. And perhaps reflecting the slightly different interests and emphases of individual photographic societies and camera clubs, there was an opinion that survey photography could indeed embrace the more pictorial aspects of photographic work. In 1908 for instance, the *British Journal of Photography* commented that a number of NPRA prints recently deposited in the British Museum possessed "pictorial value." It added, however, "the plain record of fact is the quality which is desired," and that the record print should "show everything that is to be seen — ugly or otherwise."[78] Conversely J. H. Crabtree, writing on "System in Record Work," went as far as to state, "Whenever the pictorial element can be introduced, an effort should be made to take advantage of the opportunity."[79] However, as we have seen, there was also a sense in which the affective engagement of the pictorial might be seen as distracting the viewer from the instructive and educational visualist message of the image. Constant tension arose over

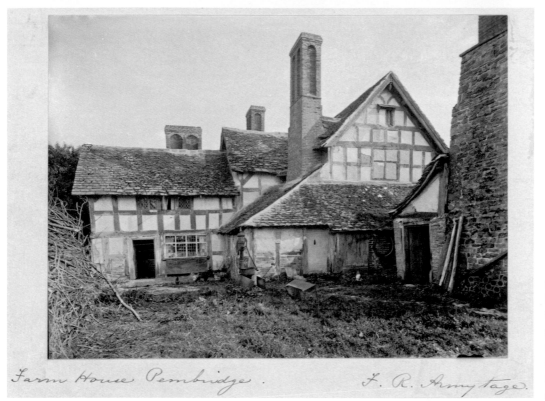

Farm House Pembridge.

F. R. Armytage.

33. "Farm House, Pembridge," Herefordshire. Photographed by F. Army-tage, 1901. NPRA Collection *(photo © Victoria and Albert Museum, London).*

34 "Call from the Miller." Photographed by E. C. Middleton, c. 1890. Warwickshire Photographic Survey *(courtesy of Birmingham Library and Archive Services).*

35. "Old Place, Pulborough." Photographed by Charles Job, c. 1905.
Photographic Survey of Sussex *(courtesy of Sussex Archaeological Society)*.

the way in which "the aesthetic and affective ap-
peal of the visual could be somehow brought
in line with contemporary scientific ideals of
objective 'observation.'"[80] As Stone stated, he
"had often admired some of those hazy artis-
tic productions which to the trained eye spoke
to the emotions of the producer but personally
. . . [he] preferred the work that conveyed the
truth of line and detail in all its untrammelled
clearness and beauty."[81]

Despite the discursive and rhetorical opposi-
tion and ambiguity of styles presented in much
contemporary commentary, photographers did
not necessarily work only in one style or genre,
and, of course, all survey photographers were
working within established and interpenetrat-
ing iconographical codes, whether they were
those of the picturesque, architectural draw-
ing, or scientific documentation. Many indi-

viduals and members of photographic societies,
such as E. C. Middleton, Bernard Moore and
William Greatbatch of the Warwickshire sur-
vey, Charles Job of the Sussex survey, and the
Reverend Thomas Perkins of the Dorset sur-
vey, worked easily across these different regis-
ters, and saw no conflict in doing so.[82] Although
their contributions to the surveys were always
carefully controlled, and were aesthetically and
meticulously produced, the fact that these pho-
tographers, who were also exhibiting at some
of the major national and international exhi-
bitions, made such extensive contributions to
survey marks the seriousness with which they
viewed the surveys' cause.[83] (See figure 35.)
However, some commentators saw picturesque
work as on the edges of appropriateness for sur-
vey photography: "[At] a recent county survey
exhibition, an ancient church with a curious

lych gate had been photographed from a stand-point some distance away, looking down a leafy avenue of trees whose branches met overhead in a sylvan arch. Here, in consequence of the worker's unwillingness to lose a pleasing set-ting, the real objects of interest — the church and the lych gate — were shown on a small and uninstructive scale, besides being partially hid-den by foliage." The anonymous writer (pos-sibly Horsley Hinton) goes on to discuss the compositional aspects that obscure the histori-cal legibility and relevance of photographs:

> We find quite frequently that places of inter-est, such as cathedrals, castles, old cottages etc. are allowed to take an entirely subor-dinate and distant position in their respec-tive pictures, while an enormous amount of foreground space will be occupied by an attractive rendering of a flower garden, a vista of altogether commonplace cabbages, or even an expanse of bare open common. This, of course, is entirely due to the pic-torial aspect of the work having been per-mitted to overshadow its practical side . . . The sole excuse, from a record point of view for taking the photographs was to show the respective buildings, and this would have been done much more effectively by getting closer . . . As it is, posterity will only be able to peer through magnifying glasses at the softened outlines of far-off spires, roofs, or battlements, as the case may be, while mar-velling greatly at the predecessor's apparent lack of foresight.[84]

Harold Baker provides an interesting example here. A professional Birmingham photogra-pher, son of a distinguished Birmingham art-ist, his brother Oliver also an artist and illustra-tor, Baker was an active member of the Linked

Ring. He was on the committee of both the Bir-mingham Photographic Society and the NPRA (through Stone's Birmingham base), and he was an "official photographer" for a local learned so-ciety, the Midlands Institute. He contributed extensively to both the Warwickshire survey and the NPRA, often producing photographs relating to his publications, such as historical tour and guidebooks to Stratford upon Avon and on the charms of Warwickshire. Yet while he moderated some of his printing techniques for the survey he did not moderate his com-positional style. All his photographs, carefully placed in the frame, beautifully printed with the meticulously controlled tonal range of the warm-bath platinum prints, are suffused with the picturesque. His study of an ancient barn at Pembridge in Herefordshire is not a record of the carpentry techniques used in an ancient building, but a study in the aesthetically pleas-ing geometry and texture of ancient timbers. (See figure 36.)

Nevertheless, even within the survey move-ment itself, the picturesque was constantly re-ferred to as a reason and purpose for photo-graphing. In a "A Plea for the Beautiful," *Amateur Photographer* asked, "Should un-limited literalism be the only object of what is known as 'record photography?'":

> Besides the dry bones of buildings, objects, persons, and scenes, there is not much value in picturing the beautiful aspects of our country and of its contents, so that future generations may in some measure enjoy the pictorial attractions which are recordable? Is it enough that we should portray com-paratively repulsive facts when we might on many an occasion include all that is material to an informative record, and at the same time endow it with some aesthetic inter-

36. Barn, Pembridge, Herefordshire. Photographed by Harold Baker, c. 1890. Donated to NPRA *(courtesy of Birmingham Library and Archive Services).*

est? No doubt it is well that, for instance, a cathedral should be photographed so that it might almost be reconstructed from the prints, but would not a fine presentment of such poems in stone, as, for instance, F. H. Evans is capable of producing, be in many ways as valuable to posterity as a mere builder's working diagram?[85]

Such thinking marks the evidential in a significant way, shaping topographical representation. For instance, the picturesque qualities of the half-timbered buildings of Kent delineated the historical topography of the county's photographic survey. Indeed, for many commentators the term picturesque was used almost interchangeably with "disappearing" and

a sense of the past, and many survey photographs were read by audiences as picturesque. (See figure 37.) As Stone himself commented, "Photography was the outcome of scientific research none could deny, but the matter of art *versus* science was a matter for personal equation of the beholder rather than for individual expression as a class."[86]

The complex dynamics between photographic survey and picturesque topography are demonstrated in the response of Derby photographer Richard Keene in a review of the exhibition the Warwickshire survey held in 1892 in conjunction with the Birmingham Photographic Society.[87] He started by distancing the survey photographs from the pictorial: "It is not to be expected that a collection got together for such a purpose as this could compete with the ordinary photographic exhibition, either in art, quality or technique, yet a large number of the exhibits would rank high, even if judged by these standards." However, he goes on to describe the exhibition precisely in terms of the picturesque, noting especially work by E. H. Jacques, Harold Baker, and "two sweet little cottage scenes at Hampton Lucy" by J. H. Pickard. The historical captions provided by the exhibition's catalogue then invite a reverie of the pastoral picturesque: "There is a delightful jumble of old fonts, church porches, tombs, castles, halls, cottages, rivers and lanes, which form an ever shifting scene in one's memory." This reverie then moves on to an account of "delightful drives along lovely lanes, tree-shaded with grassy borders and flower besprinkled banks . . . past many a picturesque half-timbered farmhouse and cottage with blossoming orchards and gardens, under unbending boughs of graceful traces, in all the fresh beauty of their varied spring attire."[88] This slippage between science and art, history and sentiment, record and the

picturesque, represents the paradox at the heart of the survey movement. The photographs here are revealed as neither art nor science. Rather they are images "suspended between both the *discourse* of science and that of art . . . [a state in which] photographic discourse has attempted to bridge the extreme philosophical and institutional separation of scientific and artistic practice."[89] These were photographs and practices riddled with ambiguity and points of fracture. The recognition of this fracture was at the root of the entropic anxieties of those involved.

MATERIALITY

While historical information could be lost through the aesthetics of pictorialism, it could also be lost through inappropriate photographic processes and archival procedures. The material performances of these values and procedures formed a set of regulatory ideals. Such practices, the banal details of decisions about plates, lenses, labels, and boxes, are too often absent from the consideration of the ways in which photography makes its meanings. However, matters of material practices were central to the ethos of survey photography and carried enormous historical weight. Material practices are a revealing "poetic detail" that mediated all aspects of the experienced realities of photographic survey and its aspirations.[90] Daniel Miller has argued, "Dwelling upon the more mundane sensual and material qualities of the object [such as a glass plate, a platinum print, or

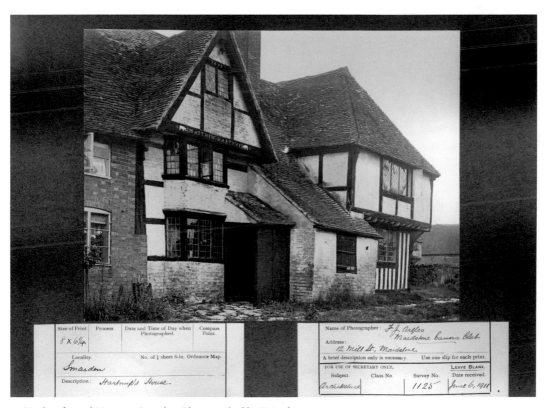

37. Timber-framed House at Smarden. Photographed by F. Argles, c. 1911.
Photographic Survey and Record of Kent *(courtesy of Maidstone Museum and Bentlif Art Gallery).*

a label], we are able to unpick the more subtle connections with cultural lives and values that are objectified through these forms, in part, because of the particular qualities they possess."[91] This "active materiality" performs the photographic surveys' core values regarding the truthfulness and authority of the historical statement, and values regarding technology, permanence, and accuracy, through the attention given to the exact nature of objects.[92] Furthermore, as has been argued in much recent work in material culture studies, notably the work of Alfred Gell, Daniel Miller, Bruno Latour, and Tim Dant, objects are formulated to perform in certain ways in order to extend or replace embodied experiences and to connect with spiritual ones, such as, in the case of survey photography, historical experience.[93] The values attached to objects thus render those objects powerful and active players in social relations.

Material practices might also be understood as a popular absorption or appropriation of ideas about the status of instrumentation in science and about mechanical objectivity, in which the proven physical integrity of the material of experimentation is vital to the perceived integrity of the knowledge that apparatus helped to produce.[94] Although amateur survey photography was seen as flawed because of its lack of both system and the mathematical precision of photogrammetry, the survey strictures regarding plate and print sizes, and the conscious engagement with the action of lenses and emulsions, constituted such an attempt to standardise data and create a sense, if not an actuality, of comparability. The influence of Harrison's scientific training is perhaps discernible here, for, as Peter James has argued, it was Harrison's model for photographic survey that became its founding statement, a statement firmly based in the values of science, even

if, in practice, the connection had remained one of aspiration, rather than actuality.[95]

All the surveys published rules that were circulated to members (see the appendix). While these were often quite brief, they were greatly augmented by the extensive reports in the photographic press and the general press that stressed the technical systems and material character of the enterprise. This disseminated a specific and clearly defined view of photographic utility and its potential as a permanent record in the public imagination. There is a striking unity and consistency of discourse, as the desire for the two key values that dominated the agendas of survey photography—accuracy and permanence—was articulated through material objects such as photographic prints, labels, mounts, boxes, and albums. The material practices of the surveys came to assume moral values in the same way that photographic style and aesthetics did. Indeed stylistic and aesthetic forms were often constituted through specific material forms. The desired procedures, especially as articulated in *The Camera as Historian*, addressed the whole process, from the production of negatives to the storage of prints. They were intended to counter the entropic dangers inherent in the photograph through attempts to exercise control over the various stages of the photographic processes that were intended to translate observation into an archive for the future.

The first concern, as the debates over the pictorial elements have revealed, was for the accuracy of inscription and transcription in material terms. These debates were about how objects of historical significance should be made visible and legible. The stress, as I have already suggested in discussing photographic style, was on the purity of the negative in the translation of its subject matter. The early surveys, such

as the one in Warwickshire, and those with a more conservative vision, such as that of Stone's NPRA, advocated the use of the large-format stand camera capable of producing a high-quality 8½″ by 6½″ whole-plate negatives that could yield an historically legible contact print with precision and finely rendered detail. As a commentator in the *British Journal of Photography* said, "We see photographs of interiors, evidently taken with a large aperture, in which near objects are sharp, while those in the background are quite out of focus. Whether done with pictorial intention or not, this is a fatal error, for a record print should show everything that is to be seen—ugly or otherwise."[96] While there was much debate about exactly which negatives were the most desirable, there was little consensus. Negative types were drawn from the vast range of commercial brands available by the late nineteenth century. Choices often reflected personal preference and experience in regard to the kind of camera being used, and the needs of the subject matter; for instance, a church interior, had very different demands, in terms of image registration, from an outdoor scene. Whatever the choices made, however, the results were to be, above all, clear and sharp and developed "so as to secure the finest definition," while at the same time maintaining the integrity of the negative.[97]

In a tangle of entropic confusion and preservationist desire, the quality of the negative and of the evidential authority vested in the chemical imprint on the negative was of great importance. There was a concern that small negatives and develop-out papers, which demanded a printing process based on enlargement, would result in a loss of detail and thus a loss of historical information, as would the use of incorrectly exposed, "weak" negatives. Yet conversely, the preservation impulse was so imperative

as to allow for vital visual information in less than perfect negatives, revealing a negotiated and perhaps compromised legibility in the face of loss. For instance, Charles Bothamley, who wrote and lectured extensively on photographic record and survey in the first decade of the twentieth century, and from 1891 had been head of technical education for the county of Somerset, stated, "For record purposes negatives which may not be of the best quality for printing still have a real value. A negative too poor to print from at all may still not be valueless as a record if it is sufficiently exposed and developed to show the form and the detail of a particular object."[98]

Lenses were also discussed. Again, the *Camera as Historian* made suggestions for different kinds of work, including telephoto attachments for some detailed architectural work, which for the most part reflected common practice, but most important was the recommendation that lenses should be used with "a small stop enough to give perfect definition."[99] Although different lenses were obviously required for different kinds of work, whether architectural or landscape, it was crucial that they should not distort the image:

It is bad enough for such historical pictures to have suffered from lens-distortion, which gives an exaggerated appearance and fails to correctly record that which is actually seen with the eye. The best lens makers have used their efforts to produce lenses which shall render scenes in the most faithful manner possible, but hundreds of views are daily taken and reproduced, in the pictorial newspapers of the day, which are grotesquely absurd in their aspects and general proportions, in consequence of this primary fault. It will be apparent, therefore, that dif-

ficulties have to be dealt with in keeping up a high standard of excellence needed for making a perfectly satisfactory record of current history.[100]

The treatment of the negative in the dark-room and the production of a print from it presented an even greater danger of dissipation in the quest for the controlled and "objective" image. Again, what these strictures on the nature and treatment of negatives were ultimately concerned with was the quality and the veracity of the print as an historical record. Like negatives, the prints had to be unmediated and straightforward—accurate inscriptions, reproducing the historically valuable information inscribed on the photographic plate exactly. The values of the indexical trace were paramount. There were to be no additive techniques interfering with the purity of the inscription; that is, no artifice of retouching, overdrawing, or overly dramatic or "theatrical" printing that often marked pictorialist output. This was reiterated repeatedly in society and competition rules and in the surveys' rhetorical claims to authority. Yet where was the borderline between enhancing, a process in which the information is literally drawn out of the negative by attentive printing that mirrored the quality of observation, and the unacceptable intervention that diminished the historical record? As Jennifer Tucker has shown, nineteenth-century scientists negotiated sets of values, which were discussed in the photographic press, for interventions that enabled the better demonstration of data.[101] But in the case of the surveys, constituted through fragile networks ambiguously poised between the aesthetic and scientific demands and expectations around the image, the situation was less clearly defined.

The quality of printing was thus subject to the same codes of regulatory and moral restraint as negatives, both in terms of visual information and technical production: "If a print is 'only for survey' there is no reason why it should not be the best obtainable."[102] However, despite the rhetoric of the purity of inscription, the "best obtainable," in terms of the clear projection of "visual fact," often depended on mediation to the extent that it was only through intervention in the negative and selective printing that photographs could be rendered "records." For instance, the sky in many of George Scamell's photographs of Essex and Hertfordshire churches has been partially bleached out so as to project the profile of a tower or spire, and the line of the nave and chancel, thus enhancing informational quality. (See figure 38.) A similar technique, employing a careful rendering of the background clouds, was employed by Robert Brereton in his studies of Somerset church towers as he sought to focus attention on the features of the tower.[103] Likewise, in Arthur Tremlett's photographs of misericords from Exeter Cathedral, photographs produced for that city's survey, the surrounding woodwork has been blanked out on the negative to leave the disembodied object the focus of attention. It was a style derived from archaeological drawing in which objects were photographed in isolation and arranged for maximum visibility, projecting the object to the viewer as pure specimen.[104] Indeed, some museum photographs of this kind were themselves absorbed into survey collections, for instance the photographs of Exeter silverware for that city's pictorial record, or social history objects from King's Lynn Museum for the North Norfolk Survey. (See figure 39.)

Sometimes the demands of the preferred process of platinum printing mitigated the desire for unmediated visibility. Its soft grey

tones, lush blacks, and often visible paper texture, offered photographers a seductive range of expressive material possibilities, which, in terms of record photographs, carried the entropic perils of pictorial or theatrical printing, which might have threatened the survey project.[105] For instance, in reporting on one of its survey competitions, *Amateur Photographer* commented that Basil Diveri's photographs of Linlithgow Palace, near Edinburgh, "would probably have ranked higher, but that in so many cases the platinotype printing had been over-done, even to the extent of solarisation in the shadows."[106] Throughout the contributions to the surveys, one can see photographers making aesthetic decisions in the choice of size, enlargement, and printing process in relation to subject matter. For instance, in the Dorset survey, Reverend Thomas Perkins, one of the photographers who worked easily in different styles, contributed enlarged and especially careful prints of photographs that had strong pictorial compositional or textural elements, such as his photograph of the village street in his own parish of Turnworth, while less 'aesthetically strong' negatives did not receive this treatment. (See figure 40.)

Similarly, one can see careful aesthetic attention to print processes and quality in Birmingham amateur Bernard Moore's luminous photographs of Tredington Church for the Warwickshire Survey, which were produced as carbon prints. (See figure 41.) In another example, Fredrick Argles of the Kent survey, a Maidstone solicitor and member of the Maidstone and Institute Camera Club, sometimes revealed himself to be more concerned with the photographically expressed texture of stone than he was in the precise nature of architectural detail. In his photograph *Ancient Door at All Saints Church Maidstone* (1910), the

Boxted Church
Essex. Geo Scamell.

38. Boxted Church, Essex. Photographed by George Scamell, 1906. NPRA Collection (*photo © Victoria and Albert Museum, London*).

39. "Antique Silver Flat Stem Spoon." Photographed by W. Bruford, 1911. Exeter Pictorial Record Society (*courtesy of Westcountry Studies Library, Devon Libraries*).

fifteenth-century stone mouldings of the door are much weathered and illegible.[107] This illegibility is accentuated by the textured art paper, which mirrors, almost skeuomorphically, the weathering of stone, serving to obscure, rather than define, the architectural features.

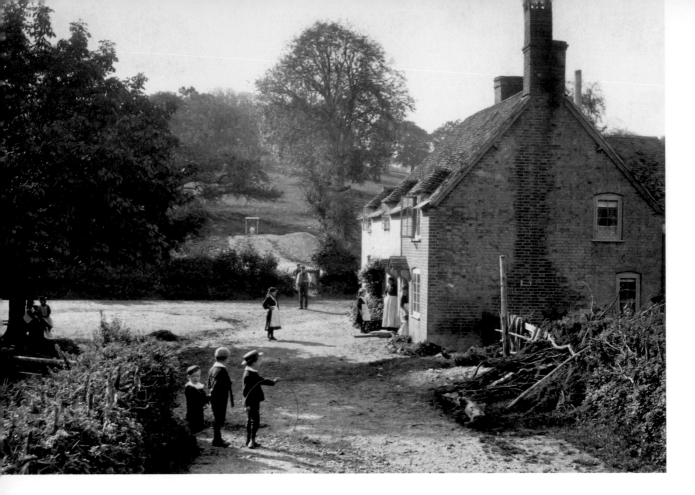

40. Turnworth, Dorset. Photographed by Thomas Perkins, c. 1893. Photographic Survey of Dorset *(courtesy of Dorset County Museum)*.

The destabilizing effects of the pictorial, however, could lurk even within the clean, untrammelled survey negative, were it subjected to "inappropriate" material practices. This was somewhat alarmingly demonstrated at the photographic convention at Canterbury in July 1909 by Harold Baker, who showed "An exhibit of considerable interest [that] took the form of a series of record negatives printed in bromoil." A report of the exhibition observed, "In a note with the collection it was stated that there was no suggestion that this method was suitable for record prints, but the prints clearly showed its pictorial possibilities when in competent hands."[108] The demonstration that record negatives could be printed interpretatively through a bromoil processes, a process that was associated with a pictorialist aesthetic, was potentially destabilising because it suggested that within every record negative taken carefully within the discourses of survey there was the potential for a pictorial image.[109]

The surveys themselves and the photographic press therefore wrestled with the problems of suitable processes. *Amateur Photographer* asked in 1905,

"[Ought] bromides be filed by Photographic Record Societies? The Surrey Survey, which has set the pace for neighbouring counties such as Kent, Sussex, and Essex, accepts them—especially in the form of enlargements. At its annual exhibition held at Croydon Town Hall, quarter-plate platinotype prints were accompanied by bromide enlargements from the same negatives. The

negatives being of the over-exposed and under-developed order, besides of small scale, it was surprising what a considerable addition of information was forthcoming in the enlarged bromide. Buried details were not only brought to light and delineated with vigour, but also magnified, so that the unaided eye could see them."[110]

The anxiety this statement suggests, that without enlargement historical information might be invisible, is exemplified by the way photographers sometimes submitted two indeed more prints in different processes from the same negative, each made with very different tonal balances and ranges so as to bring out different features. Photographs of Surrey parish churches by Dr. J. Hobson, a member both of the Croydon Natural History and Microscopical Society and the Surrey survey, demonstrate this approach. He sometimes donated two prints of same image printed very differently to give different information (indeed it is possible that the *Amateur Photographer* comment quoted above refers to his photographs). A negative of the interior of Horley Church, for instance, was printed as a ¼-plate platinum print, which was used to show the fourteenth-century arcade and was accompanied by a brief textual description of the mouldings. Next to it on the survey mount is a silver bromide enlargement of the same negative, captioned "Enlargement of No 1901 printed lighter to show the under-structure of the towers. The lower part is occupied by a vestry. . . . Note the stone corbels of the ancient roof." In this print, the arcades are illegible.[111] There are other such examples in the Dorset and Sussex surveys, and in Bristol some photographs of sixteenth-century and seventeenth-century house interiors for the Bristol survey, made by W. Moline

in about 1904, were submitted as both bromide and platinum prints. The latter case points to tensions between longevity and legibility, in that the platinum print is mounted in the survey album itself, while the bromides, with their greater clarity of image than the soft tones of the platinum print, are unmounted and interleaved through the album.[112]

If the quality of the photographic inscription, especially in negatives, stood for accuracy, the longevity of the prints that made up the collection of photographic records constituted the other major concern. As an editorial in the *British Journal of Photography* stated in July 1897 in response to the foundation of the NPRA:

41. Tredington Church, interior. Photographed by Percy Deakin, 1897. Warwickshire Photographic Survey (*courtesy of Birmingham Library and Archive Services*).

That negatives or prints may have stood for fifteen or twenty years is no proof that they are *permanent*. Negatives are easily broken, and prints may be destroyed by fire. To secure a lasting record for the use of future generations, which, we take it, is the object aimed at, we should suggest the photogravure be adopted. If a photogravure plate, in copper, be obtained, there is no question as to its permanence, and the facility with which any number of copies can be obtained at any time as required, and also of their undoubted permanence. If such a movement as the above be undertaken, it should be started on a sound basis.[113]

These photographic objects had to carry their information into the future and were to connect with the public, reproducing the values seen as embedded in historical places, buildings, and happenings.

Given that it was impossible to control the processing of images contributed to the various surveys, enormous stress was laid both on the rules and the framing discourse and rhetoric, on the use of permanent processes. Indeed, the idea of permanence also stands as the defining double metaphor of the survey movement, as both the past and photographs were feared to be "fading before the eyes." Permanence was thus the core value that informed a wide range of technical decisions, both photographic and archival. The chemistry of the silver-based processes commonly used in photography, and central to amateur practice, was inherently unstable. The silver compounds of the image-carrying emulsions underwent irreversible molecular change through the chemical action of airborne oxidants, such as sulphur, and other pollutants. These pollutants included compounds used in the processes of photographic

development and fixing, which could destroy the image from within if the photograph were incorrectly or carelessly processed. (See figure 42.) This had been known since the 1850s; successive committees of the Royal Photographic Society had investigated the problem of fading and permanence, and improvements in the chemistry were made, for instance in the introduction of separate toning in alkaline gold solutions, followed by fixing in fresh hypo. By the late nineteenth century, these problems were largely improved and stabilised, but they nonetheless continued to cause concern.

These concerns became paramount in the context of photographic survey images because the lack of permanency mitigated the aims and objectives of such projects. The avoidance of silver halide was part of Cosmo Burton's universalising preservationist vision in his series of essays in the *British Journal of Photography* in 1889 entitled "The Whole Duty of a Photographer." In these essays, which presented an encyclopaedic and appropriative archival desire of staggering proportions, he advocated the use of the camera, including the new detective and handheld cameras, for recording all aspects of life: "They [photographs] ought to be inserted in great albums, *sacred from the polluting touch of the silver print*, kept at the Royal Photographic Society of the future."[114] The platinum print, or platinotype, was thus repeatedly declared to be the preferred printing process of the survey movement and the rules of many survey societies expressed both their desire for permanence and their entropic anxiety through the privileging of this process (see the appendix). (See figure 43.) As its name suggests, the process involved a platinum, not silver-based, chemistry, but it based on sensitised potassium and iron oxalate. It had a reputation for being almost free of image deterioration.[115]

For instance, the rules of the NPRA stated that "photographs must be printed in carbon, platinum, or other permanent process" and a vast majority were indeed submitted as such.[116] Carbon prints, and photogravure offered other options but were technically more complex and were out of both the financial and skill range of many amateurs.[117] As Frank Allen stated, instigating the Somerset survey, "I use the expression 'permanent record' advisedly, not referring to old-fashioned photographic pictures, which are well known to be of the most transient character. But photographs printed by the platinum process will probably last beyond any other kind of picture, either printed or painted; and even negatives on glass may be expected to last almost indefinitely if treated with care."[118]

The suitability of processes and procedures was discussed extensively in the photographic press, not merely reporting the activities of the various survey endeavours, but commenting in relation to wider technical debates. The popularity of survey photography and surveylike photographic activity was used as a point of reference in relation to a wide range of photographic interests, photogrammetry, architectural photography, scientific photography, and even holiday itineraries. Thus the discourse of permanence and the potential for survey can be seen as linking a wide range of photographic practices. Nevertheless, throughout this rhetoric of technical certainty, the entropic still haunted photographers in the shape of human fallibility: "As a Survey Society these questions are of vital interest to us, because our collection is for all time, and any tendency to fading owing to *unskilful manipulation* or *fundamental defects in the processes employed* will be fatal, and we shall find our efforts fruitless if we disregard these matters."[119] Even platinotypes had their instabilities. For instance, mindful of the fragility of paper itself, the Photographic Survey and

42. Silver bromide print shows chemical deterioration at the edges. Church at Botolphs. Photographed by F. S. Heath, c. 1906. Photographic Survey of Sussex *(courtesy of Sussex Archaeological Society).*

Stokesay Castle. Shrop^n.　　　*F R Armytage*

43. Platinum print. Stokesay Castle, Shropshire. Photographed by F. W. Armytage, 1901. Photographic Survey of Shropshire, Shrewsbury Photographic Society. NPRA Collection (*photo © Victoria and Albert Museum, London*).

Record of Surrey noted that even platinotypes would rot if not properly washed. Their archive had some that had become spongy and rotten, whereas others had problems of permanence caused by the opening up and discoloration of the paper fibres in hot bath processes, thus affecting their longevity and, more importantly, their legibility.[120] Some papers bleached out after five or six years.[121] There was constant attention to new platinum papers that, as they came on the market, would improve the quality of inscription and longevity. For instance in 1907 the Surrey survey recommended the new Black Japine papers, introduced in 1906, for platinum printing because they showed "even greater detail" with "crisper black ranges, better for detail than brown hues of the 'Brown Japine Paper.'"[122]

For amateur photographers, chemical processes and the practices of the darkroom became enmeshed with the moral qualities of both self-restraint and self-discipline in the rigorous execution of photographic records. In fact, however, despite the rhetoric of moral weight, the rules on sizes and processes were less prescriptive than were popularly imagined. For instance the Warwickshire survey rules of 1890 stated that while whole-plate and permanent prints were preferred, other processes, including silver-bromide prints, were acceptable. Nonetheless, the technical stipulations were perceived as creating difficulties for the photographic surveys, and to an extent limited participation. Whereas the gelatin dry-plate revolution of the 1880s had extended photography

to a wider social range of amateurs and made surveys thinkable through the mobilization of amateurs, the apparent technical conservatism, particularly of the early high-profile surveys, such as those in Warwickshire and Worcestershire, and that of Stone's NPRA, were seen by some as militating against the objects and successful realisation of the surveys. With the rapid development and popularity of smaller-format cameras, film negatives, and develop-out papers, many amateurs, especially as hobby photography moved down the social scale, did not own or even have loan access to large plate cameras and their associated equipment, nor did they have the experience to deal with the physical demands of that equipment.[123] The constant rhetorical repetition of ideal material strictures about permanent printing, and indeed negative size, would seem to have restricted participation and alienated potential contributors to the surveys, and thus, more importantly, failed to harness the energies of precisely that mass of amateur photographers that survey advocates wished to recruit to the cause. Not only were platinum and carbon more specialist forms of printing, they were also more expensive. As F. M. Armytage, the borough surveyor to Shropshire County Council in Shrewsbury and a member of the Shropshire Photographic Survey, commented of members of the Shropshire Photographic Society who were making a survey for the Free Library in Shrewsbury, "So few of them worked in carbon or platinotype, and still fewer had cameras larger than half-plate."[124] Armytage's plea was suggesting that if silver bromide prints and smaller sizes were acceptable participation might have been greater. The Essex survey likewise commented that the NPRA "would receive a great deal more help were it not for the rule that only platino-type prints [were] accepted."[125] Furthermore,

there was even some question as to whether large formats could provide the level of inscription and legibility required. Quoting the distinguished Egyptologist Flinders Petrie, a pioneer of archaeological photography, Mr. Kirkwood Hackett observed, in a comment redolent with contested views about the making of visual knowledges, "It seems to have become an accepted axiom in purely photographic circles that record work on any size less than whole plate . . . is useless." But Hackett noted instead, "The time and work [spent] in using whole plate size are scarcely even repaid by the results of *practical* archaeology."[126]

A gradual shift to smaller formats and some silver-based processes had major implications for the way in which the surveys perceived the evidential quality of the data produced, in that the relaxing of technical restraints increased the flow of potential historical information and its visual presentation. This change was, in part, due to the shift in the technical and aesthetic mediation in the power base of survey, a shift from older photographic societies with overtly aesthetic interests and the equipment to realise those aims, to specifically constituted survey and record societies such as those in Surrey, Norfolk, and Sussex. These societies, although advocating permanence and accuracy as the primary values of photographic survey, took a more pragmatic, and thus ultimately inclusive, approach, deeming the record for posterity more important than the risk of the disappearance of the desired phenomena through an overly prescriptive view of technology. To this end, some survey committees offered to arrange the platinum printing of record-quality negatives submitted to them. For instance, a series of photographs of Exeter Cathedral by C. S. Wheeler was superbly printed in platinum for the Exeter Pictorial Record by Miss

44. Small-format negative and develop-out paper. Carving, Peasmarsh Church. Photographed by J. Stenning, 1908. Photographic Survey of Sussex *(courtesy of Sussex Archaeological Society).*

Mary Hare.[127] Mr. J. Kenrick, of Bletchingley and Nutfield Photographic Society and the Surrey survey printed an extensive series of photographs of Surrey farmhouses and cottages taken by Reverend Charles Fison.[128] Other surveys accepted prints in silver-based chemistries on the basis that they would be copied or reprinted at a later date—although in practice many were not.[129] Furthermore, this shift also solved some of the problems concerning the aesthetic propensities of platinum prints and large-format cameras, as the photographs submitted to, and accepted by, the surveys were increasingly of smaller format and even snapshot quality. The Manchester survey, for instance, actually encouraged the use of the instantaneous camera: "In short, anything that will record the city and borough and the habits of the people as they are today."[130] This pragmatic stance was also

reflected in the broader interpretive community of survey, for in 1902 the rules of the Photographic Record and Survey Competition, run by *Amateur Photographer*, with prizes offered by the magazine's editor, A. Horsley Hinton, had changed "in order to give workers with smaller cameras a chance," again hinting at the exclusion of some photographic constituencies.[131]

With the exception of the NPRA, which, under the watchful eyes of Stone and Scamell, accepted very few photographs smaller than half-plate, most of the surveys took this more pragmatic view, especially after about 1905, when photographic survey was increasingly the work of specially constituted record societies, rather than camera clubs. For instance, surveys such as those of Kent, Sussex, and Surrey, whose main efforts were concentrated some fif-

teen years after the first surveys started working, have a high proportion of material in quarter plate and smaller. Smaller plates were used especially in recording architectural detail. (See figure 44.) Photographs taken by antiquarian photographers such as J. C. Stenning (Sussex) and George Druce (Surrey) demonstrate this practice and probably reflect a stronger interest in archaeology and architectural history than in the mechanics of photography.[132]

Nevertheless, despite widely disparate photographic technologies, from Stone's large whole-plate tripod cameras to William Ellis's small handheld camera used in Nottingham, all the rules and their associated practices can be understood as a material performance of the objectives and values of survey photography. These practices expressed a desire not only for a permanence in which hopes for the future were grounded, but a regularity and systematisation through which survey photography aspired to align its ideals of controlled practices with scientific material and instrumental procedures. These practices reveal, too, the ways in which material objects, photographs, and the processes of their production, were integral to the ways common sets of values concerning the nature, utility, and social efficacy of the medium were negotiated by those involved in survey photography.

THE DYNAMICS OF MOUNTS: LABELS AND BOXES

The survey photographs—permanent, objective, and mechanically assured—were to complete their transformation into an imagined economy of historical value in the archive.[133] Questions of material ordering and arrangement constitute a final site of entropic anxiety, a site where meaning could be both made and

dissipated. But these collections were also sites where the hopes of future social efficacy and utility were focussed. It was here, in boxes of mounted and labelled photographs in public libraries, that the objectives of photographic permanence, in providing a dynamic future for photographs, could be realised as those objectives marked out the space of useful historical knowledge. For these reasons, as Thomas Osborne has argued, "the archive makes the ideal laboratory" for thinking through questions of historical consciousness, and reflexivity more generally.[134] Archives are "active environments for participating in the histories of objects, active environments that ultimately shape histories through preserving contexts that they themselves constitute."[135] However this dynamic of the archive was not merely through questions of archival control as ideological performance, but through socially embedded sets of relationships and negotiations around the material performance of the values of historical evidence.[136]

On the surface, the survey archives—or collections, as survey enthusiasts themselves called them, the word "archive" was seldom used—fit conventional analytical models of the archive as an immoveable, powerful grid of meaning, an instrumentality that created both an equivalence of images and a set of exchangeable values between images, "reducing all possible sights to a single code of equivalence [that] was grounded in the metrical accuracy of the camera."[137] To realise their objectives, the surveys relied not only on a self-evident realism and privileged correspondences with the historical object, but on the operation of this sense of realism within a system of juxtapositions and ordering that framed the whole as an historical statement. Survey collections, it might be argued, constituted what Derrida called "a

consignation," a gathering together of objects as signs—in this case, objects that signified an historical past—into single systems "in which all the elements articulate the unity of a single consignation."[138] Photographs, as a systematic record, had to be regulated and organised to enhance these qualities. Archival practices constituted a backstop against the "unsystematic," whether the unsystematic was aesthetic or technical, a process through which excess could be controlled. Survey collections were faced precisely with what Sekula has described as "the messy contingency of the photograph and . . . the sheer quantity of images."[139] The "practices and struggles associated with composing, assembling and controlling access to documents play[ed] a substantive role in history."[140]

The abstract and homogenising discourses of the archive, such as those just outlined, remain an important strand in the analysis of the archival practices of the survey movement. The survey's foundations were in Harrison's encyclopaedic desires for photography as a recording "of the face of the earth."[141] But such a model remains an unsatisfactory way to explain the complexities and ambiguities that saturated the practices of the survey movement. More fruitful perhaps is Tagg's sense of the banality of detail that can be seen in the survey movement. Writing of *The Camera as Historian*, he notes the book's "exemplary attention to the micro-level of bureaucratic technique and unabashed resolve to speak about the smallest detail of method, materials, rules and equipment" as "a machinery of a particular effect."[142] However, while the photographic surveys had unified and coherent aims, a material consideration of surveys' archival practices reveals those practices to be dispersed, various, and too diverse to be effectively controlled, in ways similar to the problems that beset their stylistic prac-

tices. Archival practices marked the limits and the points of fracture within the taxonomic arrangements of archival consignations to which the surveys subscribed. For while certainly the archive sets out the contexts, parameters, and methods of observation, thus establishing the authority of that observation as "both an abstract paradigmatic entity and a concrete ordering," there are also empirical reasons why one should be circumspect in making claims about the ideological formations of survey collections.[143] It is difficult to assess or analyse original orderings, taxonomic intent, and the extent of many of the survey collections; few survey collections survive in their original archival form. Most have been pressed into other contexts and other sets of meanings. Signs of their original forms, juxtapositions, and thus their meanings, have been obliterated. Only the Bristol survey collection survives in its original nine albums, each taking different aspects or areas of the city.[144] The Exeter and Manchester survey collections retain numbering systems that allow the original orders to be reconstructed, while the NPRA retains its original box divisions by county. While analytically seductive, filling the empirical void with a series of abstract concepts of the archive is not only ethnographically suspect, but does little to add to our understanding of how such collections of photographs were conceived by their makers and how they functioned socially and culturally.

What is clear is that survey collections were constituted through tensions between the structures of generality and the demands of the particular. It can be argued that the archive has two opposing but coexisting identities, one that is generalised, instrumental, and mechanically assured, and which delineated the photographs as "history," and the other localised, particular, and individual. The archive constitutes a con-

taining grid through which photographs, with their insistent realism, become self-evident. This is certainly how Stone, with his faith in the immutable power of the visual trace, perceived photographs. At the same time the images set up a specific poetic through an engagement with the traces of specific things that extended beyond the confines of the archive. Survey collections did not aim to produce "typicality" through visual equivalence. By simultaneously "endowing the singular with significance without relinquishing singularity," through collecting and articulating the historical specialness of a range of discrete objects and events, encapsulated as photographs, these objects could move in and out of sets of meanings, regrouped and linked to individual and collective readings across macro and micro levels.[145] Rather than lose richness and context through archival procedures, photographs, and the specific historical sites for which they stood, were perceived as massing specific historical statements as images in the archive or survey set acquired meanings that were both individual and contingent as units of representation.

Thinking about the material practices through which archival desire was articulated offers an expanded way of looking at the archive. In bringing the archive, as a material object constituted through a set of fluid material practices, into the centre of the analytical frame, it is possible to excavate more complex and nuanced understandings of the archival process that can accommodate both the generalising ideologies of archive, and the dynamics of the specific. How did people make archives, how were those archives used, and what did people think about those archives? Ewa Domanska claims a "material hermeneutic" goes to the heart of how the makers of the photographs saw the potential of their images,

revealing more complex practices and experiences of archiving in which "slippages and fractures . . . may disrupt the archive's matrix."[146]

The strength of the rhetoric around the production and management of survey photographs is perhaps indicative of the clear points of fracture in the enterprise and the centrality of material practices. As John Tagg has argued in discussing *The Camera as Historian*, an enormous amount of intellectual energy was expended on questions of archival management, from the choice of mounts and cabinets, to the demands of classification. More than a third of *The Camera as Historian*'s 260 pages were devoted to these questions.[147] This reflects not simply the desire to control and systematise but also an awareness of the profound instability in the overall project. Just as was the case with the questions of style and aesthetics discussed earlier, there was a series of fluid and uneven archival desires and practices clustering around patterns of historiographical intention and photographic expression. In order to excavate the slippages and fractures of the photographs in their collected archival form, it is again worth considering, albeit briefly, the apparent banalities of their formative practices, for on such little tools of knowledge, on labels, print, and mounts, the claims of the evidential and the instrumentality of the photographs depended. But such tools also constituted a space for traces of both photographic and historiographical agency, and the social textures from which the surveys emerged.[148]

Photographs, mounted on cards and labelled, constitute the formative units of the archival collections. Again, permanency and accuracy were the defining values. Mounts were to support the image and present it to the viewer. The NPRA, Warwickshire, and other earlier surveys, such as Nottingham, advocated cut

45. Mounted photograph with sunk mount. South door, Colwich Church. Photographed by A. Black, 1900. Photographic Survey of Nottinghamshire *(courtesy of Nottinghamshire Archives, DD/1915/1/209).*

and sunk window mounts. These mounts not only framed the image in a pleasing way. They secured it against handling damage, and particularly protected the surface from abrasion; that is, from the disappearance of the chemical inscription on the paper (or in the case of platinum prints, in the paper). (See figure 45.) However, for many surveys, this form of mounting presented not only the problems of bulk in storing growing collections but an unsustainable expense for large collections. The Manchester Survey before deposit in the City Library comprised, its secretary complained, a bulky "150 thick cards."[149] The Surrey survey advocated instead a system of simple, practical, flat mounting cards and was much emulated, notably in Kent and Sussex. (See figure

46.) This system was the basis of *The Camera as Historian*'s recommendation of a strong, chemically pure paper that would not damage the print itself, used with a dry mounting technique.[150] Indeed, *The Camera as Historian*, in advocating these simpler, cheaper, and more practicable mounts, put forward an argument on why cut and sunk mounts could be actually dangerous to the collection: cards warped and the sharp edges of mounts dug into other photographs, again damaging the inscription.[151]

However, while permanence and continuity dominated the discussion, the choice of mounts was nonetheless inflected with aesthetic concerns and practices of photographic exhibition and presentation more generally. For instance, grey sunk mounts of a lightly textured card were used by the NPRA and the Warwickshire survey because they balanced well with the broad tonal range of the preferred platinum prints. However, when sepia-toned gravures or albumen prints were donated to the survey, a light, coffee-coloured, textured mount was used instead, in order to complement the more purple, brown, and yellow ranges of the albumen print. Even the Surrey survey's simple card supports were preferred in a brown or sage-green Vandyke art paper, strengthened by an underpaper of grey, which, in the opinion of their photographers, were "not harmonizing well with prints."[152] These material forms were not merely serendipitous, however, but emerged from the shifting sets of relationships, social, cultural, and economic, through which the photographs were produced and intended to be consumed. They both mirrored and marked the ambiguous shift of the photographs from aesthetic to informational cultural domains, from photographic club to library. Whereas surveys based in photographic clubs tended to favour cut sunk mounts and the cen-

trally positioned image in the style of photographic exhibitions, the lighter, simpler mounts of the public institution-based projects assumed more of the character of a library catalogue card. Whatever arrangement was used, mounts were part of the system to protect the photographic print and regulate the user to ensure the longevity of the collection. What was again at stake in these debates over mounting were concerns about the long-term instability of the photographs, and the tensions between access and preservation. The very objectives of the surveys were threatened precisely by their implementation, as users rummaged through boxes and held prints in their hands.

The key site of "material taxonomy" was, however, in the complex relationship between mounts and labels. The positioning and content of labels went to the core of the presentation of historical evidence and to the precise aspirations for the photographs. Labels were intended not only to contain the semiotic energy of the image, but also to mark historical significance, containing the photograph in both time and space, giving a sense of exactness, specificity, and legitimacy as an historical statement, and circumscribing the ways in which information was apprehended.[153] The recording of certain classes of information on the label not only established the subject matter as being of historical significance. As a multitude of commentators have noted, captions enmeshed an image in linguistic forms in order to shape its reading and delineate the authority of observation. Tagg has drawn attention to the "moral fervour . . . [devolved] onto this little slip: how much it should say; to whom it should speak; to what code it should summon both object and viewer."[154] Labels, as printed forms, therefore marked out the space of useful historical knowledge, namely the clear factual descrip-

tion of image content, arranged to focus attention in certain ways, and effectuating particular experiences of the image, as Annelise Riles has commented, "Forms contain in them all the terms of analysis one would need to understand and complete them."[155]

The material arrangements are again significant. Ideally labels were to be on the front, not on the back. This not only cut down on handling but, more importantly, allowed all historical information, image and text, to be viewed at once: "The label is pasted on the upper right-hand corner . . . where it meets the eye at the same time as the print, where reference may be made from the label to the print and *vice versa* without turning the print, or even removing it from the file."[156] Mounts, cards, and labels thus had an intimate relationship. Not only did cards support images and labels. Mounts became multiply marked surfaces on which information accrued. They became a space for

46. Card and label. Corbel, Old Place, Croydon. Photographed by J. Hobson, 1905. Photographic Survey and Record of Surrey *(licensed from the Collections of Croydon Local Studies Library and Archives Service).*

inscribing and reinscribing the image. For instance, arrows were used to focus attention, specific points of interest were labelled, and so forth, producing a commentary on the photograph that constituted comparable data, materially and visually. Mounts illuminate precise textures of social relations in privileging certain kinds of information and the anticipated performance of photographs in the hands of users.[157]

Although the NPRA, following the Warwickshire survey, had used a label stamped on the back of their mounts, the most commonly adopted label was a five-inch-by-three-inch card format used first by the Surrey survey in 1903 and then widely adopted, with slight variations, by Kent, Sussex, Essex, Dorset, and Norfolk. *The Camera as Historian* stated: "With every photograph taken for record purposes there should be noted, in addition to the technical photographic data kept by every systematic photographer (date, time of day, character of light, lens aperture, kind of plate or film, length of exposure, etc) the compass point, or direction in which the lens of the camera was pointing."[158] A description of the subject matter, the name of the photographer, and the date of deposit were also required. This description, which became the nearest thing to a standard, performed the authority and legitimacy of the historical statement, linking acts of observation, inscription and the archival object. (See figures 47 and 48.)

However great the claims for the evidential quality of photographs, and despite Stone's unshakable belief in the power of the image as an historical record, text, formulated as label, nonetheless had to safeguard against a slide into historical illegibility: "A pictorial record without a label is useless or next to useless."[159] Such a statement is a tacit acknowledgement of

the limits of optical realism and indexical authority. The labels, little bits of paper stuck on card and marked with ink, contained the entropic threat inherent in the semiotic energy of survey images and carried enormous evidential and ideological force.[160]

But labels also presented a space for destabilisation and entropy because photographers filled in their own forms. The parameters of data were, however, clearly circumscribed: "An historical or antiquarian fact may add greatly to the interest of the print, but the survey label is not the place for detailed information of this kind."[161] References might have been given, but again the stress was on the authoritative and the extension of legibility: "Information should be limited to what is really necessary to make the print intelligible."[162] In practice, distinctions between photographic fact and historical opinion were not easily disentangled.

Many contributors failed to adhere to ideal standards. Some merely provided their names, named places and subjects, and dated their photographs. Others were more expansive, dating the subjects of the photographs, or relating them to historical events, attaching the photographs to a specific history, whether the flight of Charles II or James Watt's experiments with steam. But the labels also constituted a space where photographers could make historical comments, marking their visual statement in specific ways. In this one sees different, and sometimes quite idiosyncratic, interpretations of the ideas of evidence, significance, and historical intensity. The notes on prints in the Exeter survey archive, for instance, were extremely detailed and were intended to be bound into albums with the photographs. And these notes were often accompanied by extensive antiquarian descriptions. For example, a series of photographs by Arthur Tremlett of

95

Warwickshire Photographic Survey.

Subject *Old Town Mill : Tredington*
Date *April 7th 1896*
Time
Focus of Lens *11"*
Printing process and paper *Sepia Carbon*

Remarks *Sheep washing*

Contributor *W. J. Spratbatch*
Address *30 Smallbrook St*
Birmingham

47. The reverse of mount card with stamped label.
Warwickshire Photographic Survey *(courtesy of Birmingham Library and Archive Services).*

48. Ideal labels. *Camera as Historian (author's collection).*

misericords in Exeter Cathedral was accompanied by notes on the iconography by local antiquarian Kate Clarke.[163] Likewise, a series of photographs of London trade signs by Reverend J. K. Dixon in the NPRA has extensive notes of the history of those signs added to the backs of the cards.[164] Some responses could be quite eccentric in terms of survey information. In completing the notes section of the label, one contributor to the Nottinghamshire Survey, Ernest Bush, assistant building inspector for the city, concentrated on a detailed chemical description of the production of the photograph itself rather than enhance its historical meaning.[165] Other labels record the minutiae of local history. The NPRA collection includes three photographs of a window in Poole, Lancashire, from which the seventeenth-century astronomer Jeremiah Horrocks observed the transit of Venus in 1639. These were annotated by local professional photographer Luke Collinge.[166] Occasionally other voices come through, recorded as quotations. For instance, in the Norfolk survey a photograph of a shepherd, Mr. R. Bone, wearing the traditional smock, is captioned by Mr. Bone's own description of his smock-wearing habits, transcribed by the photographer S. J. Young.[167] In other cases, the captions more overtly contained the meaning of the photograph, transforming the pictorial photograph to a record photograph. For instance, the label notes for Ralph Robinson's pictorial and sentimental photograph in the Surrey survey, *The Old Windmill, Mersham*, states that the timber of the demolished mill was used for the church lych-gate and "was given by the Broughton R[ailwa]y Co on condition that the Rector pulled it down."[168] (See figure 49.) In this instance, the space of the label enabled the photograph to be further marked with the agency of its producer and the social textures of survey activity, beyond the act of photographing itself. The label created an unevenness of statements that embraced the scientific, the descriptive, and the poetic, revealing the instability of ideas of evidence and the way in which photographs might work as evidence, in ways that could not necessarily be silenced within the rhetoric of the archive.

It is significant perhaps that of all surveys, the Warwickshire survey and NPRA carry minimal captioning, perhaps reflecting Stone's belief in the ability of the photograph to articulate historical fact directly and without complication, and the strong photographic, rather than archaeological or antiquarian, interests of many of the contributors. The fact that the photographs existed and projected the traces of history into the future constituted an adequate evidential level. Labels, and their spatial relations with mounts, marked out the contained space of useful historical knowledge, aligning and cohering disparate disciplinary approaches, yet embodying the potential for expanding or contested knowledge, expressed by layers of surface markings, from the laying down of photographic chemical to additions and crossings out in captions. Here we see both subjective and objective registers of historical concern cohering at the surface of the mounted print in a box or file. What emerges from these practices and the debates around them are contested ideas concerning the extent to which historical information could be vested in the image alone and concerning the fragility of the concept of "the visual archive," a concept caught between the excess of the photographic image, the resonant subjectivities of the makers, and the recodability of photographs themselves.

In order to control readings of the photographs and the diverse interpretations of historical significance both visually and textually,

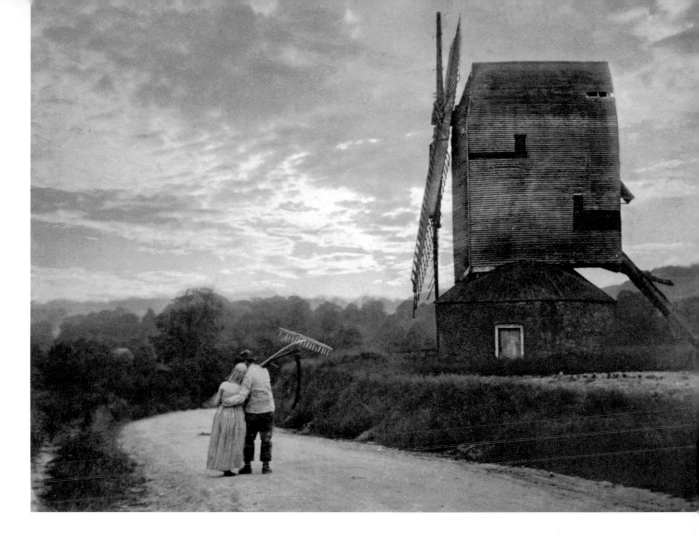

the intellectual and discursive paradigm of the archive was finally articulated through classification. As many commentators writing on museums, archives, and libraries have pointed out, taxonomic systems delineate the discursive and heuristic possibilities of the body of knowledge and its ideological rhetorics. Those analytical models are only a strand of an expanded material consideration of the concepts of evidence and archival aspiration. However, the overall identification and analysis of the epistemological frames and structures of knowledge represented through taxonomic practices remain resonant in this discussion. The long-term ambitions for the photographs' efficacy was not merely in their indexical trace but in the taxo-

nomic management of "facts," which in turn performed the epistemological frame of survey.[169] Practices of arranging and indexing were developed in response to the threat of disorder and the collapse of informational potential. But such activities have material results, the order of cards in a file, the placing of an image on the mount, and the spatial relations between photograph and text though which classification is manifested.

The organisation of the results of survey photographs was, as I have suggested, a major concern, for the realisation of the objectives of survey depended upon it. There was constant reference to the need to index in order to achieve a usable archive, and constant de-

49. Old Windmill, Merstham. Photographed by Ralph Robinson before 1897. Photographic Survey and Record of Surrey *(reproduced by permission of Surrey History Centre. Copyright of Surrey History Centre, 7828/2/101/47).*

bate about how this might best be achieved. In reviewing possible approaches, George Scamell noted, "The Warwickshire Society have adopted a system of classifying all pictures of a certain locality or parish together; the Birmingham Reference Library prefer the alphabetical method at present; the British Museum have adopted a county method; but, in any case, a copious index and complete catalogue should be kept at the headquarters of each survey society wherever prints are kept."[170] However, one of the criticisms levelled at the NPRA was that there was no system of making photographs and no control over duplication (as exemplified by the large numbers of photographs of Haddon Hall in Derbyshire, and of Stokesay Castle in Shropshire, both, significantly, sites of picturesque historical imagination). Further, there was no proper index beyond an initial listing, despite Scamell's repeated assurances that one would be undertaken.[171] As the *British Journal of Photography* commented of survey in 1908, "One would like to see greater attention paid to classification, grouping and indexing."[172] Addressing the Leeds Camera Club in 1902, the club's president, the local architect Charles D. Howdill, who wrote extensively on survey, stated that he had visited the British Museum to use the NPRA collection but found it "very muddled with no index."[173] By 1906 the lack of an index was cited as the reason the NPRA collection "had not been of the public value it might."[174]

The focus on classification became more marked after 1900, when the new professionals, such as librarians and museum curators, became more centrally involved with survey. Part of the shift in survey activity that I have already noted, the intellectual powerbase shifted from amateur photographers to those who might be described as professional "taxonomists" of knowledge. The section of *The Camera as Historian* on classification is almost certainly the work of Louis Stanley Jast, who, as librarian of Croydon Free Library, was one of the pioneers of classification and open-shelf libraries in Britain. He saw information as something to be organised, but also as something to be free and accessible. The system advocated by Jast clearly had its conceptual base in the Universal Decimal Classification system for libraries, which was coming into use by the early twentieth century, and of which Jast was an enthusiastic advocate.[175] The system he developed was based on the broad classes that reflect the organising sections of the photographic record-making activity itself: geology, architecture, anthropology, archaeology, passing events, natural history, and scenery. The notation system was built up as a series of numbers and letters, representing increasingly detailed arrays. The system subdivided and codified the description of the content of the photographs, with the subject classes being qualified by place and a special sequence representing architectural detail, for instance "541(143) Joh/C = St John's Church, Croydon or 554(192)5/Bri/Sta = British pottery, found at Stagg Field, Carsholten–on-the-Hill."[176] Classification was not merely about controlling the informational excess of photographs but about finding practical ways of navigating image content as information. Just as the material juxtaposition of images cohered the vast array of styles, subjects, and visions of the historical past, so classification constituted a controlled system for linking fragments into a coherent, signifying whole, articulating the values that had informed the making of the photographs, while at the same time maintaining the specificity of those statements.[177]

Despite its ambitions, and its capability of generating indexes over multiple topographi-

cal and subject axes, Jast's system does not appear to have been widely applied — it remained a "regulatory ideal," even in Surrey. Most surveys preferred a geographical or topographical sequencing of images, on the grounds that this was the most commonly sought approach to the collections. As the *Camera as Historian* notes, there is "great practical advantage in having the unit area for field work the same as that by which the collection itself is ordered."[178] In this we see a privileging instead of a more "naturalised" arrangement that responded to the needs of future users, an arrangement privileging the specificity of the photographs and an anticipation of future users' ways of thinking about the photographs, over the demands of rigorous and homogenising archival taxonomy. This approach does not, of course, necessarily free material from taxonomic structures, far from it, but it does constitute a fluidity in which photographs can operate over multiple meanings in relation to specific and localised understandings that are not necessarily contained by wholly archival structure.[179]

These arrangements were given concrete form through the boxes in which the photographs were placed. The containers in archives, boxes and files, are arguably the most overlooked material players in historiographical analysis. However, they are not neutral spaces. Their forms are part of the very nature of their institutional existence and part of the constitution and meaning of the archive. They are not merely pragmatic tools of taxonomic performances, but are entangled in shifting sets of values, from institutional to affective engagements with users.[180] Considerable discussion among the surveys took place, for instance, on the merits of different modes of storage, the relative merits of albums, and vertical filing cabinets for storage, discussion that would ad-

dress dual concerns of preservation and access. These containers were highly significant as material performances of survey objectives. Cosmo Burton wrote about the albums of record that would be developed for "a Royal Photographic Society of the future," and early surveys such as the Warwickshire survey also initially mounted their photographs in albums.[181] Later surveys preferred files and boxes that were infinitely expandable. For instance, the Dorset survey, faced with a growing collection, introduced a card mount and box system in 1910, although its original albums were not broken up until after 1918, when the survey restarted after the Great War.[182] The British Museum organised a set of green solander-type boxes, initially one for each county, into which NPRA material could be filed as it came in.[183]

While these practices were explained in practical terms, the debate was not merely about "safekeeping." Containers made the classification and organising of expanding archives more flexible and open to greater organisational control and anticipated a future for the collection. However containers also created a space of instability. Allan Sekula has argued that the taxonomic tool par excellence was not the camera, but the filing cabinet.[184] However, while this model might work at a conceptual level, it cannot account for how photographs embedded in such structures are actually used, how they make their meanings, or the affective qualities of the material force of the archive — of mounts, labels, and boxes — for the user.[185] Albums locked images into specific narratives created through their ordering in the volume. While users can change the order in which pages are read, skipping some or flipping back, the overall physical structure remains.[186] The filing cabinet presents a much more flexible way of working with photographs. As they could with the port-

folios of eighteenth-century antiquarians, users could locate specific images, isolate images from their taxonomic juxtapositions, and restructure their own narratives. While this was a reordering of power, it was of course not necessarily a release from the overall framework of the collection. But while the filing cabinet presents a "system of a series substitutions and equivalences within which photographic signs are disposed," the very fact of public access, present and future, threatened to destabilise that reading, not only in the infinite recodability of photographs themselves, but, as archives were subject to small acts of reordering, recaptioning, and reinterpretation, different groupings of multiple photographs are perceived at once, in an unfixed and continually shifting sense of the space, and thus meaning fosters a "myriad of random encounters with objects of knowledge rather than singular linear narratives."[187] The archive offered a dynamic future for the photographs.

Bruno Latour has argued, "Instead of using large scale entities to explain[,] . . . we should start from the inscriptions and their mobilization and see how they help small entities become large ones."[188] The survey collections and their materiality present such an entity, yet it is an ambiguous one. At one level, with their extensive remit and encyclopaedic ambition, survey collections fit the model of the homogenising and appropriating space performing sets of ideological meaning through containment and juxtaposition. Indeed, those responsible for survey collections were highly conscious of this function, for the long-term ambitions for the photographs were not merely for their indexical trace of "unblushing realism," but for the material performance of the taxonomic management of facts. This conception of the

archive allowed snapshots of architectural detail and pictorialist renderings of landscapes to exist in one rubric. A created and imaginative affinity in the archive constituted that surface of discursive unity and patterning of statements that Foucault described as a "unitary fabric of all that was visible of things and of the signs that had been discovered or lodged in them."[189] The survey collections represented an ideal of completeness linked to a capacity to believe in that completeness and place it in a potential universal taxonomy.[190] This ideal enabled the ordered massing of photographs in the collection to perform the idea of survey. Archival ordering satisfied not only the scientist desire for system and coherence that mirrored the map as a tool for the classification of knowledge in the production of photographs. Ordering also reveals the mechanisms through which the survey's historical imagination was codified and provided a material and intellectual framework through which the user can engage with the specifics of photographs.

However, the objectives of photographic survey and its collections were complex and unstable, permanently under threat at each phase in the photographic procedure, the selection of the photographic mount, the style and the subject of inscription, the type and treatment of the negative, and the making of the print and the systematisation of documentation. Three points of entropic anxiety, photographic style, materiality, and the management of visual knowledge were present in the production of survey photographs. Responses to these anxieties were articulated through a confluence of desires, actions, and procedures that materially constituted unblushing realism. The entropic anxiety, which permeated the photographic surveys, was not merely about a loss of the past, but about a loss of a future that might have been

able to embrace and be productively moulded by its past. Archival practice self-consciously provided its own narrative through the processes of making and archiving.

Anxieties over material loss, cultural loss, and social loss were inseparable at all levels of the survey movement. The material practices of photographic processes, archiving, and stylistic production represent an attempt to control and align the intersection and mutual interdependence of disparate concepts of photography and its purpose. The link between these practices and the various disciplinary practices in observation, evidence production, and material performance guaranteed the archive for the future. Those involved with survey struggled, through the process of becoming and the anticipation of loss, with the incipient archive, an archive that starts with what will become what is no longer, an archive in which a photograph in a box, itself chemically unstable, becomes the backstop against cultural disappearance and the hope for future efficacy. As Thomas Osborne has said, such an archival impulse, found in photographic survey movement, is "a site of reflection on the very status of archival politics, our archival lives, the traces that govern us and which will come to determine who on earth we have been." Archives reveal not merely a concern with the actual future but the social "ideas of futurity" that produce historical desire.[191]

As Peter Maynard has argued, material forms of photographs are not merely about making the thing itself visible but are crucially about making the thing visible in certain ways.[192] Through the banal details of plate sizes, printing processes, and labels, these struggles around concepts of loss, preservation, and archive were revealed, materialised and performed. In methodological terms, only a material hermeneutic, thinking through the detailed material processes, and moving the analysis of photographs from questions of representation alone to questions of material practice, can reveal the role of photographs as historical evidence. An articulated, self-conscious, historiographical desire marked the making of photographs as evidential inscriptions. The production of survey photographs was saturated in concerns for the material presence of evidence — in parish churches medieval market crosses and calendar customs — and the material forms of its translation as that mediated between inscription and questions of observation, evidence, and intensity of historical encounter. As Daniel Miller has argued, the potential of the material approaches lies not merely in method but in the acknowledgement of the nature of culture itself and the worlds of practice this creates.[193] Such close attention to the way the material performs the intersection of historical and photographic desire forces a more profound engagement with the nature of the historical statement so produced. What is demonstrated here is the way material practices and moral and cultural values exist in a complex and ambiguous discursive relationship played out in tensions over aesthetic and technical practices.

Eduardo Cadava has argued — in discussing Walter Benjamin, photography, and history — that the way in which "photographic technology belongs to the physiognomy of historical thought means that there can be no thinking of history that is not the same as thinking of photography."[194] In this, he clearly links technology, and thus materiality, to the inseparable relationship between photography and history. This link was understood by the photographic survey movement as amateur photographers strove to find the set of values through which such translations could take place.

The survey and record movement, organised by county, city, or town, emerged from a dynamic sense of place and a deep sense of history. The movement emphasised the importance of local ways of belonging, through the creation of a shared history, while maintaining an ambiguous relation with the national. Record photography would, as the *The Times* newspaper noted, appeal to people "who felt a national pride in the historical association of their country or neighbourhood, in family tradition, or personal association."[1] The potential for survey photography to engage in a number of simultaneous identities raises questions concerning its role and function in the making of localities and a sense of belonging across a wide range of social groupings, dynamics, and historical and cultural specifics. Entangled with the formation of these identities are the ways the performance of visual imaginings constitute a field of historical imagination in which "the multiple forms of national consciousness . . . interact, ebb and flow."[2] Photographic surveys were a fluid site of the experience of the local and locality as it is manifested through photographic desire and photographic articulation. David Matless has pointed out that the local, locality, and local knowledge are not merely a concern with ontological content but a discursive form.[3] Surveys were entangled with the tension between local and national desires and imagination, between the local negotiation of dominant structures and the translation of the local within a visual discourse of the national.[4]

The well publicised rhetorics of the photographic sur-

"To Be a Source of Pride"

Local Histories and National Identities

vey movement, especially the overtly nostalgic and nationalist pronouncements of Sir Benjamin Stone in support of his NPRA, and his dominant position in the public consciousness of the idea of photographic survey, has led to the survey movement's being characterised in terms of those particular discourses alone. Consequently, the movement has been studied as an application of a mythscape visualised as a patriotic picturesque, and defined through the ideological weight of historical space.[5] As a result, the stress on the determinism and instrumentality of photography in the construction of the nation has elided or collapsed the complex microlevels of historical desire within amateur photographic practice. Despite the potent analytical lure of nationalist discourse, an exploration of the historical desires articulated through the activities of the amateur survey charts a photographic response that embraces both aesthetic and evidential performances of place and responds to a localised sense of identity. A specific sense of the local was performed not only through a perception of appropriate subject matter, and thus image content, but through the material practices of photography and the placing of photographs in the public space. These practices were integral to the translation of location into an historically comprehensible material space of social relations, for physical locality was not only mapped visually. Survey photographs, and the desire to photograph, emerged from an emotionally engaged sense of place that, while inflected with ideas of the national and contributing to a coherent national vision, was also understood as being compellingly local.

The extension of a self-conscious visualising of the local also has to be understood in relation to other productions of historical locale of the period. These productions were part of a "broadening and deepening of antiquarian sensibility, as it became more securely integrated into the mainstream culture of English local life."[6] There is a sense in which the professionalisation of history in the late nineteenth century and the early twentieth, and the distancing of antiquarians in this process, brought about an intensification and concentration of amateur and local historical activity. This change was part of what has been described as a "militant" or reinvigorated localism in which "belonging to a locality was to be in possession of an identity, of a genealogy, and to explore and uncover the past of a county was to enrich that genealogy."[7] This localism was demonstrated through flourishing local antiquarian and archaeological societies (both well-established and new foundations), local learned journals, and more popular "notes and queries" forms of publication. The rise in local history museums and libraries and the continuing publishing activities of local record societies also expressed a reinvigorated localism. The press, both national and local, carried extensive coverage of local history. For instance, in the second half of 1905 *Athenaeum* carried reviews of William Duignan's *Worcestershire Place Names*, Frederick Snell's *Memorials of Old Devonshire*, and A. Humphrey's *Somerset Parishes*, and ran a regular column on local history, as did many local newspapers. At another level, the increasing number of tourists were furnished with local guidebooks, many of which were illustrated with half-tone photographs. These included a plethora of short local histories and church guidebooks which were produced for mass-circulation.[8] All these activities were part of the fluid and shifting processes of the historically and socially constituted production of space, place, and locale.[9] More particularly, these various foci of local historical activity reproduced a sense of a temporalised

spatiality that shaped the imagining of the local through the grids of architecture, ancient custom, and place of association.

In the context of a consideration of the survey movement, the local and locality should be defined as socio-geographical spatialities that constitute distinct, locally derived contexts for action and material experience. But the local is also, as Cohen contends, "an account of how people express their difference" and how that difference shapes their actions.[10] Consequently, the local also embraces a sentiment and sense of belonging that is premised in practice, such as the practice of photography, rather than in an abstract ideology of belonging.[11] The local and locality are therefore actively experienced as a sort of contact zone within which the present recreates the past. The question here, then, is how this sense of place and engagement was articulated photographically. A close-up view of the peripheral microlevels of cultural action, such as the survey movement, enables us to understand not only the specifics of a particular combination of technology, imagination, and affect in photography and history, but also how that combination might illuminate the broader understandings of social and political imaginings played out through the production and archiving of photographs.

The relationship between photography, place, and identity, especially in the construction of national identities since the late nineteenth century, has been extensively explored and provides some useful models. Broadly following Denis Cosgrove's and Stephen Daniels's seminal work on iconography and landscape as a cultural practice, a number of studies have explored the relationship between photography and a construction and sense of place and the locality.[12] What tends to characterise all this work, however, is a sense of an homogenised

instrumentality to photography, vision, and power, demonstrated through specific case studies and the semiotic excavation of dominant ideological formations through which constructed and experienced place is translated into photographic representation.[13]

In this model, the photographic surveys have been conceptualised as simply nostalgic and backward looking, as irredeemably entangled with bourgeois picturesque aesthetics and class hegemonies, and as part of the middle-class culture of nationalistic interpretations of literature art, science, landscape, and culture.[14] The stress has been on the instrumentality of photographs in relation to specific ideologies and has resulted in an assumption of an homogenised and unproblematic causality in the social construction of images. Related are similar problems in the way in which the preservationist and revivalist movements have been conflated with reactionary and proprietorial responses to landscape and history.[15] In these various models, photographic imagery and practice have tended to be constructed as an immoveable "truth" that simplistically reflects a set of cultural and political dispositions held by the makers of images.[16] As I have already suggested, such top-down models tend to elide relatively unarticulated local values and ascribe a self-conscious ideological awareness to photographers, resulting in an overdetermined reading of the visual economy in which photographs operate.[17] This is not to claim, however, that such ideological structures were not at work locally. Foucault's models of capillary and miniscule power provide a useful corrective, but "thinking locally" decentres and disperses the power dynamics of photographing the local in complex and significant ways. Locality is, as Arjun Apparurai has argued, as much relational and contextual as it is spatial in its constitution and is produced

"by a series of links between the sense of social immediacy, the technologies of interactivity [such as photography] and the relativity of contexts."[18]

RECORDING LOCALITY

The Essex Field Club, initiating its survey in 1906, had no doubts about the role of photographic survey to delineate the local. The Essex survey collection was to be made up of "permanent collections of photographs and other documents, so as to give a comprehensive survey and record of all that [was] valuable and representative of the County of Essex, and of the neighbouring rivers and sea."[19] This statement, typical of many others from survey projects, suggests the use of photography and photographs as integral to definition of the local, situating it in space and time through the gathering of factual data, and, by implication, placing photography among the cognitive processes of ordering information in a complex relation with the imaginative practices of visualising the world.[20]

Despite the rhetorics of "work of national importance" and the creed of collective effort for the general good, it was the local, in the parish, the county, or the town, that was seen as the natural configuration and conceptual base for photographic survey activity and the values of utility, appropriateness, and social cohesion for which the survey movement stood. (See figure 50.) *The Camera as Historian* observed of the spatial organisation of survey projects: "The question of the topographic unit for the collection is of primary importance, as the public value of the records will in large measure depend upon its proper resolution. The area . . . should have some unity of nature; its boundaries should be consistent with those of some recognised division of the country . . . for a close relationship between the organizing society and the individual workers."[21]

In Warwickshire, the unit for survey was constituted through a self-conscious engagement with the ancient organisation of the region: "Following the county, the next historical division is into 'Hundreds,' an institution dating back to Saxon times. There are five of these Hundreds in Warwickshire; and, as a commencement, one of these ancient divisions was allotted to each [photographic] society."[22] Nevertheless, what constituted region or locality, or how parts related to wholes, was not always clear cut. For instance, in Leicester, there was some debate about the inclusion of Rutland, because, archaeologically speaking, the county belonged with Northamptonshire, just as, for different reasons, the relations between the Surrey survey and the growing metropolis of London were not clear.[23]

However, the concept of local knowledge formed the basic premise of the surveys and performed their spatial dimensions. The photographic surveys aspired to a model for the collection of scientific anthropological data and for knowledge production that depended on a series of centre-periphery relations manifested through a network of amateur photographers and observers. Although the ambition and objective for the NPRA was a national visual archive, to be held in the national treasure house of the British Museum, the models of data production anticipated an atomization into a series of local endeavours that flattened the relations of data production and dissipated centre-local relations.[24] The ambitions of the survey movement did so because its data production was grounded in a system that privileged a local knowledge and immediacy of observation that was possible not only through a sense of "being

50. Shepton Mallet Cross. Photographed by F. Allan, 1891.
Photographic Record of Somerset *(courtesy of Somerset Archaeological and Natural History Society).*

there," but through a strong sense of locality in which knowledge of the local was evaluated, given authority, and utilized locally.

The value of the local (a variation of "the man on the spot") was stressed repeatedly and variously by the surveys. As Reverend Thomas Perkins of the Dorset survey said, "The work of each particular locality should be done by some resident of the neighbourhood for he or she has far more opportunities of learning all about the district than the expert . . . coming from a distance."[25] Similarly in Leicester, circulars were sent to incumbents of all parishes to elicit precise local responses. Warwickshire had lists "with interesting notes" on local churches and castles drawn up by local antiquarians and archaeologists to aid photographers, while in King's Lynn one survey advocate noted that "the Central Committee [of the photographic survey] in Lynn cannot know all existing subjects or obtain without local help, photos of passing or past events in every parish." In Sheffield, the local museum curator, Elijah Howarth, in attempting to initiate a photographic survey of the city, "appealed to those natives of Sheffield" who had "stored in their memory facts of local history." The Norfolk committee felt that "to make an adequate photographic survey it will be necessary to secure the active cooperation of many persons who possess intimate knowledge of particular localities."[26] There were also repeated appeals from the surveys for the inclu-

sion of the sizable residues of local visual histories in the surveys. Typical is the comment of Mitcham shopkeeper Thomas Francis, in his response in 1904 to local press coverage of the survey. Writing to Harry Gower, of the Surrey survey he said "You may be interested to know that our Parish Council have provided a book in wh[ich] we are keeping pictorial records of local historical events, & old houses & localities which are being destroyed or altered. Some of these prints might also be of service to you & of many I can obtain duplicates. This work I take an interest in but being in a shop, have *very little* time to devote to such matters."[27]

These examples, and there are many more, demonstrate the stress put on the local networks of association and dissemination, and the flow of local historical knowledge within the community that was needed to produce a coherent visualisation of the past. The collective archive was grounded in a sense of local knowledge that, in turn, privileged places or sites that defined the experience, the imagination, and the performance of the local. In this, the shape of the surveys follows that of local history, writing, and antiquarian description. The surveys overall reproduce a familiar pattern of the parish church, the manor house, almshouses, the village green, charitable foundations, ancient trees, and local curios, from chained bibles to whipping posts, all tropes of picturesque history and picturesque photography. These concentrations of historical imagination are given tangible form through the inscriptive powers of photography, as the construction of the local is mapped across survey photographs and is found in the boxes and filing cabinets of survey archives. While this construction of the local through historical markers was inflected with a localised form of the patriotic picturesque, these repeated photographic tropes should not

be read simply in terms of a nostalgic imagined past, a past "resurrected . . . in terms of aesthetic pleasure," although such ideas were clearly part of the formative discourse.[28] (See figure 51.)

The repeated appeals to local and civic pride and sense of place were characterised by a deep subjectivity. This subjectivity intersected with a belief in the inscriptive and culturally dynamic potential of photographs to form the connective tissue of the survey movement. The movement was not only an "imagined community," in Benedict Anderson's sense of shared values and aims, but a "structure of feeling," what Arjun Appadurai has termed a "community of sentiment," a group that begins to imagine and feel things together and is capable of taking collective action.[29] Photography was part of this process of "affect," articulated not only local knowledge but local sentiment. This is demonstrated in a speech by Stone on the proposed photographic survey of Warwickshire in 1890, a speech reported by *Amateur Photographer*:

[Survey photography] should not be considered as hard, dry, matter-of-fact, business, but as a matter of sentiment. What should inspire every one who undertook a share of that work was love of the persons and places they knew, the love of those associations which made their life what it was, the pleasure and sunshine and happiness which they and their families and their friends enjoyed. Of all these things they wanted a permanent record; they wanted to stop the fleeting events of the moment, and treasure them as long as they lived, and hand them down for the advantage and pleasure of those who came after them.[30]

A sense of pride in place was also expressed by Elijah Howarth, as he proposed the photo-

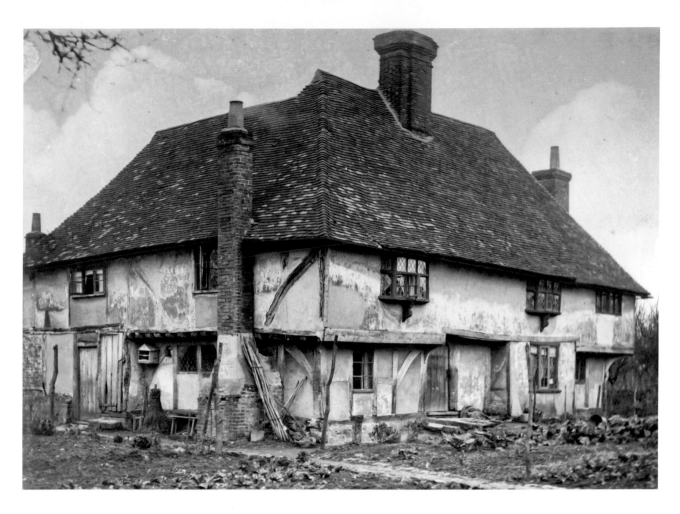

graphic survey of Sheffield in 1889: "Fellow Townsmen . . . may walk through the streets of their own town, and almost every public institution . . . can be claimed as the work of their own united action."[31] A contributor to *Amateur Photographer* in 1902 suggested that such sentiment was a precondition of amateur record work: "The true amateur spirit . . . only touches on the thing that appeals to its sympathies and predilection, doing nothing out of compulsion, as it were but lovingly and thoroughly searching after true enjoyment in the many avenues which nature opens out to her most faithful disciples."[32]

Significant here is the way in which the historical and memorialising process is not a re-moval from the head and the heart to the archive, as Pierre Nora has postulated, but an investment of the head and the heart, and of embodied observation, in the inscription of the archive, which remains replete with the emotional loading of the tangible past and its imaginings.[33] While, as Rosemary Mitchell has argued, picturesque historical discourse was tied to specific forms of national identity, that discourse also remained highly particularist and localised, and was articulated through photographs and the rhetorics around them.[34] As the *Eastern Daily Press* said in reporting a meeting on the Norfolk Survey: "A Norfolk Man could not be expected to enthuse particularly over Lincolnshire or Cornwall."[35] In 1904 the local

51. Bishop's Farm, Otham. Photographed by W. Stirling, 1911. Photographic Survey of Kent *(courtesy of Maidstone Museum and Bentlif Art Gallery).*

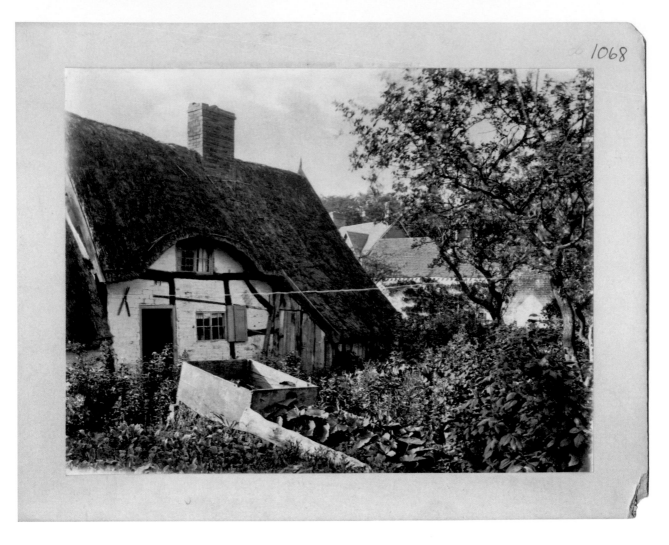

52. Back of Cottage, Berkswell. Photographer unknown, c. 1890. Warwickshire Photographic Survey *(courtesy of Birmingham Library and Archive Services)*.

photographic society in the Kent town of Tunbridge Wells likewise turned down a request to assist with the photographic survey of Surrey because Surrey was "hardly within the range of Tunbridge Wells."[36] Despite some exchanges of images and donations of materials to other regions, a repeated pattern of intense localism, of pride not only in the locality but in independent local achievement, articulates through networks of association, appears to have been at work.[37]

Despite the unifying discourses of photographic aesthetics that inflected the surveys' production, the formulation of specific concepts of locality, as the practices and processes of historical preservation, "cumulatively further[ed] understanding of locality" as unique pasts were understood through specific locales.[38] This was not merely a sense of place and locale, "of place and of spirit, the spirit of being born in the environment."[39] Survey photographers responded to the way in which the fragmenting processes of modernity had transformed landscape and topography into a set of criteria through which the landscape could be observed, judged, and addressed as historical deposit, as a site of fragility and decay, or as a site of aesthetic response. One could ar-

gue that the impact of the Warwickshire survey, founded in 1890, was not merely its very visible priority in terms of the survey concepts or its attempts at a systematic approach. Rather, it was, as Richard Keene's response to it demonstrated, because the landscape of the region, with its half-timbered cottages and associations with Shakespeare and George Eliot, appealed precisely to the aesthetic of southern ruralism and patriotic pictorialism that focussed on the rolling and hedged farmland, the nucleated village, and the hierarchies of church and manor.[40] (See figure 52.)

But the intensity might also reflect the local cultures and associations of photography itself. For instance, in the case of the Warwickshire survey, and to an extent in that of Worcestershire, the patterns and styles of historical visualisation were shaped through the survey's links with the Birmingham Photographic Society and its strong pictorialist tradition.[41] These examples point to the complex way in which the intersection of local, national, and personal applications of the concepts of evidence were also inflected with the photographer's own patterns of social association.

At one level, of course, the different emphasis and methods reflect personal interests and inclinations at the intersection of photography, history, and archaeology. Some photographers clearly had specific interests or decided that, in the unachievable inclusiveness of the survey concept, it was best addressed by specific and systematic localised response focussed on specific classes of objects. Indeed, Harrison, praising the BAAS photographic surveys of geology, anthropology, and botany, suggested subject approaches as an alternative to regional approaches.[42] For instance, Sussex antiquarian J. C. Stenning produced photographs for the Sussex survey of architectural detail (some of

which were used in his publications). Catherine Weed Barnes Ward photographed an extensive series of church fonts for the NPRA, and Robert Brereton's series of church towers of Somerset were published in the *Archaeological Journal*. (See figure 53.)

But the shape of visualisation can also be understood as defining patterns of local significance, the attribution of value, and significance to "produce" the local and perform its distinctiveness.[43] For the photographers active in survey, localities and their constitutive places were differently constituted through the ways in which people belonged to them.[44] This was articulated photographically. It was sometimes

53. The Tower, Winscombe Church, Somerset. Photographed by Robert Brereton (*author's collection*).

WINSCOMBE

expressed through the particulars of observation and photographic inscription. For instance, F. J. Allen of the Somerset survey urged photographers to attend to the "peculiar local forms of window tracery."[45] Elsewhere, whole classes of historical topography were seen as representing and visualising local distinctiveness and typifying local historical imagination. In Kent and neighbouring Sussex, the focus on local half-timbered and tile-hung cottages and farmhouses shaped the survey. Some photographers, such as Maidstone solicitor F. W. Argles and his camera club colleague J. C. Harris, made extensive photographic studies of these buildings, their black and white structures mapped across the picture plane, accentuating not only picturesque but graphic qualities.

This reading of the local historical topography, as a local form of the patriotic picturesque, was clearly articulated in 1911 by the mayor of Maidstone as he opened the exhibition of the Maidstone and Institute Camera Club. He commented on the survey photographs in a way that equated historical topography and survey with half-timbered buildings, referring to their design as "this essentially picturesque style of domestic architecture."[46] The stress on half-timbering in the surveys of Kent and Sussex in particular, but also in Cheshire, Wirral, and Warwickshire, had major connotations in terms of national identity. Half-timbering was increasingly understood as the architecture of Merrie England, signifying, in the popular imagination, an "old-world" stability and national essence within the temporal and spatial mythscape.[47] (See figure 54.)

In the King's Lynn's survey of North Norfolk, by contrast, the brick and flint vernaculars of north Norfolk were all but ignored as photographers were reminded where the true glory of the local past was located in terms of

historical visualisation: "Owing to the magnificent churches & Ecclesiastical ruins in Norfolk much of the valuable part of the record must necessarily be ecclesiastical in character."[48] Consequently no vernacular architecture, and little nonecclesiastical, beyond the great houses at Holkam and Houghton and some old inns in King's Lynn, was photographed, the focus being on the great fenland churches, such as Walpole St. Peter and Terrington St. Clement. This was not necessarily because such buildings did not accord with a model of national ruralism, but with a different set of priorities regarding local historical delineation.[49] It would be overstating the case to suggest that this is necessarily a form of self-conscious "structural nostalgia" asserting specific regionalities, but it does nonetheless point to the ways in which imaginings of the local were patterned through references to broader topographical conceptions as experiences of architectural style and form established the parameters of meaning within which the built environment could be understood.[50]

The profound sense of regionality and locality, imbued with historical depth, was therefore made visible through an identification with things, such as old buildings, that could be photographed. For instance, Manchester was described as being "poor in early ecclesiastical remains" but the same commentator in *Amateur Photography* also noted, "In the same area is quite a wealth of domestic buildings, few of them show-places, but all having points of architectural or historical interest. Moreover, change is constantly taking place, generally in details such as roofs, windows and the chimney openings."[51] This process of local identification created an historical topography concentrated on local styles and local, indigenous materials, standing for a close interaction of people and the natural environment, a

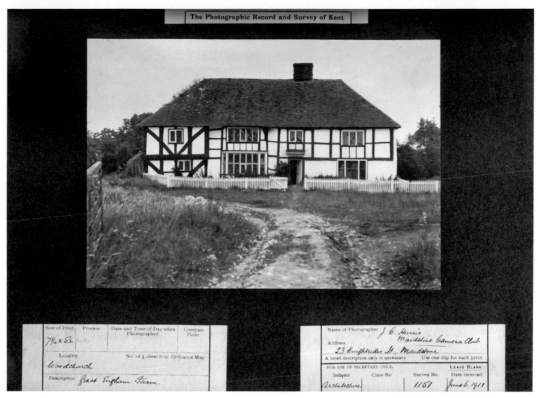

54. Half-timbered farmhouse, near Kent. Photographed by J. C. Harris, June 1911. Photographic Survey of Kent *(courtesy of Maidstone Museum and Bentlif Art Gallery).*

topography that became a defining quality of a regional aesthetic.[52] As Basil Oliver stated in his volume *Old Houses and Village Buildings of East Anglia* (1912), which was extensively illustrated with high-quality collotype reproductions, stylistically indistinguishable from those of survey: "Collectively these cottages, farmhouses, and kindred buildings play an essential part in the history of our national architecture though individually they are not of much importance. They were produced by local craftsmen. . . . The small buildings were moreover constructed of local materials in local traditional manner . . . thus being a natural product of the time and locality."[53] What is significant is the way half-timbered building, and the way it patterns the archive, can be understood as marking the com-

plex flow between local and national discourses as diverse localities, essential to the constitution of national character, were absorbed and mobilised within the national.[54] The emphasis on half-timbered buildings provides an example of the way in which photographs expanded their range of meanings from the indexical record of survey to the iconography of national ideology.

The inadequacy of a model of photographic survey as merely a conservative retreat into the past or as a hegemonic consolidation is also raised through the ways in which the surveys simultaneously accommodated an articulation of established imaginings of place, a sense of historical identity, and the conditions of their own dynamic modernity expressed at a local level. While survey perhaps articulated

a specific vision of progress, their engagement was not simply a question of that comfortable "industrial reverie" of the ordered world of capital.[55] The visual articulation of a shared experience of social change and innovation, of survival and future, was mapped through the survey archives, "a pictorial record of the state of things, physical and general, now existing," and the infrastructures of experience that were simultaneously local and modern.[56]

Examples of an engagement with the modern abound. Norfolk, one of the country's most rural counties, included photographs of shoe factories (the major local industry) and railway yards in its survey collection, notably two photographs juxtaposed to create an encompassing panorama, the tentacles of railway track filling the pictorial space. (See figure 55.) Indeed, as the Norfolk survey's lists of donors show, it appears that the survey pressed local firms, including factories, railways, and gas and electricity companies, for contributions. The resulting photographs show these technologies were new, exciting, and cohesive in their negotiation of identity. Members of the Warwickshire survey undertook extensive recording not only of the changing urban landscape of Birmingham but of its modern infrastructure, such as telegraph wires, photographed

by Thomas Clark in 1898, and the wholesale meat and vegetable markets central to the city's food distribution network.[57] (See figure 56.) In the Sussex survey collection there are photographs of post office workers, some uniformed, grouped around their new motor van, modern and efficient, and of political and election hustings.[58] The Surrey survey includes a rare photograph, given by a local newspaper, of suffragette day in Croydon in 1904, significantly, perhaps, not an image of violence and danger, but of civilised debate.[59] Exeter's collection includes several photographs of aviation, prompted by the locality being a stopping place on an aeroplane race around Great Britain in July 1911, an event that attracted large local crowds.[60] Exeter, whose survey was closely related to the local council's engagement with Geddes's model of urban planning and development, also included photographs of the provision of school holiday amusements for working-class children (the first in the country, the council claimed), and the extension of public amenities in the city. (See figure 57.) In other cases, the wealth of cities is marked topographically. The Manchester survey includes photographs of warehouses, through which goods passed for and from the Empire, and of the infrastructure of the modern city built on commercial power,

including photographs of town halls, hospitals, railway stations, and philanthropic institutions. (See figure 58.)

Likewise there was a concern with industrial histories, not only rural ones. The Warwickshire coverage of Birmingham includes various sites of industrial history, including Stone's photograph of James Watt's workshop, "which [was] absolutely undisturbed since his death in 1819," a print of which was also provided to the NPRA collection.[61] In another example, the Handsworth survey noted that the "committee want[ed] a photo of 'Notts Pool' . . . whereon was launched the first lifeboat that was presented to the nation by public enterprise and subscription." Members of the Handsworth survey noted, "Seeing that on the banks of this pool there formerly stood the factory of Bolton and Watt, the engineers, it will be readily understood that the photographs of such an historic place will be a most acceptable addition to the capital collection now being got together."[62]

These technologies were, however, understood and presented as instrumental in the change of historical landscape and people's relationship to it. Not only was there a generalised sense of loss and disappearance, but a very concrete threat to place itself from the physical carving and slicing of the historical landscape and a shift in its spatial and temporal rhythms.[63] However, the disruptions of modernity could reveal or make visible the past, especially the deep past of geological strata or prehistorical settlements revealed in making railway cuttings or gravel extraction, for instance.[64] Such photographs were especially prevalent in the Surrey and Essex surveys as they recorded the impacts of London's suburban encroachment "springing up like mushrooms."[65] As a correspondent living in rural Surrey, on being informed of the Surrey survey, commented to Professor Raphael

56. Laying Telegraph Wires, Birmingham. Photographed by T. Clarke, June 1898. Warwickshire Photographic Survey *(courtesy of Birmingham Library and Archive Services)*.

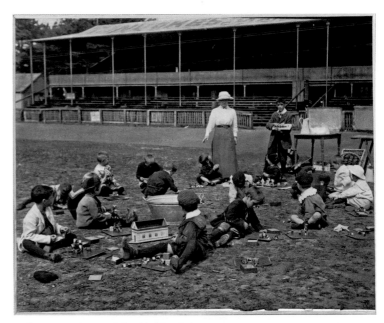

57. "Summer Vacation School held at Exeter 1913. The first of its kind to be held in the U.K." Photographed by S. Chandler, 1913. Carbon Print. Exeter Pictorial Record Society *(courtesy of Westcountry Studies Library, Devon Libraries)*.

58. "Watt's Warehouse," Portland Street, Manchester. Photographed by G. H. Rigby.
Photographic Survey of Manchester and Salford *(courtesy of the Manchester Room at City Library, Local Studies).*

Meldola, a member of the NPRA committee: "I did not know that the County of Surrey was making a survey photographically. It ought to be very interesting. I am afraid [it will be] rather a sad record in Surrey for lovers of the country, though. I must say, we have so far escaped being badly overbuilt."[66] Even the conservative NPRA included photographs of motor cars by Edgar Scamell, not only as pointers to the future but as a material culture whose design was changing rapidly.[67] Samuel Coulthurst, of the Manchester survey, made a similar plea for photographs of "tramcars, cabs and carts" because "all [would] alter and Records should be kept."[68] Although such photographs are outnumbered by those of parish churches, medieval funeral monuments, old village stocks, and half-timbered cottages, they nonetheless sit alongside traditional picturesque subjects in the archives, mounted and organised, as markers of historical significance, generalising yet locally specific.

Despite their engagement with modernity, however, the surveys had no agenda for material social change or social improvement in and of itself, beyond the social and civic value of fostering a sense of historical awareness. Critiques of the hegemonic purposes of the picturesque have tended to see representations of poverty in terms of class gaze and the appropriation of economic distress into bourgeois aesthetic codes.[69] As Malcolm Andrews has argued, preservationist discourses functioned to translate urban spaces into an aesthetics of poverty, redefined as picturesque, what he calls the "metropolitan picturesque."[70] In 1902, for instance, *Amateur Photographer* ran an article entitled "Picturesque Slums" about the aesthetic opportunities for photographers in such places: "How very picturesque these places are, the lime washed walls, where a rusty bit of old ironwork causes rusty streaks to run down here

and there, the worn-out stone step or the well-trodden wooden threshold . . . the general air of artistic untidiness."[71]

The ideological frames of the metropolitan and the rural, and the discourse of urban investigation, were undoubtedly part of the constitution of survey photography. They are manifested through, for instance, the "Peasant Portrait" classes of the Nottinghamshire and Warwickshire surveys (the latter of which, attracted a range of picturesque visual responses) and the London East End snapshots of Henry Malby.[72] However, the approach to urban poverty, to its presence in the locality, cannot necessarily be reduced to a model of aesthetic appropriation or the quasicolonial excavation of "Darkest England."[73] There is something more complex going on, for despite the ideological inflections, the purpose was to record things as they were for the benefit of the future. In the case of Manchester, "how the poor live" was a key objective of the survey from the outset.[74] (See figure 59.) While this was obviously not without significant political implications in the power structures of the production of visual knowledge, in Manchester, Bristol, and Birken-

59. Organ Grinder and children. Photographed by Samuel Coulthurst, c. 1894. Photographic Survey of Manchester and Salford *(courtesy of the Manchester Room at City Library, Local Studies).*

head (under the auspices of the Cheshire and Wirral survey), urban poverty was recorded.[75] However, the images were not intended to inspire social reform, but to form an accurate record of a city's identity and its experience, part of the public realm that entailed "a continuous urban topography, a spatial structure that cover[ed] both rich and poor places, honorific and humble monuments, ornament and ephemeral forms."[76]

Nonetheless, intervention and reform were implied as inescapable through responses to visually produced knowledge. In the words of James Wilcock, of the Manchester Amateur Photographic Society and secretary of its survey committee in 1890: "If bromide enlargements were hung in the shop windows of Deansgate [Manchester] of views taken up the alleys and courts leading from that thoroughfare, the bitter cry of the poor would not long go unheard." Photography of the poor "formed a most essential and difficult part of the survey: essential for the life of the poor . . . [and] the whole organisation of Manchester and Salford." Wilcock said, "Coming generations [without survey records] will scarcely comprehend how this existed in its present circumstances . . . A dozen prints of the Ancoats that now is, will speak volumes ten or twenty years hence."[77] The Manchester Amateur Photographic Society had a strongly articulated view of the philanthropic role of photography, of which the survey was just one aspect. For instance, the society regularly showed photographs at the Ancoats Museum, which was founded on Ruskinian principles regarding the social benefits of art and beauty, and provided photographic scrapbooks for the amusement of hospital patients.[78] *Amateur Photographer* records a lantern lecture given throughout the country by Manchester artist and socialist William Palmer (also known

as Whiffley Puncto) that was a counternarrative to the metropolitan picturesque, and in which the picturesque was used precisely to throw the plight of the poor into strong relief. The lecture's ironic title, *Merrie England* makes its intentions clear, and it demonstrated through lantern slides the phases of life of the poor and the contrasts between the lots of the rich and poor. Some of the worst slums in Manchester and other cities were brought "home to the minds of the ordinary citizen in a way nothing else could" as pictures of nail makers, chemical workers, and other laborers were contrasted "with beautiful pictures of country and sea."[79]

The diverse strands that cluster around a sense of the past, dynamic modernity and civic pride suggest a more complex photographic definition of the local and people's relation to it than a model of nostalgic longing or hegemonic desire will allow. In effect, the surveys, through multiple engagements of local photographers, were extending the range of what could be contained within the notion of national heritage, as individual localities were seen as significant in a broader sense of history.[80] As Jens Jäger has pointed out, amateur photographers, with their local knowledge and local enthusiasms, added sites to the national collection as, through the ethos of the straightforwardness of the photographic record, they brought into visibility objects of local significance that had either been overlooked as objects of historical importance or disguised within aesthetic appropriations of the pictorial.[81] The cottage was not merely a picturesque relic. It was also potentially an historical document to be read in the future. It was this fundamental point that allowed the potential translation of the local into the national because the local, appropriately presented in photographs and archives, could add to the general body of national knowledge.

The intensification of the local was reproduced in the shape and practices of archiving of survey photography, which was crucial to the coherence and function of survey photographs as a performance of historical locale. From its inception, the survey project aimed to transform the energies of amateur photographers into an archive of local and national importance, in which local free libraries and public museums were seen as a suitable places of deposit. These institutions were instrumental in the development of the photographic surveys, especially after about 1900, and were integrally linked with survey objectives regarding public provision. These institutions must therefore be understood as another crucial performance of the local. During the nineteenth century, local collections in libraries and museums, funded through the local rate, had been growing in importance.[82] By the late nineteenth century, when the surveys were forging links with local libraries, those libraries were developing an increasing emphasis on the local, especially in the decade after 1899. They undertook active collecting and, increasingly, a codifying of local history, including architecture, topography, natural history, customs, dialect, and industrial or craft history. Local institutions adopted a new purpose: "The history of the town, the flora and fauna, the geology and archaeology of the district ought to be represented as fully as practicable, so that the townsfolk may have the opportunity of becoming acquainted with their own town and neighbourhood from the point of view of history and science."[83]

The performances of photographs in local libraries and museums, spaces of self-conscious local definition, identity, and memory, were paramount: "Wherever there is a public library we believe that the public library is by far the best depository for the photographic records, so we believe that it will be found the best and most accessible place for any other records of a district."[84] What is significant here is the way in which libraries and the local collections were articulated as manifestations of regional and local identity and pride. The politics and poetics of the creation of museums, archives, and libraries as symbolic institutions of identity and citizenship at all levels, local, national, and imperial, is well recognised.[85] While at one level these institutions were a prism for the reproduction of dominant values, values regarding "who constitutes community and who shall exercise the power to define its identity," it was also closely related to the idea that such institutions should *represent* some sense of community.[86] Libraries were seen as spaces of education and self-improvement, especially for lower middle-class and working-class users, precisely those who were perceived as benefiting from a more strongly articulated sense of the past through local collections, libraries, and museums. Thus "local collections did not just add to a sense of civic unity, they also safeguarded the past cultural achievement of the locality. The custodial role of the public library was epitomized by its local history department, which stressed a respect for the endeavours of citizens' ancestors."[87] Knowing self was about knowing the topography and customs of a place, and the archive could collect and collate such information.[88] These institutions shared the preservationist impulses not only of those who contributed to the surveys, but of those who were involved in collecting local archaeology and folk-life and developing local-studies libraries. In many ways, the photographic surveys were merely an organised and self-conscious extension of these practices into the visual field, for

many libraries had been collecting engravings and, by default, photographs during the second half of the nineteenth century.

Arguably the emphasis on local instrumentality of photography became more marked as the power base of the surveys shifted from the photographic and antiquarian societies to the civic institutions of cultural production. This is demonstrated through the increasing involvement of local authorities with photographic surveys and survey collections' appropriation into local agendas of civic pride. Not only did mayors and aldermen open exhibitions, chair public meetings, and make speeches on the importance of survey photographs for the public good; local civic support was also financial. In 1911 the Exeter council unanimously voted annual support of £50 for the survey.[89] A similar sum was committed at Norwich. At King's Lynn the Librarian planned to purchase photographs for the survey collection out of the library rate because they were "specimens of art and science."[90] Other authorities, such as those in Birmingham and Croydon, supported the surveys with mounting and cataloguing work, and in some cases, such as in Rotherham, Ealing, and Woolwich, town surveys were initiated through camera clubs.

Patrick Joyce has argued that a "new demotic working class had to be brought within history which was now felt to be theirs."[91] Librarians and their collections therefore had a strong local focus. Indeed, when George Stephen, who initiated the city's photographic survey, took over at Norwich City Library in 1911, the local collection was seen as the only properly functioning part of the library.[92] These local-studies libraries not only maintained an antiquarian tradition but gave "popular" culture a tradition that reached back into the past of the nation, but a national past conceived in terms of the specific identities of a local and regional culture.[93] Mr. H. Plomer, addressing the Library's Association's meeting in Nottingham in 1892, made this clear:

> One of the many advantages to be derived from the establishment of Free Libraries is the facility they afford for studying local history . . . Everyone should take an interest in the city, town, or parish of which he is native or resident, and you will agree that the artisan or working man will be a better citizen for knowing how the place in which he lives and works has risen to its present state — how from the hamlet it has become a busy life centre. On the other hand, if there has been decay it is well that he should know the causes that have led to that decay . . . It is well, then, that every library should have on its shelves a goodly array of books on local history, and that its walls should be adorned with prints and drawings of the neighbourhood at various times.[94]

In this context, it can be argued that the use of photographs to trace the past, whether of parish churches or of beating the bounds, such as Stone's photographs of the "Clipping Ceremony" at Painswick in Gloucestershire, was an application of the historical sciences with "a veritable swarming of governmental initiatives . . . and new ways of inscribing those into the operating practices of civic technologies."[95] (See figure 60.) Tony Bennett, writing of museums, stresses the ways in which the citizen was constructed "as a subject in time . . . in the production of the progressive self." The surveys aspired to work precisely in this space, being deposited in public libraries for free access, exhibited and shown as lantern slides, connecting people to the local past and building

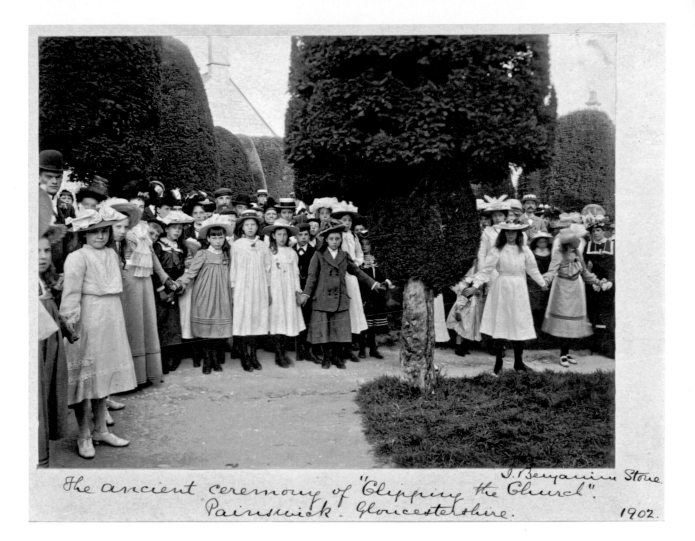

The ancient ceremony of "Clipping the Church".
Painswick. Gloucestershire.

J. Benjamin Stone

1902.

historical awareness and civic pride as "a public utility, such as will command the respect of those outside the photographic community."[96] As *The Camera as Historian* noted: "The value of adequate photographic records, kept as the common heritage, in fostering the civic spirit is not to be overlooked. A healthy corporate consciousness constitutes a quality in our civic and national life which cannot be too highly valued or too sedulously fostered. . . . And in the fostering of such a consciousness exact records of fact, by reference to which misunderstandings and misapprehensions can be dispelled, have their fitting place."[97]

Local collections and local photographs gave "people a long pedigree of blood and culture, reaching back many centuries," and "history conveyed to the powerless and disenfranchised a tremendous sense of entitlement and potential for their future."[98] While by the late nineteenth century patterns of powerlessness were shifting radically, with universal male suffrage, for example, the concerns and principles of civic society remained. But these concerns cannot necessarily be reduced to a model of producing elites and the consuming "ordinary" persons. Rather, the social dynamics and textures of the survey movement, with its varied

60. "Clipping the Church," Painswick, Gloucestershire. Photographed by Sir Benjamin Stone. NPRA Collection *(photo © Victoria and Albert Museum, London).*

constituencies as complex formations of historical imagination and apprehension of the local, destabilised any attempt at a comfortably homogenised discourse. For while the role of photographs might then be read as paternalistic and couched in class interests, the survey movement was also intensely liberal, democratic, and optimistic in its ideals and in many ways characteristic of late nineteenth-century social-welfarist liberalism.[99]

At a time when local government reform, through successive acts of Parliament, was also couched in terms of popular community involvement, the structure and function of local government itself was presented as historically significant in the performance of identity and was integral to the matrix of significances assumed by the archiving strategies for record and survey photographs.[100] For instance, intense locality was stressed, primarily through locality, by the material archival arrangements of the photographs: "The Warwickshire Society have adopted a system of classifying all pictures of a certain locality or parish together."[101] The idea of the "naturalness" of the unit for photographic attention, was drawn implicitly from these ideas, and they were informed by the same rhetorical stance of local or civic pride. In the view of folklorist Sir Laurence Gomme, who, as secretary to the newly created London County Council, was instrumental in the development of the Survey of London, the local was the preferred, even natural, form of government. Gomme believed that local government, "formed by common interests of a community dating for centuries back in the past," and possessing a "true locality," was the form in which "new functions of local government [would] best operate."[102] But "the formation of the locality of the county, of the borough, and of the township was not due to legislative action, but to forces which belong[ed] to the unconscious stages of development in English institutions. This unconscious stage [was] connected with the natural sociology of man's life ... Local government contain[ed] more natural history of man than any other parts of civilizations"[103]

This position echoed the sense of the local administrative area as the natural unit for photographic survey and, indeed, for material archival arrangements, but significantly places naturalness within a cultural subconscious rather than within mere administrative convenience. The antiquity and authority of local organizational structures played out in survey photography in mutually sustaining relations. There were constant appeals for photographs of civic occasions and of civic customs as a more intense engagement with the past: "People who live in the towns and villages where ancient customs and festivals survive will, by its 'records,' have their local patriotism stimulated and their resolution strengthened."[104] For instance, Stone produced photographs of the civic regalia of Ripon, Yorkshire, dating from the time of King Alfred (as local myth had it). (See figure 61.) Photographs of Sheriff's Ride at Litchfield, marking the bounds of authority, and photographs of aldermen of the city of London in their robes, are found in the NPRA, whereas in Exeter portraits of the city's mayors, wearing their chains of office, were added to the collection. Such subjects were not merely perceived as ancient, but they were active and material markers of local tradition, identity, and authority.

Of course, embedded in the structures of civic society and the production of the local were the photographic societies themselves. Throughout the period the structures of local association, through the proliferation of amateur societies of all kinds, formed an important

part of local civic consciousness. Although interest was not universal, the *Eastern Daily Press* commented that survey photographs would appeal to those "who like[d] to watch oblivion in the making,"[105] surveys overall were presented within a discourse of progressive modernity. In Surrey, for instance, the survey collection's presence and accessibility in Croydon Reference Library was listed annually in those statements and maps regarding the modern community.[106] In the care of local libraries, the photographic survey collections were not only perceived as being held in a place of safety, professional management and accessibility but also, perhaps vitally, linked photographic societies to the dynamics of civic pride, public utility, and local sentiment that defined communities. As the *Photographic News* reported: "There is a growing desire among the English Photographic Societies to make themselves of real service to the community."[107]

Even as late as the 1890s and 1900s, clubs and societies "were of inestimable importance in blending and articulating a coherent regional consciousness" and the militant localism noted earlier.[108] The role of societies depended on a broad base, however, and many, if not all, photographic societies cut across class boundaries to some extent, at least by the last decade of the nineteenth century. After all, as Harrison argued, "'all photographers are brothers', for it is certain that the study of this light science . . . tends to bring its fellow-workers together in no ordinary degree."[109] As Bradford photographer Percy Lund stated: "To exclude any particular class not only paves the way for the establishment of rival institutions but frequently involves leaving out the most useful and able men in the town. The broader the lines upon which an institution is formed, the wider the doors are thrown open, the more likely is it to become

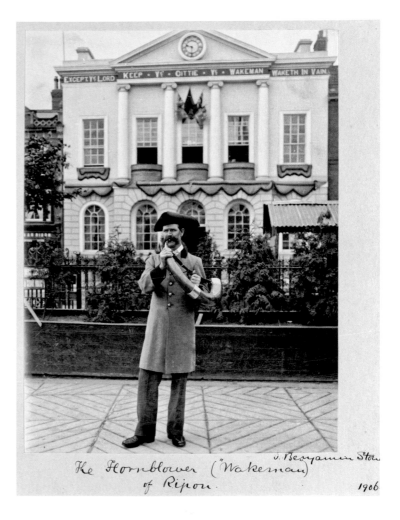

The Hornblower ("Wakeman") of Ripon. J. Benjamin Stone 1906

61. The Ripon "Wakeman" Hornblower. Photographed by Sir Benjamin Stone. NPRA Collection *(photo © Victoria and Albert Museum, London).*

prosperous, and by its genuine usefulness establish an indisputable right to exist."[110]

This seems to have been precisely the position of those who were described by the *Manchester City News* in 1892: "The variety of men connected with the society is another remarkable feature. Clergymen, lawyers, bank and other clerks, and warehousemen are to be seen at the meetings, almost all of whom are enthusiastic students of the art of photography."[111]

Despite the quasinational, and indeed international, character of photographic practice and its aesthetic values, and a sense of national endeavour, there was at the same time a feeling

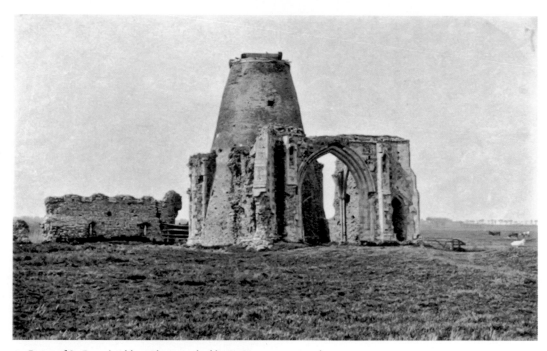

62. Ruins of St. Benet's Abbey. Photographed by D. Day, 1887, printed 1913.
Photographic Survey of Norwich and Norfolk *(courtesy of Norfolk County Council Library and Information Service).*

of regional pride in photographic achievement. Throughout the pages of the photographic press, meetings and exhibitions of provincial societies and their competitive exhibitions were reported and reviewed, as amateur societies demonstrated their own technical and aesthetic expertise. Cities such as Liverpool, Leeds, and Manchester were proud of the early foundation of their photographic societies.[112] The Birmingham Photographic Society saw the Warwickshire survey as part of its progressive vision for photography, and the public disputes between Sheffield, Birkenhead, and Warwickshire over priority in establishing photographic surveys was inflected with more than a passing sense of local pride. For instance, *Amateur Photographer* reported: "So Birmingham is to be the pioneer in the matter of a permanent collection of photographs comprising, in fact, a na-

tional survey. Well, we do lead! . . . We hope his [Stone's] dream will be realised, and that his enthusiasm will kindle into a flame many a smouldering spark that might burn to advantage."[113] As Stone commented, "We as a Birmingham association, look with pride upon our Warwickshire survey, and I am pleased that this record work has now at last become national."[114]

With a similar sense of local pride, the Norwich survey premised some of its claims to notice on the "East Anglian School of Landscape Photography," especially the well-known fenlands work of P. H. Emerson. This was also a self-conscious reference to the early nineteenth-century East Anglian watercolourists of the Norwich School, such as John Sell Cotman and Daniel Cox.[115] (See figure 62.) Similarly, the display of photographs by members of the Birmingham Photographic Society

at the Festival of Empire in 1911, as reported locally, left little doubt that "their work shows [that] the old guard did not reach their position by meretricious methods, but through a thorough knowledge of their medium, and a keen sense of artistic expression."[116] Regional federations of photographic societies in the late nineteenth century extended this localism into the regional, with the same patterns of regional pride, and called for "local centres" of survey activity, which could then represent local survey "to constitute a supreme authority by whom matters of general principle would be controlled."[117] This was not a devolved system so much as a centripetal recognition of the local basis for the survey.

Pride in the local was expressed not only in the rhetoric of the photographic societies but in their material culture, such as in the prize medals given at competition exhibitions. These objects again draw on clearly delineated and imagined local identities, often cohering around local manufacturing. For instance, the Sheffield Photographic Society, which was involved in the unsuccessful survey of 1889, designed a plaque that could be reproduced in the society's literature, exhibition medals, and so forth. It showed a figure of a Sheffield workman hammering a blade on an anvil, a reference to the city's cutlery industry. Reporting this, and complimenting Sheffield's direct simplicity of design, *Amateur Photographer* recommended the extension of this idea, suggesting that Bristol adopt a design incorporating a "girl packing tobacco," and Liverpool "a dray piled high with cotton bales.[118] The Surrey survey likewise aligned itself with the visual symbolism of the local, adopting as its logo a variation of the chequered squares of the coat of arms of the Warennes, Earls of Surrey in the Middle Ages,

63. Badge of the Photographic Survey and Record of Surrey *(licensed from the Collections of Croydon Local Studies Library and Archives Service).*

resting on the spread of the sun's rays, visually linking the local with the technology and history of photography, while "gothick" lettering suggests a sense of the past.[119] (See figure 63.)

However, the local itself was not an uncontested space, for it embraced a wide range of social interests, communities, and relative dynamics that coalesced or fragmented around temporary enthusiasms and interests.[120] One gets the sense that this complex dynamic was of the survey endeavour, and the uneven support may have been as much a result of diverse local allegiances and conceptions of community as of general photographic inertia. Not only were there questions regarding the delineation of the space and the understanding of locality itself, but the surveys sometimes became enmeshed in local power structures concerned with the inscription of history. For instance, in Cambridge, the survey, under the auspices of the Cambridge

Antiquarian Society, was seen by some as a "university" society, excluding the "town," and "leaving out of useful men," and thus a majority of amateur photographers. "One reason," wrote A. C. Haddon to a fellow officer of the society in 1907, "why fellow townsmen do not join the C.A.S. or take an active interest in it and fail to subscribe to the new Museum is because they are insufficiently represented on the Council. As we are, nominally, as much a non-University as a University Society we should make an endeavour to interest young townsmen — possibly we may discover workers [for survey photography] among them."[121] In Leicester the photographic society started a photographic survey of the city and county in 1899. However, the project was effectively appropriated by members of the more socially prestigious Leicester Literary and Philosophical Society, who began a survey project, with the support of the National Trust, that aimed to undertake a "reporting upon all the interesting buildings & objects of Natural Beauty found within a radius of 10 miles of Leicester."[122]

Another example is the occasion when the Norwich and District Photographic Society, working with the Norwich City Library, announced their photographic survey in 1913. People in King's Lynn objected, based on a very clear articulation of space and locality: "The county is very large and has over six hundred villages and a bad train service . . . following the lead of the County Council itself, and many other county institutions [the west of the county] is not inclined to let Norwich people have the entire say in county affairs."[123] Local people effectively said that the understanding of the local historical significance of the great medieval town of King's Lynn was vested locally. As a result they then proceeded to set up another survey at a meeting in the new Carne-

gie Public Library.[124] In Surrey there were similar concerns about local distribution and control. Hector MacLean, addressing the Croydon Camera Club on survey photography, stated that the Surrey survey "was endeavouring to decentralise itself by establishing local centres," as it did not wish to be identified exclusively with Croydon.[125] However, at the same time, a fragmenting sense of localism was also seen as detrimental to the higher purposes of photographic survey. As *The Camera as Historian* claimed, "Too great an emphasis cannot be laid on the necessity for securing public recognition of the Association as one for the whole county: otherwise there will be a tendency for it to drift into the position of being regarded as a local society, of interest only to those residing in the immediate neighbourhood of the collection."[126] What resonates through and unites these various local disputes and concerns is not only the desire to control one's own history through the production, archiving, and dissemination of photographs, but also the ways in which photographic survey was used as a symbol of historical identity, an identity grounded in local people and places.

The contexts in which photographic survey forged its identity and the utility of its photographs was therefore part of a process that had been fundamental to a sense of community, function, and territory throughout the experience of industrialisation, a sense through which people became intensely conscious of regional distinctions, especially in the structure of manufacture, and strongly identified with those distinctions.[127] Different regional identities, both political and cultural, were still resonant as late as the 1890s. It has been argued that late nineteenth century liberalism carried with it "a strong cultural emphasis of the provincial," and that there was an intensification of regional

and local identities through local government reforms of the nineteenth and early twentieth centuries. There was pride in the civic achievements of modern infrastructure, railways, hospitals, grammar schools, museums, and libraries. These achievements created a topography of modernity, which were traced through the photographic delineations of place.[128] While the tentacles of a central governmentality reached down through local institutions in a constantly shifting set of relations between the metropole and the provinces, the national was experienced locally, and photographic survey and the role of amateur photographers remained part of an intensely local manifestation of those relations. This sense of local endeavour was enhanced by the repeated resistance of central government bodies to take up the work of photographic survey despite Harrison's well publicised opinion that a "scheme ought ultimately to be conducted at the national expense and by national institutions," and that "State Photographers" ought to be appointed.[129] The government's resistence and lack of assistance was actually celebrated as a triumph of amateurism working outside the formal structures of the state.[130] As one commentator said, discussing photographic survey: "The work would be done more quickly and ably and greater freedom from red tape the better."[131]

The photographic surveys both responded to and constituted feelings of locality, maintaining and reinforcing those feelings through the evidentially and historically seductive photograph. While the photographs produced may have represented, on occasion, an idealised, even romantic, response to locality, the archives they formed were material performances of those feelings of local pride and social utility.

NATIONAL CONNECTIONS

In 1905 an American commentator stressed the relationship between photography, morality, and love of country in no uncertain terms: "The English photographer, with few exceptions, stays at home and photographs what is about him, his meadows, his cathedrals, his people, his home, and this love of home is the keynote of English character and success. His love of truth is reflected in his care for detail, his aversion to faking, and his inclination to make straight photographic prints."[132] How did the intensely local desire and sense of local distinctiveness translate into the national? In what ways did local experience mediate national identity?[133] Despite intense localism, central to all these projects was the idea that local, visualised knowledge, a mapping of local historical consciousness, had the potential to be transformed into a permanent national inventory, a commonly held scientific knowledge that could be archived and analysed.[134] What cohered the photographic surveys as a movement, and one that those surveys recognised, was a sense of greater good manifested through a matrix of community, history, and nation, a sense expressed through the ontological and material practice of photography.

There is a sense in which the national, the supralocal, and the local were, in photographic terms, indistinguishable, mutually constituting, and contingent, for we are looking not at alternative local pasts in opposition to national pasts, but at local inflections of a national past.[135] What made the translation from local to national possible was the recodability and mutability of photographic meanings as images performed in different contexts and different configurations of expectation. Henri Lefebvre has argued that different represen-

tations of space constitute different modes of the production of space itself.[136] Such a reading would be consistent with the nationalisation of provincial cultures in the 1890s, especially in the expanding incorporation of folk customs and literary landscapes into the vision of the national past, for instance, in the ubiquitous Morris Dancing and the ever-growing cult of Shakespeare. However, localisms, such as the half-timbered farms of Kent or the fifteenth-century wool churches of Norfolk and the Cotswolds, increasingly gave the national "distinctive meaning in an enormous range of social settings."[137]

Thus photographs that were defining indexes of the local in public libraries became, in the national context, icons, and one can understand the different performances of photographs in such a way. The most overtly nationalistic survey project was, of course, the NPRA, which developed and disseminated a strong discursive coherence around the national performance of photographs. The NPRA was, in its inclusive and encyclopaedic ambitions, intended to reformulate the local on the national stage. While the project was, as its name suggests, conceived as national, most of the photographs associated with the NPRA were of England. The limited coverage of Scotland, Ireland, and Wales points to the fragility of concepts of the national, even by the early twentieth century. Nonetheless, the NPRA accorded most strongly with conventional notions of national agenda, in that it self-consciously appealed to a collective sense of national tradition within the modern liberal state as it concerned itself with "enduring traditions, heroic deeds and dramatic destinies located in ancient . . . homelands of hallowed sites and scenery," sites in which "single monuments or framing stretches of scenery provide visible shape: they picture[d] the nation."[138]

The NPRA photographs were even occasionally referred to by contemporaries as propaganda.[139] Making such records had "an important bearing on the earlier history of our country, and indicate[d] in a remarkable manner, the true source of many an epoch-making incident in the story of British freedom and progress."[140] In the words of Sir J. Cockburn at the closing meeting of the NPRA in 1910, "These 'Archives of history' . . . would have a great part in giving continuity and solidity to our national life."[141] The flow of amateur photographs from local to national discourses extended the constitution of national discourse through the visibility of regional variation that was perceived as crucial to England's character.[142] Indeed, Stone was at pains to stress that an inward-looking localism should not jeopardise the national interest: "So important a national work should not be marred by a suggestion of fabrication, or perhaps we should rather say local emphasising."[143]

The massing of the local, and the unity and diversity it embraced, also assumed a metaphorical meaning. The massed photographs themselves were fragments of space and time made to cohere over multiple and multilayered strategies, local and national. But it was the concept of the national that invested massed photographs with authority and cohesion, eliding points of fracture: rather than being "a mere heterogeneous assemblage of photographs by enthusiastic amateurs of the camera" they were "national in their comprehensiveness and of sufficient importance to entitle them to be spoken of and looked upon as a record."[144]

The NPRA absorbed a wide range of images from an equally wide range of photographers. However, while there was some overlap in contributors, notably Godfrey Bingley and Catherine Weed Barnes Ward, a vast majority of the photographs contributed to local surveys

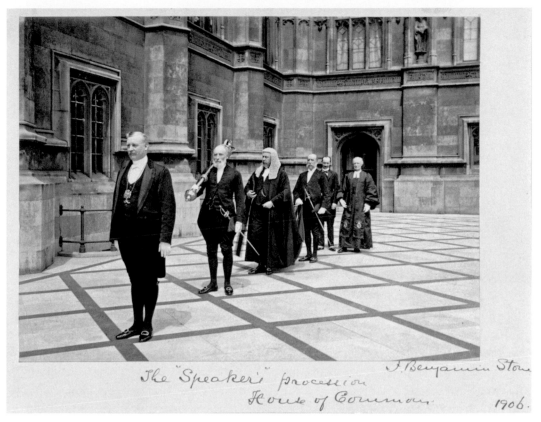

The "Speaker's procession
House of Commons.

J. Benjamin Stone

1906.

64. "The Speaker's Procession, House of Commons." Photographed by Sir Benjamin Stone, 1906.
NPRA Collection (*photo © Victoria and Albert Museum, London*).

were not contributed to the NPRA. Warwickshire donated 100 prints of photographs from their survey as a founding gift to the NPRA, but made no further donations despite close involvement with Stone. Worcestershire, Shropshire, and Hull sent a few photographs to the NPRA, the rest stayed resolutely in their local areas. This may be related to the tone of the national project set by Stone's widely reported early donations to the British Museum, the rhetoric of which project distanced the local. These photographs were of Westminster Abbey and the Houses of Parliament, not the parish churches or disappearing folk customs.

The founding photographs of the NPRA represent the places of the reproduction of core national values and are demonstrations of the antiquity and authority of British institutions. (See figure 64.) Although he went on to donate a wide range of photographs, Stone intended his photographs to present these ancient institutions as the core of his articulation of nation. This position was reiterated almost ceaselessly around the photographs donated by Stone and other contributors to the NPRA. The collection would "at some future time . . . be one of the most valued possessions of the Nation."[145] For Stone, the very act of photography and looking evoked a reverie of national history, reiterating the oft-repeated view that the qualities of observation engendered through such photography were themselves instructive and illuminating: "As he [Stone] sat and gazed on the tombs of kings and men great in history which

65. Coronation tea, Holme Pierrepont. Photographed by Charles Ferneley, June 1902. Photographic Survey of Nottinghamshire *(courtesy of Nottinghamshire Archives,* DD/1915/1/238).

surrounded him, visions of the pageantry of coronations and no less pompous funerals flitted through his mind, and formed a silent history of the nation and its peoples from the time when the Abbey was built until the present day. Every event on the page of history seemed to have its silent record in the chapels, tombs and monuments which surrounded him.[146]

It is this sentimental nationalism that frames the presentation of Stone's photographs in his two volume *Sir Benjamin Stone's Pictures: Records of National Life and History*, which would "add to everybody's knowledge of the country they love." As did the NPRA, this project stressed the national and the absorption of localities into a mapping of national antiquity and cultural depth. At the heart of this mapping is the seat of government itself, the places and people of the Houses of Parliament, which forms the second volume of the publication. The "absolutely unfaked" quality of the photographs is again stressed as if to accentuate the authenticity of the subject itself. The patriotic reading of the photographs is directed through the text and connects the viewer directly to the associative values of the images:

The deeper significance of Sir Benjamin Stone's photographs is that they tend to excite . . . an accession of admiration and affection for it [Parliament], as the representative assembly of the people, as the supreme authority of the land, as the instrument by which . . . so much has been done for humanity. It is, indeed, a place of absorbing interest, this historic temple of British liberties, with its sacred memories and heart-stirring associations; the scene of glorious achievements in oratory and statesmanship, the place where questions affecting the wellbeing of the community are determined.[147]

Outside the agendas of Stone and the NPRA, local surveys were, however, equally engaged with the national, but in ways that rendered the national local. Alongside the photographs of modern infrastructure, survey photographs articulate the events and experiences that embed people in the modern world of industry, change, and empire, linking people to the grand narratives of history. Many surveys record events around, for instance, the 1897 Jubilee, the Boer War, the death of Queen Victoria, and the proclamations and coronations of Edward VII and George V. (See figure 65.)

Royal visits were featured in almost all the surveys, as were photographs of coronation bonfires, including some rather unsuccessful attempts to show them alight. The Darwen Photographic Society in Lancashire established a special Jubilee survey section to record the occasion for posterity and donated fifty mounted platinum prints of the decorations, processions, and street scenes to the town authorities. The *Yorkshire Post* over the Pennines opined, "In the present Jubilee year there must have been many thousands of photographs

taken of local celebrations which, if brought together, would form a most valuable chapter of national history."[148] This desire for local mappings of the national was repeated by *The Times* newspaper, which saw the massing of images of local jubilee celebrations as forming "a most useful chapter of national history."[149]

Other examples abound. Norwich explicitly solicited "pictorial representation[s] of Norfolk's share in the Great War."[150] In Nottinghamshire, Charles Ferneley, a local commercial photographer from Radcliffe-on-Trent, donated to the local survey richly engaged photographs of, for instance, a sheep roast to mark the end of the Boer War and photographs of the local church decorated for the memorial service for Queen Victoria.[151] The predominance of commercially produced photographs absorbed into the surveys to record such events points to the images' addressing wider photographic desires in the local community, desires to which the surveys were, perhaps, incidental. Such images were often reproduced as postcards, seen in local shops, and sold for local consumption in a local visual economy that could connect the local and the national in an increasingly visualized environment. As *Amateur Photographer* commented on the Boer War:

> The war has caused an unprecedented interest in the various cinematographic entertainments throughout the country. The animated pictures of the embarking troops, and notable generals, who are now fighting our battles at the front, have given keener enjoyment of the masses than even the most salient sallies of pantomime, or the wiliest witticisms of comedy. The lantern has become, also, the chief attraction, even at smoking concerts, as wherever possible, the songs — chiefly martial — have had, per-

force, to be accompanied by slides of a military character. This we commend as having a tendency to increase our national and personal patriotism.[152]

The experiences around national events, which demanded local performances and local manifestations of this sentiment, were something the surveys were keen to record. Michael Billig has suggested that a sense of belonging and identity unconsciously articulated through the ordinary constitutes "banal nationalism." He argues that special events such as coronations are "conventional carnivals of surplus emotion, for the participants [were] expected to have special feelings" and "extra emotions should [have been] enacted."[153] Banal nationalism literally expressed a feeling beyond the local while at the same time intensifying the local. There were other spectacles accompanied by a plethora of images, including, by the late nineteenth century, mass-circulation photographs, of coronations, imperial durbars and colonial wars, events that offered people ways of connecting to national sentiment. Observed at a local level, these photographs constituted only one facet of identity, one that did not require the sacrificing of local identities and memories, but rather a working through of the national at a local level.

While the photographic surveys and the cultural authority they claimed was contested at local levels, that authority was equally contested, perhaps more so, at the national level. This is clearly articulated by the Manchester correspondent of *Amateur Photographer* in 1898, who effectively raised the question of the ownership of history and the loss of the local when discussing the relationship between the NPRA and local societies. His comment has entropic resonances in the way it suggests a loss of

appropriate and effective engagement: "This is all very well, but what use will these local prints be to the future local historian if they are buried away in London? They would be of much more value if deposited in local municipal libraries, such as at Darwen, Manchester, [and] Oldham [as] other societies intend. What can be gained by societies joining such a scheme[?] They have everything to lose and nothing to gain."[154] Similarly, George Brown, then editor of the *British Journal of Photography*, addressing the Surrey survey in 1914, stated: "In the early days of the movement Sir Benjamin Stone made a fatal mistake of burying the results of his efforts in the British Museum. Of course a more efficient means of separating the collection from the general public could not have been adopted . . . the doctrine [should have been] that the proper function of a photographic survey was that it should be local and locally preserved."[155] Such views would appear to confirm the very limited overlap between the local surveys and the NPRA. The pattern of image distribution also points to local, rather than national, concern.

There are other examples of tensions between provincial and local interests and the metropole, tensions that were also entangled with the professionalisation of historical disciplines. One of the reasons that learned societies, such as anthropological and archaeological societies, effectively distanced themselves from amateur photographic efforts was their sense of professional and scientific identity and their concern with the nature and quality of the knowledge produced in the name of their disciplines. These concerns underlay the tensions in Leicester that I have noted, but also the illuminating case of the photographs made by Leeds Camera Club, and notably by Godfrey Bingley and others involved in the Yorkshire Survey, for W. H. St. John Hope's *History of Kirkstall Abbey*, written

for the local Thoresby Society in 1907 under the patronage of the City Corporation. St. John Hope, a leading authority on monastic remains, had been commissioned by Leeds authorities to advise the restoration and preservation of the ruins of the abbey situated in, by then, a suburb to the northwest of the city centre. However, it is clear that there were tensions between photographic knowledge and archaeological knowledge, and that the hierarchies of that knowledge were also entangled with those of the metropole and the local and competing cultural authorities.[156] The archaeologists of the Society of Antiquaries repeatedly made what the photographers saw as unreasonable demands, with expectations beyond what was possible for the medium. Godfrey Bingley, who was coordinating the photographers, commented: "The vaulting is so dark that with the long exposure required, details get obscured by halation, although I used film supposed to counteract all difficulty of the kind. I shall have one more try and then give it up as a bad job if I don't succeed." St. John Hope's letter resonated with a sense of superior knowledge and the photographers' lack of it: "The two larger [photographs] do not show anything that does not appear elsewhere . . . the two smaller represent *not* the 'monk's footwashing trough' but a comparatively modern *privy*."[157] This exchange was understood in Leeds not only as an incompatibility of knowledges, but as a question of the provincial and metropolitan claims. As Mr. E. Clark of the Thoresby Society lamented, "I sympathise with him [Godfrey Bingley] in some little feeling about the attitude of our learned friends."[158]

Nevertheless, the rhetoric of the national good continued to inform both the conception of the NPRA and the public presentation of photographic survey. Harrison's initial

vision for survey was a universalizing one that not only cohered the national, but the international, "to link together the photographers of the entire civilized world by an extension of the 'survey' idea." He called for a "True Pictorial History of the Present Day," and believed that it was "a great pity that the results secured should be confined to the locality in which they [were] produced," rather their utility should be extended.[159] Likewise, Reverend O. Bevan, a Midlands antiquarian and an amateur scientist active in the BAAS, was concerned about the disorganization of local scientific knowledge and the possible loss of that knowledge to national concerns: "The work they [survey members] were carrying out could no longer be considered of a local nature, but national."[160]

Yet despite the discourse around survey photography and the national good, the sense of duty and the appeal to patriotism that saturated the rhetoric of the NPRA, the photographs that contributed to the construction of identity and memory to greatest effect were those available in the local free libraries and tied to local memory and civic pride, not those in the British Museum. The demise of the NPRA in May 1910 and the rapid establishment of the Federation of Photographic Record Societies might be read as the recognition that the local carried the dynamic force and potential for realization of the objectives of photographic survey, in contrast to Stone's more nostalgic desire for material totalisation and the possibility of homogeneity. The NPRA bowed to the greater success of the local surveys, unable to realize its goal of building a photographic memory bank of national history despite its appeal to a series of defining tropes of national identity in landscape, ancient buildings, and custom. Arguably the NPRA foundered precisely in the space between the national as a facet of increasing centralization

played out through imperial greatness and the banal nationalism of the local. The local had, in effect, triumphed over the national. Photographs were to be located in places where the history of the everyday environment of the parish church, the almshouses, and the new gas works, as a form of banal nationalism, was constituted and performed.

IMPERIAL QUESTIONS

It is impossible, however, to discuss the national at this period without a consideration of the impact of empire. The height of the survey movement coincided exactly with the period of high imperialism, which saw a massive increase in the circulation of imperial and colonial discourse and its impact on concepts of nation and national being. Colonial photography had, of course, made an important contribution to the definition of home, as empire became, at least in the popular domain, an increasingly photographic, indeed filmic, discourse, in a vast array of images, from postcards to advertising.[161] This raises the question, to what extent can the photographic surveys be seen as an exercise in imperial imagination — a marking of "place and home" at the core of empire? For as is well recognised, "the global reach of English imperialism into alien lands, was conversely a sentiment for cosy home scenery, thatched cottages and gardens in pastoral countryside," a patriotic picturesque that resonated through survey photography, even if survey advocates rejected its overt aesthetics.[162] Thus, to what extent can this archive of the English locale be read as an implicit "archive of the colonial or the imperial consciousness" — part of what JohnMackenzie would term an "ideological cluster" around an imperial consciousness that "came to influence and be propagated by every organ of British

life at the period?"[163] To what extent did an imperial imagination lurk beneath the agendas of a photography of the perceived disappearance of an English past?

An increasing amount of scholarship has questioned the degree and ambiguous nature of imperial saturation and its shifting patterns, and has tried to move the debate from the assumptions of ideological hegemony to the range of experiences of people, as the imperialist and imperialistic were consumed or rejected over a wide range of cultural engagements.[164] It could be argued that the surveys were only thinkable because of the all-embracing presence of empire. Yet while one could claim that the surveys constituted a mapping of empire at home, and the recording of monuments in Wales, Scotland, and particularly Ireland certainly did, overt references to empire are remarkable in their absence. While the NPRA and its endeavours were often referred to within an overall imperialist environment and the economic base of the surveys was entangled within the colonial—for instance, the wealth of Manchester, which ultimately enabled the city's survey through patterns of wealth, leisure, and association, was based in massive colonial markets—there was no direct appeal to empire or to overtly imperialist sentiment within the rhetoric of the survey, especially at the local level.

Harrison had proposed a universalising vision for a survey "of the face of the earth," undoubtedly resonant with imperial reach, an ambition to spread survey across the globe and devise "the inauguration and direction of photo-survey work in the British Colonies," including photographs from "British travellers, in unexplored, wild, barren or savage regions of the earth."[165] However, the failure of survey photography to produce a sustained and coherent record compared unfavourably with colonial activities. For instance, adherents of survey asked how it was that a photographic survey, linked to the preservation of monuments, could be organised in India through the Archaeological Survey of India, but not at home, where the need was, if anything, greater.[166] Britain was presented as great, powerful, and historic, but the survey vision was contained locally within the parameters of an island history. In practice, the ways in which the survey and recording desires were experienced by local photographers recording local churches were barely national, never mind imperial. Because there was resistance to the national, there was perhaps likewise more marked resistance to the overtly imperial. While the imperial and the colonial formed the cultural parameters through which history and identity were experienced and constituted through a matrix of time, place, and race, the imperial was not articulated as a core concern of survey photographers, who were almost self-consciously inward looking despite the colonial inflections of so many values that informed their practices.

In many ways, the ideas of English identity that permeated the surveys emerged in relation to other European powers, rather than empire, at least in their overt articulation. This is demonstrated through the values attributed to architecture, especially Norman architecture. What is significant is that these values were articulated in the contexts of photography. G. A. T. Middleton's statement in his manual on architectural photography from 1898 is not without ambiguous colonial resonance: "Their thick walls, massive construction, semicircular arches and flat proportions . . . speak out of the masterful repression by the mailed warrior of a subject people."[167] Likewise, the sense prevailed that English architecture developed into the pure, restrained lines of the perpendicular style rather than suffer the excesses of

the French late gothic flamboyant style that led architecture into "degeneracy and ostentation": "There is always something substantial however in English Architecture, redeeming and often obliterating the defects of even the most luxurious times and rendering in stone the differences of character between the English and the Continental Nations."[168] Such local articulations also became sites of the national for, to quote a paper given at the Royal Architectural Institute, the preservation of churches, such churches as were especially valuable "because their Perpendicular style was predominantly English . . . [and] therefore a matter of national pride."[169]

On the other hand despite these relational identities the England that was defined through the surveys, and particularly through Stone's NPRA photographs of Parliament and coronations, was one of deep antiquity, its hierarchies and order expressed through the material traces of a great yet hybrid island race, with the qualities I have described, order, democracy, and freedom under the law, firmly in place. Yet in this context one could argue that the surveys were indeed a colonial or imperialist enterprise at the metalevel. It is precisely the definition of home that, if one follows Cannadine's *Ornamentalism* argument, was defined for reproduction in the colonies and endowed those colonies in Asia, Africa, and the Pacific with the authority to act as agents of change.[170] Even if the surveys had no proclaimed interest in the colonial as such, what they were defining was profoundly colonial, for they were constructing historical identities and delineating the material traces of identities in relation to the home of empire, and within the context of the magnitude of imperial and colonial reach. The representational tropes of the survey movement were quietly defining the heart of empire and through that

definition, might be read as part of the "dual struggle of defining the national past and preserving this invented past from the contaminations of Empire." Astrid Swensen has argued that the preservation movement more generally was concerned with the preservation of the core for the definition and benefit of empire.[171] Indeed, an awareness of those broader reasons might explain the relative lack of any formal relation between the photographic survey movement, with its sense of intense localism, and the preservation movement.[172]

However, this position does not represent an explicit eliding or suppression of the imperial. Colonial and imperial subjects form an ambiguous presence in the surveys' photographs. Not only did the surveys employ tools such as Ordnance Survey maps and the language of survey itself, which had been honed in colonial environments as forms of rational and ordered knowledge, but colonial subjects resonated through its records.[173] An example is Stone's photographs of visitors to the Houses of Parliament, which are archived in the NPRA. These included photographs of foreign dignitaries who visited the Houses of Parliament, such as those of a delegation from Lesotho (then known as Basutoland) in 1907 who visited the Colonial Office in 1907.[174] The Sultan of Perak, who visited for the Coronation of Edward VII in 1902, was also photographed by Stone.

But while there were different local and national performances of photographs, there was equally a shift of meaning between national and imperial contexts. In the national reading, the portraits of colonial visitors and their captions are stylistically identical with other Parliament pictures, whether of the doorman or Joseph Chamberlain.[175] Also in this category one might place the photographs of Indian and African troops who attended the coronation of

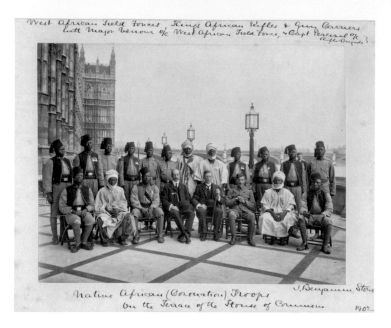

West African Field Forces, Kings African Rifles & Gun Carriers with Major ____ o/c West African Field Force, + Capt Percival o/c ____

Native African (Coronation) Troops On the Terrace of the House of Commons 1902 *J. Benjamin Stone*

66. Soldiers from the West African Field Forces on the Terrace of the House of Commons. Photographed by Sir Benjamin Stone, 1902. NPRA Collection *(photo © Victoria and Albert Museum, London).*

Edward VII, photographs taken at their temporary barracks at Hampton Court. Viewed as a whole collection, rather than individual images, the photographs are about the work of Parliament, in relation to the colonial, rather than about race, hierarchy, or colonial desire as such.[176] (See figures 66 and 67.)

This reading is borne out by the patterns of archiving and dissemination of Stone's famous and overtly racialist images of Batwa people from the Congo, produced in 1905. These photographs show a visiting group of Batwa people on the steps of the House of Commons, infantilized, dressed in sailor suits. A second set of images, showing the Batwa people naked as anthropometric specimens, and photographed in a back yard. Neither of these sets is included in NPRA archive. One cannot be certain of the reasons for their absence, but one can conjecture that with their overt racial connotations, these fall outside that archive's particular shaping of a national narrative.[177] However, the photographs were published in Stone's *Records of National Life and History*. Framed by the rhetoric of this publication, with its stress on

the authority of Parliament and the traditions of English folk practices, they assume overtly imperialist, racialist, and colonialist functions embedded in an exoticising text. Introduced as "strange and notable visitors from far-off lands," the subjects of the photographs are presented as the successful product of colonial policy intersecting with a racial discourse. Of the Sultan of Perak, Stone commented, "Short and frail in stature, of light brown complexion, with the flat features and high cheek bones of the Mongolian races, his mild and contemplative expression suggests the religious ascetic rather than the warrior of a primitive and warlike people."[178]

The imperial and colonial also mark local surveys, often appearing in the form of passing events and curiosities, obliquely informed by the imperial, rather than being overtly imperialist as such. For instance, when Indian troops visited Croydon in 1903 they were photographed for the passing events section of the Surrey survey. Celebrations for the end of the Boer War were photographed for the Nottinghamshire survey, just as the return of troops from the Boer War to Maidstone was photographed for the Kent survey. Most of these photographs were again donations from local commercial photographers who were responding to a general photographic desire in the wider community to record such events.

A further suggestion of imperial resonance is the way survey photography positioned itself in relation to empire, not only in Harrison's imperial vision, which he presented at the Chicago World's Fair, but through the representation of survey at the Festival of Empire in 1911 at the Crystal Palace, itself photographed for the Surrey survey in a series of snapshots by E. N. Pearce. Staged for the coronation of George V, the Festival of Empire featured an all-British

exhibition with displays such as "Old English Fair," and "Tudor Village," and the associated Pageant of Empire saturated in the tropes of Merrie England: Morris dancers (included in Pearce's Surrey photographs), Sir Francis Drake, and so forth. A substantial photographic section, which merged the aesthetics of nation with an implied sociality of photography itself, was anticipated: "All the principle Photographic Societies throughout the Overseas Dominions are also being invited to send collections of pictures, and so there will be presented to the public an opportunity of comparing the relative beauties of the integral parts of our Empire. Also this will make the first occasion when productions of Photographic Societies of the entire Empire will be brought together side by side."[179] Although survey photography did not appear in the official catalogue, there were a number of separate references to its presence—certainly a section of the Photographic Survey of Kent was shown, but exactly what was shown is not known.[180] What is clear is that the original plans for the Festival of Empire included a coherent presence for survey photography within the imperial spectacle, a delineation of England to appeal to visitors from overseas: "An exhibit of photographs from the collections of the respective Photographic Survey and Record Societies would form a feature of great interest, especially to colonial visitors."[181]

The presence, or intended presence, of survey photography at such an imperial extravaganza raises the question of what kind of visibility was accorded to a visualised English past in the colonial domain itself. The photographic surveys assumed the positive inflection of the notion of the primitive within and the material remains of the past, in that they constituted the origins and survivals of valued national character. Yet there appears to have been little, if any,

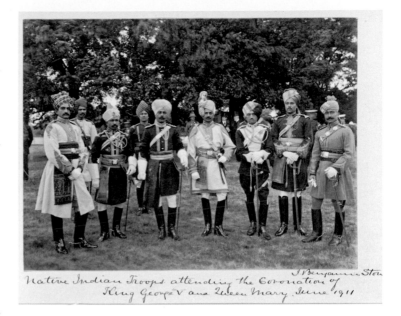

Native Indian Troops attending the Coronation of King George V and Queen Mary. June 1911

J Benjamin Stone

circulation of photographs of English traditions, especially any of an English primitivism, in the projection of English values onto a colonial context. In the first decade of the twentieth century, the Colonial Office Visual Instruction Committee, founded in 1902, prepared a series of lantern-slide lectures to "convey an authoritative picture of Britain to children in the Empire."[182] Under the direction of geographer and educationalist Halford Mackinder, specific variations of this visual narrative were made for each colony and took the form of a visual journey to London, the imperial city, English scenery and "Historic Centres and their Influence on National Life."[183]

The traditions that appear in these colonial projections were aimed at both expatriate colonial British and indigenous colonial populations and stressed the antiquity and traditions of English and British institutions. Reminiscent of the iconographical emphasis of Stone's early donations to the NPRA and parts of his 1901–1902 touring exhibition for the Board of Education, they showed coronations, state openings of Parliament, the traditions of the

67. Indian troops, visiting for the coronation of George V, camped at Hampton Court. Photographed by Sir Benjamin Stone, 1911. NPRA Collection (photo © Victoria and Albert Museum, London).

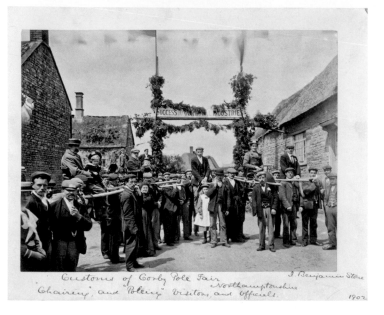

Customs of Corby Pole Fair
Northamptonshire
"Chairing" and "Poling" Visitors, and Officials. J. Benjamin Stone 1902

68. Corby Pole Festival. Photographed by Sir Benjamin Stone. NPRA Collection (*photo © Victoria and Albert Museum, London*).

conscious aesthetic control in structuring specific meanings in the reading of photographs, made survey photographs profoundly inappropriate colonial statements. (See figure 68.)

Therefore to what extent can the surveys be characterised as colonial or imperial discourses? At one level, as David Cannadine argues, the local and international or imperial were part of a complete interactive system, a world "system of modernity."[186] What is striking throughout the discourse of survey from about 1885 up until the Great War is that, with the exceptions I have just quoted, there was an almost total absence of empire in an overtly imperialist form. Britain was, as many commentators have argued, part of a vast interconnected world that stretched from local to general and that included empire but was not necessarily defined through it. One could argue that empire constituted the political unconscious of the surveys — that "absolute horizon of reading and interpretation," to use Frederic Jameson's elegant phrase, that nonetheless constitutes a saturating political discourse.[187] One can argue that everyday imaginings of England moulded imaginings of empire and vice versa, that the NPRA and the survey movement defined the topographies of antiquity and their associated social structures and values, structures and values that were expanded through empire and for empire. If this is imperial, then one could argue that the survey movement had colonial or imperial undercurrents that were not articulated, what Lefebvre describes, in relation to graphic forms, as masking "the will to power and the arbitrariness of power beneath the signs and surfaces which claim to express collective will and collective thought."[188]

Yet what is demonstrated photographically is the ambiguity and unevenness of the impact of

judiciary, the great cathedrals, the glories of Shakespeare, and the patriotic picturesque charm of the market town, the village green, and the rural cottage.[184] It was from these localities that the imperial machinery was peopled. To quote Mackinder's lantern lectures for use in India in 1909, these English places "have reared the generations of men who have spread over the whole world making the Empire."[185] What is equally consistent in all these visual performances of nation is that these images do not reveal the primitive superstitions of, for instance, the Abbots Bromley horn dance, the Hungerford Hocktide, or the Corby Pole fair to the colonial subject, nor do they reveal the presence of poverty, such as was recorded by the Manchester survey. Thus while the primitiveness of the colonial subject could be made visible to both colonialiser and colonialised, unsurprisingly, given the specific agendas of colonial education, the primitive survivals of the colonialisers were not made visible to the colonial subject. The subject matter, the profound localism, and in many cases, the lack of self-

imperial discourses even in a period of intense and high-profile imperial expression—the rapid expansion of the colonial domain both in and beyond Africa, the Siege of Khartoum, the Boer War, the Younghusband expedition in Tibet (photographs of which were widely discussed), and celebrated in pageants, festivals of empire, coronations, funerals, jubilees, and durbars. The equation of nation with national culture initiated an intensification in the character and power of representations. Yet the rhetoric of the photographic survey movement was in many ways a retreat from that position. The surveys were effectively inward looking, either to be performed through the local liberal institutions of social progress, or in the case of Stone and the NPRA, through conservative political, intellectual, and photographic practices that were concerned with a contained vision of national consolidation. There is little sense that the English past was being defined in relation to the history of a great imperial nation, but rather a sense in which "inside Great Britain lurked Little England," as was represented in the history of the gentle, everyday experience of everyday people defined through the histories written into the church, manor house, and cottage in the landscape and local experiences of modernity.[189] With the survey movement's discourse of the future, rather than simply an empty nostalgic past, it is almost as if the photographs were being used to define a self despite empire. One of the reasons for the failure of the NPRA was that it tried to move the visual inscription of this "everyday past," which was perceived by those engaged with it as profoundly local and involved with local identities, onto a national, and thus an imperialist, stage. But the impetus remained local. The imperialist society of spectacle may have offered people moments

of a differently figured identity, but it was one they could engage with without sacrificing the localised sense of being English. What the survey photographs reveal to us is that spectacle of the local.

Thinking through photography as a self-conscious desire for the historical past to work for the future allows us to see questions of identity not simply as an ideology entangled and produced through hegemonic values of nation but as a *practice* that complicates that position.[190] This approach reveals multilayered and expansive possibilities for a history of locality that is not merely symbolic but is actually used as photographs perform a range of functions in the fostering of historical sensibility.

The photographs donated from the provinces to the NPRA may have been absorbed into an aspiring and coherent vision of the national through Stone's rhetoric and the material deposits in the British Museum. However, photographs, along with the discourses that embed them and which they themselves generate, can be used to gauge the uses of the past in the construction of ideas of locale. This is significant because while the concept of survey was one of totalisation and universal legibility, the close-up view of the practices and experiences of these loosely cohering groups around the photographic survey movement points to greater complexity.

Not only is the content of the photographs significant, but how survey photographs and their embedding rhetorics and archival management, despite their aspirations to objectivity, created a subjective map that linked people and place is significant as well. The rhetoric of the survey movement also demonstrates how photography and its constitutive powers operated

69. Survey as war memorial, 1918–19.

69a. Lance Corporal William Aldis (9th Norfolks). Photographic Survey of Norwich and Norfolk *(courtesy of Norfolk County Council Library and Information Service).*

69b. Private William Ludkin (1st Norfolks). Photographic Survey of Norwich and Norfolk *(courtesy of Norfolk County Council Library and Information Service).*

within the relationships between past, present, and future, between local memory and grand narrative. This rhetoric also functions in a space where engagement with the values of the past was not necessarily merely a retreat from the modern but also an engagement that aimed to foster a better future that would cohere identities and localities within the national. John Langton has observed that ideas of localism, regionalism, and nation do not provide an answer to the problem but complicate it with other dimensions.[191] This is certainly so in relation to survey photography. Centralized views promulgated by Sir Benjamin Stone and the canonical, or alternatively hegemonic, views of his subsequent commentators have failed to account for the tense and complex relations between the local and the national and the way

in which survey photography operated in this space. It was a sense of the local that drove the historical and preservationist concerns of photographers as amateurs who harnessed their energies and invested their time and their money in survey activities. While inflected with a sense of loss and disappearance a sense of the future was felt at the local level through what people actually saw around them and translated into photographs. The ideological dimension of images spread through a fractured visual field that complicated the dynamics of production and the legibility of the archive. This is not to deny the ideological significance of images in the larger picture, but to point to the complex negotiation of image, value, and meaning between the local and the national and the imperial, in which many different and diverse

69c. Private George Colman (9th and 10th Norfolks). Photographic Survey of Norwich and Norfolk *(courtesy of Norfolk County Council Library and Information Service).*

69d. Private William Grace (5th Norfolks). Photographic Survey of Norwich and Norfolk *(courtesy of Norfolk County Council Library and Information Service).*

localities were constitutive of nation. Photography gave the local and the national both a specificity and a generality within these complexities.

The apotheosis of a local working out of the national, and the functions of locality, memory, and identity, was perhaps at work in Norwich in 1918, when the photographic survey was transformed into a war memorial.[192] (See figures 69 a–d.) In arguments that were a further atomisation of the local, there was resistance to the memorialisation of the war fallen in the cathedral and in the county city of Norwich alone.[193] The desired memorialising of the grand narrative of war, and of sacrifice for the national good, was for memorialisation at the village level — the soil from which the fallen had come. A regional expression emerged instead as a collection of photographs of the fallen as part of the "Roll of Honour" donated by the bereaved to the photographic survey under the auspices of the City Library. Each photograph is labelled "Photographic Survey of Norwich and Norfolk," on the standard forms, in the same way as are other relics of the past, to be projected into a collective future.

70. The ruined church at Ibberton. Photographed by Thomas Perkins, c. 1896.
Photographic Survey of Dorset *(courtesy of Dorset County Museum)*.

In launching the Dorset survey in 1896, Reverend Thomas Perkins summarized the values of the survey movement. As a member of the Society for the Protection of Ancient Buildings, which had been founded by William Morris and his supporters in 1878, he was acutely sensitive to the patterns of loss of the material traces of the past: "If we cannot check the current that will soon destroy all the valuable work of past ages yet remaining to us, we may at any rate endeavour to secure some record, accurate and permanent, of what these things were like before the touch of the destroyer came upon them. This can be best done by photography."[1]

Despite the active engagement with modernity and the present that marked the photographic surveys, at least in part, the survey movement's dominant temporal impetus, that of disappearance and loss, cannot be ignored. Questions of record, as a counter to such fragility and destruction, were therefore entangled with more overt discourses of preservation. (See figure 70.) Within concerns about loss and disappearance the local merges with national narratives, as local loss stands for the diminution of national textures of the past. It is in the context of this cultural dynamic that the practices of survey align themselves most clearly with dominant narratives. Ideas of disappearance and loss saturate the discourse and rhetoric of the movement, legitimating and valourising its representational and archival practices by presenting amateur photographers with the morally inflected imperative to record "before it is too late." A number of surveys are documented as emerging not simply from an unfocused

"Doomed and Threatened"

Photography, Disappearance, and Survival

sense of loss, but precisely in response to demonstrable disappearance and fragility. For example, the Norfolk survey was established in part as a response to the destructive flooding in the city of Norwich in 1912. The Richmond survey commenced when the local librarian "saw an historic old house being pulled down without any photograph ever having been taken of it for the eyes of future generations," and the Manchester survey was triggered by "the gradual demolition of some fine old houses named Gibralter."[2] In the same spirit, the Warwickshire survey called for "procuring records of fast-disappearing Midlands scenes" and Yorkshire photographers were reminded that "old Leeds is fast disappearing."[3]

However, it is necessary to consider the practices that cluster around ideas of disappearance, because it is through the rhetoric of loss that tensions in ways of seeing, the foundations of visual response and entropic anxieties, become most clearly articulated in the photographs themselves. The *British Journal of Photography* noted two key strands of survey photography, "buildings of historical interest and ancient customs in their necessarily modern survival."[4] Photographs were created to address loss and the entropic over three interrelated sites of the visible past—the parish church, the village, and the "folk custom." These sites can be understood in terms of complex intersections of poetics, salvage, and science. Picturesque historiography had been challenged by scientific modes in the course of the nineteenth century, and the methodologies of the survey movement and its production of photographs oscillated between historical imagination and the powerful facticity and inscriptive qualities of photographs. It is here that the aesthetics of disappearance, which echoed the tropes of romanticism, intersected and combined with those of science.[5] As

the public profile of photographic survey became more active and widely disseminated during the late nineteenth century and the early twentieth, there was a commensurate increase in the emphasis both on the vandalism perpetrated on old buildings, and on their rescue and salvage. This emphasis was articulated in the photographic press and in the language of photography more generally. The linked ideas of survey and salvage crept into more articles as photographers were urged to hurry to record.

Writing on photography has consistently emphasised the relation between photography and the presence of death. This is exemplified in Barthes's well-known statement, "Ultimately what I am seeing in the photograph taken of me . . . is Death. Death is the *eidos* of [the] photograph."[6] In his argument sense of loss, disappearance, and death is articulated through the inherent and insistent qualities of photographs, those of the surface tracing and fragmentation. It has become almost a commonplace to define photography's symbiotic relationship with modernity in terms of loss and death, and to attribute that relationship to anxieties due to rapid change, dislocation, and fragmentation.[7]

Yet while these strands of fragility, disappearance, and anxiety were powerful presences, survey photography cannot be reduced to them. Anxiety here should not be simply or exclusively equated with worry, nor does it necessarily carry connotations of a depressive or pessimistic outlook. Anxiety, in this context, involves a sense of loss that produces psychical energies, activating dynamic courses of action that remain, nonetheless, informed by the values of disappearance and loss. Nostalgia, in the context of survey photography, is therefore far from a "trivialising, romantic sensibility" that produces "an isolate and consumable instant of time" disconnected from the present.

Rather, it is an affective and sensory relation of past material to the present, through the performative, dynamic, and integrated forms of transformative potential.[8] Survey advocates hoped to excite that transformative power of historical imagination in survey archives. Consequently, the past was represented through a series of present activities and practices in spaces that were marked with the past; that is, in living, active spaces of perceived continuity and the transmission of values. As *The Camera as Historian* commented: "Photographic survey work is by no means merely concerned with the somewhat melancholic task . . . of recording scenes and objects of beauty and interest which have vanished or are vanishing; records of existing things are themselves undoubtedly a factor of no small importance in the preservation of that which is pictured for us in the camera."[9] This statement typifies the ambiguous relationship the surveys had with the way in which they constructed the past. While there were rhetorical appeals to exaggerated nostalgic discontinuities with the idealised past, the photographs served not only as a reminder of how things "were," but of how things "are"— that is, they were a record of the vital present.

This dynamic relation between past and present was generated in a culture whose self-image was undergoing a critical process of re-definition, a culture for which an apprehension of the past was central. It was that historical desire, poised between discovery and recovery, that produced the tensions and ambiguities in which a sense of loss was coupled with a dynamic view of the potential of photographs to at least partially counter that loss. An interplay between love and loss, disappearance and visibility, melancholia and hope, drove the survey movement.[10] This discourse reveals the complex weaving of commonplace temporal categories of past, present, and future that were applied through photography to an historical topography, both real and imagined. Time inflects all aspects of the surveys. It defined the subject matter itself, the sense of urgency, the sense of disappearance and loss, and the anticipation of change as time rolled across the landscape at an ever increasing rate, whether across buildings, communications, agriculture, trade, or cultural practices.[11]

The late nineteenth century was a period in which time became both palpable and a source of entropic anxiety in new ways. The forms and rhythms of disappearance shifted. In Pierre Nora's words, there was "that sense that memory [had] been torn."[12] Time informed concepts of evolution and progress, of modernity and disappearance, and, of course, of the excavated past, revealed in layers in the landscape. Time also informed the experience of the present and anticipation of the future. Indeed, change itself defines the potential of continuity as "change can be visualized as a sequence of events that 'happens' to something that otherwise retains its identity . . . continuity makes change evident"—change and continuity are contingent upon the other to demonstrate their effects.[13]

The concept of photography was shaped in relation to time. Photographs made in the present could be conceived of as being "of" the past in a self-conscious temporal slippage between observation and the consumption of the image. Indeed, through the insistence of the photographic trace, the photograph rematerialized time itself as it contributed to a sense of "closeness" to the past, bringing its trace into every middle class drawing room, school room, and illustrated book.[14] This massing of temporal signifiers was manifested not only in the control of photographic fragments of time but in the way in which photographic subject

matter signified time. This massing merged the temporal interjections of photography with cultural perceptions of deep time, whether through languages, customs, natural history, levels of civilization, physical, consciousness or unconsciousness—almost all of which could be excavated by the camera. Consequently, there was an overriding concern with time as photographers self-consciously engaged with the layered temporalities of survey practice and the photographic rendering of a history visualized through a densely temporalised concept of place.

The sites of parish church, village, and folk custom were archetypes of collective imaginings that were entangled in two related temporal dynamics, those of disappearance and survival. These two tropes simultaneously constituted a past locatable in the present, and were intertwined with questions of identity, record, and sentiment. These sites, as localised intensities of the mythscape, function as Bakhtinian "chronotopes," in that they are constituted through the interconnectedness of temporal and spatial relationships forged into a concerted whole. Chronotopes are places where "time becomes, in effect, palpable and visible," making narrative events, or even human experience, concrete and "the place where knots of narrative are tied and untied."[15] Bakhtin describes a dialogical relationship outside representation itself, in which authors, performances, and users are entangled, a relationship in which historical density is concentrated and condensed in selected "scenes," condensed in the stones of church, in the space of the village, or in the practices of an ancient craft.

These sites of concentration of imagination and topography share a common sense of the historical, the relic, and survival that patterns the archive, with its preponderance of photographs of parish churches and villages (from manor houses to cottages) and ancient folk customs and "ethnographic" subjects. Folk customs, in particular, remained a key chronotopic site for survey photography because of the enormous force of "ancient custom" in the historical imagination. In this patterning of the archive there was a folding together of the historical environment of ancient buildings and landscapes and their photographic inscriptions as photographs themselves stood for the chronotopic. Indeed, the whole concept of the photographic survey archive was dependent on such a relationship. Photographic records thus enabled not merely the Barthesian slippage between the "there-then and the here-now," but the conceptualisation of a layered and folded time, as conceptualised by Michel Serres, itself inseparable from space.[16] In this context layered time was not necessarily linearly constituted, but constructs a narrative of the past that brings together distant points of space and time, while simultaneously dispersing others. The acts of photographing and archiving become, in this model, endless "regatherings" shaping complex and ambiguous histories.[17]

SALVAGE ETHNOGRAPHY AND COLLECTING THE PAST

The driving force for amateur photographers was a sense of urgency, to record "before it is too late." As a contributor to *Amateur Photographer* commented in 1907, "it should be recognised almost as a duty by all those who possess a camera to obtain when the opportunity offers records of subjects that in a short while will inevitably disappear."[18] The camera, with its mechanical inscription and clear descriptive qualities, was seen as the salvage tool par excellence, literally a backstop against disappearance. The

camera was an "unrivalled means of record-ing things of interest and value to the histo-rian and the archaeologist, and therefore to all those who take interest in the story of human life and progress [photography] is becoming more apparent every day."[19] However, behind this simple technological statement, a series of ideas informed a range of popular assumptions around ideas of change, modernity, and disap-pearance, and informed the tensions between historical topography and mechanised progress that addressed the moral as much as the scien-tific.

Progressivist ideas, and their obverse dis-appearance, had been fully and variously ar-ticulated within nineteenth-century science, notably in biology, anthropology, and archae-ology. These theories were not, however, con-fined to these emerging disciplinary spaces. By the late nineteenth century, progressivist ideas, premised on the concept of a cultural evolution from the primitive and the savage to the civil-ised, were well established, permeating ideas not only of folklore and custom, but of the every-day experience of change. Darwinian theories of evolution were the most widely known. In the popular domain, such ideas were deeply embedded in social and cultural consciousness, and informed commonplaces about the past, about origins and identities over a wide social range. They also became the rubric through which a range of broadly evolutionary ideas, such as Herbert Spencer's social evolutionism, became bracketed. By the late nineteenth cen-tury, such ideas had been fully integrated into historical thinking in general and manifested themselves in progressivist thought in relation to the experience of the present.[20]

The period saw a massive expansion of the discussion of scientific ideas in a plethora of journals.[21] Contemporary debates in the disci-plines concerned with accounts of cultural ori-gins — archaeology, anthropology, and folk-lore — were widely circulated. Not only did many local papers have columns and features that described local history, often under the guise of "Notes and Queries" or "Bygones" columns, and carry reports of the meetings of local clubs and societies, both antiquarian and photographic. Newspapers and magazines also circulated the debates of metropolitan science, whether in the reporting of new publications or public lectures by eminent scientists. For in-stance, while notice of the methods and objec-tives of the BAAS Ethnographic Survey of the British Isles appeared in the *The Times*, *Nature*, *Athenaeum*, and *Daily Graphic*, they were cir-culated more widely as meeting reports, digests, and snippets of interesting information.[22] Like-wise, meetings of the Anthropological Insti-tute were reported in the daily press and were often picked up to be syndicated in the regional press because anthropology, with its reach into human and cultural origins and colonial appli-cation, was viewed as one of the key sciences of the day.

These broad evolutionary, or progressivist and developmental, models resonated through the interpretation of the historical environ-ment as it was experienced by amateur photog-raphers and as it formed a partially articulated legitimation for their practices. For instance, G. A. T. Middleton, addressing the Camera Club in London, argued an evolutionary model of architectural history from Stonehenge on, a model advocating "a study of the buildings in which people lived, or which they reared for other purposes." Middleton claimed, "We are thus able [with such a study] to trace the inner life of a nation better than we can by other means."[23] Stone used an evolutionary model to explain the development of the tomb chests

found in many country churchyards — much photographed by survey photographers, such as Stone himself and George Henton, for the Leicestershire survey — from the prehistoric cromlech.[24] Likewise, the "ethnological," in its salvage dimension, was a clearly articulated concept informing the surveys. In establishing the Warwickshire survey in 1889, photographers were reminded specifically to address subjects of "archaeological, ethnological and scientific interest," subjects that "told a tale which was necessary to build up the chain of history." Photographers were instructed to "despise nothing because of its familiarity. Get it by all means and store it away."[25] Thus *Amateur Photographer* recommended, "Ethnological subjects should have special attention, such as dress, occupations, amusements, local customs, or celebrations. In particular, records should also be secured of such customs as are in a state of transition, as for instance, the use of the flail, plough, churn etc., which may at any time be changed by the introduction of machinery."[26]

Although there was limited, if any, formal or structural connection between the learned societies of cultural description and the photographic surveys, there was nonetheless an overlap in their material domains. Different groups had investments in certain kinds of objects and, through the transactional network of different domains of science, shared, at a basic level, the theoretical domains through which assumptions and actions were shaped. Of particular significance, and a point of reference continually alluded to within photographic survey, was the BAAS ethnographic survey of the United Kingdom.[27] Following a suggestion by Dublin- and Cambridge-based anthropologist A. C. Haddon, Edward Brabrook representing the Anthropological Institute launched the project at the BAAS Edinburgh meeting of 1892 where

he read a paper entitled, "On the Organisation of Local Anthropological Research."[28] The survey's object was to "obtain authentic information relative to the population of the British Islands, with a view to determine as far as possible the racial elements of which it is composed . . . a satisfactory solution of the problems involved will mean the re-writing of much of our early history."[29] Despite a stress on physical anthropology, the survey's brief, which included photography, was much wider, embracing, for instance, folk practices, dialect language, prehistoric remains, and of course the material remains that were the focus for photographers.[30]

These points of connections and influences were found through the survey movement. Not only did scientific ideas become absorbed and refigured as a legitimating practice. There were clear transactional links and very real ways in which the anthropological concepts of disappearance and salvage and their practices intersected with those of amateur photography. In setting up the Yorkshire Photographic Survey, for example, Leeds Photographic Society wrote not only to the secretary of the NPRA, George Scamell, but to Francis Galton, of the BAAS-ethnographic survey, seeking advice.[31] Edward Beloe, inaugurating the North Norfolk survey, suggested that the survey "could be run on the lines suggested in the report of . . . the Ethnographical Survey of the United Kingdom," while the founders of the Oxfordshire survey based their schedule firmly on both the BAAS project and the Anthropological Institute, suggesting that a duplicate set of photographs of "ethnological subjects," which were to include, customs, costumes, amusements, and celebrations, be deposited in the institute.[32] Likewise, *Photogram* recommend that photographers support the "photographic side" of the district and subject ethnographic surveys of the BAAS.[33]

The influence of the BAAS ethnographic survey desiderata is mirrored in the kinds of subject matter, from ancient churches to agricultural clothing, to which the attention of photographers was directed. The subject matter of the Cambridge survey was being developed by Haddon himself (see the appendix). The input of anthropology was therefore clearly seen as important. Even if it was only partially understood or crudely applied, anthropology was not merely a label. This fluid connection was never better demonstrated by the fact that the Melanesian missionary Reverend James Lawrie won a competition for survey photographs in *Practical Photographer* with a series of photographs of everyday life, not of Britain, but of New Hebrides (now Vanuatu).[34]

The moral duty, urgency, and exhortation to energized engagement that characterised the survey movement was also found in anthropology. Haddon's comment that "the most interesting materials for study are becoming lost to us, not only by their disappearance, but by the apathy of those who should delight in recording them before they have become lost to sight and memory,"[35] is directly comparable with the ethos of the survey movement. This is well demonstrated in Haddon's comment on western Melanesia in the pages of *Nature* in 1897. He stated that those interested in anthropology had a "bounden duty to record the physical characteristics, the handicrafts, the psychology, ceremonial observances and religious beliefs of vanishing peoples, this is also a work which in many cases can alone be accomplished by the present generation . . . The history of these things once gone can never be recovered."[36] Even if the English were not in danger of "vanishing" physically, the traces of the past that defined their identity were understood as endangered.

This broad view, articulated in different ways with different intensities, informs a wide range of salvage agendas in the late nineteenth century and the early twentieth. Although one cannot, of course, be certain of the extent to which individual photographers were, or were not, aware of these theories, what is clear is the correlation between science, especially ethnography and anthropology, its poetic translation as salvage and preservation, and the values of the photographic survey and related movements such as architectural preservation. This broad currency of ideas is patterned by shared epistemological assumptions around temporalities of salvage and preservation. There was a sense of urgency: "The matter is one that will not brook any undue delay . . . as the evidence is slipping out of our grasp."[37] This sense of disappearance reflected an "irrevocable break of peasant culture, that quintessential repository of collective memory."[38]

As folklorist E. Sidney Hartland said, rather poetically, in a lecture that linked the BAAS ethnographic survey directly to photographic survey, namely that of Warwickshire:

> Scattered up and down the country . . . there are hamlets and retired places where the population has remained stationary, and affected but little by the currents that have obliterated their neighbours' landmarks. To such districts as these it is proposed to direct attention. Where families have dwelt in the same village from father to son as far back as their ancestry can be traced, where the modes of life have diverged the least from those ancient days, where pastoral and agricultural occupations have been the mainstay of scanty folk from time immemorial, where custom and prejudice and superstition have held men bound in chains which

71. "Market at the corner of Swan Street and Rochdale Road," Manchester. Photographed by Samuel Coulthurst, c. 1894. Photographic Survey of Manchester and Salford *(courtesy of the Manchester Room at City Library, Local Studies)*.

all the restlessness of the nineteenth century has not yet completely severed, there we hope still to find sure traces of the past.[39]

What links these transactions is a sense of fragility and loss. As the Surrey survey stated: "It is only with co-operation in many instances that interesting occurrences can be recorded, which otherwise would disappear from sight, and in a few months be forgotten."[40] A speech made at the inauguration of the photographic survey of Essex lamented, "Old country features are being so rapidly swept away . . . that unless they are now recorded in photographs the memory of them will soon entirely disappear."[41] C. J. Fowler, writing in the *British Journal of Photography*, clearly relates loss and disappearance to anthropological desire on the one hand and so-

cial change on the other in ways that echo Hartland: "Greater attention should be paid to the manners and customs of the people, especially in villages and country towns. School boards and parish councils are rapidly revolutionising the quaint habits and occupations of rural populations, and unless the opportunity of portraying them is quickly seized, it will be lost for ever."[42]

The salvage agendas of the photographic surveys could also be read as an attempted excavation beneath the surface of the modern in order to visualise and preserve the productive roots of English history and identity. Photographs performed a reification of "tradition" in a consumable form, standing for "a dimension of historical depth, representing . . . the outcome of long historical formations which can be re-

constructed."[43] This implied that underneath the visible in the photographs was a series of vital "causal-functional, genetic [and] symbolic connections which constituted this salvageable past."[44] Consequently, underlying the rhetoric of the scientific that informed survey projects at every level was a claim to the very roots of identity. For at the core of the salvage rhetorics of the survey movement was the ambiguous way in which photographs made claims both on the possibility of scientific knowledge and on the affective. James Clifford has termed this complex interplay the "ethnographic pastoral," in which the deep-rooted cultural "primitivism" of the idealised, unbroken community and the root of traditional values are articulated and rationalised through photography and salvage.[45]

Christopher Pinney has noted two related paradigms in connection to photography under the general rubric of "salvage," both of which are temporally inflected.[46] First is the "detective paradigm." This assumes a continuing social vitality. It is premised on a representation of the past through a series of present activities and practices, yet one that must, driven by a curatorial desire for preservation, be recorded for the future. Second, the "salvage paradigm" assumes a fragility and ultimate disappearance. It is associated with urgency and capture. Both forms engage with an historical imagination and can be seen within survey photography. For instance, Samuel Coulthurst's photographs of everyday scenes in Manchester streets, made for the Manchester Amateur Photographic Society's survey,[47] might be understood as a 'detective paradigm' addressing a vitality that would be of future interest. (See figure 71.)

Conversely, the more direct sense of the disappearance of the "salvage" paradigm informed the photograph of the parish clerk of Burton Joyce working at his knitting frame, a photo-

72. Parish Clerk and Framework Knitter. Photographed by Lancelot Allen. Photographic Survey of Nottinghamshire *(courtesy of Nottinghamshire Archives, DD/1915/1/126).*

graph made for the Nottinghamshire survey by Lancelot Allen.[48] The photograph's unusual nature, in the context of the overall pattern of survey photography, suggests a conscious sense of urgency, for it marks the disintegration and thus the disappearance of a socioeconomic structure of the protoindustrial textile industry that stood for the region, its local topography, and its identity. (See figure 72.) The two axes of "detective" and "salvage" can be found resonating off each other through the discourse of the surveys, potently mixed with the tensions of aesthetics and entropy. Survey photographers not only demonstrated a strong sense of the present "by recording passing events and by preserving aspects of things as they are" but a sense of fragility and transience, a sense of the "successive generations of mankind [that] pass away" that Harrison lamented in his initial call for photographic survey.[49]

73. Gateway, Eltham Palace, Photographed by E. W. Andrew, 1908. Photographic Survey of Kent *(courtesy of Maidstone Museum and Bentlif Art Gallery).*

the past that were imbued with fragility as old fabrics crumbled and were replaced by the restorers' modern machine-cut stone. The recognition of "cultural and historical value" is both complex and ambiguous in this context. That value is given its clearest articulation in photographs of ruins, where a temporally inflected imagination fills the space with meaning and significance. Survey collections abound with examples: photographs of the ruined abbeys of Yorkshire, of the great late medieval palace at Eltham, or of the demolition of Belle Vue Gaol (Manchester). (See figure 73.)

These photographs create, it can be argued, fertile allegories and metaphors for the past; they create the past's relation with the present for fear of forgetfulness and the entropic dissipation of historical topography.[51] However, whatever the traces of actual disappearance, the temporal dynamics of photographs played into the aspect of salvage that Clifford has described as a "relentless placement of others in a present-becoming past."[52] This would seem to accord with Robert Colls's claim that survivals that were the focus of salvage were not only "behind the times" but also "out of the way," in the elsewhere of modernity.[53] Complex ambiguities of time and space are found to be at the heart of survey photography as it sought to negotiate the backstop against the romantics of cultural disappearance while at the same time claiming a scientific authority and dynamic future for survey photographs.

CULTURAL SURVIVAL AND CULTURAL ORIGINS

The concept of cultural survival that informed the survey movement was articulated, in particular, by the anthropologist E. B. Tylor in his

The incipient historical and cultural values of the detective paradigm were perhaps most strongly articulated through photographs of the built environment, for instance in photographs of churches and market crosses still in use but also carrying meaningful traces of past experience. As Hippolyte Jean Blanc, writing in the *British Journal of Photography* in 1897 stated, one could "learn more from architecture of the people of bygone centuries than written texts can tell."[50] It was these telling traces of

influential book *Primitive Culture* (1871). His book laid down the model for his later work, including his popular and widely read *Anthropology* (1881), which was published for a general audience in the Macmillan's Manuals for Students series (significantly the same series that published Balfour Stewart's *Lessons in Elementary Practical Physics*, which included the basics of entropic theory).[54] Inflected with Darwinian ideas, Tylor's works, with their inclusive and comparative method, shaped ideas of disappearance and, especially, survival, into coherent scientific concepts of cultural evolution and survival. Tylor argued that the cultures of advanced peoples, or indeed of any people, contained within them survivals from earlier stages of cultural development and that these survived as customs, rituals, and festivals that had no apparent purpose, but that nonetheless were rigorously adhered to: "Looking closely into the thoughts, arts and habits of any nation, the student finds everywhere the remains of older states of things of which they [contemporary practices] arose."[55] The ideas clustered around survival therefore offered a unifying strategy to account for the perplexing irregularities of "levels" within cultures.

Tylor's model of relics of past practices surviving in contemporary societies was not necessarily new. Ideas of cultural evolution and survival had been in circulation for some time. They resonated through the work of eighteenth-century and early nineteenth-century antiquaries such as that of John Brand, author of *Observations on Popular Antiquities* (1777), which, published in an enlarged popular edition in 1849, surveyed northern customs as relics of another age. Likewise, local clergymen and antiquarians, with whom the photographic survey movement shared a broad history and

objective, had collected local histories, ballads, dialect speech, archaeology, folklore, material culture, and so forth, as remnants of a past age. Similarly romantic writers such as Wordsworth, Coleridge and, particularly, Sir Walter Scott, with his romantic medievalism, idealised the "folk" as the historical remains of the nation.[56] While these antiquarian tropes were a strong formative strand in the popular historical imagination and in photography, Tylor's contribution, and those of his colleagues and followers, was to mould ideas of survival into a coherent, scientific theory of culture.

While Tylor's popular output was limited before *Anthropology* (1881), his ideas and those of his scientific colleagues were covered extensively over a range of journals and magazines with accessibility and clarity.[57] The historian and folklorist Andrew Lang commented of Tylor: "His admirable chapter on 'Survival of Culture' is so attractive, so pellucid, that an intelligent child could read it with pleasure, and become a folklorist unawares."[58] Tylor restated his theory in the widely available ninth edition of *Encyclopaedia Britannica*: the "Process of 'survival in culture' has caused the preservation in each stage of society of phenomena belonging to an earlier period, but kept up by force of custom into the later, thus supplying evidence of the modern condition being derived from the ancient."[59] The key elements of Tylor's ideas found fertile ground in the popular historical imagination and the sense of survival that permeated every level of survey activity. His ideas offered not only a narrative of origin but an inclusive model of scientific validity, over a wide range of subjects, that appealed to the scientific apparatus of the amateur photographers engaged in survey work. In a way similar to the absorption of the concept of entropy,

even if those involved with the surveys had not read Darwin or Tylor, their ideas, given shape and expanded globally and imperially, were, in Colls's word, "everywhere" by the end of the nineteenth century.[60]

These ideas were widely applied in folklore studies and in the popular domain, as well, especially by eminent folklorist George Laurence Gomme, who, as chief clerk of London County Council was instrumental in the photographic recording of London. He argued, "There has grown up of late years a subject of enquiry—first antiquarian merely, and now scientific, into the peasant and local elements of modern culture," that posited a "scientific conception of the development of nation or people among whom survivals exist."[61] Again, one sees these ideas resonating through the objectives of the photographic surveys. For instance, it is evident in the urgent desire of the committee of the Surrey survey to acquire "photographs of survivals of old May Day customs . . . and any other survivals of old customs, the individuals taking part in them, and the paraphernalia incidental thereto."[62]

The sense of fragility and imminent disappearance within modernity cast the subjects of survey photographs as survivals of an earlier social configuration, survivals that were marked either in the mind through archaic practices, or on the landscape and built environment. It was a history vested in belief, customary observance, and ancient sites that gave rise to a history that broadened the base of historical imagination. In the words of Gomme, belief and observance "point to some fact of history of the people which has escaped the notice of the historian." Thus the folk customs and ancient sites of England represented a form of folk memory, the attributes of "native uncivilisation" that constituted "immemorial custom

sanctioned by unbroken succession."[63] They also carried moral and political lessons: "By a study of these survivals of early appliances and persistencies of ancient customs, we may throw much light upon the points which are obscure in the archaeological and historical record . . . [and] reconstruct to a great extent the ancient conditions of human life and industry, by not distaining to learn from the primitive survivals in modern times the lesson which they have to teach us."[64]

In this context, one can see clear links, for instance, between Tylor's concerns with the origin of government and the concepts of survival in the national discourse informing Stone's series of photographs of the workings of Parliament and the institutional structures of power and sovereignty.[65] Tylor specifically drew attention, for instance, to "the history of parliamentary government [that] begins with the old-world councils of the chiefs and tumultuous assemblies of the whole people."[66] The photographs of the Tynwald gathering on the Isle of Man, and the various photographs of the Houses of Parliament by Stone can be seen in this context. These photographs celebrated the apparent continuance of practices of government from the deep past and were statements of authority and legitimacy regarding the modern nation-state, both domestic and imperial.[67] Consequently, within the overall body of photographs produced for the surveys, photographs of the opening of Parliament and the traditions of the judiciary taken by Stone and donated to the NPRA collection could be read in terms of equivalence with those photographs of folk customs as belonging to a coherent matrix of longevity and survival.

However, there were important differences in the dynamics of survival as the concept informed the survey movement. To Tylor and his

colleagues, the project of anthropology was the great liberal reforming science, a science that identified and purged cultural survival as a force that restrained civilization and thus progress.[68] In contrast to the Tylorian view of survivals as volcanoes ready to erupt and destabilise under the smooth veneer of civilised culture, in the discourse of the survey movement, especially in Stone's rhetoric, survivals of customs and cultural practices were seen as intrinsic to the vital continuance of people and culture. While this had hierarchical implications for the primitive rural, as opposed to the civilised urban, the primitive rural was nonetheless positively cast as the root of identity and historical authenticity. Historical authenticity opened the space for a "romantic" reading of survivals, survivals that, divested of the sense of the raw and threatening primitive, were invested with a strong sense of origin within the discourse of development and progress. Thus entangled with aesthetic tensions photographic recording was characterized by a slippage between the concept of the positive, even a celebratory romantic, in the rendering of "folk" and landscape, which could be simultaneously pictorially celebrated through photography and that which was made visible and objectively known through photography.

The anthropological concepts of salvage and survival therefore shaped the conceptual framework of the surveys and its sense of evolutionary inevitability. Yet this position was temporally ambiguous, for while privileging historical depth and the value of the ancient, folk practices, in particular, were also seen as doomed through the march of modernity and evolutionary inevitability. The *British Journal of Photography* lamented "the disappearance of buildings, customs, and people which must inevitably disappear in the process of time."[69]

While one cannot be certain that these sentiments were directly linked to Tylor in any causal sense, the tentacles of his ideas resonate through their discussions and their aspirations. The close aspirational relations between the surveys and popular science, with its concern for human origins, its theorising of cultural evolution and survival, and its methodological trope of "salvage ethnography," meant that anthropology constituted an important intellectual orientation for the photographic survey, even if that orientation was not necessarily recognised by all participants.[70]

What is significant is the extent and regularity with which these ideas and sentiments were played out within photography and in the photographic press, as were explicit notions of disappearance, salvage, and survival as photographers were urged to record "quaint old customs which linger on in rural haunts to link the present with a former age."[71] These concerns, balanced between the pictorialist historical aesthetic and objective science, became more marked and inflected with greater moral urgency during the 1890s and 1900s. There was a steady stream of articles on photographing the "quaint" or "bygones," on photographic "jaunts" and pictorial competitions that framed the activities of amateur photographers. The persistent rhetoric of disappearance, specifically related to survey activities pervaded the photographic press. For instance, *Photogram*, a monthly magazine, ran a column entitled "Doomed and Threatened," which listed ancient buildings in danger of demolition or restoration. A "Photographic Survey and Record Notes" column ran in *Amateur Photographer* every week between 1902 and 1908. This column presented readers' photographs and antiquarian notes on ancient survivals from churchyard yew trees to village whipping posts. It was

headed every week by an engraving of an ancient sundial, marking the inevitable passage of time, setting up both the "historical value" and "age-value" of the pages' content. The pages of *Amateur Photographer* were also littered with references to the disappearing historical topography, especially of major cities, building up a cogent rhetoric of disappearance. For instance, giving a clear sense of the way association and the relation between people and buildings marked historical topography, *Amateur Photographer* reported in August 1898: "Owing to the craze, or perchance the necessity, for rebuilding, many houses in London interesting for their associations are being demolished. Some very old houses in Baynes Street, Coldbath Fields, have just been pulled down. They were built as far back as 1737. Grimaldi, the prince of jesters, at the time lived in Baynes Street. . . . Now Ridler's Hotel in Holborn, formerly the Bell and Crown Inn, is coming down.[72]

The values, oscillations, and ambiguities of photographic practice itself were entangled with those of salvage and survival. On the one hand, the act of photography itself focused attention and heightened and accentuated survivals, giving them a sense of the concrete and the permanent that would inspire confidence in "the permanence [that is future efficacy] of what seems fleeting and evanescent."[73] However, on the other hand, the serendipitous and uneven production of the survey movement combined with the fragmenting qualities of photography to constitute a "sense of separateness, a notion of item, discontinuity, that encouraged an acontextual comparative method."[74] In this, photography also emphasised the collection of unconnected pieces of data, pure and simple, rather than the coherent body of material that amateur survey enthusiasts sought. This emphasis was analogous to

cultural survivals themselves which were seen as "fragments of uneven character," as Gomme put it.[75] As such, photographs might be said to work on the cusp of disappearance and survival, fragment and cohesion, as is expressed through their subject matter, material practices, and their interpretation.

TEXTURES OF THE PAST: THE PARISH CHURCH

Landscapes are potent mediums of socialization, the production of knowledge, and the transmission and reproduction of both the spatial and temporal discourses of mythscapes. But they contain other places within them, villages, churches, trees or cottages.[76] These detailed locations constituted a sense of historical place that was the focus of survey photography. Much of the amateur photographic activity was connected not with the panoptic view as such, but with the marking of specific points of historical significance in which time and space merged chronotopically. It was through the amalgam of these multiple and complex signifiers that the historical topography was constructed. Ideas of disappearance and survival manifested themselves around clusters of photographic attention, subjects that became "devotional sites" of historical imagination, patterning the survey archives as the past was reduced to and refined through selected tropes.

The survey archives are dominated by photographs of the rural built environment, photographs centred on the parish, the village and its church. About 80 percent of extant survey photographs fall into these categories. The church, as an architectural palimpsest, was at the core of the concept of the village and the parish as a unit of society. Not only was the church often the most ancient building sur-

viving, but it stood for the longevity and cohesion of a community. The popular topographical writer P. H. Ditchfield summed up such a sentiment: "The old tower of the village church that has looked down upon generation after generation of inhabitants seems to say *Je suis, je reste*. All things change but I. I see the infant brought here to be christened. A few years pass; the babe has grown to be an old man and is borne here, and sleeps under my shadow. Age after age passes, but I *survive*.[77]

Again, as Tylor's ideas did, these tropes had a long history. Much of the earlier antiquarian tradition was in the form of church and parish recording, and the church stood at the centre of historical narratives of place. When, for instance, the eighteenth-century clergyman historian Richard Gough wrote his *History of Myddle*, a small town in Shropshire, he began in the parish church of St. Peter. He used the layout of pews and the families who occupied them every Sunday as an entry into the histories of those families and of the town.[78] The parish church was his site of memory and his chronotope. The idea of the parish, its church, and its village continued to have vitality throughout the nineteenth century, especially in the face of perceived social change, and was again very often the starting point for local histories and guidebooks that continued their description through a spatial hierarchy.[79]

There was also an extensive and growing historical awareness around architecture throughout the nineteenth century.[80] As G. A. T. Middleton stated, writing for photographers: "Few countries in the world, in fact are richer in architectural monuments of both beauty and archaeological interest than our own. Every man who has eyes to see recognises it, and, further, knows intuitively that the charming erections of brick and stone, which are to be found dotted all over the land have some interesting tale to tell, if not individually, at least collectively."[81] For photographers, ideas of survival were strongly inflected with a Rieglian age-value, with its emphasis on the visible and resonant apprehension of the past.[82] The architectural stood for that potent and visible past, and for privileged values of identity formation. Middleton stated this clearly:

In England . . . we have buildings which tell aloud to him who cares to read of the life of our forefathers, as nothing else can do. There is the stern work of the Norman feudal lord, followed after but a short interval by the elaborate soul-elevating Early Gothic of the days of chivalry. The Norman buildings of the twelfth century, with their thick walls, massive construction, semi-circular arches and flat proportions, all, whether castles or churches, speak out of the masterful repression by the mailed warrior of a subject people; and the contrast is most marked with those of the following period, having thin walls, lofty proportions, and elegance both of general form and detail, all combined with perfect workmanship. It was an age whose spirit is best appreciated in its architecture—an age of lofty aspiration, true nobility, and manliness, when the armed men lived for honour . . . our great cathedrals and abbeys, as well as our village churches are, all alike, the monuments of the age, reflecting its glorious energy and its high ideals.[83]

There was a strong Ruskinian sense of an inviolable space of identity represented through architecture, in that architecture became the nation's memory house.[84] (See figure 74.) History and its moral force were represented in the

74. Norman arcade, South Kilworth Church. Photographed by George Henton, c. 1903. Photographic Survey of Leicestershire. From the half-plate negative *(reproduced with permission of the Record Office for Leicestershire, Leicester, and Rutland).*

very fabric of churches and other buildings, almost as a living entity, as suggested by Ditchfield's personification of the church tower. Encouraging photographers to record churches, *The Yearbook of Photography and Amateur's Holiday Guide* of 1896 declared, "The very walls are covered with the marks of their past life. They speak of their birth, the alteration, the decay."[85] Despite the apparent solidity of the parish church as an institution, as material object and as a rhetorical focus, there was concern that the church lacked the detailed photographic attention demanded by its status as an historical object, especially as so many churches were threatened with the vandalism of restoration: "If we look round the walls of our exhibitions, we find that a very large percentage of the architectural studies hung are pictures obtained in our great cathedrals and best known churches, and it is surprising that we do not see more work from our village churches depicted."[86] Likewise, *Amateur Photographer* exhorted, "We have urged over and over again that photographers should . . . deal with every ancient building, not only the magnificent fanes of the [Westminster] Abbey, but also the

smallest parish church; they all deserve similar treatment."[87] In addition, ignoring the humble parish church had profound moral implications: "If it be but an old village church, how many things have conspired to make it sacred! The 'rude forefathers' sleep beneath its walls, it belongs to their children from age to age. To demolish it, and extinguish its venerable association, is to strike a blow at Religion itself."[88]

Survey photographs repeatedly negotiate the relations between the aesthetic rendering of architectural space and the facts of history. The range of photographic interpretations of churches and the ambiguity between overview and detailed inventory goes to the heart of the tension between what survey photography was about, and the way in which the demands of photographic survey were understood differently by different photographers. This cannot be explained by different technical capabilities, but by different understandings of significance and how the record might be constituted. The building was ideally mapped across the picture plane, almost in a mode of architectural drawing. The subject often filled the frame. Photographs were to show as many features as possible, and be supplemented by further photographs of key features such as Norman doorways, carvings, and miscellaneous material culture that carried the weight of time, such as ducking stools, ancient biers, or chained bibles. Detail, a survey advocate argued, was perceived as "generally more valuable than general views"[89] and "interiors more important than exteriors because it is where 'character' is to be found."[90] Photographs were not to be "a comprehensive view of the interior straight up and down the nave, but [of] the smallest detail, every corbel, every mullion should be registered."[91] (See figure 75.) However, in practice many churches were photographed simply from the exterior, either

from the southern elevation, which would, in most cases, render inscriptions of the tower, porch, style of fenestration, presence of clerestory, and the nave in relation to the chancel, and thus give a clear impression of the overall design and layout of the building. Alternatively churches were photographed from the southwest angle, which gave an oblique and more compositionally satisfying, but less legible, record. General views were seen as aesthetically problematic because, as was pointed out "interest is scattered, the lighting frequently very flat, and nothing definitely attracts attention to any one point."[92] These photographs, showing the church as a freestanding object of attention, evinced the quality of objectivity and authority to which survey and record photography aspired.[93]

In these photographs of churches, one sees also the tensions between collective and individual vision, between science and aesthetics. A scientific approach is represented by those many blank mappings of elevations across the picture plane, such as are seen in Scamell's photographs of Essex and Norfolk churches for the NPRA (See figure 76), some of Perkins' self-consciously 'objective' photographs of Dorset churches, and close-up photographs of details such as corbels, mouldings, and capitals (using telephoto lenses). Photographs of architectural detail in particular were the least aesthetically aware photographs, and there is a sense in which detail came to stand for the "realness" of both the record and the past.[94] J. Hobson's photographs for the Surrey survey of corbels and changes in masonry, for instance, exemplify exactly the kind of detailed record that photographers were accused of ignoring in their preference for the merely aesthetically pleasing. His photographs are about complete and unequivocal visibility and legibility as they trace

75. "Double Hagioscope, Leatherhead Church." Photographed by G. C. Druce, 1904. Photographic Survey and Record of Surrey *(reproduced by permission of Surrey History Centre. Copyright of Surrey History Centre, 7828/2/94/1).*

the straightforward record of stones across the picture plane.

But there are also lyrical renderings of ancient space. For example, the formal qualities of church architecture and the sense of the layered past both informed Bernard Moore's and Harold Baker's photographs for the Warwickshire survey a few years earlier and William Greatbatch's photograph of the flower-strewn archway at Lapworth Church. (See figure 77.) George Henton's photographs for the Leicestershire survey, with their self-conscious points of view, create patterns along the columns of Jacobean tomb chests at Breedon-on-the-Hill through the light raking down a late Norman north aisle at South Kilworth or the geometry of a Norman doorway and tombstones askew at Horninghold, prints of which are in both the Leicestershire survey collection and the NPRA. These images instil a sense of "pastness" as a romance of survival, the sentiment of place and the Ruskinian qualities of aged stone that must be held for the future. (See figures 78 and 79.) Yet, it is precisely this affect, so integral to the impact of the photographs, that must be controlled. In attempting semiotic containment

within the objective discourses of survey, the factual descriptions used in the captions of the photographs—"Looking across nave towards South Door," the caption for Percy Deakin's superb interior of Tredington Church for the Warwickshire survey—belie the affective qualities of the photographs. Thus, in such photographs, archaeological details, such as changes in masonry, become both markers of structural change and affective textures in stone, pointing again more to the central ambiguity of survey practice in which photographs were to both inform and affect collective historical imagination.

Churches were also used to signify stability in a sea of change, especially in urban spaces. A good example is Samuel Coulthurst's photo-graph of Manchester Cathedral, taken from Fennell Street. The cathedral is surrounded by cleared land with builders' boarding half obscuring the building. (See figure 80.) A similar process is at work in the Leeds Photographic Society's and the Yorkshire survey's constant and detailed attention to Kirkstall Abbey in Leeds as they defined the authority vested in the submerged medieval core of the modern industrial city. Such images do not merely transcribe, but engage with the effect and impact of cultural change on valued historical topographies.[95] They raise the central question: Where were the traces of the past located and under what conditions, technical and stylistic, could survivals of the past be rendered legible?

76. Sheringham Church, Norfolk. Photographed by George Scamell, 1904.
NPRA Collection *(photo © Victoria and Albert Museum, London).*

Responses to the disturbance of ancient fabric give a clear view of the values that informed amateur photographers, because concepts of survival, disappearance, and historical weight in what was photographable and its historical import were especially strongly articulated through debates on building restoration. Restoration was not merely about the repair of damaged or worn fabric. Many restorers wished to remove the historical layers of churches to return them to an imagined medieval purity. This meant stripping away the architectural survivals of various periods and disrupting the temporal identity of the building and its moral significance as an historical statement. This is related, importantly, to the quality of photographers' observation, which was integral to amateur survey practice. It became crucial, in order to avoid the evidential traps of the restored church, for the photographer to be able to distinguish between "genuine old work full of life and thought, and the individuality of the original mason or carver, and the cold, lifeless, imitative work of the modern restorer."[96]

There was much hyperbolic talk about destruction and vandalism, aimed at both church authorities and builders. But crucially, photographers, with their interests in both the aesthetic and informational qualities of ancient buildings, were seen to have an active and vested interest and role in these debates in ways that resolved differences between picturesque and evidential approaches, for "nearly every photographer is a bit of an archaeologist, and nearly every archaeologist is a bit of a photographer."[97] As Harold Baker, who was on the NPRA committee, proclaimed in the pages of *Amateur Photographer*, "Photographers . . . should deplore the terrible destruction which is going on all over this beautiful country," a destruction that transformed ancient buildings as

Lapworth Church

77. Lapworth Church gateway. Photographed by W. Greatbatch, c. 1890. Warwickshire Photographic Survey *(courtesy of Birmingham Library and Archive Services)*.

78. Jacobean Tomb chest, Breedon-on-the-Hill. Photographed by George Henton, c. 1903. Photographic Survey of Leicestershire. From the half-plate negative *(reproduced with permission of the Record Office for Leicestershire, Leicester, and Rutland)*.

they were, "scraped and scoured till [they] possessed as much beauty and interest as a jerry-built villa."[98] The vice president of the Surrey survey was moved to state in 1905 that there were two great destructive forces of the built environment, fire and builders, and the latter were usually worse because at least the former

left something standing.[99] Restoration, as it was debated in photographic press, owed much to Morris's SPAB, one of the primary objectives of which was to maintain the ancient fabric, the stones of valued buildings, especially in parish churches.[100] A letter quoted in SPAB's annual report of 1885 typified this sentiment in a description of Packwood Church in Warwickshire, a building much photographed by the Warwickshire survey,[101]

I wish I could describe the charm of the old church and its surroundings before it was irreverently mangled. . . . Though patched and altered by rustic church wardens, their additions were by the softening hands of time harmonised, and visibly to the most careless observer, was written the history of a village church and its worshippers for the last three hundred years. It was, in a word, one of the few "unrestored" churches in the county. Its broken floor, stained walls, old mural tablets, and inscriptions commemo-

79. Norman doorway and gravestones, Horninghold. Photographed by George Henton, c. 1903. Photographic Survey of Leicestershire. From the half-plate negative *(reproduced with permission of the Record Office for Leicestershire, Leicester, and Rutland)*.

80. Manchester Cathedral. Photographed by Samuel Coulthurst, c. 1892. Photographic Survey of Manchester and Salford *(courtesy of the Manchester Room at City Library, Local Studies)*.

rating half-forgotten squires and landlords, whose hatchments hung on the wall, the oakwood screen, the pews grey with age, the windows mended with glass of every tint, all told of those who in by-gone years once worshipped within the old church and now lie buried in the churchyard.[102]

This is not the place for an extended discussion of nineteenth-century restoration and preservation movements. What is significant, however, and what had an impact on the way photographs were produced, is the fact that the moral values of restoration were continually discussed, often negatively, in the photographic press. Restoration was seen as an assault on the values of historical depth that the surveys hoped to preserve for the future: "We have lost, in fifty years, one half of our old art, which . . . was mostly enshrined in our churches, and have hopelessly vitiated and falsified the other half."[103] As Thomas Perkins wrote in a correspondence on the virtues and evils of church restoration in *Amateur Photographer*: "The life given to their work by the old builders and carvers has been destroyed; the mellowing effects of time have been obliterated; the appearance of venerable antiquity has vanished, and the church is practically a new building."[104] These discussions were integral to the sense of urgency of salvage. Survey advocates exhorted every photographer "who hears that an ancient building is to be restored, should lose no time in photographing all the features of that building that are of any interest."[105]

Photographers were therefore not engaged simply in an undifferentiated practice of a nostalgic picturesque but in the broader values of preservation and restoration that were conspicuously debated in the contexts of photography for the consumption of all. (See

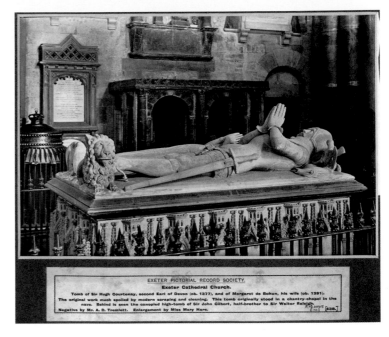

81. "Tomb of Hugh Courteney, Exeter Cathedral." The caption reads, "The original work much spoiled by modern scraping and cleaning." Photograph by A. Tremlett, printed for the survey by Mary Hare, c. 1913. Exeter Pictorial Record Society *(courtesy of Westcountry Studies Library, Devon Libraries).*

figure 81.) The concern was not merely the loss of the picturesque, but the loss of scientific evidence. In 1901, for example, there was an exchange in the pages of *Amateur Photographer* between Harold Baker, William Tilt, and Thomas Perkins in terms that drew heavily on the values of Ruskin and Morris, but also on what kind of evidence churches and their fittings might be.[106] While focused on the restoration of St. Mary's Church, Warwick, the debate was premised on considerations of the nature and power of the authentic, the definitions of "original" and "old," and on contested knowledges. Running over several issues of the journal, the debate brought these issues to the centre of photographic concerns, where their relevance to the medium and the interests of amateur photographers was unquestioned.

The survey movement also contributed to the dissemination of these values in the local press. For instance, in an account of an exhibition of Sussex survey photographs in Brighton entitled *Pictures for Future Historians*, the local paper commented, "Mr R. G. Pearman,

TREDINGTON
S. Door

Bernard Moore
1896

2189

of generations. All the magnificent wood-work of the nave — work when joiners' work was at its perfection — was cleared out, sold or broken up . . . the fine plaster ceiling hacked off . . . and if that was not enough the floor dug down to thirteenth century level. The fifteenth century floor was found, all over the church, almost perfect . . . This is the end . . . work [that] had stood then the storms of the seventeenth century . . . could not withstand the destroyers of the nineteenth.[108]

What links all these statements, and there are many others in a similar vein, is a valourisation of ancient fabric. Mary Douglas, in her classic work, *Purity and Danger*, has argued how the categories of the pure and the impure are used to create social order.[109] The preservationist discourses of amateur photographers in relation to unrestored and restored churches might be understood in this way. Those churches that reflected the depth of history and, therefore, the values attributed to history were deemed desirable, as opposed to those "impure," restored churches in which "matter out of place" — unsuitable practices — disrupted the "natural" historical layers, and thus their symbolic density. The unrestored and preserved church became a marker of the "architecture of reassurance," of continuity and stability, a site of historical and continual social action, and thus the focus of historical desire for amateur photographers.[110] For not only did the unrestored church fulfil the demands of a dominant picturesque aesthetic, it demonstrated photography's efficacy and contribution in addressing widely-held values and was a site of dynamic action. The photographic press and the debates of survey and record societies espoused these values energetically. These debates are lit-

82a and b. The south door, Tredington, before and after restoration. Photographed by Percy Deakin, 1897, and c. 1900? Warwickshire Photographic Survey *(courtesy of Birmingham Library and Archive Services).*

who does so much for the Survey, is able to include photographs of Rustington Church taken prior to those recent vandalistic restorations which, in their destruction of venerable ancient work, one would have thought impossible in these days of education."[107] Likewise a heartfelt description of the perceived horrors of restoration and its disruption of the "marks of communality and action, the marks of vigour and energy of the people" is given by Edward Beloe, instigator of the King's Lynn and North Norfolk survey. The restoration of King's Lynn parish church, he said,

> was carried out without feeling or intelligence by the then vicar and wardens against every protest and obliterated the costly care

tered with references to buildings threatened, restored, and demolished, and sometimes they respond to specific threats. For instance, in 1905 *Amateur Photographer* noted that there was "the urgent need of a thorough photographic survey of the Churches in York," and, as a direct response to perceived threats to some of the medieval buildings in the city, offered prizes for "the best and second best sets of platinotypes or carbon prints illustrating the Architectural and other Antiquities of York."[111]

What was repeatedly stressed is the sense of excavation of the original intention of the builder or maker: "In selecting for beauty, and also for sentiment, the wise photographer will take the guidance of the architect, for the designer of any really fine piece of architecture was a much better trained artist than the photographer is likely to be, and he built for beauty and sentiment. Compare the lines of a Norman cathedral (massiveness and solemnity) with those of Gothic style (dignity and aspiration), and these again, with a well designed modern ingle-nook (warmth and comfort), and you will see how the architecture itself suggests varied photographic treatment."[112] Photographic treatment required a sensitivity to the past in which the individuality of the photographer had to be subservient to the historical character of the building: "The photographer, to be thoroughly successful, must to some extent sink his own individuality in that of his predecessor of possibly many centuries ago, and strive to enter the feelings and aspirations of him who originally conceived the work which it is intended to portray."[113] Consequently, the relationship between the response to a building and its correct rendering in terms of its maker's original intention, the scientific and aesthetic predilections of photographers, and attempts to recapture the spirituality of the ancient building, became

part of the salvage and recuperative agenda for photographers.

Churches had also, of course, symbolic and spiritual qualities that were part of the photographic discourse. While one would not argue that survey photographers were necessarily self-consciously aligning themselves with this discourse, spiritual and symbolic qualities were part of the powerful constitutive force of devotional sites. Importantly, these values, perhaps linked to those of moral impulsion, were happening within photography, especially in its overtly aesthetic practices. There was an energetic visual economy of photography comprising magazines, exhibitions, and circulating lantern shows that reproduced the aesthetic values of photography and cohered centre-periphery

83. Porch, Walsingham Church. Photographed by Edward Peake, 1907. Photographic Survey of Norwich and Norfolk *(courtesy of Norfolk County Council Library and Information Service).*

and responses to restoration, tensions between the spiritual and the scientific can be discussed in relation to the stylistic choices made in response to certain buildings. These tensions are exemplified in a pair of photographs of Tredington Church, taken a couple years apart by Bernard Moore for the Warwickshire survey. The unrestored doorway is photographed according to the aesthetic principles of picturesque architectural photography so as "to bring out [the doorway's] character and relief . . . [with] just sufficient distance seen through to give it a charming final touch . . . a thoroughly pleasing picture." The door is open, looking into the ancient space of the church, connected to human community and spirituality, whereas the restored doorway is taken in the style of a factual statement, with the door closed and the blank wall and door filling the frame, "an exact copy of ornamentation or details."[116] The differences in rendering the doorways demonstrate the complex value systems around the photographic inscription of disappearance and loss as they intersect with those of aesthetics and science. (See figure 82 a and b.)

Such values are repeated extensively, and their ambiguous photographic rendering suffuses the survey archives. Building on the symbolism of doorways, Middleton urged in the pages of *Amateur Photographer,* "Of all the features of a church, the porch is that which is most full of human, as apart from ecclesiastical or architectural interest, . . . their [porches'] very existence, indeed, is due to human needs and desires." He continues, "It is the peculiarly human interest of the particular porch upon which a plate is being exposed that the photographer needs most to accentuate, rather than its architectural style or detail."[117] (See figure 83.) Thus photographs of church interiors were seen as operating on the cusp between record and affect in which

relations through a wide range and levels of practice.[114]

In relation to photographing churches, the work of the celebrated architectural photographer Frederick Evans was especially notable. He exhibited widely and wrote extensively for the photographic press, but he was also interested in the symbolist movement and its exploration of emotional and affective qualities in the arts. The doorway, archway, or porch, opening onto light became a major trope of architectural photography. For Evans, the framing of the space beyond a doorway carried especial resonance as "the arched doorway of spiritual transition" and as a "visual pilgrimage towards interior illumination."[115] Linked to age-value

space is marked by past human experience in a way that positions the salvage of past experience with a recuperative quality. Fonts also became a focus for a more symbolic aesthetic and subject in an equally Rieglian debate, as "attention [had] several times deservedly been called to the remaining old fonts of England, and the desirability of obtaining photographic records of them before the so-called restorer or the village stonemason [was] called in to clean and patch them up a bit—in many cases, otherwise ruin them, to please the spick and span ideas of [the] twentieth century churchwarden."[118] Often placed near doors, fonts stood for the baptism through which a child entered into the community.[119] These sets of values around the representation of parish churches, such as were found in H. W. Fincham's photograph of the priest's doorway of Breccles church, Norfolk. The concentrated light in Fincham's photograph becomes diffuse over the floor and wooden benches. Sidney Pitcher's beautifully lit closeups of Gloucestershire fonts for that county's survey transfer over, unremarked, into survey photography.[120] (See figure 84.) Above all, the church and its palimpsest of constituent parts stood for the survival of community and was a visible history in the landscape. Despite objective claims of record and the rational procedure of the photographers, churches stood for a poetics of history at a local level and were a mythscape within a wider cultural dynamic. As Richard Keene noted, writing of Warwickshire survey photographs, "Ah, that church is a dream, a poem in architecture."[121]

THE VILLAGE: OF MANOR HOUSES, GREENS, AND COTTAGES

In the discourse of ruralism and of a sentimental English pastoral, saturated as it was with the

84. Lead Font, Down Hatherley. Photographed by Sidney Pitcher, c. 1900. Photographic Survey of Gloucestershire. Silver bromide enlargement *(courtesy of Gloucestershire Archive, SR44.36297.97).*

entropics of disappearance and loss, villages stood as a metaphor for the organic community and national home, idealised domesticity and the reassertion of lost values.[122] This is amply demonstrated in 1902 when the *British Journal of Photography* summed up, in a discourse of both origin and locality, the sentiments of village for photographers:

There is something about "the village" that appeals to the imaginations and sympathies of most men. The attraction is probably in part instinctive, and due to blood and race. Affection for the village is characteristic of the English stock. The earliest accounts that we have for our distant ancestors, the German tribes of Tacitus, show them to have been fiercely jealous of the independence of the small village communities in which they lived. History proves the same feature to have been characteristic of the villages of Saxon and Mediaeval England. The manorial village was a self-contained and self-ruling unit, and we are now instinctively returning to the same form of government, as far as we reasonably can, with our rural

and parish councils. But outside of this consideration, the calm and quiet of a village is so complete a contrast to the noise and bustle of the town, that we naturally turn to it and its suggestions as a restful foil to over-sensitive nerves and harassed minds. The attraction takes us to villages for our holidays, the pleasant remembrances of which still further tend to strengthen our regard . . . One is in love with the highly rural village with its low grey church tower and bridge-spanned brook, its blacksmith's forge, wheelwright's shop, and cottages set in gay, sweet-scented gardens, built at varying angles to the road, the whole compactly and artistically packed together in a gentle turn of the smiling valley.[123]

This description of the appeal of the subjects of church, village, and custom draws on a wide range of both scholarly and popular historical writing of the period and merges those historical discourses into one of pictorial desire for photographers. In it one can discern the resonances of, for example, Lawrence Gomme's folkloric reading *The Village Community*, published as part of Scott's popular series for the contemporary science library in 1890. in Ditchfield's antiquarian, romantic, and nostalgic rendering of the quintessential English village and in the sentimental and highly popular watercolours of English cottages by Helen Allingham were also claimed as "records" of local styles and building materials.[124] Not only had the village become a marker for the idealised sense of community and longevity of social values. It was also a focus of academic histories in the nineteenth century, a grid through which disciplinary values were made. For instance, distinguished historians F. Seebohm and E. A. Freeman had, in their different ways, placed such structures at the

centre of the emergence of a community where democracy flourished—markers of fulfilment and return of tradition that appealed to both conservatives and liberals and which permeated popular writings on history.[125]

The late nineteenth century saw an enormous local publication and circulation of antiquarian pamphlets on local customs, local families, and local churches, many illustrated and many originating from local newspapers.[126] The parish church, the manor house, the village, and the practice of ancient customs were central to the conception of the community and the past and offered "constancy of place," which reinforced locality in the midst of perceived change in ways that allowed an imaginative connection, and thus affective engagement, with "people who once occupied the space [the British] do now."[127] Above all, villages and their constitutive elements were complex sites of both tangible and intangible survival: "Every local institution of Great Britain—the parish, the manor, the borough—bears upon it the impress of its origin in the primitive village."[128] There were also evolutionary elements that merged neo-Lamarckian qualities with ideas of the local: "Cottages were an evolution which has grown on very marked lines from primitive times, and almost in every instance, is influenced by local surroundings."

The village, therefore, was not only a major focus of the pastoral idyll and the patriotic picturesque, but was also a chronotopic focus of salvageable survivals of the past. In a rhetoric similar to that used for ecclesiastical buildings, *Amateur Photographer* exhorted amateur photographers to make records in the face of disappearance:

Within the recollection of most of us, nearly every village gradually absorbed into

its adjacent town or city had at least a village pump — aye, and some a whipping-post and stocks! Where are they now? Not even a photograph exists in many cases to record them. Finger-posts or sign-posts at the parting of the easy are fast disappearing — they will all be gone soon, and nothing left to tell of the order of things of which they were so important an item. The drinking trough and place where once the post-chaise or coach drew up, and now the farmers' wagons rest on their way to the far-off market city, will soon give place to a new condition, when farm produce is conveyed by motor van and there are no post-horses with steaming flanks to quench their thirst. This is no season's work; all the year round there are matters of interest in every district which should be recorded. Time presses. We will help you all we can.[129]

The village was, however, as an historical topography, made up of groups of buildings in relation to one another, a natural form in which points of community connection were laid out. As Karen Sayer has argued, "The village connotated the nation on a small scale . . . an age-old fundamental link between soil and house, nation and village, as if the cottage had grown up out of the land on which it stood."[130] Despite this stress, what becomes clear is the relationship between the expansive rhetoric of place and identity, articulated through the spatialised mythscape of the village as a collective entity, and the photographic language of survey, focusing on constituent parts — the manor house, the church, the cottage, the almshouses, the green, the forge and the stocks. The collective place, the village is repeatedly constituted through these fragments of individual structures and their qualities, echoing the pre-

ferred approach to recording churches through a massing of detail in which those details "are part of a larger representational whole whose unfolding image is a function of their intended purpose as documents to aid in the construction of a historical narrative associated with place."[131]

There are general views of villages, such as the series of Leicestershire villages taken by George Henton, which show cottages, shops, and forges, the gathered marks of the past, clustered around the village greens of the county's typically nucleated villages, but these are outnumbered by photographs of individual buildings. Photographs of individual buildings pattern the archive, with photographs of single buildings or other features such as ancient trees or village stocks. However, there was a concern that, as was the parish church, village features were inadequately addressed by photographers. For instance, a speaker at the NPRA meeting in 1897 opined that while "abundant and full information has been secured as to churches, cathedrals, and the like, the cottage and domestic buildings of this country [Britain] been quite neglected, and there was certainly scope for work in the interiors and exteriors of such buildings."[132] As was the case with churches, photographers were encouraged not to overlook significant detail that marked the past. *The Camera as Historian* provided an almost breathless list: "Interesting specimens of the following minor but often valuable objects should be looked for: "chimney pots, ventilators, leadwork, cast and wrought iron work, pipeheads, railing standards, gullies, vanes, hinge straps, knockers, locks, keys, padlocks, door handles, window lathes, dog grates."[133] This focused observation was not merely a function or acceptance of the fragmenting nature of photography itself, but an acceptance of

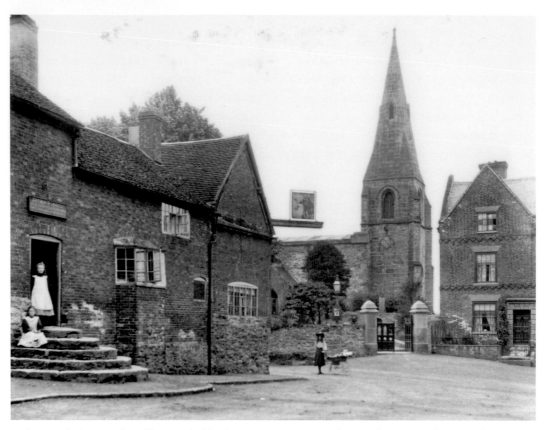

85. Diseworth, Leicestershire. Photographed by George Henton, c. 1903. Photographic Survey of Leicestershire. From the half-plate negative *(reproduced with permission of the Record Office for Leicestershire, Leicester, and Rutland).*

the way in which the concept of a record as an individual inscription and valourisation of constituent parts could be moulded into a narrative in the collective and cohesive practices of the archive, the way in which an idea of village and its record could be constructed. (See figure 85.)

Village buildings were photographed largely for architectural reasons, and in most cases such photographs eschewed an overt picturesque aesthetic, but within the complex discourses of photographic survey, the signifying power of the village rendered these photographs aesthetically and historically legible. While the rhetoric of the surveys responded to rational calls for scientist record-making, what made ancient cottages, manor houses, farmhouses, and barns valuable as markers of historical

topography was a complex matrix of competing values and signifying systems. There is a marked overlap, in this context, between subjects of the surveys and subjects of picturesque desire as they are presented in the photographic press, for instance the values represented in the Reverend A. H. Blake's illustrated series "Picturesque Spots," which ran in *Amateur Photographer*. Thus while many photographs of villages were not stylistically picturesque in photographic terms, the signifying properties of the subject matter were far-reaching. (See figure 86.) Nevertheless, in the photography and discourse of the village amateur photographers of the survey were at their most elegiac, and saturated village photographs with ideas of change. Not only were these values marked in the pro-

duction of photographs, but also in the narrative woven through their captions, which noted survivals, past uses, restorations and disappearances. The discourse of disappearance and loss was often focused through specific buildings. For instance, J. H. Stanley's photograph of a half-timbered building at Lingfield for the Surrey survey is captioned as "Butcher's shop, until 50 years ago was used as a market house. A very ancient building."[134] Indeed, one of the most common remarks to be added to the descriptive captions of the photographs related to disappearance, for instance, "demolished 1906" and "pulled down 1908."

While photographs of churches and customs were also inflected, to a greater or lesser extent, with the discourse of objective record, the rural-ist entanglements of the concept of the village produced much more ambiguous images. Even if not directly or overtly picturesque in stylistic terms, they carry those aesthetic marks powerfully. It is perhaps significant that the call for detail was not as extensively realised in relation to houses and cottages as it was for churches, possibly reflecting the more strongly developed archaeological approaches to church architecture, but also perhaps reflecting the holistic concept of the village and its symbolic role. Photographs of villages also remain, however, inflected with debates regarding the local itself and local civic pride. For instance, villages stood for local social and occupational networks, and for local-level civic pride as evidenced by the countless examples of village halls, such as

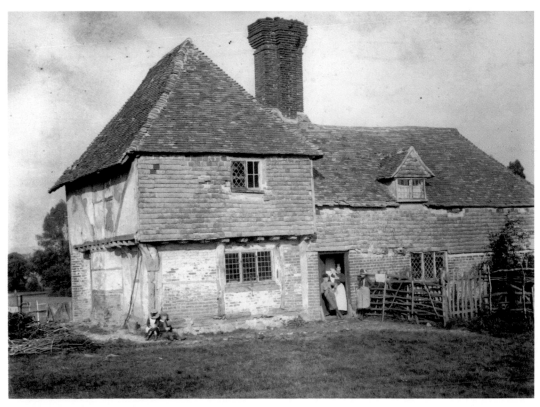

86. Farm house cottage, Kennington. Photographed by Thomas Nottidge, 1890, printed 1904. Photographic Survey of Kent. Later bromide print *(courtesy of Maidstone Museum and Bentlif Art Gallery).*

Millbrook Gorge. Bedfordshire.
J. Benjamin Stone
"The Valley of the Shadow of Death". of Bunyan's Pilgrim's Progress. 1904.

87. "Millbrook Gorge, 'The Valley of the Shadow of Death,'" Bedfordshire. Photographed by Sir Benjamin Stone, 1904. NPRA Collection (*photo © Victoria and Albert Museum, London*).

those photographed for the NPRA, signs, ceremonies, rituals, almshouses, and celebrations of local illustrious persons, all of which were mapped through the archives of the surveys.[135] There was nonetheless a strong iconographical clustering around specific tropes of the ruralist and the English pastoral that translated the banal and ordinary space of the village into a discourse of both national survival and national identity, as "picturesque images not only provided a patriotic translation of landscape or monument, they allowed one to inscribe national virtues on the very details of a scene."[136]

Consequently, photographing villages and cottages connected other historical and topographical imaginings. This is especially marked in the photography of literary landscapes, in which national literature took on a topographical force, visualised and concretised through photographs. Shakespeare,[137] Bunyan, Wordsworth, and Goldsmith, for instance, were traced onto the landscape, as was George Eliot (Mary Anne Evans), whose birthplace at Arbury was photographed for the Warwickshire survey in

1895. Especially interesting is a set of eleven photographs of the places associated with John Bunyan, made by Sir Benjamin Stone in 1904 and deposited with the NPRA. Through the photographs, Bunyan's life and work are mapped across the Bedfordshire landscape: images of the chapel, his cottage, the tower of Elstow village church where he was a bell-ringer, and the door of his cell from Bedford Gaol, photographed as preserved in the local museum. Places take on their identities from *The Pilgrim's Progress* — Elstow Green is Vanity Fair and Millbrook Gorge the Valley of the Shadow of Death.[138] (See figure 87.) Similarly a photograph of "Dinah Morris' cottage" from Eliot's *Adam Bede* appears in an imagined topography of Staffordshire in the NPRA, photographed by Florence Gandy from Derby.[139] Real and imagined topographies are merging in these photographs as statements of both locality and national identity, a process is given force through photography's discourse of unmediated realism, permanence, and truth value. This is not disappearance as such but a further layering of the landscape and village space through an exercise in historical imagination.

The emphasis on villages and churches as the devotional sites of historical topography and cultural survival did not go unchallenged. Some saw that emphasis as a very limited interpretation of historical significance. For example, a commentator in the local paper the *Nottingham Daily Express* commented on the Nottinghamshire survey exhibition in 1897: "The collection strikes one as rather meagre or feeble, however it looks as if some difficulty was experienced by the workers in finding features of sufficient interest to be worth taking. This can hardly be so in reality ... there should be other scenes in a village that are worth taking besides the church or the parsonage."[140] This commenter further

suggested that this feebleness was the result of the lack of local knowledge and the "want of co-operation on the part of the inhabitants of the villages, who could render valuable help in pointing out features that are of interest."[141]

Likewise there was concern that the surveys, because of picturesque tendencies on the one hand and the readily accessible and visible on the other, were not, in fact, addressing themselves to the primary concern of the disappearing, which were the practices of everyday life, traditional industries, agricultural production, small-scale artisanal industrial practices, and buildings under genuine threat of demolition, especially in the towns and cities where the speculative builder and civic development constituted a greater threat to the historical environment than the restoring parish clergyman in partnership with an overzealous architect. Survey photographers, it was claimed, contented themselves with making "impermanent records of permanent objects," rather than address what were seen as the true concerns of disappearance and loss.[142]

At one level, this historical topography reproduced by the photographic surveys was one of social hierarchy, centred around the conservative elements of church, manor, parsonage, and cottages, which themselves constituted the pastoral idyll of the unchanging rhythms of the rural, the feared and anticipated disruption of which informed the salvage agenda. But it is important to consider that this archival pattern might not necessarily have resulted from a self-conscious performance of picturesque historical imagination alone. It is perhaps also the result of more structural controls on photographers, in which property, access, and thus visibility, within the historical environment, was not automatically a matter of choice. Access to specific historical sites framed by class and social connection, undoubtedly shaped survey production. For instance, Stone used his status and connections as a member of Parliament to photograph not only the Houses of Parliament but Windsor Castle and the royal family's country house at Sandringham in Norfolk, and to negotiate access to other major country houses such as Holkham Hall, and Norfolk and Charlecote House, Warwickshire. Likewise, it would appear that local social position and connections allowed Charles Cornish Browne, of the Dorset survey and a member of a local gentry family, access to the large country houses of the county, photographs of which were his major contribution to the survey. While survey committees and societies often gave their members "identity cards" explaining why they were photographing (examples survive from Surrey and Leicestershire), not all photographers enjoyed such privileged access: "Survey of this sort is essentially a labour of love involving considerable expenditure of time and money in securing proper photographic records of historic buildings, places and things; and it is not too much to ask that the 'nobility, clergy and gentry' should give every facility to accredited 'surveyors' in making these altogether desirable records. Cards of authority might be granted, signed, sealed, and delivered in official form."[143]

Conversely, the parish churches, village greens, cottages, stocks, and market crosses were not only very visible historical survivals of earlier times in the public space but open to all. (See figure 88.) As Mr. H. W. Bennett wrote in the pages of *Amateur Photographer*, "Though there are many fine old characteristic private buildings, but few photographers have access to them, while ecclesiastical establishments are, with few exceptions, free to all."[144] Implied in this is a sense of the invisibility of other histories within the landscape, especially within the

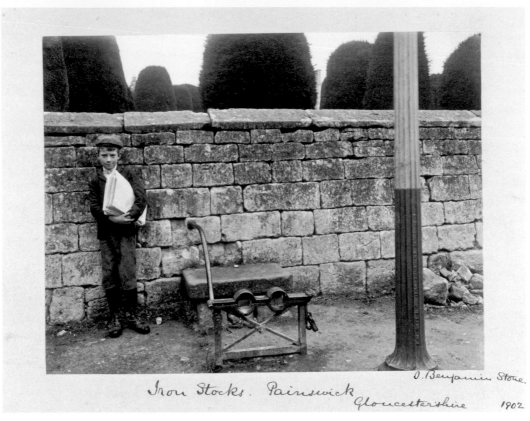

Iron Stocks. Painswick Gloucestershire 1902

J. Benjamin Stone.

88. Iron stocks at Painswick, Gloucestershire. Photographed by Sir Benjamin Stone, 1902.
NPRA Collection (*photo © Victoria and Albert Museum, London*).

ideologically constrained space of the OS maps used by many photographers. But the focus on churches and villages can also be seen as dominant precisely because they constitute the main modes of access through which most amateur photographers were able to recognise the historical and to connect to it. This raises the question of how selected a tradition this was, or to what extent it was the result of the wider social structuring of space itself.

OLD CUSTOMS

The ideologies of landscape, church, and village that marked the work of survey photographers encompassed the folkways and traditions that could be found in these spaces. Consequently,

folk customs formed the final devotional site of disappearance, survival, and historical imagination for survey photographers. The photography of these subjects was strongly informed by a range of ideological discourses of national origin, authenticity, and longevity, responses to which were related to a range of social, cultural, economic and political needs, indeed "for [a] variety of ideological purposes . . . their fragile, threatened presence was a structural necessity. Theirs was a culture which had to be revived through reperformance."[145] What is of vital importance here is the way in which photography was part of that reperformance as it placed traditional cultural practices visually in the popular historical imagination. Through traces inscribed in the photograph, ideas of survival and

folkloristic theory became visible and tangible, as a route into the undocumented past. Although they were contemporary performances, the customs photographed became historical forms through the temporal slippages of photography itself—the "that which has been" of the medium became doubly forceful.

Questions of disappearance, salvage, and survival were most strongly articulated in relation to folk customs and bygones. By the late nineteenth century, the peasantry imagined by revivalists did not exist in the English countryside, however. Agricultural decline and increasing suburbanisation gave rise to a concern that the "old ways" of the countryside, its people and traditions, were being contaminated, changed beyond recognition, or obliterated.[146] Ancient customs were "slowly, but surely, disappearing, and it [was] therefore highly important that, wherever [a photographer came] across such survivals, . . . an immediate record should be made, not merely for the sake of the scene itself, but for its intimate association with history."[147] "Ancient customs" carried a potent symbolic role within survey discourse. One survey advocate contended, "The recording of customs and manners is a particularly important feature of our work, because they pass away more rapidly than buildings, and leave no record whatever behind them unless they are recorded at the time."[148] Aspects of social life, whether customary, ceremonial, or everyday practices, therefore became not only overtly inflected with a sense of the internal exotic, which thus took on an authenticity in objects, but also had a chronotopic density in which, as Bakhtin describes it, "time as it were thickens, takes on flesh."[149]

At the same time, the use of historical and anthropological data to provide universal and "scientific" explanation for folk customs had vital implications for the understanding and status of such phenomena within the revivalist and preservationist movement. It moved the significance of the events from contemporary sociocultural contexts to an undocumented area of the past, accessible only through the application of folkloristic theory.[150] For survey photographers, and more importantly for their audiences, while the photographic trace became marked as an historical form through the temporal slippages inherent in photography itself, these slippages also informed a heightening of the relentless "placing of the present becoming past" that shapes salvage ethnography.

The influence of Tylorian concepts of survival were most keenly felt in the aspirations of the survey movement in connection to the contemporary existence of ancient practices. Ancient customs were seen as particularly potent survivals of the ancient and essential culture of the people. They were also integral to a sense of place, both discursively and literally, as folk customs were very often spatially focussed in those other devotional sites, the parish, the village, and the church, as exemplified by photographs of Tissington Well Dressing in Derbyshire, or

89. "Tissington Well Dressing, Derbyshire. The 'Hands Well' and its Decorators." Photographed by Sir Benjamin Stone, 1899. NPRA Collection (photo © Victoria and Albert Museum, London).

of the "Clipping" revived at Painswick Gloucestershire, both photographed by Stone. (See figures 60 and 89.)

The language used by the surveys of this category of photographic activity is significant. Folk and everyday practices were referred to variously as "customs," "anthropology," and "ethnography," or even as "events." They were seldom referred to as "folk customs," which was the language of scientific anthropology and folklore, but were more often referred to as "ancient customs," "old customs," and "bygones." While the concept of "folk" was heavily inflected with the temporal (in the popular domain of photography there was a more direct appeal to the temporal), folk customs were positioned in relation to "the old," constituting a direct and unequivocal appeal to the validity of antiquity, and locating spiritual values in the idea of the traditional community.[151] In some ways, this language, despite the strong sense of experience and affect of the historical imagination, was an appeal that privileged time over people, "old" over "folk." This was entirely consistent with the privileging, in photographic subject matter, of the actions and marks of time in the built environment that stood for the experience of people, the stones of the church, the space of the village green, over the actual performance of customs, the everyday practices passed on from generation to generation.

Yet despite this and the consequent prevalence of photographs of churches, ancient inns, and half-timbered houses, for the amateur photographers of the survey movement nonmaterial, intangible heritage was seen as being most at risk and was the focus of extensive rhetoric. This was especially so as the institutional structures for collecting folklife and custom in England were markedly underdeveloped. As Stone commented, "A record of it [folk prac-

tices] could only be made by photography, as no museum for ethnological subjects alone existed in this country."[152]

Folk customs were repeatedly privileged, in terms of photographic desire and rhetoric, over historical and ancient buildings: "A careful study and record of the real costumes of the countryside ought to be made before they vanish altogether or get modernised out of all recognition." As an editorial note in the *British Journal of Photography* noted in 1905: "It is surely a matter of regret that these customs and others such as rush-bearings, beating the bounds, fairs and feasts etc that have found universal acceptance at the hands of people at one time, should pass away unrecorded by that most conscientious servant of the graphic arts: photography."[153]

Significantly the power of the rhetoric of loss and disappearance has endowed the limited number of photographs of customs with a symbolic weight within the overall archive, a weight that continues to this day. Stone was described in *The Times* newspaper: "[He claimed that] ancient things were disappearing so fast. He did not refer so much to historical monuments as to the simple trivial things of life."[154] C. J. Fowler, of the Warwickshire survey, had no doubt about the desirability and urgency of photographing customs: "Attractive as architectural subjects always are to the photographer, I think greater attention should be paid to the manners and customs of the people, especially in villages and country towns." He continued, "unless the opportunity of portraying them is seized quickly . . . [to] provide illustrations of contemporary life taken on the spot [customs will be left] to be filled in afterwards by the imagination."[155]

Despite the rhetorical focus on ancient customs and traditions, which were so integral to

the construction of the patriotic picturesque and the nationalist discourse of Merrie England on the one hand, and such a major part of the construction of anthropological theory in the nineteenth century on the other, the relative absence of photographs of folk customs is one of the perplexing features of the survey archives overall. While there was continual exhortation to take photographs of folk customs and disappearing practices in crafts and local industries, and while the anthropological and salvage rhetorics were employed, remarkably little material of this nature was submitted to the survey collections, even allowing for the undoubted concentrations and unevenness of the extant photographic record.

The lack of ethnological or anthropological subjects was a frequent concern of those involved with record and survey projects. One survey advocate noted, "Much of the time of survey people is devoted to fonts and architectural work that may possibly last longer than the negatives or prints, and too little attention is given to the commonplace things of every-day life which are passing into oblivion rapidly."[156] In every one of the survey collections I examined, ethnography was most sparsely represented in the archives. While the random excess of photography occasionally intervenes, recording a line of washing, small children dressed in pinafores and clogs and watching the photographer, or a carrier's cart down the street, in fact only about 10 to 15 percent of the photographs can be described as relating to folk customs or even everyday practices.

Although photography was generally encouraged for the recording of folk customs, as Haddon told the Folklore Society, clearly thinking of the surveys, "Amateur photographers, and especially the numerous local photographic societies, should photograph all objects

and customs of folklore interest in their neighbourhood," and while the Folklore Society was itself collecting by this date, there is no clear explanation for the relative paucity of folk customs photographs, particularly photographs from amateur photographers, rather than folklorists.[157] The Surrey survey commented on "anthropological" photographs somewhat cryptically and without elaboration: "No opportunities [to photograph] are being lost or allowed to slip, but as regards anthropology (folklore) the photographic aspect of it is not always easy."[158] Its committee lamented in 1904, "Attempts have been made to obtain particulars of photographs of survivals of old May Day customs, unfortunately so far without success. It is to be hoped that those who have leisure to do so will observe and obtain photographs of these and any other survivals of old customs, the individuals taking part in them, and the paraphernalia incidental thereto."[159] It is possible that there were problems with this kind of work in the practices of amateur photographers more generally. Power relations, analytically assumed, might have been more complex in practice. Perhaps some photographers found taking such photographs inappropriate, intrusive, or reliant on awkward social relations in some way. For instance, perhaps there is a hint of what might have been involved in a note on the Warwickshire Survey outing: "Greatbatch got hold of an old chap with gaiters and smock frock and brought him down to the pub yard to be photographed."[160] This may also account for the paucity of photographs of domestic, craft, and trade interiors.

Furthermore, there may have been technical difficulties, given the material concerns of survey photography. Perhaps there were tensions over the photographic technology deemed appropriate for such recording, and for the pro-

duction of photographs of customs that would both rise above the level of the snapshot and be historically legible. It is also possible, given the disintegration of the archival integrity of some collections, that some of the more interesting or attractive images have simply disappeared unrecorded in exchanges, as unreturned loans, or even because of theft. Some Surrey photographs, for instance, on their labelled Survey mounts, were, at some stage, and by persons undocumented, removed to the Folklore Society.[161] But for surveys for which original inventories survive—those of Exeter, Manchester, and Surrey—it appears that this paucity of anthropological material was the pattern from the beginning.

Significantly, the survey movement did not distinguish between authentic tradition and invented tradition, although contributors were fully aware of the revived and invented status of much that was presented as traditional.[162] Rather, they saw all folk customs, authentic, revived or invented, as integral to the rich matrix of historical engagement and imagination, part of people's experience of the past. This sense of the past might be understood as a merging of salvage paradigms as many of the practices recorded remained vital, but were also perceived as endangered. Photography offered the possibility of stabilisation. For instance, Surrey survey expressed its interest in obtaining photographs of an unspecified ceremony "which was revived two or three years back at Croydon Parish Church."[163] Likewise, Stone photographed the revived tradition of Knutsford May Day, showing the results as scientific documents at a conversazione of the Royal Society in 1902.[164] Yet this reveals a differential and ambiguous relationship with the "restored." The restoration of ancient practices and folk customs, so prevalent in the nineteenth century as articula-

tions of romantic origins entangled with a salvage dynamic, were viewed as positive, though quaint statements of a timeless and authentic tradition, whereas the restored church was seen as a travesty of the original, an act of the worst sort of vandalism, the destroying stone that carried the marks of ages and the soul of the past. Whatever the focus of these customs, their antiquity and their status as survivals and signifiers of deep history were repeatedly stressed. Writing of Stone's photographs, shown at the St. Louis Exposition of 1905 with descriptions and histories of the customs, George F. Parker commented, "Every photograph in the collection throws a strong light upon some feature in the life of humanity, and is of deep interest in the only half-written, ill-understood history of institutions."[165]

Many of the customs recorded for the surveys had already attracted the attention of antiquarians and had been described and published over many years.[166] But photographs endowed them with a clear existence, mechanically inscribed, that stressed the reality and concreteness of their survival. While they resonate with a sense of collective antiquity, their local singularity was also valourised. For instance, "The Collection of the Wroth Money," at Knightlow Cross, Warwickshire, was photographed by Stone in 1899, a series of five prints being deposited with both the Warwickshire survey and the NPRA. The way that a contemporary local historian positioned this custom in relation to a series of temporal and spatial markers as authenticators is informative. He claimed, "This ceremony has survived and remains as a link connecting us with the early history of our island, creeping back into the mists of time," and he cited the seventeenth-century antiquarian Thomas Dugdale as an authority. The author goes on to position the custom both

Helston "Flora Day" May 8th 1901.
He early morning "Furry Dance" through the Town 1901.

Equipment of a "Press Gang" party.
Official Staves, Drums, Constable &c.
Fordwich, Kent. 1906.

J. Benjamin Stone

90. Helston Floral
Dance, Cornwall.
Photographed by
Sir Benjamin Stone,
1901. NPRA Collec-
tion *(photo © Victoria
and Albert Museum,
London).*

91. Displaying press
gang equipment,
Fordwich, Kent.
Photographed by
Sir Benjamin Stone,
1906. NPRA Collec-
tion *(photo © Victoria
and Albert Museum,
London).*

spatially and temporally: "Warwickshire, the geographical heart of England, the home of the immortal Shakespeare, is rich in historical and legendary lore, traditions and customs." While historical weight is given to the custom, which is described as dating from Druidical times, while its site, Knightlow Hill, is noted as a prehistoric tumulus.[167]

The extant photographs of folk customs can be said to fall into two categories, those of cyclical folk customs and those of everyday practices. Significantly, these two categories elicited very different photographic styles and practices. The most prolific provider of photographs of old customs was Sir Benjamin Stone. His well-publicised interest in the subject meant that he received invitations from local bodies to attend specifically to photograph their events. Stone depended on his importance and highly visible public persona as "Knight of the Camera" for invitations to various events. Part of that persona was premised on his tireless pursuit of old customs and was given a romantic urgency as he returned from London or Birmingham after "travelling all night."[168] But invitations were also, given Stone's profile, a way for the often middle-class organisers and revivers of such events to enhance the legitimacy and authenticity of the performance of ancient customs, as inclusion in Stone's project bestowed visibility and significance, both locally and nationally.

Stone addressed customs in an overtly performative way that was responsive to the self-conscious visibility and qualities of ritual observance and performance. For instance, his photographs of the Helston Floral Dance (1901) and the Corby Pole Festival (1901) create self-conscious tableaux of culture through a negotiated photographic encounter. Stone's use of a large-format stand camera, which, as I have noted, rendered a detailed inscription capable of historically legible inscription, demanded certain forms of social engagement in the act of photography, an act of scientific demonstration for the camera. Stone's photographs are not the record of naturalism or experience, but of an arrested movement, a stopping of time to create a *tableau vivant* of ancient custom. Often the associated material culture was carefully displayed to the camera, as it is in photographs of the Press Gang objects at Fordwich in Kent (1906). In photographs of the St. Cross Dole at Winchester (1904) the act of giving alms and the material form of "the dole" was self-consciously presented to the camera. Even more overt demonstrations are those photographs of the ducking stool, also at Fordwich, where an unfortunate young man, soaking wet, has clearly volunteered, or been volunteered, to demonstrate the process and effect of the ducking stool for Stone's camera.[169] (See figures 90 and 91.)

The photographs resulting from these carefully orchestrated demonstrations of folk custom constitute not so much documents of impending loss but self-conscious theatres of tradition. The traditions were seen as having both local and national importance. As was noted at an NPRA meeting in 1900 in "the places where such celebrations were still carried on the people of the locality eagerly looked forward to the repetition of such quaint customs year by year, and many came from far to witness and take part in them."[170] Consequently, these photographs are marked with the agency of the participants, facilitators, and spectators in a discourse of cultural survival and revival that was spread across a wide social range. There is a level at which the subjects imprint themselves on the ethnography, participating actively in the photographic act, and are not merely objects of an appropriating gaze. This is certainly evident

in the almost ludic quality of some of Stone's folk custom images, but a sense of agency, even within complex and uneven sets of relations, comes through a number of the bygones and ancient custom images in the survey archives. A notable example is S. Young's photograph of Lord Cranworth's shepherd Richard Bone, of Shipham, produced for the Norfolk Survey and also published in the local press within a discourse of disappearance in an article entitled *The Passing of the Smock*. In this photograph, Bone cheerily performs his smock, the focus of the photographer's historical imagination, for the camera. (See figure 92.) But not only is he actively engaged in the making of the photograph, his own voice comes through, recorded in the caption and in the newspaper, where he states that he has "worn [the] smock from the age of 7 every winter, and as a child, the year through."[171] While one should not give too much analytical weight to such a comment, it nonetheless raises the question that haunts the survey movement, namely, whose history, on what terms and for whom, and what are the points of fracture where other histories might emerge?

However, as Mr. Bone's smock indicates, disappearance was not only about what had become the intentional spectacle of revived folk custom, especially in its late nineteenth century manifestations, but also about the disappearance of the practices of everyday life. There was again an acute sense of loss and disappearance as "the commonplace of to-day [was] frequently only the memory of tomorrow."[172] As *Amateur Photographer* lamented, "If only our readers would realise how transient are the commonest things of the wayside!"[173]

There is a clear stylistic disjunction between Stone's conceptualisation of folk customs and the often banal snapshot quality of many of the

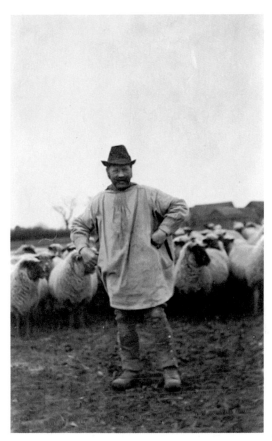

92. Mr. R. Bone: "States has worn smock from age of 7 every winter, and as a child the year through." Photographed by S. J. Young, 1913–14. Photographic Survey of Norwich and Norfolk. Silver print in postcard format *(courtesy of Norfolk County Council Library and Information Service).*

other anthropological or ethnographic images. Mr Bone's photograph stands in marked stylistic difference from, for instance, Stone's photographs of agricultural labourers at Stratford-upon-Avon's mop fair, in which three figures stare uneasily into Stone's large-format camera. Often images in this category were those of everyday and ordinary craft practices, seen as endangered through the increasing industrialisation of processes: a barrel hoop maker (Sussex), charcoal burners (Surrey), sheep shearing (Sussex), haymaking (Warwickshire and NPRA), house and cottage interiors (Dorset and Warwickshire), bee keeping (Nottinghamshire), fishing for elvers (Gloucestershire), fish and fruit sellers (Cheshire and Wirral), and the village forge (Leicestershire). (See figure 93.)

93. Interior of skep beehive. Photographed by E. and A. Bush, April 1900. Photographic Survey of Nottinghamshire *(courtesy of Nottinghamshire Archives, DD/1915/1/640).*

What was desired was a sense of naturalism and immediacy of the lived experience: "Here the photographer should not yield to the temptation of making mere portraits or posed groups of the workers. Instead, his aim should be the portrayal of the actual methods of working, and to illustrate how the finished article is produced."[174]

In many cases, the everyday was conflated with what were termed "passing events," which marked the linear time of the everyday, a time in which photographs could "stop the fleeting events of the moment" and produce "a truthful and accurate record of current events."[175] These photographs were related to the integral role of modernity in the practice of the surveys and a sense of anticipated memory. Some of these photographs often have more in common with Stone's "theatre of tradition," such as Walter Ruck's donation to the Kent survey of commercially produced photographs of the proclamation of King George V in Maidstone, or Charles Ferneley's photographs of the sheep roast to celebrate the end of the South African War (the donor of the sheep being carefully recorded).[176] (See figure 94.) Many of these photographs were produced commercially to

address the photographic and memorialising needs of the community, not merely for survey collections. But others, like the anthropological photographs, were a more immediate and unstructured response, for instance, the numerous photographs of coronation bonfires in different survey archives, or the photographs taken by A. J. Leeson, presumably from the stands and with a handheld camera, of the famous Warwick Historical Pageant of 1906.[177] While passing events were not directly inflected with a sense of loss and disappearance, their value was seen as holding the possibility of memory that would be relevant in the future. While the recording of passing events was also inflected with a sense of national identity the national was also expressed through the local. As *Amateur Photographer* commented on the occasion of the coronation of King Edward VII in 1902, "No doubt many interesting local celebrations will take place in all parts of the country which will be of interest to the future, and it is only by the efforts of local photographers that a collection of pictures of such events can be got together."[178]

Disappearance was also articulated, however, as a loss of that sense of locality and historical depth that was so central to the delineation of survey desires, historical imagination, and the production of photographs: "Dress is becoming uniformly ugly—a smock frock will soon be a curiosity—and improved means of communication are rapidly reducing the manners and customs of every county to a dead level."[179] Survey advocates observed, "These old customs are gradually dying out, and it should be our endeavour to obtain a photographic record of such unique local scenes."[180] Nonetheless, concepts of survival also opened the space of more romantic and elegiac perceptions of the survival of the past as "the real" was placed into imagined constructions of place and defined

through those imaginings as motifs of the local. This is especially marked in Dorset, where the photographic survey was closely entangled with the imagined Wessex of Thomas Hardy's novels, their harsh realism notwithstanding. In launching the Dorset survey with an address to the Dorset Natural History and Antiquarian Field Club, Thomas Perkins stated, "We see the old-world habits and customs passing away, the smock frock of the rustic giving place to the shoddy jacket or the fashionable broadcloth. Village life is changing, the maypole is now seldom seen, the fairs are shorn of the ancient glory, the harvest home has given way to the thanksgiving service, and perhaps many evils die with these old things, and the changes are changes in many cases for the better." Yet Perkins, who was a personal friend of Hardy, appealed to local sentiment by framing the concept of survey through Hardy's representations of an imagined Wessex past: "His books are photographs, so to say in words, but I should also like to see photographs in permanent platinum salts of such men and women as Gabriel Oak with his sheep on the downs, Tranter Dewy with his hogs head of cider, Old William with his bass-viol . . . and poor pure Tess among the cows on the dairy farm, or hacking Swedes on the bleak hills of central Dorset."[181]

However "old customs," whether cyclical or everyday events, were not exclusively rural, although they were perhaps rurally inflected in terms of survival. Some of the most coherent series of images in this category emerge not from rural environments but from a keen sense of urban vulnerabilty. Not only is this related to questions of civic pride and a sense of history, but there was also a strong sense that questions of survival and tradition were equally under threat from the radical change in both the social and built environments of the urban space.

The NPRA, for instance, not only included rural customs but some of those customs that survived within the great cities. While there is extant material from Manchester, Exeter, Birmingham, and Bristol, a majority of the urban work was focused on London and the NPRA. Stone himself photographed the custom of "picking up sixpences" in the churchyard of St. Bartholomew, Smithfield, on Good Friday. (See figure 95.) There are important sets of children's games from the East End of London by Henry Malby, of street traders by Edgar Scamell, of market traders in Manchester by Samuel Coulthurst, and of traders in Birmingham by numerous photographers.[182] There were constant pleas for photographs of "everyday scenes and events which daily occur around us" such as those of "Life in the London Slums." Implied in these photographs is that the survival of traces of entwined national and local origins could be found, even in the modern city. These photographs were positively inflected, for even beneath the veneer of the modern imperial city were survivals that symbolised the deep past of

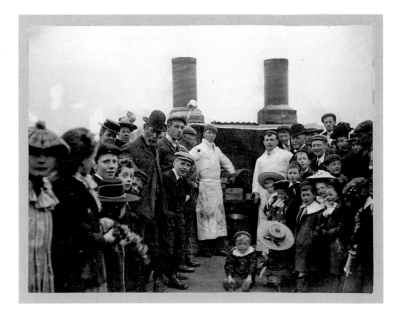

94. Sheep roast to celebrate the end of the South African War, 1902. Radcliffe on Trent. Photographed by Charles Ferneley. Photographic Survey of Nottinghamshire *(courtesy of Nottinghamshire Archives, DD/1915/1/341).*

the city's social structure and functions. These survivals, according to Gomme, "put Londoners in touch with [the] living past [and with those who] would awaken to a pride and sense of civic virtue the city had known under the Romans."[183]

Significantly, many of these urban customs and buildings, like those of the Tower of London and the City of London, were connected to law and order. Indeed, throughout the surveys, and the NPRA in particular, there were many photographs of stocks and whipping posts, sites of ducking pools, and, from Leominister in Herefordshire, a ducking stool itself (preserved in the church and photographed by Stone).[184] The same concerns and cohering forces of these photographic representations found in the larger cities are replicated in the smaller urban spaces, where the civic ceremonies, invented traditions, and ancient regalia of small English market towns, such as Hungerford in Berkshire or Ripon in Yorkshire, were photographed. Here, along with Stone's Parliament photographs, a clear sense of making visible the values on which constituted English identity, as

custom, local, and national identities and civil order, played out as a cohesive force for the camera. These are survivals that matter, because they constitute the roots of positive identities. It is tempting to read this patterning of photographs as reactionary, reflecting only the status quo and conservative concerns with law and order. It is possible that this was part of the discursive shaping, especially in Stone's rendering of the historical topography, marked by the institutions of government and the legitimacy of certain power structures. But the shape of this record is equally related to patterns of visibility and, in turn, patterns of local civic pride, local claims to authority, and local knowledges and historical imaginings.

The shifting photographic practices around cultural representation that mark the different stylistic approaches to recording folk custom recall the resonances of anthropology and its own concerns with salvage, for these shifts in what was deemed appropriate were not unique to the survey movement. The 1890s saw two attempts, which were also reported in the photographic press, to define evidentially appropriate photographic strategies for recording cultural information. On the one hand, there was the naturalistic ethnographic recording advocated by Everard im Thurn, and on the other the interventionist scientific control that was used to demonstrate an ethnographic point, an approach advocated by M. V. Portman.[185] These debates, themselves part of a larger debate on the morality and aesthetics of intervention and on evidential naturalism in photography, went not only to the heart of the photographic surveys and thus to how they conceptualised their anthropological activities, but were also ultimately concerned with the nature and purpose of photography itself. Portman's vision of the inscriptive certainty and immutable mean-

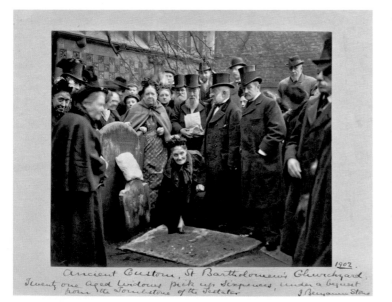

95. "Picking up Sixpences" on Good Friday, St. Bartholomew, Smithfield, London. Photographed by Sir Benjamin Stone, 1902. NPRA Collection *(photo © Victoria and Albert Museum, London).*

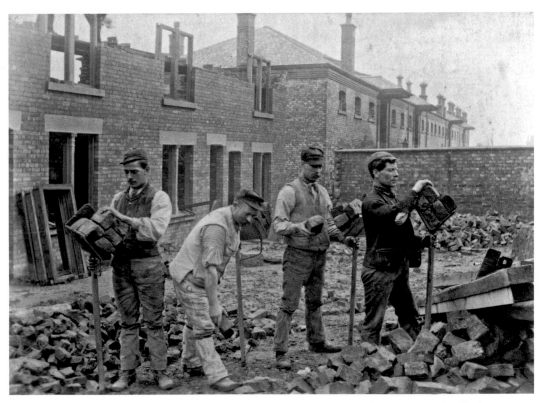

96. Bricklayers. Photographed by George Wheeler, c. 1896. Photographic Survey of Manchester and Salford. Bromide prints in 6½" x 4" format *(courtesy of the Manchester Room at City Library, Local Studies).*

ing of the photograph had much in common with Stone's idea that culture was performed for the camera to create anthropological fact. George Wheeler's photographs of Manchester bricklayers at work for the Manchester Survey (c. 1896) could also be seen as relating to the absorption of these scientific visual practices. (See figure 96.) He carefully poses them to show the modes of dressing and of carrying bricks in a hod, while in a companion image the practices of bricklaying themselves are demonstrated, visually arranged and arrayed across the picture plane to present straightforward visual facts. Likewise, A. H. C. Corder's photograph of a man holding a Sussex threshing flail up to the camera is reminiscent of the ethnographic type found in Portman's method.[186]

Conversely, many of the photographs of the everyday accorded with a sense of immediacy and naturalism emerging as a central observational trope in representations of culture. For instance, Coulthurst's photograph of an Ancoats organ grinder with small children and R. G. Dugdale's photograph of fishing for elvers, were both taken with handheld cameras and employed a sense of naturalism, immediacy, and truth to observation that has more than a little in common with im Thurn's approach.[187] This trace of immediacy and the experience of the everyday, rather than the controlled demonstration of scientific fact, was becoming the increasingly dominant truth value in record photography. That trace is another marker of the shifts in survey ethos and practice that clus-

97. "Fishing for elvers, near Gloucester." Photographed by R. G. Dugdale, c. 1900. Photographic Survey of Gloucestershire. Bromide print and hand held Camera? *(courtesy of Gloucestershire Archives, SR44.36297.122).*

ter round the future utility of photographs. (See figure 97.)

The patterning of the archive constitutes a materialisation of the patterns of historical concern. At one level, it constitutes a predictable pattern of antiquarian interest and local desire inflected with questions of class, authority, and the power and ability to make historical statements for the future. The emergence of these patterns of devotional sites was part of a broader and widely disseminated series of ideas around local and national development. Within this, the nation disclosed itself and realised itself at multiple levels, through a visualised response to the historical, in ways that can be linked to the idealist philosophy of liberalism.[188] These are

not unfamiliar values and strategies, and photographers were picking up, in various and ambiguous ways, on what had become, by the late nineteenth century, commonplaces regarding the past and the built environment, and about disappearance and survival. But what is important was the ability of these ideas to frame photographic activities in dynamic ways. That ability presented, on the one hand, a sense of fragility due to the encroaching and destructive influences of industrial mass-modernity, but on the other hand were customs of ancient lineage, alive and well, and, in many cases, revived. And if all else failed, those customs survived in the prosthetic memory of the archive. The discourse of loss and disappearance also carried a neo-Lamarckian resonance in the significance

of the apparently irrelevant and unnoticed detail of the ancient within the everyday, for it was impossible "to say to-day which or what description or photograph out of those they were gathering together would in a generation hence be of most interest or value."[189]

While the surveys aspired to systematic and objective notions of "historical value," their choice of subjects and their photographic treatment was often inflected with the material textures of age-value within a discourse of disappearance and survival. It was not merely the fact of historical existence that endowed these devotional sites with their power of historical imagination, but the very appearance of a natural decay that was not arbitrarily disturbed, and which stood for an historical and thus a social stability. But photographers were integral to this discourse, for while greater objective historical value was located in the original form of the historical object, as Riegl argues, the cult of historical exact copies (in this context, photographs) could be endowed with documentary significance and thus historical power.[190] Although it should not necessarily be claimed that "the object world and visual copy merge," the impulsive response to loss and disappearance that the photographs represent can nonetheless be seen as a "bringing closer" what Benjamin describes as "the urge [that] grows stronger to get hold of an object at very close range by way of its likeness, its reproduction."[191] The photograph became the salvage tool par excellence, bringing closer and holding. It was able to merge the photographic exactness of scientific inscription with a fluid, temporal dynamic of historical imagination. These collective values and practices enabled the photographs to stand for the collective past, to define devotional sites and establish mythscapes. For as Duncan Bell has argued, the more successful, "objective,"

and scientific history might become, the more strongly mythscapes emerge: "Myth is history's *alter ego*, accompanying like a shadow wherever it goes: Indeed, paradoxically, myth is the best measure of history's own success."[192]

In all these debates about loss, disappearance, survival, and photography, there perhaps remained a unifying discourse only partially articulated in the survey imagination. Ultimately at stake were questions of the disappearance and survival of the island of Britain itself, site of the cultural origins and survivals that shaped its people. This sense of loss was understood not only in terms of the destabilisations of empire and the fear of miscegenation, but perhaps even more importantly a sense of an instability and erosion besetting the island of Britain itself. There are repeated references to coastal erosion, which can be linked to the survey impulse. Erosion was noted by Harrison in launching the concept of international photographic survey in 1893 as he used the forces of the sea as a metaphor for the disappearance of the historical: "Successive generations of mankind pass away and leave but little more record of their physical peculiarities than the waves which beat upon the seashore."[193] Articles on coastal erosion appeared in popular magazines, such as the *Strand*, and a parliamentary commission on coastal erosion, photographed by Stone as part of his Parliamentary series, sat from 1906 to 1911.

There was a sense in which local history and local studies, such as photographic survey, could recuperate the physical extent of historical England. It is significant that the Norfolk survey, with its threatened North Sea coastline, devoted a whole box to coastal erosion, notably images of the medieval church of Eccles as it slowly disappeared into the sea. (See figure 98.) The church's plight, which had been discussed

98. The remains of Eccles Church. Photographer unknown, c. 1912. Photographic Survey of Norwich and Norfolk *(courtesy of Norfolk County Council Library and Information Service).*

and illustrated in later editions of Sir Charles Lyell's *Principles of Geology*, became an archetype of fragility and disappearance.[194] Likewise, survey advocates noted, "The changes on the sea front at Sheringham during the last twenty years should not be lost to public memory. They are valuable lessons for those interested in protection against sea encroachment." Photographs of the erosion of the Essex coast were also donated to that county's survey in 1906, photographs that "might become interesting in connection with the rapid changes which are taking place in that part of our coast."[195] It was perceived as an ultimate irony, that while the nation's imperial expansion was dependent on

sea power, that the very waves were destroying "sea-coasts, the beauteous villages and smiling pastures which have been swept away for ever into the inexorable salt flood."[196] As the *Strand* commented elegiacally, evoking the devotional sites of photographic activity: "It is pathetic to see churches . . . hanging on the very edge of a precipice and all but in the maw of the ocean which a century or two since were the centres of happy villages, all unconscious of doom, of which to-day not a trace remains but the coffined bones and dust of the 'rude forefathers of the hamlet'—dust which next year or the following will be scattered to the four winds of Heaven by the tottering of the cliff."[197]

Photographic surveys were involved in a work of public utility. This utility was linked to the sense of public duty and moral imperative that informed not only contemporary concepts of rational leisure, as typified by the idea of photography as a hobby, but a sense in which amateur photographers and historians could participate in the recording, and thus in the inscription, of history. The act of photography and the resulting photographs collected and archived under the rubric of "survey photography" were active in the public domain. This function was "public history" in that it was a history constituted and reproduced through the public domain by the photographs themselves, but also through their performance in spaces of knowledge production—the press, the exhibition, and the lantern lecture. This performance was the ultimate intention for survey photographs and the way in which photographs were put to work within a visual economy shaped by producers, archive practices, and the dynamics of utilization within political, economic, and social matrices. In the spirit of Kansteiner's assertion that studies of cultural memory and memory media require a consideration of audience and their social agency, I shall argue that these practices ultimately produced photographs as a constituent part of collective historical imagination and cultural memory.[1]

The idea of public history, as it is currently constituted, acknowledges the role that knowledge plays in people's lives and is concerned with remaking the past in useable form—to create and imagine a different future.[2] Central to the aims, objectives, and rhetoric of the survey move-

"To Quicken
the Instincts"

*Photographs as
Public History*

ment, both nationally and locally, was the vital public engagement with the photographs produced. The public role of photography and historical imagination was part of a vast network of increasingly visualised historical imagination, in which decisions to record photographically, to archive and show photographs in publications, local conversazione, salons, lantern lectures, and exhibitions "rippled across the social structure," as "practices of mass-seduction and the mass-production of illustrated history," through an array of sites of knowledge production, and were managed through a range of visualising technologies.[3] It was hoped that interaction with the photographs would inspire a sense of community, citizenship, and national pride for the general good by inculcating a shared past and shared values. While the number of people actually producing photographs was limited, the results of their work were seen by a substantial number of people and their photographs were intentionally used to foster a historical sensibility among the public. For example, the *Bromsgrove Messenger* reported a lantern lecture on Westminster Abbey given by Stone to the East Worcestershire Camera Club in 1896 as a subject "of considerable interest to any freeborn Englishman and Englishwoman when they walked through the aisles of the abbey, pictured the different scenes that had occurred there at different times of our history. . . . [The] memorials within its walls were an inspiring influence to their young people."[4]

The authority of the photographic trace as a production of fact was key, as *The Camera as Historian* stated, "In the fostering of such a consciousness exact records of fact, by reference to which misunderstandings and misapprehension can be dispelled, have their fitting place."[5] In ways that reflected William Morris's belief that looking at the arts and the quality of life were integrally linked, members of the survey movement, and especially its facilitators, located its sense of social improvement through photographic access to historical topography that would foster an historical sensibility focused on place, and access to historical survivals mapped across the landscape or townscape: "How valuable are these and similar glimpses into the past history of the social condition of the people. There is perhaps nothing more useful in guiding the present generation."[6]

Underlying this concept of public utility and the expectations placed on the images was a distinct neo-Lamarckian quality. This line of thinking, which was widely disseminated outside science and increasingly influential in the late nineteenth century, maintained that external forces must have some bearing on human development, that these external forces, sometimes in the form of apparently barely perceptible or minor details, imprinted themselves on the organism through repeated exposure, and that these acquired characteristics were the basis of heredity.[7] Thus, not only can one read the survey archives themselves as a form of prosthetic memory bank, but as an external force that, through a sense of affective photographic "presencing," rather than simply photographic representation, would shape the future. The processes of the dissemination of the photographs provided just such an environment for repeated viewing. Through this dissemination, concepts of the past and its values were performed and multiplied in the future, through a process famously noted by Barthes, in which "The photograph mechanically repeats what could never be repeated existentially."[8]

In a similarly neo-Lamarckian cast, it was also through photographs, with their reproductive and repetitive qualities and their random inclusiveness, that unnoticed detail could emerge as

significant. The espousal of such ideas within the broader rhetoric of the survey movement implied that the photographs, when viewers absorbed their information and values, could foster a newly invigorated sense of the past that could be handed down to future generations, as sensibilities to the past imprinted themselves on the culture of both photographers and viewers. There is, for example, a neo-Lamarckian resonance in the significance of the apparently irrelevant and unnoticed detail in the comment on survey photography by Stone: "It was a matter of extreme importance to the future generation that objects and events now common should be preserved and handed down, and it was astonishing what great secrets could be exposed by putting together what looked like insignificant details."[9]

Such ideas are echoed repeatedly in the rhetoric of the photographic surveys, as people were to be improved by constant exposure to the photographic traces of their past, enabled through access to the material. In this way, the past could resonate through the future, multiplying, disseminating, and repeating the existentially unrepeatable. It was this idea that united archive, exhibition, and lantern lecture. Public engagement with the photographs was therefore perceived as having a double relevance, not only to teach the facts of history but to elevate, imprint and transmit moral values through both the symbolic value of the subjects photographed but also through their wider connection to qualities of citizenship, local, national, and, by implication, imperial — values that would be carried to future generations.

Entangled with these ideas, photography was also increasingly becoming a touchstone for debates on the benefits and consequences of extensive and increasingly secular mass-education. In this context, cultural literacy could be achieved through visual literacy, in ways that were linked to questions of social mobility and aspiration.[10] Photography did not, of course, invent this set of assumptions, but the suggestion of neutral vision and facticity, coupled with the vast reproductive capacity of the medium and those underlying transformative impulses, enhanced the power of the argument.[11] All these strategies can be connected with the reform and expansion of education more broadly. Mary Warner Marien has linked the use of photography in mass-education to broader campaigns for literacy. In the course of the nineteenth century, photography expanded from being part of an aesthetic education for an elite (one thinks of the vast number of photographs of classical statuary, medieval antiquities, and Italian Art in circulation since the 1860s) to a mass medium that was concerned with the "record building and externalisation of thought that photography and literacy support[ed]," and created a "sharper recognition of pastness" as facts were dispensed through photographs.[12] The teaching of history was increasingly encouraged in elementary schools: as a contemporary commentator stated, it was necessary that history in schools was "taught, or ought to be taught, in the hope that the study will engender a patriotic pride in connecting the memories of the past with the scenes in which great things were done and endured by our forefathers, or in which generation after generation have lived their unrecorded lives." This commentator goes on to suggest that the treasures of the national landscape were as important as those in the British Museum.[13] This is precisely why Stone wanted to deposit the NPRA photographs there; so that the landscape, the built environment, and the associations of history were added, prosthetically, to the British Museum.

The aspirations for the photographs were

also related to ideas of universality and factuality, which were key to the mass-production and dissemination of information, demonstrated in particular in the rise of the illustrated magazine. Magazines such as *Illustrated London News*, *The Graphic* and a mass of weekly and monthly journals emerged after the introduction and improvement of half-tone image printing in the 1870s and 1880s.[14] History was increasingly visualised. This visualisation is found in an extensive range of publications. For instance, the illustrated version of Green's *Short History of the English People*, which appeared in 1897 (a copy of which Stone owned, and he was probably not alone among survey contributors in this regard) and which was referred to as a case for visual history at the inaugural meeting of the Essex Photographic Survey.[15] In another example, children learned English history from teaching books by colouring in outlines of famous historical paintings from major British art galleries, paintings such as Sir John Everett Millais's *The Boyhood of Raleigh* and W. F. Yeames's English Civil War melodrama *When Did You Last See Your Father?*. The illustrations were accompanied by short texts presenting the main historical facts of a period. Such books aimed, in a rhetoric remarkably similar to that concerning survey photographs, to "enable the child to visualise the event, and thus associate *historical fact* with *geographical setting*."[16]

That survey photographs constituted part of this visualisation of the past was made clear, for example, Mr Welch, the librarian of the Corporation of London, stated in 1902 that "record photographs" were increasingly called upon as teaching aids for board schools and as a way of teaching history from the "known" to the "unknown"; that is, from the local to the general, national, or imperial, *The Times* reported, "Con-necting the story of the past with the actual local life of the present . . . the School Board believe that the knowledge of the local area and the feeling of local patriotism which . . . custom helped to produce can be secured by the presence of each successive generation of school children at lectures on local history . . . amply illustrated by magic lantern."[17] In the same vein, a school inspector, Mr. A. P. Graves, urged that school halls should be "hung with photographs of local and other views, which might be turned to good account in the training of scholars."[18] The Surrey survey noted that a good deal could be accomplished "by showing children these pictures of the past."[19] Indeed, possibly inspired by the activities of the Surrey survey, the Surrey Education Committee ordered a million pictorial postcards of places of historical interest in the county, at a total cost £500, to be given as rewards to encourage regular school attendance.[20] Likewise in 1885, Harrison, developed the extensive use of lantern slides in teaching science, slides made from his own photographs, thereby self-consciously bringing the ethics and authority of direct disciplinary observation into the classroom. He suggested that photographs should be used in "beautifying the bare walls of our Board Schools and of similar institutions. Frames of good photographs—and especially perhaps, enlargements—would bring forcibly before the minds of children some of those beauties of nature which, alas! many of them never behold."[21] Furthermore, through the involvement of local natural history societies, objects of natural history were also placed in cases on the walls. Harrison continued on this theme, "I feel sure that the Kyrle Society—which is doing an excellent work in adding an element of beauty to the interior of our schools—would welcome the gift of good local photographs,

more especially if they were produced by some permanent process, as platinotype or carbon printing."[22] These comments point to a very real belief in the way in which the understanding of the past in the future would be shaped by photographs. In this, visual teaching would become central: "Pictorial Illustration too was rapidly taking the place of word descriptions and complex text-books. The former conveyed ideas more readily, and in more acceptable form than the most finished word-pictures, and it is quite possible that the chief part of elementary education of another generation would be thus imparted . . . it seemed therefore, almost a national duty that photographic records of our time should be collected and preserved for the use and instruction of those who were to follow us."[23]

The idea that images could unite the nation, presented in some of the more extreme rhetorical claims of Stone and the NPRA, were overoptimistic, but the circulation of photographic images did bridge the gap between social groups, building a mass-readership that would be receptive to the idea of "history photographs."[24] As Jennifer Tucker has argued in relation to scientific photography, the massive expansion of the illustrated press not only contributed to a general awareness of, and a use of, visual evidence in a wide range of fields, from current events and travel to microscopy and spirit photography. Illustrated publications also "linked visual reproduction with ideas of the democratisation of scientific and artistic taste."[25] Survey photography was integrally related to the rise in illustrated publications. Survey photography was part of a vast network of increasingly visualised historical imagination in which the display and discussion of practices of record photography, of archives and publications, taking place in

local conversazione and salons, during lantern lectures and exhibitions, constituted a highly significant massing of the production of illustrated history over a wide social range.

Historical enthusiasm, and the emergence of historical activity at all levels of society, does not suggest a society that was becoming dehistoricised or insensitive to its past, as has been argued by some critics of modernity. Rather, there was increasing public interest and public articulation of the historical during this period, an increased interest of which the photographic surveys were but one manifestation. The enthusiasm for the potential of photographs as public history can be understood in relation to the broader interest in history at a popular level. As the distinguished historian Mandell Creighton stated in 1897, the year of the NPRA's founding: "There can be no doubt that in late years there has been a very decided increase of general interest in history amongst us. The nature of political questions, and the tendency of thought about social questions, have given decided impulse in this direction. In small towns and villages, historical subjects are amongst the most popular for lectures; and historical allusions are acceptable to all audiences. It was not so fifteen years ago."[26] Opinion was not, of course, united on this point. Although one member of the Surrey County Council was moved to comment rather sourly that "he should like to see more interest taken in it [survey] by the lower middle classes and the lower classes, who nowadays had no relish for anything connected with olden times and were all wrapped up in mere matters of £.s.d.," the local paper in Norwich was of the opinion that "there [was] plainly in the community an eager sense of the interest of things present and past and a full perception of the value of putting them on record."[27] Further-

more, an exhibition of Old Leeds in 1908 at the city art gallery was visited by over 40,000, although it is not clear if the exhibition included photographs. One observer noted, "That fact [of the large attendance] alone will be sufficient evidence of the interest the general public takes in 'grandfather's days.' Not only has there been appreciation shown by the citizens of the efforts of the promoters by their attendance, but the entire issue of the first edition of the Handbook has been sold out and a large hole has been made in the second edition." *Amateur Photographer* noted, "Readers who have sympathies with record and survey work—in fact all photographers who can make it possible to visit—will find much to interest them [in the exhibition]." [28]

Interest in photography was integral to interests in history through illustrated guidebooks, places of literary association, and the sale to tourists of topographic photographs of castles, abbeys, cathedrals, and historical towns. This was increasingly so with the rise of the postcard trade in the first decade of the twentieth century. The broad interest in matters historical was clearly apparent in the culture of the camera clubs in which the visualisation of the historical played a major role. These visualisations were presented as informative entertainments, often a mixture of pictorialist renderings of the picturesque concept of history and historical education. As in other associations, from literary and philosophical societies to mechanics institutes, an enormous amount of low-level historical education took place through camera clubs, photographic societies, and the photographic press, which not only worked to refine taste and discernment but to cohere a productive sense of the past. A common theme for lantern-slide lectures was the history of architecture, which was presented as a cipher for

English history. Camera clubs received illustrated lectures on, for instance, Cistercian Abbeys, the half-timbered buildings of Shakespeare country, medieval misericords, Welsh castles, the Perpendicular style (a uniquely English style), the Inns of Old London, and so forth. For example, in 1907 the Norwich and District Photographic Society held a lecture of 100 slides on Winchester Cathedral by a Mr. S. Kimber, a member of Southampton Camera Club and the Southampton survey, which was also attended by 250 members of the public. [29] Literary landscapes also played a major role in this imagined historical topography. For instance, Henry Snowden Ward and his wife Catherine Weed Barnes Ward gave photographic lectures on "The Canterbury Pilgrims" and "Shakespeare's Town and Times," in which the audience was able "to picture what remains of the scenes that Shakespeare saw." [30] These events and their enthusiastic reception point to the way in which the discourse of survey, and indeed photography more generally, was shot through with the "competence of experience" that, as theorist of history Jörn Rüsen has argued, characterises historical consciousness— "learning how to look at the past and grasp its temporal quality." [31] (See figure 99.)

These educational functions of the amateur camera clubs extended, of course, to the values of survey itself and were indeed formative in the ethos from which survey developed. [32] For instance, "a capital set of lantern slides of Old Birmingham places" was shown by Frederick Lewis, the assistant secretary of the Birmingham Photographic Society. The slides revealed "places which in many instances now dwell only in the memory of some of the older inhabitants." [33] Likewise, in January 1900, Manchester Photographic Society held a "survey night." The first part of the evening was occu-

99. Canterbury Cathedral. Photographed by Catherine Weed Barnes Ward, c. 1903. Photographic Survey and Record of Kent. Also published in her *The Canterbury Pilgrimages*, 1904 *(courtesy of Maidstone Museum and Bentlif Art Gallery).*

pied by Mr. E. Hartley Turner, of Preston, who exhibited and described an interesting series of slides, made by himself from negatives taken by various members of the Preston Scientific and Photographic Society. The slides illustrated first fruits of the Preston Photographic Survey, "Old Parish Churches." This first part of the presentation was followed by an "exhibition of about eighty slides of subject bearing on 'Photographic Survey work in Manchester and Salford' by Mr S. L. Coulthurst, who gave a short account of some of the most interesting as they appeared on the screen."[34] The NPRA put together lectures and lantern slides extolling the virtues of such photographic activity, which were widely shown as part of the educative and inspirational agendas of the camera clubs. For instance, it was reported, "The Chorley Photographic and Sketching Society . . . had a set of slides from the National Photo-

graphic Record Association on 'Photographic Survey Work' which gives a capital insight into the manner of conducting photo-survey work, either local or county. The lantern slides accompanying the lecture were of much higher-order than is usually sent out with such lectures."[35]

Thus, although many involved in the survey already had highly developed historical interests, and there was, as I have noted, a sizable overlap in membership between surveys and local antiquarian, natural history, and literary and philosophical societies, there was an element of self-education, especially in the camera clubs, that, broadly speaking, attracted a wider social range than the old, established antiquarian societies. For instance, in 1897, C. J. Fowler, of the Warwickshire survey, claimed that survey photography would lead to survey members' "becoming students as well as photographers" so that, as another commentator noted, photog-

raphers could "study the buildings, their evolution, the events of which they were the centres, and the National epochs with which their parts synchronise[d], so as to be able when displaying their pictures to fit them into their proper place in the wonderful mosaic of English history."[36] These sentiments echo Harrison's call for a national photographic survey, that there "would be one great good resulting from the task." Indeed, from the beginning, Harrison had seen photography as an action and photographs as images indissolubly linked to education.[37] Similarly, for *The Camera as Historian*, the self-improving potential of survey photography was to result in the "turning of one's energies to systematic photography [that] will open up avenues of thought and lead to studies which will enrich life with pure pleasures of the intellect."[38] A demonstration of this, and perhaps a marker of a form of historical anxiety, is the practice of Godfrey Bingley, the Leeds amateur who was instrumental in the Yorkshire survey. He kept a little aide-mémoire of styles of English architecture, with drawings and dates, in the front of his photographic notebooks to inform his survey photography, and these notes were copied into his new notebook each year.[39] The observation of the built environment therefore constituted both an historical and a civic education in which photographers could be actively involved. As Peter James has argued, it is this sense of self-improvement and education through the democratisation of photography and "its inherent democratisation of participation in information gathering" that radically distinguishes Harrison's original vision for survey activity, and indeed many subsequent survey projects, from Stone's "simple promotion of the idea of 'history photographs'" that could be controlled in their production and passively absorbed through exhibitions and archives.[40]

Visual historical knowledge was thus integral to photographic culture. It was on this that the surveys drew and which they cohered into socially useful work. This emphasis on instruction and the related activities of collecting permeated the survey movement, but was certainly not restricted to it. Related hobby groups, such as cycling societies, produced papers on interesting topics, including the historical, "in the manner pursued at the different learned societies, and discussions would follow the readings[,] . . . [discussions] on the physical states and the peculiarities of places . . . visited by the reader."[41] There was a sense in which it was believed that firsthand experience of the historical environment would not only teach the hard facts of architectural history or British history but would act as a stimulus to the preservationist disposition more generally.[42] Thus the amateur photographers who contributed to the surveys were active in a much broader cultural matrix of self-improvement, social duty and competing visual practices, the tentacles of which extended over an enormous range of social and cultural activities.

THE PHOTOGRAPHIC PRESS

The presence, opinions, and influence of the press was of fundamental importance to survey activities. In particular, the photographic press aimed at amateur photographers forged photographic and broader identities in ways that were not simply reflective of culture but constitutive of it. The photographic press circulated the values that underpinned the whole concept of survey photography, values from rational leisure to objective observation, from moral duty to collective endeavour. The photographic press formed the point of cohesion and affinity of the survey movement and its forms

of dissemination. At the same time the general press, both national and local, disseminated the ideas and values of photographic survey widely and brought arguments about the purpose of the medium into the public domain.

By the end of the nineteenth century, there were many photographic magazines for all segments of the photographic community. There were magazines for the experimental chemist, for the amateur weekend snapshotter, and for the aspiring aesthete. Part of a massive increase in periodical literature, aimed at an increasingly educated and functionally literate population, this body of published material emerged in the 1850s and by the end of the 1870s was beginning to appeal to the increasing number of middle-class amateur photographers, as photography moved beyond the milieus of gentleman experimenters and commercial producers to an increasingly socially diverse and expanding group of amateurs.[43] The range of magazines and journals, especially those aimed at relaying a mixture of scientific and aesthetic values and information, was also available to an increasingly wide audience, as they were subscribed to by camera clubs, working men's reading rooms, and public free libraries. These journals were intended to democratise photographic, and indeed artistic, knowledge. As was so of the ethos of the survey movement, which stressed selflessness, self-discipline, and a commitment to the collective, photography, more generally, was seen as a hobby that required "openness and [the] sharing of information," indeed, "the phenomenal growth of the medium itself was widely attributed to the 'united efforts of many minds.'"[44] The ethos was also linked to related debates, such as those on architectural preservation, aesthetics, and the management of the rational leisure of photographers, by way of reported meetings and encouraged partici-

pation in record and survey. The photographic press was therefore a crucial part of the dynamics of photography in its public history role, and the way in which that role was experienced by amateur photographers. The photographic press reported meetings and lantern-slide lectures on historical subjects, it carried articles on the photographing of architectural features, discussed preservation, and commented on restorations, reproducing sets of values about the past.

As Benedict Anderson's well-known argument has it, imagined communities cohered in part through the circulation of commonly held values and shared sets of images and styles, perceived affinities and aspirations articulated and circulated through printed media, or "print capitalism."[45] The photographic press operated in precisely this way, creating what Jennifer Tucker has described as a "brotherhood of photography." The imagined community constituted through journals, newspapers, and correspondence "criss-crossed levels of skill, status and training," cohering the disparate elements that constituted the survey movement.[46] In a way that mirrors press support for wider preservationist agendas, such as campaigns against railways in the English Lake District and the enclosure of the New Forest in Hampshire, the photographic press regularly noted the survey endeavours of local societies, almost always with an admiring and encouraging tone: "All photographic societies will have their 'survey section' . . . new life will then be put into the societies which are cropping up in every town; it will raise them from the level of dilettante societies, and the work done will be of permanent service to the nation."[47] The press also carried snippets of information about historical buildings and folk customs, not solely in terms of the picturesque but as potential

photographic subjects worthy of intellectual engagement. Most importantly, the press also subscribed to the values of preservation, values inflected with a sense of loss, urgency, and action that underpinned the survey movement but also positioned photographers as dynamic and engaged citizens. "Energetic" was the word often used to describe contributors to the surveys. One commentator contended, "The members of an active and progressive race like ours so always try to excel in subjects which they take up as hobbies."[48]

Perhaps the major manifestation of the imagined community of survey was the "Photographic Record and Survey" column that ran in the weekly magazine *Amateur Photographer* from 1902 to 1908. (See figure 100.) With close links to the NPRA, *Amateur Photographer* offered readers membership of "The League of Record Photographers," kept an index of photographers with antiquarian interests who could be put in touch with one another, and published their photographs of antiquities, with commentaries, on its weekly page: "We should like every reader who is in the least interested, or who feels that he or she would be willing to join in an organised movement, to let us hear from them, in order that we may at least know approximately what amount of active sympathy and interest exists throughout the country.[49] With its merging reader involvement, photographic and antiquarian exchanges, and inspiring rhetoric, this column represented the core "print community" of the survey movement, disseminating its values week after week. The column commented on the responsibilities of amateur photographers:

> The rapid changes of the last few years will
> be yet more marked in the next decade, and
> it should be recognised almost as a duty by

all those who possess a camera to obtain when the opportunity offers records of subjects that in a short while will inevitably disappear. How great a number those subjects are, and how widely divergent in type, may easily be judged when we cite some of the prints that have been received during the last few weeks for inclusion on our "Record" page. In addition to the number of fonts and sundials, always popular subjects for the camera, we have received prints of fireplaces, old towers and halls, windmills, historical trees, stocks, pumps, gargoyles, and misereres, bridges etc. . . . Remember this when you next go out with a camera, and be sure and send us the results of your "record" hunting.[50]

Here the belief in indexicality and the truth of photography's mechanical transcriptions preserved and maintained the idea of historical topography as imbued with, and as an expression of, shared values that were filtered and performed through the journal column. Every week, the "Photographic Record and Survey" column published between four and six amateur photographs of some relic, bygone, or antiquity, with a short, informative and descriptive text. Thus, over its lifetime the column put between 1500 and 2000 amateur antiquarian images into mass-circulation. These ranged from photographs of traditional Welsh clothing, medieval market crosses, church rood screens, ancient stones, folk customs, and ancient yew trees, as well as the ubiquitous stocks and whipping posts. Indeed, the magazine devoted several weeks to photographs of ancient stocks alone: "So especially numerous have been the photographs and descriptions of ancient Stocks sent to us, that we are constrained to devote an additional page to the reproduc-

Photographic Record & Survey

"The Amateur Photographer" Record League

for the interchange of prints and information between all those who are interested in photographic record work.

Conducted by Edgar H. Carpenter.

The photographer who desires to specialise in some branch of architectural detail will hardly find a more interesting subject than the seven-sacrament fonts which are to be found chiefly in the Eastern counties. Of these the best is at Walsingham, where the font, as will be seen from the illustration, is raised on several ascents, the actual base being in plan an eight-pointed cross. These fonts are octagonal. On seven of the sides are representations of the sacraments of Baptism, Penance, Confirmation, Holy Communion, Holy Orders, Matrimony, and Extreme Unction; on the eighth side, facing the minister of Baptism, on the west, is usually a small representation of the Crucifixion. The little panels are often full of detail, the figures vigorous in attitude, and the accessories of great interest to the student of ecclesiological detail. Some of the panels will always be found difficult, being lighted flatly from a south or north window, in which case the use of a little magnesium wire to accentuate the lights and shadows will be found advisable. Fonts of this kind may be found at East Dereham and Westhall, and other places in Norfolk and Suffolk. They have often been mutilated by the Puritans. A complete record of every font of the kind, with each panel separately recorded, would be well worth the making.

The old Market House at Ross-on-Wye is an old red sandstone building of the seventeenth century, but has the appearance of being much older. It was built by the Thyme family in the reign of Charles II. The house seen to the left of the Market House is the residence of John Kyrle, the Man of Ross.

FONT AT WALSINGHAM. BY "ALFSTANE."

PANEL OF FONT, WALSINGHAM. BY "ALFSTANE."

FONT AT EAST DEREHAM. BY "ALFSTANE."

MARKET HOUSE, ROSS ON WYE. BY F. SIDLOW.

100. *Amateur Photographer*, Photographic Record and Survey *(courtesy of Birmingham Library and Archive Services).*

tion of a few of them, with yet another batch to follow next week."[51]

Amateur Photographer was not alone it its support for survey activity. The *British Journal of Photography* regularly ran features on photographic survey, some of them quite critical of the survey's practicability, and reported meetings of societies and exhibitions of survey work, as did *Photographic News* and *Photography*. *Photogram* magazine, under the editorship of Henry Snowden Ward and his wife Catherine Weed Barnes Ward, ran a column entitled "Doomed and Threatened," which listed buildings that should be photographed as a matter of urgency. Ward and Barnes are interesting because of their extensive and active championship of historical topography through their books such as *The Real Dickens* (1904) and *The Canterbury Pilgrims* (1904), books for which Barnes took the photographs. Not only did they fill the pages of their journal with discussions of a wide range of photographic practices, but, through the "Photographer's Guild," launched in conjunction with *Photogram*, through which they attempted to give shape to the sense of imagined community, "to provide the advantages of a photographic society for isolated workers all over the world."[52]

What the photographic press demonstrates is the way in which the survey impulse reached further than the formally self-constituted "survey movement." The journals advocated not only the survey and record movement itself, but also espoused surveylike activity, with its systematic aspirations, collecting, and taxonomic practices, as a form of rational and improving leisure and personal engagement with the past. As H. C. Shelley stated, "What could be more interesting than for an amateur to set himself the task of securing photographs of all the historic castles in England? He might limit

himself to those buildings erected after a certain date, or to those associated with a definite period of English History. I shall never forget the pleasure I derived from a sustained effort made to hunt out and photograph all the castles connected with the history of Mary Queen of Scots."[53] Although photographic productions such as Shelley's images were outside the exact parameters of the survey movement, in that they were not necessarily made specifically in response to appeals to make survey photographs, and were not archived for the collective good; they nonetheless share a similarly shaped historical imagination, often articulated through the devotional sites of village, church, and custom. As if to stress these collective values and intentions, the weekly page heading of the "Photographic Record and Survey" column, with its ancient sundial marking the passage of time, reproduced these values and placed readers' photographs clearly within this discourse, as tropes of the past are repeated, binding the "interpretative community."

One of the ways the photographic press attempted to support the survey movement was through competitions run through their magazines. These events were specifically intended to stimulate survey and record work: "The sole object of the competition being to stir up interest and learn what work was being done."[54] There was a strong tradition of competitions in the amateur photographic press offering small prizes, medals, and publication in the journal. Not only did they offer amateurs a chance to put their work in front of a large photographic audience but they promised the possibility of critique of the work and the accumulation of cultural credit in the public domain of photographic authority. *Amateur Photographer* was particularly active in this field. Unlike its more august companion the *British Journal of Pho-*

tography, which was the publication of the Royal Photographic Society and aimed more at the professional and scientific market, *Amateur Photographer*, founded in 1884, was specifically aimed at the amateur, as its title suggests. Often survey competitions were held in addition to the regular and themed competitions run by the journals, and as was the case in the photography of the surveys itself, there was a stress on public value and utility: "by this means the competitions [became] of real and permanent use."[55] The competitions were overtly linked to the interests of the NPRA in particular, on whose committee *Amateur Photographer*'s editor, A. Horsley Hinton, served. In 1900, for instance, there was a competition for survey photography that was judged by George Scamell, secretary of the NPRA. One of the honours awarded to the winners was that the photographs would become part of the NPRA collection in the British Museum.[56] What was stressed was the way in which survey competitions were different, not necessarily judged on aesthetic merit, and were therefore open to a wider range of photographers: "The competition is of such exceptional character and is one in which all may join with equal chance of winning a prize, that we hope the entries will be especially numerous. In which case we have promised to double the number of prizes."[57]

Competitions were also couched precisely in terms of the anxieties of loss and disappearance and the material qualities of photographs. The rules of *Amateur Photographer*'s competition in 1901, again judged by Scamell, specifically stated the requirements: "A set of six prints in carbon or platinotype are asked for, illustrating some buildings, or objects of archaeological or historical interest — sites, monuments, costumes or customs, especially such as, in the process of time, are in danger of being demolished,

obliterated, or forgotten."[58] This rhetoric was repeated in the announcement of the results:

> From the number and character of the entries sent in to the above competition we are glad to find that so many of our readers have secured photographs of an interesting and unique character, which are not only valuable now as records of archaeological interest, but may be of assistance to future historians, architects and archaeologists, who in many cases will probably be unable to see the originals for themselves, and we would advise photographers to take every opportunity of securing such records, which are not only of local but of national interest.[59]

Some competitions overlapped with other branches of amateur practice and its aesthetic agendas. For example, in 1897 *Photographic News* ran a competition for architectural photography that was won by Cecil Gethin, who was instrumental in the Herefordshire survey, for his photographs of Hereford Cathedral, photographs which were "good specimens of work of the kind, not very difficult subjects but still requiring some taste and technical ability to make satisfactory results."[60] Gethin presented prints of these photographs to the NPRA in 1901. What the competitions did, however, was extend and concretise the imagined community of survey by bringing into the survey movement photographers who might otherwise, for whatever their personal or practical reasons, have remained outside it. A number of photographers who make only one donation to the NPRA collection can be traced back to competitions in the photographic press: Frank Parkinson, a Spalding bricklayer and one of the few working-class contributors to NPRA, and

101. Scything hay, Cowpit, Lincolnshire. Photographed by Frank Parkinson. NPRA Collection (*courtesy of V. and A. Images, Victoria and Albert Museum, London*).

who won the gold medal in the *Amateur Photographer* competition of 1901 with a series of photographs of haymaking at Cowpit, Lincolnshire (see figure 101); Reverend J. K. Dixon, whose photographs of old London signs in 1903 entered the NPRA; and Luke Collinge, whose photographs of the window through which Horrocks observed the transit of Venus in 1639 also entered the NPRA collection through a similar record photograph competition held by *Photogram* magazine in 1905.[61] Conversely, other winners are known also to have contributed to local surveys, for instance, A. Laughton of Southwell, Nottinghamshire, who contributed to that county's survey; Frank Armytage of the Shropshire survey; and Frank Littledale, of the Worcestershire survey. There are many more examples. The participation in these contests shows the fluid networks, categories, and routes through which survey photographs were constructed, for not all the photographs were necessarily taken intentionally for survey purposes but became absorbed into survey archives through a complex matrix of subject matter, style, and ideas of appropriateness in relation to both the demands of competition and survey itself.

One of the striking things about the competitions is how, despite the rhetoric, there was limited interest in them after an initial wave of enthusiasm. Deadlines for submissions are constantly being extended in the hope of attracting more entries, and this reticence acted, to an extent, as a register of the limits and problems of the survey movement within the overall aspirations of amateur photographers. For instance, *Amateur Photographer* reported:

> Our persistent efforts to foster the interest of our readers in photographic survey work do not always meet with as much encouragement as we could wish. True it is that since we have regularly published "Record and Survey Notes" a large amount of correspondence on the subject has reached us, and often some interesting and useful communication. The Special Competition for survey work which closed on July 31st, and had been from time to time referred to in our columns since first announced (May 29th), terminated so unsatisfactorily that we have delayed announcing the result, hoping that some solution of the difficulty would present itself.[62]

This lack of response to the press encouragement of survey photography can perhaps be related to the shift from the influence of Stone and the NPRA that defined the values of photographic survey through the press, to the more local and independent survey and record societies, such as that of Surrey. These societies depended more on local networks for eliciting material and on local dissemination for articulating their goals, and there was a simultaneous and commensurate decline in the national rhetorics of survey. Furthermore, these societies moved photography away from the realms of

aesthetic and technical judgement, which had framed the competitions, to an emphasis on the archiving of the trace. The photographic press continued to report on survey photography, exhort survey photographers to produce images and provide a commentary on and support for the values to which survey endeavours aspired. For instance, following *Amateur Photographer*'s announcement of the founding of the Surrey survey the magazine reported, "We have received a large number of letters expressing approval and desire to take part in any organised movement which we can arrange in connection with Survey and Record work."[63] So despite the decline in participation in competitions, the photographic press, and notably *Amateur Photographer*, remained at the heart of the imagined community of survey practice. The magazine linked different localised endeavours rhetorically and discursively, by noting exhibitions, annual reports, and other activities, and by maintaining the values of survey through the Photographic Record and Survey column, which was revived by reader demand in 1910 after an absence occasioned by the merger of *Amateur Photographer* and *Photographic News* in 1908. Reinstating the logo featuring the sundial, *Photographic News* stated: "A great number of our readers have expressed a desire that we should devote some space to the subject of record and survey photography. It may be remembered that a few years ago this phase of photographic work was the subject of a regular weekly feature in *The Amateur Photographer*. In view of the recrudescence of interest in survey and record work with the camera that appears to have arisen, we shall be pleased to deal with the matter again."[64]

In addition to the efforts of the photographic press, another key publication of the survey movement was *Sir Benjamin Stone's Pictures:*

Records of National Life and History, which appeared in twelve parts as a fortnightly magazine in 1906, and costing 7 pence an issue, although it could also be purchased as a handsomely bound work. (See figure 102.) In *Sir Benjamin Stone's Pictures* survey and record photography was at its most nationalistic, as the discursive tenor of Stone's photographs became explicit. The publication also constituted a form of miniaturization and encapsulation of the survey project that would accord with Susan Stewart's analysis of the nature of the miniature and its dynamic containment and distillation. The book addressed the relations between, in Stewart's terms, the microcosm of the cultural survivals and the macrocosm of liberal democratic gov-

102. *Sir Benjamin Stone's Pictures.* Magazine edition, front cover *(courtesy of Birmingham Library and Archive Services).*

ernment. But at the same time, *Sir Benjamin Stone's Pictures* addressed the tensions between the realism of the photographs and the spatial and temporal relations inherent in miniaturisation that "transforms [the photographs] them into the infinite time of the reverie," a reverie related to interiorisation and nostalgia.[65] As the advertising material for the book claimed, "You will prize them all your life."[66]

Divided into two volumes, *Festivals, Ceremonies and Customs* and *Parliamentary Scenes and Portraits*, *Sir Benjamin Stone's Pictures* presented 188 half-tone full-page photographic reproductions. Much more extensive than the NPRA coverage, with which the book's images overlapped, *Sir Benjamin Stone's Pictures* included photographs of, for example, Knutsford May Day Festival, Hallaton Hare Pie Festival, and Garland Day at Abbotsbury. In the second volume, portraits of members of Parliament, parliamentary servants, such as furniture cleaners, and the spaces and practices of authority, from the Grand Committee Room and the Library of the House of Lords to the Lying in State of Lord Gladstone, were reproduced. The subject matter of each photograph is described in a short text with an explanatory letterpress caption describing the custom or function of Parliament. *Sir Benjamin Stone's Pictures* become vehicles for the presentation of positively inflected survivals of customs, with the traditional authority of Parliament and governance in a seamless discourse of national value. By the "records," presented in the book, readers would, it was claimed, "have their local patriotism stimulated, and their resolution strengthened still further."[67] For what coheres these disparate and apparently very different narratives is a sense of historical depth and continuity at all levels of society as they constitute the nation, but a sense that escaped "the ordinary

chronicles" of national life.[68] What this suggests is that, whatever the conservative frames of the discourse, the visual could constitute a different and even alternative narrative of history that valourised the local or the specific within the narrative. Furthermore, the longevity of the affect and historical worth was stressed through both the technologies of modernity and their materiality—as the advertisement stated: "The Pictures are reproduced by the Most Modern Processes, and Paper of Superfine Quality is used to ensure Perfect Results."[69]

The book itself attracted extensive press coverage, on account of Stone's public persona as the high profile maker of "history pictures." Significantly the volumes were published by Cassells, who, since the 1850s, had specialised in works of encyclopaedic self-instruction. They published standard and educational works in cheap parts; for example, *Cassell's Popular Educator* (1852), a self-instruction course that sold for 1penny a number, and popularised knowledge for the "operative class," also publishing, for instance, Shakespeare, Bunyan, Dante, and Don Quixote in cheap parts. By 1862 the publisher was selling between 25,000,000 and 30,000,000 issues annually, at a time when board school education had increasingly introduced classics of literature to the masses. Cassell's also published the enormously successful *Cassell's History of England*, nine volumes that ran to several editions. These volumes were extensively illustrated with dramatic line drawings and high-quality half-tone plates based on well-known contemporary history painting taken from historic paintings.[70] By the 1890s, Cassell's had eight monthly magazines running with sizable circulations, and nearly fifty other serials, and for the 1897 jubilee produced *The Queen's Empire*, "a pictorial record in which the modes of government, national institutions,

forms of worship, methods of travel, sports, recreations, occupations, and home life of the British Empire [was] portrayed by means of photographs."[71] In its coverage of the traditions of Parliament and government, the publisher anticipated the second volume of Stone's photographs. Furthermore, Cassell's was associated with firm moral values and temperance, which makes them a revealing choice for the publication of Stone's photographs. This decision to publish perhaps anticipated a desired or expected market or audience, for the book's introduction claimed, "While [the book] will appeal specially to some classes of the community, it has been planned for all."[72]

Overall, the role of the photographic press was not simply in relation to the promotion of the surveys and active encouragement of participation. The photographic press also reproduced the values that informed historical topography, the observation of architecture, restoration and preservation, loss, disappearance, and duty. Furthermore, these publications negotiated photographic value in the amateur domain, attempting to steer a broad and inclusive course while maintaining the aesthetic values on which, for many amateurs, photography had a claim. It was the photographic press that, above all, constituted a crucial focal point of the survey movement, doing much to formulate its values and stimulate its activities over a broad cultural domain that linked photography clearly and discursively to an evaluation of the past.

EDUCATION, ACCESS, AND HISTORY FOR EVERYONE

The values of survey and record photography were disseminated beyond photography itself, and practices were established to ensure the utility and efficacy of survey photographs. This utility was, of course, also secured within the discourses and material practices of production and archive. Libraries and, to a lesser extent, museums were at the centre of the exhibitionary complex, as Tony Bennett has termed it.[73] They were the open and public arenas through which the values of record and survey were disseminated, and they were, as the photographic press was, integral to the forging of an imagined community, not only in relation to survey and photography, but to history and a sense of the past. These institutions were indeed official spaces through which objects, such as photographs and their referents, were apprehended and values reproduced as "a set of educative and civilising agencies" and as "new forms of self-fashioning on the part of newly enfranchised democratic citizenships."[74] However, these institutional spaces constructed not only through the official and structured ways of seeing, but through the unofficial or incidental. The tensions between the desires of liberal instrumentality and the potential of photographs themselves to produce counterreadings, were entangled with questions of reception and the spaces in which knowledge is made and transmitted. These spaces were constituted not just through displays and exhibitions, but through networks of practices of access and visibility, networks through which densities of historical place were "performed" as exhibitions, displays, lantern lectures, and openly accessible archives in local museums and free libraries, in technical and mechanics institutes, in local societies and workers' education rooms.

Central to the efficacy and aspiration of the survey movement was, of course, the relationship with public institutions of collective memory and endeavour, namely museums and free libraries, places of safe deposit and public ac-

cess. These institutions, and their custodial relationship with survey photographs, and related practices of exhibition and lantern slide displays, were central to the role of the photographs in the negotiation of local identities and a sense of civic pride in its history. But importantly, these institutions and their activities were also places of self-improvement and rational entertainment.

Interest in survey photographs was part of the expansion and the public education libraries and museums provided in the late nineteenth and the early twentieth centuries. In some cases, these two institutions were often conceived of as parts of a unified whole. For instance, at Exeter and Maidstone (Kent) the boundaries between museum and library were somewhat blurred at this date. The questions of efficacy were extensively discussed during the 1890s, at precisely the time when Manchester, Birmingham, and Rotherham, for example, were linking photographic survey to those educational activities. Libraries often supported survey projects either financially or in helping with mounting, classification, and storage. However, there was at the same time uncertainty in the minds of some librarians about the status of these activities; for instance, in 1913 Mr. H. Rennie, librarian of the small town library in King's Lynn, wrote to George Stephen, his more experienced colleague in Norwich, about the legality of financial support for photographic survey endeavours. Stephen replied promptly, "I know that several libraries have paid for mounting and storage of local photographs presented by local photographic societies." He continued that it was the intention at Norwich "to defray part of the cost of acquiring a collection of local photographs from the income derived from the Library Rate."[75]

Libraries also offered particularly appropri-

ate sites of organisation and regulated access, physically, ideologically, and in the organisation of knowledge, and provided suitable moral environments in which the public aspirations for the photographs were realised. The knowledge-claims of photographs became authenticated and legitimated through their transmission in the ideal social domain, the space of the library. And as one observer noted, "To my mind the atmosphere of our free public libraries, in their freedom from officialdom and their painstaking helpfulness, comes as near to the Utopian conception of universal and mutual service as we are likely to reach in our generation."[76]

In words that echoed the rhetoric around survey photographs and their temporal qualities, Stanley Jast, of the Surrey survey, stated, "The reading room enshrines both the past and the present, but it energises the future also . . . To the mind which is alert it is an opportunity, a stimulant to be up and thinking, a powerhouse, not a grave."[77] Museums and libraries in the nineteenth century and the early twentieth are strongly linked to the emergence of the civic societies of modernity and have been seen by commentators variously as "agencies for creating modernity, policing the working class, creating legitimacy for the elite, producing national and imperial discourse, and developing new forms of professional and subject-based authority" related to broad ideological and educational ends.[78] As Patrick Joyce has argued, public free libraries were "central to the new vocabulary of the social" and to constituting new meanings of "the public" within the expanded liberal state. In this, libraries were entangled with museums, mass-education, and broader articulations of culture and citizenship, of which "governmental transactions as such were only one aspect of publicness."[79]

Of course, photography was, as were mu-

seums, galleries, and libraries more generally, a way of binding the poor to the values of the middle classes. Certainly libraries and museums were entrenched in paternalistic values. Since the 1880s, there was a need to turn members of the newly enfranchised, male working class into active, responsible citizens through education and incorporate them into the civic structures of modernity. This process had meant that libraries and museums also addressing the increasing desirability of understanding the self as a part of a newly figured social whole and as a responsive and self-aware citizen.[80] The new demotic working class had to be brought within a history that was now felt to be theirs. These libraries gave popular culture a tradition that reached back into the past of the nation, but a national past conceived in terms of the specific identities of a local and regional culture. Such a process "Conjoined local, regional and national culture [and] was elaborated alongside conceptions of the nation's inevitable development towards the traditions of a liberal parliamentary system."[81]

The survey movement was undoubtedly linked to these discourses of class, power, nation, and taste, and was marked by the tensions between scientific and picturesque visualisations of history and by the debate about the ultimate purpose of photography and where its transformative power might be located. However it can be argued that photographs became hegemonic, not through their individual readings or the intentions of the makers in any overt sense, but from "the sheer interconnectedness of many of the symbols and narratives of identity . . . reinforc[ing] each other because of their ubiquitousness, ordinariness and everydayness."[82] It was into this discourse that photographs of churches, cottages, folk customs, and bygones, but also of modern infrastructures,

were absorbed to perform their meanings as discourses of local and national merged.

The past visualised by amateur photographers was highly selective, legitimating certain forms of historical knowledge and preserving aspects of cultural heritage within certain institutional structures, such as those of education, which accorded with the dominant values and interests of the historical moment.[83] But at the same time, the production and archiving of photographs cannot be reduced to an overtly and cynical "social control" model, because the interaction between photography, ideology, and the individual was far more complicated than simple matters of propaganda and indoctrination would indicate. As Herzfield argues, the hegemonic model that assumes a binary split between producing elites and consuming "ordinary" fails to take account of how ideas and icons actually functioned in the heterogeneous environment of social use.[84] While libraries and museums were about creating distinction and legitimacy for local elites, and to some extent about controlling the working class, as Hill has argued convincingly in the case of museums, they were also sites of contestation, places where dominant ideas could be challenged and where the uses of collections could constitute "ways of operating"—the "innumerable practices by means of which users reappropriate the space organised by techniques of socio-cultural production."[85]

Working-class challenges might not always have been successful but, reflecting the background of many involved as survey photographers, the lower middle class was actually more successful in using museums and libraries than the traditional elites. Indeed, "it could be argued that municipal museums represented a more inclusive version of middle-class-ness by the end of the century."[86] Libraries were also

the spaces where there was increasingly free access to knowledge. This access combined with the ethos of inclusive photographic engagement (obviously limited to those with access to photographic technology) and access to the results of that engagement through free libraries. This access accorded with a liberal, if not quietly radical agenda, for as Patrick Joyce has pointed out, the liberal mode of governmentality that included archives, libraries, and museums carried "a certain tendency towards conflict and self-destabilization."[87] So while Stone's own vision of history, and the medium and technology of photography, with its inherent relations with industrial capitalism, remained conservative, on another register the entanglement of survey photographs with the free library ethos might be seen as a manifestation of the way in which photography, as an expanded practice, came to stand as a widely shared social metaphor for utopian promise and egalitarian politics.[88] While this might be somewhat overstating the case in regard to record and survey photography, what was at stake for the various constituent interests in survey was the nature of the future. Indeed, for some, a criticism of the collectivist vision in photography and, by implication, in the surveys, a vision that favoured the sacrifice of individual artistic ambitions in photography for "this work of lasting good," was that it might be seen as alarmingly socialist.[89]

Consequently, while it would be wrong to suggest an explicit radical agenda for the surveys, neither can they be reduced to that conservative retreat into the past. Despite the apparent conservatism that has tended to be the focus of previous commentaries, almost all of the surveys espoused the creeds of universal access, education, and improvement, which had informed reforming agendas and, at a micro-level, the formation of museums and free libraries, through successive legislation during the nineteenth century. For instance, in March 1904 the president of the Surrey survey, in a speech reported in full in the *Surrey Mirror*, commented, "A large number of people can be made familiar with the ancient beauties of the county, and we shall be able to hand down to our successors traditions of the past which will enlighten the homes and quicken the instincts of those who hereafter will have no opportunities of seeing the originals for themselves."[90]

It is significant that three of the librarians most actively engaged with the efficacy of the photographs they took into their collections, Stanley Jast in Croydon, George Stephen in Norwich, and H. Tapley-Soper in Exeter, were active and innovative librarians with an interest in library reform. Certainly, again, there were paternalistic elements; for instance Tapley-Soper is reputed to have refused to have anything as frivolous and unimproving as general fiction in Exeter Library.[91] But Jast and Stephen pioneered the introduction of open-access libraries for all, which meant that, within the parameters of the heavily filtered material on offer, there was a transparency of knowledge. Users could browse the shelves, putting information together in ways that suited their needs and interests, fostering self-help and self-education. Open access, argued Jast, brought the reader *into* the library "in place of relegating him to the forecourt of the treasure house."[92] Likewise, these librarians were committed to local studies and developed extensive local-studies collections within their institutions, and the acquisition of survey photographs and other visual materials became a logical and natural extension of those collections. While such collections were concerned with local identities and civic pride, it is essential to see them also as

part of a broader system of the democratisation of knowledge giving a wide section of the community access to knowledge that had previously been hidden in the spaces of the private collection. Photographs and their circulation were part of this. The local newspaper in Norwich, commenting on the library's growing survey collection, saw this opening up of knowledge from private space as social duty: "The collection is destined to be a treasure house of information to those who come after us; and whatever satisfaction private owners may get out of privately hoarding such interesting things, we are sure that there are very few who would not, now [that] such a depository exists for those things, know that their treasures are in public keeping, forming part, and adding to the value, of a comprehensive local record."[93]

Libraries and museums offered "proper regulation," through which viewers were disciplined, as viewing was shaped in certain ways and the photographs themselves could be monitored. Proper regulation and the controls it represents can also be linked to the entropic anxiety. However, we know remarkably little about viewing practices for the photographs, despite the good offices of *The Camera as Historian* and a mass of commentary, because these debates tended to represent ideals of engagement rather than actual experience. In most cases, the concept of proper regulation, as it was applied in a hosting library or museum, was also applied to survey photograph collections; for instance, the Surrey survey was "open for consultation by any member of the general public from 10am to 9pm every week day."[94] At Norwich, "a visitor requiring information on any given subject capable of photographic expression [could] apply at the Reference counter . . . and [would] then be shown . . . whatever pictures there may be bearing on the subject in hand."[95] There was

concern about damage through inappropriate handling, the responses to which were tackled materially. This material approach was used in the case of the loan of original material from the archive and lantern slides, for fear of loss or damage. The Surrey survey made a duplicate set "of representative work" especially for the purposes of loan exhibition, but stated clearly where the overall priorities lay: "The collection is, after all, got together for the public advantage."[96]

Generalisations are always dangerous, and in relation to responses to survey photographs the evidence is incomplete, but in terms of public engagement there seems to have been a pattern. There appears to have been a correlation between, on the one hand, surveys in the large towns with a very broad middle class and even artisanal participation, and the adoption of a broad liberal agenda of civic status, scholarship, democratic access, and utility that saw the photographic surveys as a form of public engagement with history. On the other hand are those surveys run by older, and in many cases, more socially prestigious antiquarian societies that tended to be concerned with their own purposes more than public access. This is reflected not only in their social makeup, but would appear to be part of the shift in the control and dissemination of knowledge, including historical knowledge and the scientific knowledge of photography, from the traditional amateur elites to the new professionals, the teachers, curators, librarians, and government officers involved in new patterns of civic association such as photographic and natural history societies.

This shift is manifested in exhibition and "outreach" strategies around survey photography. While the exhibitions of antiquarian societies and the like tended to be restricted to the private meetings of the societies, the

new groups, based in the institutions of public education and utility, employed survey photographs as a crucial part of the interface between photographic endeavours and the broader objectives of the movement. The Cambridge survey, although open to townspeople, was almost exclusively a university society and showed the survey's photographs as exhibits at the society's meetings, as did the Somerset survey, although the Somerset survey planned a public exhibition that never came to fruition. The Somerset survey's museum in Taunton Castle, however, was already "a fine series of views, unfortunately now much faded, of churches of one section of [the] county."[97] Conversely the Birmingham and Surrey survey groups held regular public exhibitions that toured the region and were reported extensively in the local press to encourage local interest in the work of survey. For instance, an exhibition of Sussex survey material in Brighton Municipal Gallery in 1909 was "intended as a stimulus to photographers to add to the collection."[98] In terms of sheer numbers and visibility the municipal gallery and public library, run by the new professionals, was more successful in positioning survey photography as a form of public history. Indeed, those surveys that died, such as the Somerset and Cheshire surveys, tended to be those that did not have a clear vision of the broader social and culture role of photography.

EXHIBITIONS, SALONS, AND LANTERN SLIDES

While long-term access was assured through the archives in libraries and museums, another major form of dissemination of survey work and associated values was through exhibitions. There is a sense in which exhibitionary complexes through which survey photographs were disseminated reproduced hegemonic notions of history and historical significance, clustered around the church and the village. However, there are more complicated and ambiguous dynamics at work. These exhibitions were held in publicly accessible places, often in libraries where, "trustees would . . . gladly receive them and exhibit [images] in frames on the walls or on screens in the museum."[99] They were often free of charge, philanthropically inspired and entangled with a wider sense of civic well-being.

Sometimes exhibitions were, as in Birmingham or Ealing, linked to the photographic society; other exhibitions, such as those in Surrey, Nottingham, Sussex, and Norwich, were devoted specifically to survey endeavours. These different contexts and environments positioned the photographs quite differently. In exhibitions of photographic societies and camera clubs, there was a certain resistance to the aesthetic dissipation threatened by survey photography, and for many, survey photographs sat uncomfortably with the more general exhibitions of photography. Furthermore, the purpose of camera club exhibitions was to display the technical mastery and aesthetic sensitivity of club members; they were showcases of aspiration, claims to authority, education, and civilised sensitivity, and the accrual of cultural capital through the production and display of photographs laid claim to these values. In the larger societies, the aesthetic weight and discourse of these exhibitions was enhanced by loan prints from leading artistic practitioners such as Thomas Craig Annan, or the maritime photographer Francis Mortimer. Thus in many ways in these exhibitions, survey photography, despite the rhetoric of collective good around it, threatened to destabilise the aesthetic agendas of the societies and the aspirations of amateur photographers. If these tensions were dif-

ficult to accommodate in the relative privacy of the clubroom and its meetings, exhibitions made these tensions public. There was a constant sense of excusing survey photography for departing from the norms of aesthetic aspiration. At Birmingham, for instance, judges were reminded of "the necessity of judging the Survey classes from the value of the photographs as records as distinct from their pictorial merit."[100] (See figure 103.)

Yet at the same time the practices of arranging photographs in classes and offering prizes, as was the practice of amateur photographic exhibitions more generally, also marked survey photography in certain ways, in the making of series and juxtapositions. The structure of the classes, for example, for three photographs of church porches presented in platinum demanded and reproduced certain ways of looking at historical topography. While this produced a coherent order of comparable data, it also served to reproduce aesthetically constituted tropes throughout the survey endeavour. It meant that the qualitative judgements, conflating aesthetics and trace, were upheld through the offering of prizes.

The practices of exhibition also marked the status of survey photographs within wider discourses. First, exhibitions were very large, 700 or 800 photographs were not unusual, and, in the exhibitionary practices of the time, images were displayed very close together. In many cases, they were hung in groups to construct an historical narrative of place. On many occasions, survey photographs were mounted and framed in groups, whereas artistic photographs were presented one to a frame. In part this difference in presentation was due to the ways the competitions worked. For instance, at Birmingham and Nottingham, prizes were offered for series of photographs around a theme, such

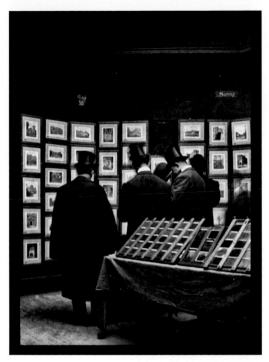

103. Judging Warwickshire survey photographs at the Birmingham Photographic Society Exhibition, Birmingham City Art Gallery. Photographer unknown, 1898. Lantern slide *(courtesy of Birmingham Library and Archive Services)*.

104. Exhibition of the Norwich and Norfolk survey, the library and art school exhibition room. Photographer unknown, 1913. Lantern slide *(courtesy of Norfolk County Council Library and Information Service)*.

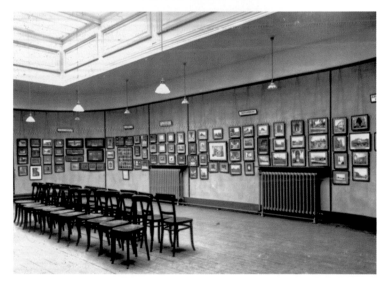

as three historic buildings in Warwickshire or three churches in Warwickshire. At Nottingham, the classes and prizes followed the structure and organisation of making the photographs, a systematic representation undertaken village by village. The competition of 1897 had,

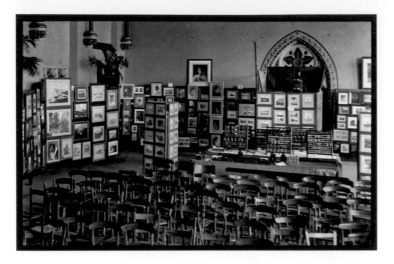

105. Exhibition of Warwickshire survey photographs on the right and on the central stand within the photographic society's annual exhibition, Birmingham. Photographer unknown, 1896. Lantern slide *(courtesy of Birmingham Library and Archive Services)*.

for example, a class for survey photographs of the villages of Linby and Papplewick, near Nottingham, that reproduced the topography of devotional sites. The competition's rules stated, "Views must include the Church, the Cross, the Main Street, and any other three views selected by the competitor."[101] Exhibitions also stressed the material values of survey. For instance, both Warwickshire, under the auspices of the Birmingham Photographic Society, and Nottinghamshire specifically forbade retouching prints submitted for competition. In these configurations, exhibitions were made to perform the methods, values, and aspirations of survey photography, and communicated them in the public space. (See figures 104 and 105.)

Because of the cultures of exhibition for photography there was also, despite the collective ethos of the survey movement, a tension between content and authorship. This tension is exemplified at Birmingham where photographs for the Warwickshire survey were hung, as works of art would have been, "by contributor."[102] Nonetheless, the seriality of these images and the massing of their presentation emphasised their informational rather than aesthetic quality, and indeed suppressed the picturesque elements in the photographs by the stressing

of seriality and their archival potential, as was noted in the instructions to judges. Whereas these competitions, were intended, as journal competitions had been, to simulate interest and support for survey, the effect was also to blur the boundaries, yet again, of competing visual practices of record, the straightforward and the picturesque.

This approach was even more marked in the societies specifically formed for the purposes of making survey and record photographs or specifically aligned with scientific societies. While aesthetic responses resonated through the collections of these societies, outside the aesthetic frames of general amateur photographic exhibitions these societies stressed the photographic aspects of the work. This was not in technical terms but in an application of photography that demonstrated the quasiscientific values of the straightforward and the ordinary, rather than simply in a didactic and instructive exercise with a focus of image content. That is, these societies were concerned not only with the forensic possibilities of content but with the discourse and practices of the photographic production of evidence. Most of the evidence that survives comes from the southeast region where the impetus for survey emerged from natural history and archaeology rather than from photography itself. These exhibitions, notably those in Surrey, Sussex, and Kent, were premised solely on the nature of and assumptions concerning photographs as documents. They did not offer prizes, nor did they arrange the hanging of their exhibitions through aesthetic tropes. In these exhibitions, the viewer was confronted with glass museum-style cabinets containing serried ranks of photographs, their survey cards pinned to the background. Information was provided by the caption labels on the cards that met "the eye at the same time as the print."[103]

In these displays, rows of comparable images were arranged by type to create specific sets of relations that organised visual space in order to create specific ways of looking at the photographs. (See figures 106 and 107.) These had more in common with the display styles of natural history exhibitions, rather than art exhibitions. This was also related to finding cheap and accessible ways of displaying photographs in the public space, such as mounting them on strips of wood with pins or behind taut wire or string, "a device successfully used . . . in display[ing] some 200 record prints for several weeks in a gallery at the Crystal Palace."[104] Photography's purpose here was clearly defined as an applied technology, and its subject matter unmediated. This exhibition practice mobilised an idea of photography itself, through its instrumental practices, which was not merely apprehended as history, but was positioned as being at the very centre of the system that made it so, that of objective regularity and procedural correctness. Yet at the same time, the effect of this massing was the reinforcement of certain tropes of historical value, the devotional sites that shaped the archive. (See figure 108.)

But throughout, whatever the precise structure, the instructive and morally uplifting quality of the exhibitions was stressed. On occasion, indeed, a social agenda linked to a clear historical agenda were overtly expressed. In Manchester, photographs, probably including survey photographs, but this is unclear, were regularly loaned to the Ancoats Museum, which would "thankfully accept for [its] walls or album, photographs of places and objects of beauty or of antiquarian or historical interest."[105] In 1906 the Surrey survey loaned 100 photographs for the opening of the Plough Road Museum in Battersea, which was situated in the poorest part of the borough. The museum included a gymnasium, baths, a children's room, and a games room. The agendas of social improvement, the context in which the loaned photographs were to be seen, were clearly stated by the mayor of Battersea at the opening ceremony in October 1907:

The inhabitants of the neighbourhood—[are] not over blessed with this world's goods and its pleasures [are] not too frequently brought to their doors. The council had felt that something ought to be done to brighten the lives of people in that district and to give the rising generation some opportunity of improving themselves. . . . "It is a long way from Plough-Road to South Kensington, and very often people had not the wherewithal to pay the bus fare for the journey." "If in a spare half hour they could find some little exhibits there which would improve their mind and give them an idea of how Battersea had progressed."

The mayor concluded, the report continues, that "he trusted that the exhibition would serve its purpose, that of improving the minds of man and women, and especially the rising generation of Battersea."[106]

The reference to South Kensington museums is of both general and particular import here. At South Kensington in 1901 and 1902 Sir Benjamin Stone's photographs had been shown under the auspices of the Board of Education and the art circulation department of the South Kensington Museum (Victoria and Albert Museum). The exhibition, which also included photographs from the National Art Library of the South Kensington Museum, comprised over 400 of Stone's survey photographs, in 109 large frames, and included those photographs calculated to evoke a sense of pride in the an-

106. Exhibition of the Photographic Survey of Surrey at Crystal Palace. Photographer unknown, 1908 *(licensed from the Collections of Croydon Local Studies Library and Archives Service).*

107. Exhibition of survey photographs from the Federation of the Photographic Record Societies at Crystal Palace. Unidentified survey, possibly Warwickshire. Photographer unknown, after 1910 *(licensed from the Collections of Croydon Local Studies Library and Archives Service).*

cient roots of parliament, church, and monarchy, but images of devotional sites, of church and village, as well as of those country mills and churches advocated as sites of history by J. R. Green in his *Short History of the English People* were also displayed. All were described as scenes "intimately associated with the history of the country."[107] The exhibition was shown in Birmingham, Bootle (near Liverpool), Plymouth, and Warrington, as well as in the Indian Galleries at South Kensington. In Warrington, the librarian Charles Madeley had imbibed the survey ethos while working at Birmingham Free Library. The tour ended only when Stone asked for his prints to be returned, possibly to be sent to the St. Louis Exposition in 1903, as there was an overlap between the two displays.[108]

In many ways, these objectives of photographic utility and social impact can be linked to the nineteenth-century idea that visual art was a force for social good and to photography's own battles to be accepted as an artistic form. Although Ruskin, with his expansive social mission for art, had been espousing such ideas since the 1850s, by the 1880s there was a fully developed notion of the way in which the power of art might not just improve the lives and experiences of the poor but the poor themselves.[109] These reforming and improving ideas were, for instance, at the foundation of what became the Whitechapel Art Gallery, where Reverend Samuel Barnett and his wife, Henrietta, held annual art exhibitions for the poor in Whitechapel beginning in 1881, a strategy that built on a number of democratising moves, such as Sunday afternoon openings, to make cultural institutions more accessible. The exhibits, which incidentally included history painting, were intended not only to give access and aesthetic education but moral guidance — in this case instil a vision of a perfect Christian world. Art,

Barnett believed, encapsulated moral truths, allowing viewers to "grow in sensitivity and imagination," refining working-class tastes and lives through culture.[110] As Canon Lyttleton, chairman of the Art for Schools Association, commented in 1898, "There was a demand — latent perhaps — in the English nation at large for education on the subject of pictures."[111]

The shape of survey discourse at its most expansive and rhetorical was very similar, though the surveys stressed history, and often a picturesque history, they drew on core aesthetic values. Again, in neo-Lamarckian ways, through understanding history and the possibility of continual access to these photographs in public institutions, the moral lesson of the historical weight of the built environment and survivals from the past could be socially effective. If sensitivity to beauty should be fostered in childhood by art, so sensitivity to history should be fostered through photographs.[112]

Furthermore, there was a sense in which photography was seen as appealing to working-class cultural tastes. However, beyond research on the domestic sphere, the only sphere reasonably documented, almost no work has been

108. Exhibition of survey photographs from the Federation of Photographic Record Societies at Crystal Palace. Photographer unknown, after 1910. Probably work from Surrey, Sussex, and Kent *(licensed from the Collections of Croydon Local Studies Library and Archives Service).*

done on working-class audiences for photography.[113] Numerous accounts survive of the attractions of the medium, how the photographers' shop windows were almost treated, not unproblematically, as a working-class visual gallery, as people absorbed images of celebrities, local views, events, and disasters that filled the windows of photographers and stationers.[114] As Kate Hill has argued, it was assumed that working-class gallery and museum visitors liked realist and narrative painting (indeed, the Barnetts record the lack of interest in landscape painting and portraits among working class audiences), whereas the educated middle class of refined taste, preferred, or at least professed to prefer, the more metaphorical.[115] In paternalistic modes of dissemination, photographs were well suited to the task of appealing to a mass audience because of their immediacy, clarity, and transparency. "Photographic data . . . is apprehended directly in the imagination; the experience of viewing what the photograph represents — it becomes a distillation and enhancement of the experience, of seeing the objects in nature."[116] Thus photographs were understood to address the audience directly by means of easily legible indexical traces with which viewers could connect and position themselves, perhaps projecting the self into the space of the image through memories and feelings related to cultural commonplaces.[117] Indeed, as *Amateur Photographer* noted in relation to the Warwickshire survey: "Record photographs . . . will certainly prove a very strong attraction to a large proportion of the public, who could not be numbered among the ranks of camera enthusiasts in general."[118]

Exhibitions were often accompanied by lectures and lantern shows, often free. These lantern slide shows were part of the culture and sociability of camera clubs, but more impor-

tantly lantern shows put survey photography and its values into the public domain, as is demonstrated by Harrison's surely self-conscious reference to the language of popular utilitarianism: through "first-class lantern slides of good pictures, shown in the best possible way [it was] perhaps possible to secure the greatest happiness of a greater number than by any other photographic exhibit."[119] Indeed, the original lantern lecture, "Camera as Historian — County Record Work in Surrey," produced in 1907, was delivered to eight societies of various sorts and a further nine in early 1908.[120] These kinds of lantern lectures were to demonstrate the benefits of photographic survey for both makes and users. Some surveys, again such as Surrey, used lantern slides extensively with lectures at the library and elsewhere in the county, lectures that were widely advertised and reported in the local press. Likewise, C. J. Fowler, who was involved in the Warwickshire survey, claimed in the pages of the *Photographic Journal* that such slides with well-written, descriptive lectures could be "enjoyed by thousands of people in every town and village in the country."

Lantern slide shows were therefore understood as an essential element of the dissemination of images and of visual instruction more generally, and as an element of the surveys in particular. (See figure 109.) A writer identified as "Menevia" argued in *Amateur Photographer*, "If a lantern slide 'Record and Survey' competition could be organised and the lantern slides lent out to societies, they would help to fan the flames and stir up an increase of interest in 'Record and Survey' work all over the kingdom."[121] Such displays of images connected at both a collective and individual level as through lantern-slides "many thoughts [would] be thereby evoked, which [would] be of service both to the thinker and the community."[122]

The lantern slide is a much underestimated player in the formation of historical consciousness and imagination, yet by 1900 it was being used in many elementary and new secondary schools around the country and was part of a vast array of rational entertainments for a broad adult population through working men's clubs and the like.[123] It is possible to argue that the affective tone of the photographs in fostering historical imagination was particularly well served through the multisensory and all-absorbing experience of the lantern slide. Indeed, *The Camera as Historian* claimed that lantern slides made an impact that the carefully archived and arranged prints themselves could not.[124] Lantern slide shows were hugely popular entertainments until the advent of the cinema. To see lantern slides as a form of affective knowing, however, one has to think about their material apprehension. The viewer sits in a darkened room while the image, intensified by light, enlarges to fill the space. The body was wrapped in both darkness and light, the attention was focussed, nothing else was visible, and "disbelief was suspended." Viewers seemingly confronted real artifacts from other times and places, artifacts "enlarged in the light beam of the projector, while at the same time the viewer [was] drawn deep into its pictorial space."[125] Significantly, given the affective or emotional connection to history that resonated through survey practice, this experience was, like that of early cinema, "an immediate and non-contemplative mode of viewing" in which the "enormous enlargement, brightness and clearness insisted upon" was seen as forcing itself upon the viewer, as a material sensation that destroyed aesthetic contemplation, but enhanced those values of informational clarity and immediacy which were so valued in survey photographs.[126]

The dissemination of survey material through

109. Mr. Baynton and Mr. Moore, lanternists, at Birmingham Photographic Society, 1900. They were closely involved with survey and showed their photographs at lectures and exhibitions. Lantern slide *(courtesy of Birmingham Library and Archive Services).*

lantern slides was widespread. In 1897, for instance, possibly stimulated by the foundation of the NPRA, a Mr. James of Worcester showed lantern slides at the local institute of many of the photographs collected by the Worcestershire survey.[127] As part of its "educational outreach" the Surrey survey put together lantern-slide lectures, which were administered through the local library and could be borrowed within the county. For instance, the Surrey survey assembled a lantern-slide set titled "The Evolution of Architectural Styles," drawing largely on the survey's own collection. The set was borrowed six times in the course of 1906–1907 but, to put this in perspective, the set was less popular than another lantern set on beekeeping.[128] However, in educational terms there

were financial limitations on dissemination by lantern slide. Lord Farrer pointed out at a meeting of the Surrey survey (in response to Topley's enthusiastic claims for the democratic reach of survey lantern slides) that there were major problems with rural schools that were "very poor and could not afford lantern lectures."[129]

AUDIENCES

It is difficult to know exactly what people made of these exhibitions and other disseminations of the survey photographs. There is little hint beneath the rhetoric, and many local newspapers simply reproduced information provided by the organisers, rather than venture any critical engagement with the objectives. Yet while the photographs constituted a "shared component" in historical imagination, the engagement with the photographs was nonetheless a "non-confrontational, non-referential and decentralised process [that was] extremely difficult to reconstruct after the fact."[130] Consequently, different visitors to exhibitions inevitably came with different foci that cannot necessarily be excavated historically, but at the same time one must beware of making ideologically grounded assumptions regarding the exact message taken away.

Attendance at exhibitions was often high, but it is not necessarily clear who attended, although many exhibitions were free and thus theoretically open to all. The South Essex Camera Club exhibition in 1910 included a survey section and was visited by 5000 people in a week. Nine thousand people visited an exhibition of the Sussex survey in Brighton Art Gallery over a two-week period. In Dundee in 1913, a survey exhibition at the local art gallery had 38,000 visitors in a few weeks. Some visitors to exhibitions came in school groups to be incul-

cated about local history, as part of a curriculum instilling civic spirit. Although easier to implement in urban schools, one of the provisions of education reforms of the period was that visits under proper guidance to museums and similar cultural and historical venues could count as "educational attendance," something that was seen as an opportunity both for museums and the dissemination of photographic survey.[131] The mayor of Richmond, Surrey, wanted parties of school children to be "taken by the teachers to the library . . . and shown the local survey, in order that they might know something of the town in which they lived." What marked comments like the mayor's was a sense of the relationship between photographs and historical imagination, a relationship involving affect and improvement, not merely the spectacle of history. Nearly 600 city pupils were brought in groups to see the survey exhibition in Norwich Free Library in 1913. Clearly the groups of school children were brought to the survey exhibitions in an overtly didactic and pedagogic context. One can only conjecture on the content, and the ways in which the students' attention was directed, probably with a cocktail of local history, civic pride, and national relevance. Others, for instance the 10,000 who attended the Cuming Museum exhibition in 1909, possibly went because the exhibition was free "instructive entertainment" for the working class, and the museum, with opening hours tailored to suit working class people, was popular because it offered something free, different, and even warm in an area where cultural amenities were largely lacking.[132]

Surrey also held exhibitions at the Crystal Palace in the early twentieth century, just as the NPRA and the Warwickshire survey had joined forces to show over 100 photographs as part of the massive Royal Photographic Society

extravaganza in 1898, which was seen by 75,000 people in just 2 weeks, although it is difficult to know how many went specifically to see the photography and how many just went for the general attractions.[133] In addition, photographs from the Essex survey were regularly displayed at the West Ham Technical Institute. Norfolk survey photographs were displayed in the library in Norwich, and in Nottingham at both the Mechanics Institute and the Castle Museum. (See figure 110.) At Croydon survey photographs were displayed in the lecture room and on the stairs of the public library; for example, a practice through which Surrey survey photographs were absorbed as part of the cultural furniture. Croydon Library also frequently held small survey exhibitions in its lecture room. For instance, one in March 1905 attracted 300 visitors over each of its four days.[134] The exhibition was accompanied by a lantern-slide lecture in the library by active Surrey survey member J. M. Hobson, entitled "Some Ancient Churches of Surrey." But this should also be linked to wider agendas for showing "instructive photography." For instance, in Croydon, not only did the Library acquire books and journals on photography, but it even showed scientific photography, on occasion. In 1913 it exhibited, for instance, Eadweard Muybridge's plates from *Animal Locomotion*.[135] This series of photographs was hardly new by 1913; it had first been shown and published in 1887, but it demonstrates the library's interest in photography and education.

While there clearly was, for survey photography, as for other forms of mass-instruction, an "imaginary public" that is a projection of a series of intended values that could be worked with at the moment of reception, the extent to which the audiences of the survey movement's photographs accorded with that imagining is

110. Capital from Southwell Minster. Photographed by A. Laughton, whose survey photographs decorated the walls of the Nottingham Mechanics Institute *(courtesy of Nottinghamshire Archives, DD/1915/1/424).*

not clear.[136] One can only speculate on the responses to the survey photographs, whether the message got through and to what extent meanings were appropriated and refigured, for as Hill has argued, the regulation of these spaces was insufficient to prevent their appropriation to working-class agendas. Likewise, because, as Roland Barthes asserted, there are no authors, only readers, reading gave audiences the power to "transform received messages and render them 'less than totally efficacious and radically acculturating.'"[137] It is now accepted museological theory that exhibition visitors take away a vast array of meanings from

objects and images, drawing on their individual and collective articulations of historical understanding, cultural parameters of class, and educational experience.[138] There is no reason to think that audiences in 1900 were any different.[139] Furthermore, it is perhaps a mistake to assume that popular culture and the responses of audiences were neutral or empty of their own political and cultural ideologies yet passively receptive to those of outsiders. Ideas were formed through education, but were increasingly mediated through a range of extracurricular activities, such as cycling, walking, and hobby photography. Evidence suggests that there was clear working-class support for preservationist agendas, linked to increased working-class mobility and democratic agendas for access to landscape, an agenda that can, one might conjecture, be linked to the reception of the photographs shown by the survey movement.[140] Thus the representation of values, which Stone and the NPRA especially desired, were very much more complex, and glimpses of this complexity are seen in the dissemination of survey photographs. Yet surveys accommodated both a sense of historical identity and their own agency in the construction of a narrative and the conditions of their own dynamic modernity, a shared experience of social change and innovation, survival and future. These beliefs formed the basis of the material and intellectual conditions of public access.

It is also difficult to gauge overall usage of survey collections and exhibitions or the social makeup of those users. Indications are, however, that usage was strongly local. Much of the evidence for this, and for exhibitions, comes from the Surrey survey, which is the best-documented of all the surveys. But with the area's experience of encroaching suburbanisation and attendant demographic change, and its easy access to London, one cannot be certain that of the pattern of engagement with the Surrey survey was necessarily representative of the broader pattern, although the indications in the more slight evidence from elsewhere suggest that there were indeed characteristics in common. It is clear that in the spaces of the free reference libraries there was steady, if not extensive, use of survey photographs, and one can be more secure in extrapolating usage in libraries than attendance at exhibitions, which have left little trace of either their content or effect. For instance, the Surrey survey reported that in 1907 alone the 2500 photographs deposited in the reference library at Croydon Town Hall received a staggering 7477 users.[141] It is difficult to know precisely who these users might have been. Certainly with the suburban expansion to the south of London and the fashion for "cottage" or "vernacular-style" houses in the region, some were architects and restorers; indeed, the Surrey annual report notes such a usage: "Many people—writers, archaeologists, antiquarians, historians, lecturers, scientists, students and others [are] continually travelling down to Croydon to use collection 'in order to fortify their work by the aid of our photographs.'"[142] Geologist William Whitaker, the chairman of the Surrey survey, had found in a visit to Croydon Library an eminent historian of architecture "engaged in consulting the photographs for the purposes of a lecture he was preparing." The historian was evidently surprised "by the completeness in many matters of architectural detail."[143]

However, it is unlikely that these groups accounted for all the usage. Given that only about 25 percent of the population could be described as middle class at this date (although this descriptor is clearly highly problematic) and that users of free libraries tended towards the lower

middle class, artisanal and working classes, it is not unreasonable to assume, even in the absence of firm figures, made up at least part of the collection users and that they derived interest and instructive pleasure from looking at the photographs.[144] (See figure 111.) Library user records can give some indication as to who these people might have been. For instance, Norwich City Library's annual report gives a breakdown of new readers by occupation — by 1900 there was a preponderance of clerks, drapers, machinists, teachers and housewives, but no "gentlemen" or members of professional classes.[145]

Furthermore, history books were widely available in libraries. In Croydon from 1901–1902, over 8,000 loans, out of some 43,000, were for history books, whereas at Nottingham Mechanics Institute, whose camera club ran the photographic survey, loans of history books and books of political economy rose 30 percent in the early 1890s.[146] There are many ways one might account for these figures, of course. Historical imagination is not contained solely within history books, far from it; historical imagination saturates literature and art. A clear causal link between the use of history books and the use of survey photographs cannot necessarily be inferred from such slight evidence, but the libraries created the kind of environment in which the historical interests of the wider population could thrive and be satisfied. The photographs were part of the matrix of possibilities offered. A correspondent in the *Sheffield Independent* stated that the local museum, run by Elijah Howarth, who had tried to instigate the photographic survey in Sheffield, had many respectable working class visitors, "small tradesmen and their wives, clerks and the more intelligent of the working men and youths."[147] This comment is significant in the way it points to museum visitorship more gen-

111. Croydon Reference Library. The space in which the Surrey survey was consulted. Photographer unknown, c. 1922 *(licensed from the collections of Croydon Local Studies Library and Archives Service).*

erally. This was precisely the demographic that was involved on the edges of the survey movement. Consequently, it is also reasonable to assume that such users of the free museums and libraries were at least some of the users of the survey.

Through the large numbers of people who saw the photographs, and the not inconsiderable number of lower middle-class and even skilled working-class people who were engaged in producing survey photographs, one begins to get a sense of the way these photographs were engaged in public histories. It is difficult to assess shifts in consciousness of the photographs and

the way in which "ephemeral images gathered their own historicity and accumulated their own unique power of witness."[148] But the desire of people to connect with and possess their own history was articulated through the power of the photographic trace of local place. Photographs encouraged viewers to experience a kind of history that was both subjective and objective, bringing discontinuous strands into cohesive whole through practices of archive and style. It was an historical practice that involved the viewer.[149]

The dissemination of survey photographs and the survey movement's values cannot be reduced merely to a set of paternalistic and hegemonic practices. Throughout its activities there were tensions and possibilities for counterreadings in the spaces between the desires for liberal state instrumentality through state institutions, the potential for photography, and the spaces of engagement. Dissemination operated through a complex network of competing and at times contradictory spaces—galleries, archives, lecture halls, and scientific meetings—that offered different ways of thinking about the photographs, from the overtly controlling and conservative to quietly radical and transformative. This complexity of ambition was realised through a network of official and unofficial agencies, including libraries, museums, school boards, photographic societies, and patterns of association and exchange.[150] In these spaces, there were tensions between official ideologies and unofficial practices, and readings that might or might not have accorded with one another. But they constituted ways photographs could be active in the production of historical imagination over a wide constituency.

Afterlives and Legacies

An Epilogue

In March 2006, the monthly magazine *Heritage Today* published a brief news item that had a strangely familiar feel to it. It celebrated the success of a "groundbreaking heritage initiative" called *Images of England*.[1] Founded by the National Monuments Record in 1999, this project ran until early 2008 and involved more than 4,000 volunteer photographers, many of them "members of The Royal Photographic Society or local camera clubs across England," in a "huge photographic survey" of listed buildings in England. In addition to hosting the some 320,000 photographs produced during the project, the *Images of England* website gave full details of its aims and objectives and the methodology devised for achieving them.[2] The scheme was an attempt to create a "point in time" photographic record, a "snapshot of the buildings listed at the turn of the millennium," for the benefit of current and future generations. In terms that are again strangely familiar, volunteers, having been "fully briefed," were allocated a number of listed buildings to photograph in their local area and were asked to capture a single "defining image" of building exteriors, a "truthful image" of a "high technical quality," showing "the architectural character of the building" and indicating its historical function and context. The films were then processed and scanned, the results were "quality assured," and the successful candidates were placed on the website in batches, alongside existing listing information. The website claims to form "the world's largest free, online digital image library," enabling "anyone with access to the internet at home, school or work," and "conservation and local history groups" to

access information about local buildings "at the touch of a button."[3]

The afterlife of the photographic survey movement, both as a concept and as a practice, relates to the cultural biography of the collections themselves and photography's role in a continuing historical imagination. What happened to the survey photographs? And what can their history tell us about both the status of this kind of amateur photographic material and the ways in which the history of photography is written? What can it tell us about how photography more broadly is conceived as being historically "important" and how has that history being patterned by subsequent archival practices? How is the historical, and thus analytical, integrity of the archive compromised and complicated by these histories? The ways in which history is texted by the pattern of its archiving is powerfully demonstrated through the fate of the photographic surveys and the work to which they have been put. This discussion is also inflected by my own archival experiences in undertaking the research in this project. But, above all, this discussion is part of the wider debate on the relationship between photography and history.

CHANGING GEAR

I have chosen to end my study in 1918, at the end of the Great War, for this marked both a point of fracture, disappearance, and reformulation for many survey endeavours and a shift in cultural uses of the past (See figure 112.) Many of the surveys went into abeyance during the war as there was a general shift of energies to the war effort. Not only did younger male photographers go off to the front, but travel was increasingly difficult. There were problems of photographing buildings in public spaces, an act

that might have been misconstrued as hysteria about German spies took hold. As the Dorset survey noted: "No outings — difficulties of getting motors and brakes, uncertain train service in some areas because of troop movements and 'sentimental reasons.'"[4] Furthermore, public libraries, working with reduced staffs, and increasingly female staffs, were more involved in public information about the war that ensured "the preservation of democratic institutions." In Croydon Stanley Jast suggested that librarians could help people understand "the present conflict, the meaning of civilization, the values of various ideas and conceptions of the human mind."[5] There was a sense too that the surveys could be part of this. Yet at the same time, after the outbreak of war, Prime Minister Lloyd George demanded economies in the public sector, and this affected libraries. It was not, he said, the moment to "embark on great municipal enterprises." Thus library incomes fell by some 13 percent, and as rampant wartime inflation took hold, by some 27 percent.[6] These factors played a part in the stagnation of the survey movement.

What marks the war years of 1914–18 is an increased emphasis on collecting, rather than making, photographs. Whereas the surveys had, from the beginning, made appeals for old negative stocks to be presented for printing for the survey collections, it was only in the Great War that this began to happen on any scale. The Surrey survey accession registers, for example, show the extent of this shift from a very small number of "copies," to printing from extant negatives from earlier periods, to a predominance of this mode of acquisition. This is perhaps not merely about practicalities as the war wore on, however. One can perhaps also attribute this shift to the heightened intensities of the themes that had so strongly informed the

surves, those of place — the very soil of England — fragility, and loss. A heightened sense of passing not only gave rise, in broad terms, to the neoromanticism of the interwar period but also to the reevaluation of historical images. At a local level, this perhaps encouraged the recognition of the memorialising value of such images, hence the increasing numbers of older photographs donated or lent for printing.[7] It is no mere coincidence that *The Camera as Historian* was published in the middle of the war. The book was the product of the heightened sense of destruction and fragility: "This book appears while Europe is still under the black shadow of the Great War. It is not, therefore, inappropriate, for the Great War itself has furnished illustration of the value of the work herein advocated and described." Indeed, a review in *Amateur Photographer* linked the moral duty of survey specifically to the despoliations of war; the book was "worthy of a careful and thoughtful reading by every camera worker in the country wishful for the preservation of monuments, buildings etc., likely to attract the attention of the aerial Hun."[8]

Many of the surveys regrouped after the war — those in Warwickshire, Surrey, Worcestershire, and Cambridgeshire, for example. But the ethos, and thus the imaginative possibilities of the past, that informed amateur photographers was changed, and many of the concepts that had underpinned survey endeavours at the local level were absorbed into a more overtly national agenda. While the pre-

112. Essex regiments mustering in Norwich city centre, August 1914. Photographed by Mrs. G. Swain. Photographic Survey of Norwich and Norfolk *(courtesy of Norfolk County Council Library and Information Service).*

war period was marked by a sense of loss and disappearance, however problematic in its articulation, this feeling was accentuated through the experiences of the war and the increasing insularity of England after the First World War, as the slow transition from "global capital to small nation" was underway and the expansion of "Englishness" in an age of high imperialism began to fade.[9]

But there was also a sense in which amateur survey was increasingly limited in its ability to meet the social and cultural needs of the emerging new order. Although the work of survey photographers filled public libraries and museums, those photographs were marginal to the new and increasingly centralised scienticity of town planning, education, and social welfare. There was little space in the professionalisation of these fields for the amateur photographer. In many ways, the historical sites that had been the focus of survey endeavours became, in the mainstream discourse, transformed through the geographic and the sociological. Despite the continuing fantasy regarding an encyclopaedic total archive, perhaps best known through the activities of Mass Observation — which owes little to the surveys despite surface similarities between the two movements — the concept of survey became increasingly focused and systematized. This was either through the regularization of photographic recording in the work of town planning departments, such as in Birmingham, which had an extensive photographic programme related to planning, conservation, and architecture, or through the regional survey movement pioneered by urban planner, sociologist and educationalist, Patrick Geddes, and disciples of the French sociologist Frederic Le Play, who was concerned with the social potential of neighbourhoods, communities, and networks.[10]

It is significant that many of the later surveys began to look increasingly to the thinking of Geddes in particular, to position photographic survey in the broader progressive domain. Geddes's concept of regional survey was in itself highly visualised in its concern with the encyclopaedic and inclusive possibilities of the trace of light and "sight, synopsis and synthesis," a concern that could also have summarised the photographic surveys.[11] This was clearly expressed in *The Camera as Historian*: "The work of the record photographer has . . . an important part to play in the growing movement for what are termed 'regional' surveys, so strongly and eloquently advocated by Professor Geddes and others. The regional survey is a wider survey than the photographic. It includes practically every kind of record in respect to the region surveyed, but the photographic record is an indispensable part of the work."[12] Indeed, when a number of surveys reformed after the First World War, they looked to Geddes's model of regional survey, urban evolution, and progressivism as a production of locality and local knowledge. In Manchester, for instance, ideas to undertake yet another photographic survey were closely linked to other local moves to institute a regional survey, widening "the scope of enquiry to include the collection of data relating to the historical, scientific, geographical and social conditions of the area in addition to pictorial records."[13] In Croydon, in a similar move to the idea of regional survey as early as 1913, the power base shifted away from the photographic survey society to the natural history society. The objectives were made clear when the anthropological section of the Croydon Natural History and Scientific Society "held a meeting in the Library . . . in connection with the Regional Survey. . . . [The society] hoped to hold an exhibition of Regional Sur-

vey Work in the lecture Room in the Autumn, and so help to create local interest in a work which might well be of great practical importance in the future of the borough, as bearing on many problems of local government; it will in any case be of considerable value for purposes of research."[14]

The link with Geddes is most clearly articulated in Exeter. The city's Pictorial Record Society not only concentrated on the glories of the city's medieval past, but on the infrastructure of modernity, precisely those facets through which the city increasingly defined itself. The photographic survey was funded through the town planning committee of the local authority that was, at the same time, actively espousing Geddes's model of urban development. Geddes himself gave a lecture entitled "Cathedral Cities: Past, Present and Possible" to a packed audience in the town hall. This lecture was understood as being specifically related to the activities of the local photographic survey. In this model of urban and social development, the growth of urban infrastructure, such as the libraries where survey photographs were deposited, was tied up with concepts of the general good and well-being of future generations: "Historical enquiry [undertaken] was in order to understand the present and prepare for the future."[15] For Geddes, the use of resources was a matter of morality, as it had been in the ethos of the earlier surveys. Geddes's vision of the future was built not on utopian ideals but on practicable, realisable objectives to enrich lives. Thus the survey, and the efforts of amateur photographers in Exeter, was not merely scientific but "humanistic."[16] (See figure 113.) Yet despite this looked-for role for photographic survey, in a general review of regional survey produced in 1928 in a tribute to Geddes, amateur photographic survey was described as a useful "spon-taneous accessory" to the systematic activities of regional survey, rather than as central to its purpose.[17]

Although photographic survey activities continued, they effectively retreated back into camera clubs and societies, and into the more conservative and preservationist discourse from which they came. Local photographic societies and clubs remained, regrouping in the aftermath of war. For instance, the Surrey survey remained active up until the Second World War and was not finally disbanded until 1954. The Worcester survey continued under the auspices of the local archives office and the Warwickshire survey was reformed between 1946 and 1955, adding another 3000 photographs to its collection. The Shropshire survey remained active through the local photographic society and continued to donate photographs to the local archives.[18] In Norwich, the photographic society was still contributing photographs well into the 1960s, while the Cambridgeshire society undertook a rephotography project, revisiting sites photographed in earlier surveys. The rephotography project was imbued with a sense of the longevity of "devotional sites" and with a sense of change and duration as "volunteer photographers were given photocopies of the Antiquarian Society's old photographs together with a map and asked to take new shots from as near the original viewpoint as possible."[19]

Photographs continued to be collected by institutions but the public role of those photographs was less visible and less dynamic (the coverage of survey in the photographic and local press slowly dwindled). At the same time institutions holding survey archives grew more concerned with preservation than active public engagement. There had been an awareness of such a fate for collections from the beginning. C. J. Fowler had commented in 1897, "It

113. The restored Lant Almshouses, Bartholomew Street. Photographed by J. Hinton Lake, 1911. Exeter Pictorial Record Society *(courtesy of Westcountry Studies Library, Devon Libraries)*.

may be said with some degree of truth, that in a few year's time the hundreds of pictures lodged at the libraries will become buried and lost to view to all but the occasional patient searcher."[20] This would appear to be a position that emerged early in some cases. Under the heading "The Fate of Some Record Prints," *Amateur Photographer* reported in 1910:

> One of the dangers of Record and Survey work has just come to light at Ealing. Members of that society, some six or seven

years ago, made and presented a collection of record prints to the Town Council for the benefit of the public and posterity, and it is said that £50 was voted to provide a suitable resting-place for the photographs. That resting-place is three parcels wrapped up and stored away, out of reach and out of sight of any but the few people who knew of their existence. It would not under such conditions take many more years for them to be entirely forgotten, and then what value are they either to public or posterity?[21]

When Stanley Jast became librarian of Manchester Central Library in 1920, he attempted to instigate a photographic survey of Manchester, apparently ignorant of the Manchester Amateur Photographic Society's efforts some thirty years earlier, the archive of which was actually within the walls of his own institution. At the foundation of the National Buildings Record in 1940, during the Second World War, a surveylike call went out to amateur camera clubs and antiquarian societies to make records of major historical buildings deemed most at risk of heavy bomb damage, especially, in a way reminiscent of *Amateur Photographer*'s comment during the First World War, those of the east coast, nearest to Germany. A letter from the secretary of local East Riding Antiquarian Society concerning Hull, East Yorkshire, reveals a vague folk-memory of the earlier survey but no knowledge of what became of it: "I am slightly worried about the monuments in Holy Trinity Church [Hull]. They were I know taken in hand some time ago by the local photographic society, but we have no definite information as to their completion or the whereabouts of negatives and prints."[22] Indeed, while the Warwickshire survey lists were submitted to the National Buildings Record, as it mustered its photographic archive of the nation's significant buildings, those working at the National Buildings Record were apparently entirely ignorant of the NPRA material by then gathering cobwebs and bird droppings (some of which still mark the boxes) in the British Museum.

So at one level the survey archives merged into undifferentiated "image collections," serving local historians engaged with forensic evidence and illustration. But while the surveys became almost historiographically in-

visible, there was one strand of high visibility, in that the memory of the photographic survey had been dominated by the presence of Sir Benjamin Stone. This memory is worth considering in some detail because the historiographical processes, through which certain bodies of material become valourised in the canons of history of photography and others not, with subsequent distorting effect, is fundamental to the understanding of those bodies of material. Allan Sekula has noted the way the romantic approach to aesthetics privileges the singular controlling voice, and Stone fits such an art-historiographical privileging. Not only has he come to stand for the whole survey movement, in a way reproducing his own rhetoric. The focus has also been almost exclusively on his folk custom images and their appeal to a form of neosurrealist and postmodern aesthetics—his "bizarre and entertaining images."[23] His photographs became, in effect, "objects of secondary voyeurism—a marker of the viewer's aesthetic."[24] Stone has been cited by a number of contemporary photographers, such as Tony Ray-Jones and Daniel Meadows, as their inspiration for undertaking surveylike work as a project of cultural retrieval and recuperation.[25] By implication, Stone's work is also an inspiration for the construction of a genealogy of their work. For others photographers, such as Homer Sykes, who produced the series *Once A Year: Some Traditional British Customs* (1977), Stone's work has been used in curatorial commentary to position the work and to find a distinctly British history of photography in which the work might be understood. This trend in contemporary photographic practice can also be linked to the increasing interest in the photograph as a "human document," through the 1960s and 1970s.[26] At the same time, Stone's

place in the canons of the history of photography was firmly established when in 1970 Bill Jay chose to highlight Stone's work in the first edition of *Album*, a journal of contemporary photographic practice that was part of an attempt to create a continuum between photographic pasts and presents.[27] Not only did Jay describe Stone as "one of the best, and certainly the most prolific photographers of Victorian and Edwardian England," Stone's photographs were "absorbed into a discourse of contemporary photography and presented alongside the work of Bill Brandt and Lee Friedlander in a manner that inflected [that discourse] with tensions between realism, documentary and surrealism."[28] The position of Stone's work in the canon was strengthened in 1972 when Jay published *Customs and Faces: The Photographs of Sir Benjamin Stone, 1838–1914* and when, two years later, Colin Ford, the newly appointed curator of photographs at the National Portrait Gallery, produced a major exhibition of Stone's work, *Sir Benjamin Stone, 1838–1914: Victorian People, Places and Things Surveyed by a Master Photographer*. This was followed by a number of provincial exhibitions of Stone's photographs, such as that at Woodstock Museum, Oxfordshire (Oxfordshire Museum Service) in 1974.[29]

These selective archival excavations and their publication established not only specific readings of Stone's photographs but cast the idea of survey into a discourse of the internal exotic and a different set of historical imaginings that in reality had little to do with the survey movement as it might have been understood by its participants. This is significant because it marks the contemporary desire for a certain kind of aesthetics and a certain politics of the image in which photographs become not only recoded, but renarrativised in terms of dominant aesthetic concerns.

Of course this recoding is not unusual, for photographs are infinitely recodable and variously legible across multiple discourses. Nor does recoding insist on the absolute authenticity of one narrative over another. But through the valourisation of certain elements and the historiographical weighting towards one figure, Stone, this recoding has created an endlessly repeated reading at the expense of others. Stone's folk custom material is endlessly reiterated, assuming the status of signature images for a certain period of British photography, yet this material constitutes a small minority of his entire photographic output, an output that is more representative of the survey movement as a whole — work recording parish churches, houses, cottages, market towns, and "curiosities." This valourisation was extended to the whole of amateur survey photography, or at least to what was known of the survey movement at the time. This selective vision was, for instance, once again reproduced in 1974 during the planning of the Arts Council exhibition *The Real Thing: An Anthology of British Photography 1840–1950* (1975), when one of the organisers wrote, "It seems that a large number of local camera owners from the middle class, people such as parish priests, museum curators . . . saw one of their primary tasks as that of recording types and occupations of rural England at a time of rapid social change."[30] The exhibition itself, though it included a few Warwickshire survey photographs, again valourised Stone and folk customs to the exclusion of other material, claiming, "Stone's record of folk-life in Britain in pictures . . . is the most notable attempt to achieve a documentary programme."[31]

Of course knowledge moves on and expands, but the longevity of this particular historiography is significant. Two recent manifestations of this particular narrative were at the Tate Britain

exhibition *How We Are* (2007) and the touring exhibition *No Such Thing as Society* (2008). In the former, six of Stone's images stood not only for an internal exotic, but, demonstrating the powerful assumption that has clustered around the survey movement, were wrongly captioned as belonging to the NPRA collection. The captions also describe the subject matter as "folk customs" conflating one-off historical pageants of historical imagination with cyclical folk customs, either ancient or invented.[32] This example demonstrates the way the surveys have generated their own mythology. This mythology was reiterated in the exhibition *No Such Thing as Society* (2008), which uses Stone as a repeated point of reference, in ways that obscured more complex readings of the survey movement. The exhibition was a tenacious piece of historiographical imagining. Furthermore, the particular historiographical purpose, represented in the exhibition, paradoxically contributed to the archival and analytical invisibility of the amateur photographers of the survey movement because these photographers failed to accord with the assumptions through which their activities have been imagined and therefore with the questions brought to the surveys more generally.

But the archive has always been a place of dreams, from Harrison's desire for the encyclopaedic, to *The Camera as Historian*'s hopes for regulative control; such work is merely another layer of dreams around the archive as nineteenth- and twentieth-century survey becomes a founding myth for contemporary photographic practices. Myth is all this historiographical imagining can be, for Stone never did undertake, as a recent commentator claimed, "photographic tours around Britain by a wagon caravan," though the idea is both delightful and ideologically loaded.[33]

THE CULTURAL BIOGRAPHIES OF SURVEY PHOTOGRAPHS

In the course of my research, I encountered a huge range of responses to my pursuit of survey material, and equally diverse conditions of viewing. Some were elegant print rooms equipped with viewing easels and white gloves. In other places I had to sit under the table in museum basements because that was the only way to open the crammed filing cabinets in a tiny space. In yet other places I nearly suffocated in the dust of baking attics, my hands stiff with dirt. I leafed also through series of 150,000 images to spot the ones on survey mount cards. These experiences suggested the complex ways photographs have been evaluated within the hierarchy of historical sources. This process of evaluation is in part responsible for the way historiographical weightings have been able to multiply. Patterns of archiving merge with specific discourses of visibility and invisibility. Although survey collections provided their own strong narrative through the processes of making and archiving this narrative became lost and destabilised, and in many cases was reformulated, over time. For while the makers of survey archives dreamed of utopian permanence, the archives were entangled with the temporal dynamics against which they had been assembled.

Like all objects, archives and photographs have social biographies that change and accrue meanings as they move through space and time. Absorbed into library iconographical collections, many survey collections effectively lost their discrete archival identity. (See figure 114.) Reduced to isolated fragments and gobbets of visual information, survey photographs in this trajectory were reduced to mere content with little sense of the processes of

114. The typing office, Birmingham Central Library, housing the Warwickshire Photographic Survey. Photographer unknown, c. 1960 (courtesy of Birmingham Library and Archive Services).

their cultural, technical, or intellectual production. While some archives have remained intact and in their registry order through "benign neglect," for example those of Kent and Bristol, and are thus rich research resources, others have lost their original identity and have assumed others through successive interventions of curatorship. The NPRA had remained at the British Museum, uncatalogued in its original boxes and arranged by county. This material arrangement was maintained on the collection's being moved as part of a major transfer of photographic material to the Victoria and Albert Museum in 2000. The Nottinghamshire survey material was rescued from the demolition rubble of the Nottingham Mechanics Institute when local photographic enthusiasts spotted the boxes and "their significance was only realised at the last moment because each print had a label which gave details of the location and date when it was taken." The collection was deposited in the local archives office in 1992 to mark the centenary of the Nottingham and Nottinghamshire Photographic Society.[34]

Other collections have been dispersed, notably in Surrey, where, as late as 1987, the collection's 14,000 images were split according to the perceived importance of the collection, in terms of a more insistent localism formulated around changes in local governmental boundaries and shifting institutional priorities. In some ways, however, this dispersal that had been suggested as early as 1906: "It is hoped that local collections will be deposited in other centres."[35] The collection, which had been in Croydon since 1903, was dispersed between public libraries in Croydon, Lambeth, Thornton Heath, and Merton, all boroughs of outer London. The remainder of the collection, primarily photographs of rural Surrey not distributed to those libraries was sent to the Surrey History Centre at Woking. Nonetheless, survey photographs remain on their original cards and are identifiable, even if they are scattered, at least within the libraries, throughout massive image files according to image content, and categorised through the Universal Decimal Classification system. Conversely, the Handsworth survey was conflated with the Warwickshire survey in Birmingham at an unknown date. The Shropshire albums, which were given to the Free Library in about 1908, appear to have been broken up and scattered throughout general image files, although a cataloguing programme currently being undertaken might, in time, reveal the collection. Other collections have suffered disasters. All the Norfolk survey coverage of Norwich city was lost in the disastrous reference library and archives fire in August 1994. There is no record of what was lost, as no listing existed. Survey photographs classified differently survived because they were stored elsewhere.[36]

Other collections have disappeared without a trace. A number of institutions I contacted denied the existence of such a thing as a nineteenth-century or early twentieth-century

survey in their region, even when presented with evidence to the contrary. This does not necessarily mean that the photographs are not in the collections of those institutions, but the processes of undocumented format changes, such as rephotographing, cropping, relabeling, and remounting, and of undocumented policy shifts, such as the disposal of "duplicates," reclassifying or reordering, the focus on content and an attendant lack of concern for production, has meant that photographs have been entirely stripped of any sense of their own historicity and functional origins (although it has to be said these actions unintentionally saved a good proportion of the Norwich survey). Although I saw many photographs which *could* have been from the ghost surveys, there was absolutely no evidence surviving that would mark them one way or the other. In other cases, I suspect that collections are entangled with other photograph collections that are uncatalogued, unmanaged and without even a basic institutional knowledge of photographs. In one case, my suggestion to a curator that we could narrow the search for some missing photographs by looking for platinum prints because I had good evidence that this is what had been deposited, was met with incomprehension, followed by the breaking off of all communication. The life of a researcher is a vexing one.

The variable fates of survey archives reflect how photographs are perceived within institutions in ways that privilege content over other historical dynamics in which collections are entangled. In a broader context, this situation represents a set of practices from which photographs in particular appear to suffer and which would be considered unacceptable if visited on other classes of historical objects. This lack of engagement is a reflection of the ways in which photographs are understood and institution-alised as "history" and as "documents" within discourses of information, documentation, authentification, and representation, rather than as historical objects in their own right, objects, in this context, that constitute a further historical object: "the local survey."[37]

The concept of an all-encompassing, centrally powerful archive is complicated, therefore, at a number of levels. The authority of the archive, as it was envisaged by its creators, has become dissipated. Despite the realist insistence of and claims for photographs, they remain an awkward archive, for they are historical modalities that, as their treatment shows, are not necessarily given the same weight as other classes of material. But photographs remain, for all their claims, "assembled unevenly, haphazardly, anonymously—and [are] not easily rendered up for scrutiny, not through design but through lack of prioritization."[38] These shifting values were, as I have suggested, given spatial force as photographs were moved around, downgraded to basements, typing pools, offsite storage and, on occasion, oblivion.

However, this lack of prioritisation of in the history of collections should not be allowed to mask other important shifts in the work of photographs in the popular historical imagination. The social biography of photographs was stimulated by new contexts and perceptions of transformation, change, and speed, in both rural and urban contexts. This was not only linked to new historiographical modes, such as the rise of alternative historical narratives through the work of organisations such as the History Workshop. As Raphael Samuel pointed out in the 1960s and 1970s, the "resurrectionist" moment in photography and the "look of the past" came to saturate popular culture, in for instance advertisements, on record sleeves, or in pub décor. Indeed, the lure

of the photographic runs throughout Samuel's book *Theatres of Memory* (1994).[39] Much of this trend was being worked through at a local level. Local-studies libraries and record offices started the systematic collecting of "old photographs" with which the survey collections often became entangled. The change was a result of "the ways in which history [was] being rewritten and reconceptualised as a result of changes in the environment, innovations in technologies of retrieval, and democratizations in the production and dissemination of knowledge."[40]

In postmodern scholarship, which has provided the overall frame for such shifts in historical and historiographical "range," the photograph was increasingly problematised and a robust analysis and understanding of the social practices of photography and photographers emerged. However, this scholarship's impact on the public perception of photographs, and in particular on the institutional practices that shape and maintain the meanings of collections, was for the most part limited. For despite several decades of critical theory in both photography and in the analysis of its institutions such as archives and museums, the use of visual resources, especially those such as the survey photographs, with their insistent realism, has failed to grasp the fluidity and complexity that shape these photographs and their production. Rather, photographs have become those isolated gobbets of information, entangled in institutional practices that homogenise them into an archival empiricism.[41]

Local publishers continue to churn out books of old photos, often mined from local archives, in which the photographs remain dehistoricised, with an "almost universal absence of concern for the relevance of who actually took the photographs or the contexts and processes of that making."[42] Because history is located unproblematically in the content of the image, these projects entirely decontextualised the photographs and reinforced the same narrow range of readings. This creates further barriers to understanding what photographs actually do. Institutions are complicit in such practices because institutions tend to meet a specific and unproblematic need without addressing the complex nature of photographs. Consequently, it has been commented that "in this complacency, categorisation and description are a stable enterprise precisely because we can still pretend that the image is what it purports to be."[43] In many ways, of course, it was precisely such unproblematic and direct readings that those involved with survey photography were attempting to establish for their images through discursive and material practices. But at the same time, because of the active and clear entanglement of survey photographs with discourses of locality, education, and efficiency, the value of a survey collection and its institutional handling was integral to its visual affect.

NEW DYNAMICS

Despite the vicissitudes of archive management, many of the survey photographs survived and continue to be engaged in dynamic situations of interface between people and their pasts. As Paul Ricoeur warned, "As soon as the idea of a debt to the dead, to people of flesh and blood to whom something really happened in the past, stops giving documentary research its highest end, history loses its meaning."[44] At the core of this process of rediscovery, whatever its problems, was the burgeoning and vital interest in local histories, an interest often with strong visual components—forms of atomised histories—in genealogy, family histories, and street histories. They form histories which are

intensely localised and subjective and which are in many ways the descendents of the historical desires that informed the surveys.[45] Survey photographs were absorbed into this discourse. For instance, at Nottingham the rescued survey photographs were used in an exhibition, *Now and Then*, to mark the centenary of the photographic society and to appeal to local sentiment.[46] In many ways, this newly figured usage of the photographs might be seen as a reinforcement of nineteenth-century documentary positivisms, but at the same time it reconnected people to their pasts. This suggests that the survey photographs have an engagement and affective tone that enables them to function as intended, at the interface of information and affect. If meanings are therefore fluid, marginalized and dissipated, they are performed on the one hand through a social biography of material neglect and the disintegration of the archival integrity, while on the other hand survey photographs move into different yet similar spaces of meaning. The reshuffling and remediation of collections constitute a proliferation of possible discourses around people and objects in which the photographs are entangled.

Pierre Nora's well-known argument that the emergence of modernity and the nation-state saw a shift from memory to "history," from the head and the heart to the archive, does not necessarily explain photographic archives or collections in digital environments.[47] These archives and collections retain their potential for affect beyond the merely forensic. This is not only because of the photograph's infinite recodability, but because the fragmentation of the archive and the explosion of potential meanings across a range cannot be contained within the archive as such. Yet this is no Derridean archive spiralling towards some uncertain future, but a re-

formulation and refiguring of a tightly fused collection of contained signs of historical significance.[48]

A number of survey collections have now been digitised, and other digital projects are planned, for example, in Warwickshire, although not all survey collections are accorded their archival integrity. Exeter's digitisation project is perhaps the most successful. (See figure 115.) The project has gone hand in hand with a recognition of the material qualities of the images and an exploration of the history of the collection available in the public domain.[49] The admirable level of research and resource assessment that has gone into the planning of the digitisation of the Warwickshire survey collection promises another productive translation.[50] In Boston, the late nineteenth-century survey collection was digitised in response to my research, work that was able to identify and contextualise the material and bring the idea of the process and archival integrity to the understanding of this material.[51] The Manchester survey and the Handsworth survey, disentangled from the Warwickshire survey in the "Digital Handsworth" project, are available online, but their identities as surveys is not clear from the

115. Exeter Pictorial Record Society Website *(courtesy of Westcountry Studies Library, Devon Libraries).*

way the photographs might be accessed.[52] In another example, Norfolk survey photographs in the "Picture Norfolk" web resource, which has focussed efforts on the soldiers from the First World War because of the obvious links with the desires and needs of family historians, have entirely lost their relationship to the Norfolk survey in their online record presentation.[53]

It has been argued that "digitized surveys now occupy a liminal space, diffused into various narratives, many of which are divorced from their original objective."[54] This is so at one level, as I have just indicated, but it is not an accusation that can be simplistically laid only at the door of the digital. Digital environments constitute not merely a disintegration but also a massive expansion of the "photography complex" that both dissipates and, crucially, coheres in new ways. This is part of a continual process of constitution and reconstitution, coding and recoding, that marks the social dynamics of the images as they move into differently constituted collectives where mediations between image and viewer are themselves differently constituted. At one level, this is simply the most recent of a series of remediations, which might also include that of microfiching, as was undertaken with the Worcestershire survey photographs. These remediations do not necessarily depart from "original objectives," nor are those objectives framed in terms of nostalgia, loss, and disappearance alone, but in terms of more vital temporal discourses in the dynamic relations between past, present, and future. As John Berger, writing of photographs, has argued, "If the living take that past upon themselves, if the past becomes an integral process of people making their own history, then all photographs would reacquire a living context."[55] The level of public access to and engagement with survey photographs is precisely

as the originators would have wished. One can imagine that the authors of *The Camera as Historian* would have wholeheartedly supported the aims of "Images of England" and the Exeter Pictorial Record Society website, for they have overall aims in common with the survey movement. Availability in libraries, within series of local image collections, and more recently in digital environments, means that the photographs collected together could be inserted into other subsequent histories. They become "collection points for bringing the output of the photography complex" into a continuing social biography.[56]

More problematic methodologically is the reduction of survey images to series of singularities and forensic apprehensions. This is part of a wider problem. The methodologies that have been brought to survey photographs emphasised singularity whereas the power of the survey archives is in multiplicity, both within and across collections, collections in which photographs, their materialities and their archiving, constitute "part of a comprehensive organization of people, ideas and objects" that mould "meanings and symbolic codes that can create communities of people."[57] These complex processes were in play for the amateur photographers contributing to the surveys, and remain in play in new, yet perhaps related, contexts.

Arguably this shift is part of a wider historiographical process. There are perhaps ontological and conceptual links between the nature of the photographic document, the expansion of that fragment through subjective engagement, and the atomisation of broader historical narratives into complex and subjective relations between grand narratives and personal narratives of the past. Frank Ankersmit has noted the increasingly centripetal nature of contemporary fascination with the experience of events, as opposed

to the centrifugality of meaning in deconstruction.[58] I would argue that photographs are integral to this shift. In a way that was perhaps again anticipated by the survey photographers, photographs move understandings toward the mundane, toward the presence and the experience of the small players. those amateur photographers involved in survey, imagined significance in ways that cannot be entirely contained, or necessarily explained, within macrolevel discourses. For though the way in which photographs still time and create fragment, they figure the banal — the cottage, the market cross, and the coronation tea — as significant, both in the sense of impact and in the creation of meaning. In the "greater personalization of events, narratives and testimonies . . . shifting away from the collective and toward the personal" the immediacy of photographs and their still, material insistence on past experience fosters "a greater sense of participation, [and] less dependence on official expertise" through "decentralized, unevenly dispersed [and] profoundly contradictory relations."[59] In their privileging of the visual it was not simply a matter of the accurate inscription of the material and experienced world that was at stake. Despite their conservative appearance, the surveys collectively offered a challenge, from the moment of their inception, not only to traditional modes of historical recording, but to the relationships between history and memory.

This historiographical position suggests an atomisation of the precise nature of the "histories" imagined through such relationships, of the role of photographs in the individualisation of investment in history, and in an intensification of experience that fuses photography with the daily experience of communication in a digital age.[60] "Photos are material evidence of connectedness to what is now 'past.' The more

photos connect, the more they are valued. Photos are stories about connections through time, affirming the existence and significance of the past in the present."[61] Photographs become both conduits and nodes of historical imagination and are embedded in the connective tissue "between archives, memory, the past and narrative."[62] It has been argued that history's unease with the photograph is because interpreters of historical material ask too much and too little of the image. Asking the whole truth, will lead to disappointment. Photographs seem inadequate to the task of history. Photographs lack, in the final analysis, the exactness of the evidential. Alternatively, as so much photographic theory has done, ask too little is asked of photographs, "immediately relegating them to the sphere of the *simulacrum*," thus excluding them from the historical field. If photographs are relegated to "the sphere of the *document* . . . [historians] sever them from their phenomenology, from their specificity; and from their very substance."[63] I have tried to reclaim the middle ground between asking too much and asking too little of photographs through a process of bringing the practices of photography, as a series of values and behaviours that intersect with a technical medium, to the centre of the analysis.

All the shifts, appearances, disappearances, and reappearances of the photographic survey movement point to wider assumptions and values concerning the relationship between photography and the historical imagination, and to the relationship between photography, the past, and the future. These ebbs and flows provide an opportunity to ask in what sense photography might be history, and to raise questions about the shifting fortunes of, and privileging of, different and successive historical narratives. The very clear ways in

which the photographic survey movement articulated the processes for which I have tried to account are not merely photographic problems. Photographs expose questions that apply to all historical sources, "not simply [to] the potential and limits of *photography* as an historical source, but [to] the potential and limits of *all* historical sources and historical inquiry as an intellectual project."[64] How and under what terms could photographs be history? This was, in many ways, the question that motivated amateur survey photographers. It also raises different questions regarding the production of knowledge and the forms of appropriate historical narrative. But the question also suggests how placing photographs in the centre of the analytical frame as things intrinsic to and constitutive of, not merely illustrative of, historical imagination allows us to understand more clearly the way histories might play out in the dynamic social textures of the surface of the image.

WARWICKSHIRE PHOTOGRAPHIC SURVEY 1890[1]

I. Prints may be of any size, but the whole plate size (8½ inches by 6½ inches) is recommended to those who wish to take negatives for the survey.

II. Prints must be by some permanent process — carbon or platinum preferred, but bromides will be accepted.

III. The standard mount shall be a cut-out mount measuring 14 inches by 1 inches, having grey margin and cream centre. Each mount will take one whole-plate print, or two half-plates, or four quarter-plates. The opening or "hole" may be 9⅝ inches by 7¾ inches, for whole plate prints, to 10 inches by 8 inches for halves and quarters. Larger mounts shall be provided as may be found necessary. The frames shall be of plain oak with removable backs.

IV. The following particulars shall be given (under printed headings) on the back of each mount.

WARWICKSHIRE PHOTOGRAPHIC SURVEY

Subject. .
Date. .
Time .
Focus of lens. .
Printing Process and paper .
Remarks .
Contributor. .
Contributor's address .

V. The Curator shall draw up a catalogue of all prints.

VI. Workers may mount their own prints, but they are recommended to send them in unmounted, with their names pencilled on the back

of each print. They will then be mounted (by Mr Shakespeare) and returned to the donors, so that full particulars may be filled in on the backs. (It was felt to be better to have no labels gummed on the back of the mounts, as such labels are liable to become detached &c.)

VII. The prints collected shall, if possible, be exhibited annually in some public place; and then be handed over to the municipal authorities of Birmingham, with a request that they shall be kept in a suitable case in the Free Reference Library.

VIII. A printed "permit" shall be prepared, which workers for the survey may show to owners whose property they visit.

IX. The Curator shall be provided with a set of twenty of Stone's patent boxes in which to classify and keep the mounted prints. These boxes measure (outside) 15½ inches by 12½ inches, by 4 inches in depth. They will each hold fifty mounts. These boxes cost 3s 6d.

X. A cupboard with folding doors, containing twenty compartments (each of the size to contain one of the Stone's boxes just mentioned) and a large shelf for documents, &c., is also provided for the use of the Curator. Such a cupboard was made by Mr George Hill, of 186, Broad Street Birmingham, for the sum of £4,10s.

XI. The Curator shall keep a book or register, in which he shall enter particulars of all the prints received, giving each print a running number, and entering the same number in his book.

XII. No retouching or "improving" shall be permitted upon and prints presented to the survey collection.

XIII. In addition to the information supplied under the printed headings on the back of each mount, the title of the subject and the name of the photographer, shall be placed upon the *front*, underneath the print.

PHOTOGRAPHIC SURVEY AND RECORD OF SURREY (1903)[2]

The work of the Society is divided into SECTIONS, each being under the direction of a Committee.

The whole of the collection will be housed at the Public Library, Town Hall, Croydon. It is hoped that later on, local collections will be similarly deposited in other centres.

Members of the Survey and all others interested are earnestly invited to help the work by communicating with the Hon. Secs., and particularly by sending in Photographs of objects as classified below.

All Photographs are to be subject to approval by the Council of the Survey; must be sent in trimmed but unmounted, preferably of whole plate, half-plate or quarter-plate size, but larger sizes will not be excluded; preferably in Platinotype or Carbon, although under exceptional circumstances untoned Bromides may be admissible; must be accompanied by the following particulars written on a separate slip: – *a.* Subject; *b.* Date of Negative; *c.* Compass point where known; *d.* Name and Address of Contributor; *e.* Brief description; *f.* Process. Printed slips will be provided on application. It is desirable to indicate some manner of scale in the pictures.

Classification Of Subjects

ARCHITECTURE SECTION. — All buildings of interest whether ancient or modern. *Churches*, including monuments and all Church furniture. *Public Buildings and Dwelling Houses*, exteriors and interiors. *Street Architecture*, illustrating the relative positions of houses and boundaries at the present time. *Engineering Works. Ruins.*

ART AND LITERATURE SECTION. — *Art.* 1. Paintings, Drawings and Engravings. 2 Sculpture and Carvings (not architectural). 3. Art Work in Metals. 4. Pottery and Glass. 5. Tapestry, lace and other Fabrics. 6. Art Furniture and Other Objects of Art. — *Literature.* 1. Printed Books, when old, curious or rare. 2. Manuscripts. 3. Maps and Plans. NOTE. — The Committee will be glad to receive information of the existence of objects of interest falling within their province, since a great deal that is most valuable is in private hands, and may otherwise be unknown to them.

ANTHROPLOGY SECTION. — *Antiquities.* Prehistoric and Historic (non-architectural). *Physical Anthropology. Folk Lore.* — 1. Material Objects. 2. Ceremonial. 3. Traditions (games, holy wells, social and religious subjects).

GEOLOGY SECTION. — *Land Contours. River Courses. Sections.* NOTE. — It is advisable that a Geologist be present when a geological photograph is taken.

NATURAL HISTORY SECTION. — *Zoology.* 1. Mammals — *a.* Rare Species; *b.* Habits; *c.* Homes and Young. 2. *Birds* — *a.* Rare Species; *b.* Habits; *c.* Homes and Young; *d.* Migration. 3. Reptiles. 4. Fishes. 5. Insects (including economical Entomology). 6. Pond Life. *Botany.* 1. Trees, peculiarities of growth. 2. Shrubs and Herbaceous Plants. *a.* Habitat; *b.* Peculiarities of flowering; *c.* Galls and other forms of Parasitism. *Meteorology.* Haloes. Remarkable Cloud Appear-

ances. Hailstones and Frost Effects. Lightning. Aurorae. *Photo-Micrography. Astronomy*. Eclipses. Comets. Meteors, &c.

SCENERY AND PASSING EVENTS SECTION. — *Scenery*. 1. Landscapes. 2. Views of places of special beauty or interest, other than architectural. *Passing Events*. 1. Scenes from every day life. 2. Processions. 3. Carnivals. 4. Bonfires &c.

THE OBJECTIVES OF THE NATIONAL FEDERATION OF PHOTOGRAPHIC RECORD AND SURVEY SOCIETIES

- To collate and disseminate information as to the best methods of survey work, and to stimulate the exchange of ideas between photographic record societies.
- To collect and classify all documentary matter issued by record societies, or bearing on record work, for reference by duly authorised persons.
- To encourage and assist the formation of record societies in all parts of the country where such societies do not exist.
- To keep a register of names and addresses of record workers, and in the event of their removal from one district to another, effect their introduction to societies engaged in record work in their new districts.
- To receive and transmit to the appropriate record society prints taken by photographers non-resident in the district photographed.
- To introduce to local record societies persons able to assist them in their work. Generally to further and arouse public interest in the work of photographic survey and record by every suitable means.[3]

PHOTOGRAPHIC SURVEYS

The following are the photographic surveys that I have identified in the course of my research. The list is incomplete — some surveys have almost certainly eluded me. It is also sometimes not clear whether some surveys are new projects or revivals of earlier ones.

PLACE	DATE	ORGANIZER	COMMENTS
Barnstaple	By 1892	Barnstaple and North Devon Photographic Society	
Birkenhead/Wirral	1888–89	Birkenhead Photographic Society	*Includes Wirral; does not appear to be related to the later survey of the same area.*
Brentford	By 1904	Brentford Free Library	
Bristol	c. 1905	Bristol and Gloucester Archaeological Society	
Buckinghamshire	c. 1910?	Buckinghamshire Architectural Association	
Bury St Edmunds	By 1901	Bury St Edmunds Camera Club	
Cambridgeshire	1904	Cambridge Antiquarian Society	
Cheshire	By 1897	Unknown	
Chester	By 1892	Chester Society of Natural History	
Chiswick	1893	West London Photographic Society	
Chorley	By 1898	Chorley and District Photographic Club	
Cleveland	1900	Middlesbrough Photographic Society?	
Clifton	By 1904	Unknown	*Possibly with Bristol*
Coventry	By 1916	Coventry Public Library?	
Darlington	By 1892	unknown	
Darwen	1895	Darwen Photographic Society	
Devon	1897–99	Devon Association	
Dorset	1894	Dorchester Archaeological and Natural History Society	
Ealing	1902	Ealing Photographic Society	

PLACE	DATE	ORGANIZER	COMMENTS
Essex	1899–1906	Essex Field Club	*There appear to be two attempts to start a survey.*
Exeter	1891	Exeter Amateur Photographic Society	*Appears unrelated to the city's survey in 1911.*
Exeter	1911	Exeter Pictorial Record Society	
Gloucester	1894–1904	Bristol and Gloucester Antiquarian Society	*The collection was deposited in 1904. It is not clear if this is the same project as that of 1894.*
Guilford	By 1893	Guildford Photographic Society	
Hampshire	?	Hampshire Archaeological Society	
Handsworth	By 1897	Handsworth Photographic Society	
Hereford	By 1900	Hereford Photographic Society?	
Hertfordshire	1901?	Hertfordshire Antiquarian and Natural History Society	
Huddersfield	c. 1908	Huddersfield Naturalists and Photographic Society	
Hull	By 1901	Hull Photographic Society?	
Ipswich	By 1904	Ipswich Scientific Society	
Kent	1904	Maidstone Institute Camera Club	
King's Lynn	1911	King's Lynn Free Library	
Kingston upon Thames	By 1897	Unknown	
Lancaster	1899	Lancaster Town Council?	
Leicestershire	1901–1916	Leicester Photographic Society, Leicester Literary and Philosophical Society	*Two attempts to instigate surveys.*
London	1894 on	Survey of Memorials of Greater London	*Quasi-official status*
Manchester	1889–1904	Manchester Amateur Photographic Society	
Norfolk	1913	Norwich Public Library, Norwich and District Photographic Society	*Initially discussed 1908*
North Middlesex	1903	North Middlesex Photographic Society, Hornsey Library	

PLACE	DATE	ORGANIZER	COMMENTS
Northamptonshire	1913	Northamptonshire Natural History Society	
Nottinghamshire	1893–1900	Nottingham Mechanics Institute	
National Photographic Record Association	1897–1910	Special Committee under Sir Benjamin Stone	
Oldham	By 1910	Oldham Photographic Society	
Oxfordshire	1894	Oxford Architectural and Historical Society	
Preston	By 1900	Preston Scientific and Photographic Society	
Richmond, Surrey	By 1916	Richmond Public Library	
Rochester	c. 1904	Unknown	
Rotherham	By 1900	Rotherham Photographic Society	
Rutland	c. 1899	Unknown	*With Leicester?*
Salford	1889	Manchester Amateur Photographic Society	*With Manchester*
Sheffield	1889	Sheffield Camera Club/ Sheffield Museum	
Shropshire	c. 1900	Shrewsbury Photographic Society	
Somerset	c. 1890	Somerset Archaeological and Natural History Society	
Southampton	1905	Southampton Camera Club	
St. Albans	By 1901	St. Albans Photographic Society	
Staffordshire	By 1892	Stafford Free Library?	
Suffolk	By 1916	Ipswich Scientific Society	
Surrey	1903	Photographic Survey and Record of Surrey Society	
Sussex	1904	Sussex Archaeological Society	
Sutton, Surrey	1888	Sutton Scientific Society	
Warwickshire	1890	Birmingham Photographic Society	*Survey Society semi-independent*

PLACE	DATE	ORGANIZER	COMMENTS
Wiltshire	1895	Wiltshire Archaeological and Natural History Society	*Possibly never begun*
Wimbledon	1912	John Evelyn Club	
Wirral	By 1904	Unknown	*Does not appear to be related to 1889 Birkenhead Survey*
Wolverhampton	By 1892	Wolverhampton Photographic Society	
Woodford, Essex	By 1904	Woodford Photographic Society	
Woolwich	c. 1902	Woolwich Photographic Society	
Worcestershire	By 1896	Worcester Photographic Society?	
Yorkshire	c. 1890	Leeds Photographic Society	

Dear Sir or Madam

Permit me to draw your attention to the aims and objects of the Joint Committee for the Survey of Leicestershire.

For some time past there has been going on in many parts of England a well directed movement for the registration and preservation of all places of historic interest and natural beauty, and when the "National Trust" in November, 1900, approached the Leicester Literary and Philosophical Society to assist them in compiling a register of places of historic interest and natural beauty within a radius of 10 miles from Leicester, it was felt that the time had come to undertake this work on a wider and more extended basis, which would include all objects of archaeological, architectural, ethnographical, geological and historic interest, in fact all objects a record of which was likely to prove useful in the future, and that photographs of all those objects should be procured on a uniform basis.

A meeting was convened and held under the auspices of the Mayor on the 14th day of March last, to which all Societies interested in this work were invited. It was very well attended, and the unanimous feeling of the members present was enthusiastically in favour of the work being undertaken, and that without much delay. It was explained that the first work could be a complete register of all objects of interest, after which they should be photographed.

In the end a Joint Committee of the various Societies represented was elected, and I have been instructed by this Committee to invite you to assist it and to co-operate with us in carrying out our aims and objects, which I trust may have your hearty approval.

I enclose a form, in duplicate, which kindly fill up as far as lies in your power, and return one copy to me. Should you be in a position to render us further help, kindly let me know.

When complete it is intended to publish this information for the benefit of all, and to deposit one copy of the photographs taken at the British Museum and the other at a central place in Leicestershire, probably the Museum in Leicester, if the necessary consent can be obtained for this of course.

My Committee is now also engaged in framing definite rules for the guidance of all photographers who can be enlisted in this work, and when these rules are completed they will be issued.

Yours faithfully
H. Alfred Roechling

List of subjects to be photographed, 1904.

– Churches and other places of worship with their details, especially furniture and miscellaneous objects, as being most liable to destruction or alteration.
– Ancient Church plate.
– University and College Buildings.
– Monastic Buildings.
– Ancient Houses, especially cottages, farmsteads and barns.
– Houses connected with persons or events of importance.
– General views of streets, both in towns and in villages; also of village greens.
– Windmills, dovecots, sundials, stocks, whipping-posts, pounds and the like.
– Ancient earthworks, fen drains and lodes.
– Customs and ceremonies (e.g. markets, fairs, village feasts, dances, mummers, May-day games, Plough-Monday celebrations, children's games).
– Relics of characteristic costume (e.g. Sun-Bonnet and print gown, smock-frock and breeches).
– Agricultural and domestic implements, ancient and modern.
– Rural occupations, turf-cutting, fruit-picking and the like.
– Pictures and rare engravings of local interest, including portraits.
– Geological features, quarries, roads and railway cuttings.
– Characteristic landscape (e.g. unclaimed fenland).
– Remarkable trees.[5]

Note on captions: Throughout the book where original captions are used, these are given in quotation marks. However, the original information given in the captions for survey photographs is divided into different sections on the label, such as description, date, and photographer. Captions for photographs here have been constructed by combining these sections. All photographs are platinum prints in whole-plate or half-plate sizes unless otherwise stated. The quality of the originals is often variable; they are not perfect art photographs. They often suffer from patches of over-exposure, graininess, halation, and other technical problems. This is part of their history and is reflected in their reproduction.

ABBREVIATIONS

AP *Amateur Photographer* (after 1908, *Amateur
 Photographer and Photographic News*)
BJP *British Journal of Photography*
BJPA *British Journal Photographic Almanac*
CAH *The Camera as Historian*
PG *Photogram Magazine*
PN *Photographic News*
PSRS *Photographic Survey and Record of Surrey*

Other journal names are given in full.

NOTES TO PREFACE

1 Jay, *Cyanide and Spirits*, 1.
2 Pinney, *Photos of the Gods*, 8.

NOTES TO CHAPTER 1: AMATEUR PHOTOGRAPHY AND IMAGINING THE PAST

1 Gower, Jast and Topley, *The Camera as Historian* (*CAH*), 2–3. For another commentary on *CAH*, but one that engages only "discourse," not photographic practices, see Tagg, "The Pencil of History." Pugin's *Examples of Gothic Architecture* was a well-known and much reprinted book in the nineteenth century. A. C. Pugin was the father of the celebrated neogothic architect A. W. N. Pugin.
2 Harrison, "Some Notes on a Proposed Photographic Survey of Warwickshire," 505; Harrison, "The Desirability of an International Bureau," 548.
3 Harris, *Private Lives, Public Spirit*, 3–4.
4 Pinney, *Photos of the Gods*, 8; Williams, *The Long Revolution*, 47.
5 Bridges-Lee, "Photographic Records," 13.
6 Flint, *The Victorians and the Visual Imagination*, 5.

7 Arago, "Report of the Commission of the Chamber of Deputies," 15–25.

8 Marshall, *Photography*, 12, quoting Baron Pollock at the Photographic Society.

9 Boyer, "*La Mission Héliographique*"; Foote, "Relics of London"; Blau, "Patterns of Fact," 40–57; James, "Birmingham, Photography and Change," 99–102.

10 See Tucker, *Nature Exposed*; Edwards, *Raw Histories*, 131–55; Daston and Galison, *Objectivity*, 115–90. Harrison, *A Proposal for a National Photographic Record and Survey*, 2, positioned photographic survey in an historical trajectory from the Domesday Book.

11 Cousserier, "Archive to Educate"; *CAH*, 29–30; Jorge Luis Borges's famous paragraph-long story "On Exactitude in Science" tells of a map on the scale of 1:1, so accurate and realistic as to be entirely useless.

12 See Rollins, *A Greener Vision of Home*; Becker, "Picturing Our Past"; Manikowska, "Building the Cutural Heritage of a Nation."

13 Martin and Francis, "The Camera's Eye," 241.

14 Tagg, *The Burden of Representation*, 16–19; S. Edwards, *The Making of English Photography*; Taylor, *A Dream of England*, 43–50.

15 *AP*, 10 May 1889, 302.

16 Ibid.; Wiener, *English Culture and the Decline of the Industrial Spirit*, 68.

17 Ricoeur, *Time and Narrative*, 116; Kansteiner, "Finding Meaning in Memory," 191.

18 McQuire, *Visions of Modernity*, 108.

19 Le Goff, *History and Memory*, 89.

20 There is a substantial literature in the field of historical consciousness, memory practice, and modernity. Those works that I have found particularly useful are Rieger, *Technology and the Culture of Modernity in Britain and Germany, 1890–1945*; Bann, *The Inventions of History*; Wertsch, *Voices of Collective Remembering*; Seixas, *Theorizing Historical Consciousness*; Kansteiner, "Finding Meaning in Memory"; Collini, *English Pasts*; Becker, "Everyman His Own Historian"; McQuire, *Visions of Modernity*; Flint, "Painting Memory"; and Hobsbawm, "The Social Functions of the Past."

21 I am drawing strongly here on Schwartz's and Ryan's reading of photographs which in turn draws on David Harvey's concept of "geographical imagination." See Schwartz and Ryan, introduction to *Picturing Place*, 6. On Kitty Hauser's "archaeological imagination," see Hauser, *Shadow Sites*, 2–5.

22 Barthes, *Camera Lucida*, 77.

23 Doane, *The Emergence of Cinematic Time*, 4.

24 McQuire, *Visions of Modernity*, 113.

25 Colls, *Identity of England*, 251.

26 Doane, *The Emergence of Cinematic Time*, 4, 11.

27 Ibid., 21.

28 Sachse, "The Camera as Historian of the Future."

29 Nead, *The Haunted Gallery*, 3.

30 Mitchell, *Picturing the Past*, 2. See also Melman, *The Culture of History*.

31 Dellheim, *The Face of the Past*, 37.

32 Ibid., 40.

33 See, for instance, Mandler, "In the Olden Time"; Mitchell, *Picturing the Past*, 16.

34 Nora, "Between Memory and History," 9. Attridge, *Nationalism, Imperialism, and Identity in Late Victorian Culture*, 4.

35 Joyce, *Visions of the People*, 145; Tagg, "The Pencil of History," 287; Crane, *Museums and Memory*, 6; Hobsbawm and Ranger, *The Invention of Tradition*.

36 There is a huge literature on nationality and identity in the nineteenth century and the twentieth, and the various histories, origins, processes, shifts, and nuances of the terms "Englishness" "Britishness" and "national character" have been extensively and energetically debated. A detailed consideration of the debates is beyond the scope of this book. However, the following have been especially useful in thinking about the survey movement: Baucom, *Out of Place*; Young, *The Idea of English Ethnicity*; Colley, *The Britons*; Joyce, *Democratic Subjects*; Kumar, *The Making of English National Identity*; Colls and Dodd, *Englishness*; Colls, *Identity of England*; Mandler, *History and National Life*; Mandler, "The Consciousness of Modernity"; Gillis, *Commemorations*; Wiener, *English Culture and the Decline of the Industrial Spirit, 1850–1980*; Burchardt, *Paradise Lost*; Mandler, "Against 'Englishness.'"

37 Kumar, *The Making of English National Identity*, 176.

38 Nora, "Between Memory and History," 7.

39 See Readman, "Preserving the English Landscape."

40 See, for example, MacDonald, *The Language of Empire*; Cannadine, *Ornamentalism*; Baucom, *Out of Place*; Haseler, *The English Tribe*.

41 Baucom, *Out of Place*, 47.

42 *AP*, 19 March 1897, 222.

43 See Young, *Colonial Desire*; Cannadine, *Ornmentalism*; Collini, *English Pasts*, 27.

44 Janowitz, *England's Ruins*, 3.

45 Daniels, *Fields of Vision*, 5. There is likewise a huge literature on place, memory, nation, and identity. See, for instance, Cosgrove and Daniels, *The Iconography of Landscape*; Matless, *Landscape and Englishness*; Schwartz and Ryan, *Picturing Place*; Mitchell, *Landscape and Power*. For an account of the politics of land entangled with this position, see, for instance, Readman, *Land and Nation in England*.

46 Palmer, "From Theory to Practice," 191.

47 Bell, "Mythscapes," 65, 69.

48 Billig, *Banal Nationalism*, 8. See also Palmer, "From Theory to Practice," for an application to landscape.

49 Palmer, "From Theory to Practice," 5–6, 42–43.

50 Nora. "Between Memory and History," 13.

51 Phythian Adams, *Re-thinking English Local History*, 2–3.

52 Seixas, *Theorizing Historical Consciousness*, 5.

53 Roth, "Photographic Ambivalences and Historical Consciousness," 93.

54 Le Goff, *History and Memory*, 95–96.

55 Bender, "Time and Landscape," 103–4, 106.

56 Fentress and Wickham, *Social Memory*; Halbwachs, *On Collective Memory*, ix.

57 Bell, "Mythscapes," 65.

58 Fentress and Wickham, *Social Memory*, 90.

59 Barthes, *Camera Lucida*, 4.

60 The early nineteenth-century French biologist Jean-Baptiste Lamarck (1744–1829) argued that evolution was premised not on dynamic biological development within the organism (the core of Darwin's mechanical model of evolution) but on inorganic, external, and disembodied factors such as environment and experience, factors imprinted on the development of the organism and its patterns of heredity. It was thus an evolution through the inheritance of acquired characteristics. For an examination of photography and neo-Lamarckianism, see Edwards, "Samuel Butler's Photography."

61 *Eastern Daily Press*, 2 December 1913; *CAH*, 4.

62 Burton, "The Whole Duty of a Photographer."

63 Kansteiner, "Finding Meaning in Memory," 179–80.

64 *PSRS, Second Annual Report*, 1904, 7.

65 MacDonagh, Introduction to *Sir Benjamin Stone's Pictures*, vii; Harrison, *A Proposal for a National Photographic Record and Survey*, 2.

66 Report on the NPRA, *AP*, 8 October 1897, 308.

67 Sekula, "Reading an Archive," 121; Tagg, "The Pencil of History," 291, 286–87.

68 Bann, *Romanticism and the Rise of History*, 127; Tagg, "The Pencil of History," 287, 289–90.

69 Green-Lewis, *Framing the Victorians*, 4. There is an extensive literature on the evidential discourses of photography; see, for example, Tucker, *Nature Exposed*; Tagg, *The Burden of Representation*; Tagg, *The Disciplinary Frame*; Solomon-Godeau, *Photography at the Dock*; and for a different view, see Baer, *Spectral Evidence*.

70 See, for example, Green-Lewis, *Framing the Victorians*; Armstrong, *Fiction in the Age of Photography*. Tagg, *The Burden of Representation*, 4.

71 Green-Lewis, *Framing the Victorians*, 33; Tagg, "The Pencil of History," 286.

72 Green-Lewis, *Framing the Victorians*, 28.

73 Gaines, "Introduction: The Real Returns," 8.

74 I am drawing these terms from Sekula, "Reading an Archive," 126.

75 For a detailed discussion of these issues, see Edwards, "Photography and the Material Performance of the Past"; Tagg, "The Pencil of History."

76 Ankersmit, *Sublime Historical Experience*, 9.

77 Riegl, "The Modern Cult of Monuments," 33. The photograph could also be seen as arresting the inherent decay through which age-values contribute to the demise of the photograph's object (Riegl, 32–33).

78 [Harrison], "Work for Amateur Photographers," 304.

79 Riegl, "The Modern Cult of Monuments," 37–38. Riegl specifically notes colour photography.

80 McQuire, *Visions of Modernity*, 119–24.

81 See Mandler, *History and National Life*, 55–57. Hobsbawm and Ranger, *The Invention of Tradition*. For a useful summary, see Readman, "The Place of the Past in English Culture," 147–49.

82 Readman, "Preserving the English Landscape," 198.

83 See Judge, "May Day and Merrie England."

84 Readman, "The Place of the Past in English Culture," 150–51, 157–59. See also Melman, *The Culture of History*, for a detailed account of a wide range of popular uses of and engagements with the past.

85 Reverend Thomas Perkins, of the Dorset survey, contributed pocket-sized volumes on the great abbeys at Romsey, Malmesbury and St. Albans, and on Manchester and Bath to this series.

86 Readman, "The Place of the Past in English Culture," 150, 160. Naylor makes a similar point in relation to late nineteenth-century antiquarianism of which the surveys can be seen as part. Naylor, "Collecting Quoits," 319–33.

87 See, for instance, Taylor, *A Dream of England*; Pollock, "Dislocated Narratives and Sites of Memory."

88 Taylor, *A Dream of England*, 67.

89 Jäger, "Picturing Nations"; Andrews, "The Metropolitan Picturesque"; Mitchell, *Landscape and Power*.

90 The extent and impact of this position has been extensively debated. See Wiener, *English Culture and the Decline of the Industrial Spirit*; Readman, "Landscape Preservation, Advertising Disfigurement, and English National Identity"; Mandler, "Against Englishness," 156–57; Howkins, "The Discovery of Rural England," 64–65.

91 Ankersmit, *Sublime Historical Experience*, 9; Tagg, "The Pencil of History," 290.

92 J. Edwards, "The Need for a 'Bit of History,'" 150.

93 Seremetakis, *The Senses Still*, 4–5.

94 Burchardt, *Paradise Lost*, 100. Rollins, *A Greener Vision of Home*, 14, makes a similar point in relation to the Heimatschutz movement.

95 Macdonald, *The Politics of Display*, 30.

96 Readman, "Preserving the English Landscape," 207.

97 Part of the reason for this is that studies have focused on the early surveys, such as the survey in Warwickshire, whose methods and outputs were in many ways atypical of the wider movement as it developed.

98 Helva, "The Photography Complex," 81.

99 Latour, "The Berlin Key or How to do Words with Things."

100 Ibid., 81.

101 *Amateur Photographer's Weekly*, 8 September 1916, 230; Pollock, "Dislocated Narratives."

102 See Hauser, *Shadow Sites*; Mellor, *A Paradise Lost*.

103 Minute Book 1, PSRS Papers, meeting, 4 November 1907 (Croydon Local Studies Library).

104 *Architectural Review*, April 1917, 24. BJP, 10 November 1916, 614. The book was extensively and positively reviewed in the photographic press but received a more lukewarm reception elsewhere. For instance, *Burlington Magazine* commented that the book was "valuable for students but contributes little to the history of the Fine Arts" (vol. 30, no. 168, March 1917, 120).

105 All three authors were members of the Photographic Survey and Record of Surrey and had strong interests in science, being members of the Croydon Microscopical and Natural History Society. Both Gower and Topley were employed by the Croydon Gas and Coke Company, while Jast was the borough librarian.

106 Moretti, *Graphs, Maps, Trees*.

107 For such a discussion, see Leith, "Amateurs, Antiquarians and Tradesmen."

108 Engelke, "The Objects of Evidence," 9.

109 Stoler, "Colonial Archives and the Art of Governance," 92 For a discussion of the centrality of materiality in survey discourse, see Edwards, "Photography and the Material Performance of the Past."

110 Pinney, Introduction to *Photography's Other Histories*, 2.

111 Ankersmit, *Sublime Historical Experience*, 279.

112 Tucker, *Nature Exposed*; S. Edwards, *The Making of English Photography*, 4–5.

113 *Church Family Newspaper*, 20 October 1899, 606; *Clarion*, 24 April 1897, 130.

NOTES TO CHAPTER 2: AMATEUR PHOTOGRAPHERS AND THE MOVEMENT

1 Harrison, "On the Work of a Local Photographic Society."

2 See Crary, *Suspensions of Perception*.

3 "Illustrated Cities," *AP*, 1 April 1888, 211. This project does not appear to have been entirely photographic. The project included an explanatory text of 10,000 to 12,000 words to create an illustrated book. For a detailed consideration of the chronology of the emergence of the early surveys, see James, "William Jerome Harrison, Sir Benjamin Stone and the Photographic Record and Survey Movement," 32–44. Pollock, "Dislocated Narratives and Sites of Memory," 1.

4 Jeffs, "Geological Photography." Jeffs had presented an earlier version of this paper to the Liverpool Science Students Association in 1885 (*AP*, 30 January 1885, 267). Another version was presented at the BAAS meeting in 1888 under the title "On Local Geological Photography" (BAAS Report, 1888, 653).

5 Jeffs, "Geological Photography," 273.

6 Harrison, "On the Teaching of Science in Public Elementary Schools," 285. Harrison (1845–1908) was a trained scientist and a noted geologist. He worked as a curator in Leicester and then in education in the West Midlands, as an advisor and a teacher in scientific education. He was equally distinguished in the photographic world, writing extensively on photography, natural history, and science.

7 These ideas, first proposed by the German philosopher Felix Eberty in the early nineteenth century and elaborated on in Camille Flammarion's *Lumen* in 1872 (although only translated into English in 1897, the year of the founding of the NPRA), had gathered popular momentum and were linked to the history of film as early as 1899. For an illuminating account, see Nead, *The Haunted Gallery*, 233–34.

8 Harrison, "Light as a Recording Agent of the Past."

9 Sachse, "The Camera as Historian of the Future," 653.

10 James, "The Evolution of the Photographic Record and Survey Movement," 210.

11 Harrison, *A Proposal for a National Photographic Record and Survey*, 2, 14.

12 *AP*, 11 June 1907, 528.

13 For a detailed and authoritative consideration of the roles of Harrison and Stone in the emergence of the photographic survey movement, see James, "William Jerome Harrison, Sir Benjamin Stone and the Photographic Record and Survey Movement," and James, "The Evolution of the Photographic Record and Survey Movement." See also Edwards and James, *A Record of England*.

14 George Scamell to T. D. Atkinson, Cambridge Antiquarian Society, 30 November 1897, CAS Papers, Congress of Archaeological Societies volume, Haddon Library, Cambridge.

15 Photographic Survey Papers, Leicestershire Archives, DE 600/1/3/2.

16 Society of Antiquaries, London, Report of the Standing Committee, 6 July 1898.

17 *The Times* (London), 4 April 1897.

18 Congress of Archaeological Societies, Annual and Special Reports, 1893.

19 *Western Press*, 15 April 1897, (JBS Cuttings, vol. 4, Birmingham City Library).

20 Stone was elected to Parliament for East Birmingham in 1895.

21 James, "The Evolution of the Photographic Record and Survey Movement," 211; James, "William Jerome Harrison, Sir Benjamin Stone and the Photographic Record and Survey Movement," 54–55.

22 Harrison, "The Desirability of an International Bureau."

23 Harrison, "The Desirability of Promoting County Photographic Surveys."

24 *CAH*, 36–37.

25 Minute Book, 9 April 1902, Records of Leicester and Leicestershire Photographic Society, DE 3868/2.

26 Letter to the editor, *Sheffield and Rotherham Independent*, 11 June 1890.

27 See, for instance, Taylor, *A Dream of England*; Pollock, "Dislocated Narratives and Sites of Memory."

28 *Transactions of the Devonshire Association* 29 (1897).

29 Anderson, *Imagined Communities*.

30 King's Lynn Public Library, Photographic Survey File. This is probably J. Bowker of an important local family of maltsters.

31 Norwich Public Library Minutes, MS21396, 3 January 1913; *PSRS First Annual Report*, 1903, 4.

32 Also see, for instance, *AP*, 15 January 1910, 284.

33 Report of NPRA annual general meeting, *BJP*, 16 November 1906, 912.

34 *BJP*, 19 April 1907, 287.

35 *BJP*, 11 March 1910, 170–71.

36 *AP*, 1 March 1910, 196.

37 Perkins, "A Plea for Systematic and Associated Work in Photography," 344.

38 See, for instance, Taylor, *A Dream of England*; Tagg, "The Pencil of History"; Pollock "Dislocated Narratives and Sites of Memory."

39 Harrison, "The Desirability of an International Bureau," 548.

40 "National and Local Photographic Record," *BJP*, 19 April 1907, 287.

41 Ibid., 15.

42 Gunn, "The Failure of the Victorian Middle Class," 24. See also Gunn, *The Public Culture of the Victorian Middle Class*. Even "solicitor" could refer equally at this period to someone from the landed gentry or the lower middle class (Harris, *Private Lives, Public Spirit*, 9).

43 Boyes, *The Imagined Village*, 15.

44 William Ellis worked in and ran a small lace-finishing ("gasser") workshop in Nottingham. He was a member of the Nottingham Mechanics Institute and participated in the survey through their photographic club. I am not using quantitative definitions of the various groups. I have only been able to identify about 80 percent of the survey photographers who have left archival traces, and some of these without absolute certainty. Consequently, the data is too uncertain and incomplete for such an analysis to be meaningful. However, the figures give a rough but grounded estimate of participation in the survey movement.

45 See Rose, *The Intellectual Life of the British Working Class*, 434.

46 Florence Gandy was a keen amateur photographer and the wife of the managing clerk of Derby County Council. She exhibited photographs widely, winning many prizes and medals. The *BJP* described her pictorialist photograph "Stour Floods" as the "most admirable study by an accomplished lady practitioner" (*BJP*, 15 March 1901, 169). She and her husband were founding members of the Derby Photographic Society. She attended photographic conventions with her husband and contributed to the NPRA, although he did not. She appears to have stopped taking pictures, or at least contributing to the surveys, after the death of her husband in 1905.

47 See Palmquist, *Catherine Weed Barnes Ward*.

48 One should note, however, that the visibility of women was limited to those clubs and societies that admitted women. Although most camera clubs and photographic societies were open to them, not all were.

49 Williams, *The Long Revolution*, 48.

50 George Embrey was a local government scientist, working as the public analyst and district agricultural analyst for the Gloucester region.

51 Wratten's company was one of the major dry plate manufacturers of the period, his photographic plates used the world over by photographers of all kinds.

52 Readman, "Preserving the English Landscape," 198.

53 For such sentiments, see, for example, Murchison, "Photography with an Object," 450.

54 Price, *Town and Gown*.

55 Castel and Schnapper, "Aesthetic Ambitions and Social Aspirations," 103–4. Taylor, *A Dream of England*, follows a similar analytical line.

56 Readman, "Preserving the English Landscape," 208–9.

57 For example is Edward Felce was a commercial clerk from Northampton. He was a survey photographer, an NPRA contributor, and a member of the Architectural Detail Club. Some of his photographs of misericords were published in the *Photographic Art Journal* 1 (1902): 370. He contributed an article entitled "A Photographic Ramble through Central Northamptonshire" to the same journal in 1901 (175–80).

58 Wells, *A History of the Old Cambridge Photographic Club*.

59 *AP*, 15 September 1904; *Photogram* 1, no. 1 (December 1897): xxi.

60 Luckhurst and McDonagh, *Transactions and Encounters*, 6.

61 Bingley was a retired engineer. He had very active interests in photography, history, and natural history, especially geology. He had served since 1900 on the Committee for the Collection of Photographs of Geological Interest, part of the BAAS.

62 Haddon was trained as a zoologist and held a post in natural sciences at Trinity College, Dublin. Through his interest in Irish ethnography, he became increasingly involved with anthropology, and after his two expeditions to the Torres Strait (in 1888–89 and 1898), anthropology became his main focus. Haddon was probably the anthropologist most closely involved with photographic survey, not only methodologically, but in terms of subject matter. He was involved with the BAAS ethnographic survey and with the Cambridgeshire photographic survey.

63 Bingley was especially well known as a maker of lantern slides, notably of geological and architectural subjects. He demonstrated his technique to camera clubs across the north of England and judged lantern slide classes.

64 It is not clear if Lovett actually made photographs. He was perhaps more of a survey facilitator as anthropology section chair of the Surrey survey.

65 Fincham was not only president of the North Middlesex Photographic Society but, because of his active interest in antiquities, he was on the publishing committee for the Survey of London.

66 Gunn, *The Public Culture of the Victorian Middle Class*, 14.

67 NDPS Minutes, vol. 2, SO 187/2, 25 May 1909.

68 John Lindsay, the Twenty-Sixth Earl of Crawford, was a distinguished amateur scientist, notably in astronomy and with strong interests in photography. He was president of the Royal Photographic Society from 1897 to 1900. The Fourth Earl of Rosse was an astronomer and engineer, also with strong photographic interests. His parents, the Third Earl of Rosse and Mary, the Countess of Rosse, were notable scientists who also made contributions to the development of photography.

69 Raphael Meldola (1845–1915), distinguished chemist. Specialising notably in dyestuffs, he was also interested in photography and wrote a standard text book *The Chemistry of Photography* (1889). He was on the Committee of the NPRA as representative of the Royal Society. He clearly knew Stone socially, too, possibly linked to Stone's interest in Jewish history.

70 Readman, "Preserving the English Landscape," 199.

71 Luckhurst and McDonagh, *Transactions and Encounters*, 7.

72 "A Photographic Record and Survey," *BJP*, 13 May 1892, 306.

73 Williams, *The Long Revolution*, 50.

74 Ibid., 52.

75 Ibid., 8.

76 Pitt-Johnson, "A Plea for Our Village Churches."

77 J. Edwards, "The Need for a 'Bit of History,'" 148.

78 Ibid.

79 Gloucester Archives, SR44/36297/78.

80 *BJP*, 23 March 1900, 181. For a detailed account of this shift, see Lang, *The Victorians and the Stuart Heritage*, especially 218–26. See also Mandler, *The English National Character*; Dellheim, *The Face of the Past*; Howkins, "The Discovery of Rural England," 70–71.

81 Manchester Survey Photographs, Manchester City Library, 6020.

82 *Eastern Daily Press*, 2 December 1913 (NHC Stephens Scrapbook, 52).

83 Hansen, "Modern Mountains," 187.

84 Harrison, "On the Work of a Local Photographic Society," 426.

85 Harrison, "The Desirability of Promoting County Photographic Surveys," 58; Goodman, *Homes Counties Magazine*, vol. 4, 1902, 3.

86 *CAH*, 38–39.

87 *BJP*, 20 July 1900, 484. See also Boyer, *The City of Collective Memory*, 4. For an extended consideration of the urban aspects of surveys, see Edwards, "Urban Survivals and Anticipated Futures."

88 Crary, *The Techniques of the Observer*, 6.

89 Harrison, *A Proposal for a National Photographic Record and Survey*, 2.

90 Coulthurst, "Notes on a Photographic Survey," 116.

91 *Photographic News*, 20 May 1892, 332.

92 See also Edwards, "Unblushing Realism and the Threat of the Pictorial."

93 Tucker, *Nature Exposed*.

94 MacDonagh, Introduction to *Sir Benjamin Stone's Pictures*, vii.

95 As Bann has argued, photography, with its promise of "reproduction without representation," became the logical extension of nineteenth-century objective history, which was premised on the concept of "truth to sources." Bann, *Romanticism and the Rise of History*, 127.

96 *Birmingham Gazette*, 9 July 1898 (JBS Cuttings, vol. 4, Birmingham City Library); Report of the NPRA, *Photography*, 15 July 1897, 438.

97 Naylor, "Collecting Quoits," 315.

98 Kelsey, *Archive Style*.

99 *CAH*, 48.

100 Daston and Galison, "The Image of Objectivity," 81–82; see also Daston and Galison, *Objectivity*.

101 Lockett, "Measuring and Surveying by Photography," *AP*, 24 March 1908, 329.

102 *BJP*, 1 May 1892, 306.

103 *CAH*, 48.

104 Ibid., vii.

105 See Tucker, *Nature Exposed*.

106 Urry, "*Notes and Queries on Anthropology* and the Development of Field Methods in British Anthropology."

107 Anderson, *Predicting the Weather*; Tucker, *Nature Exposed*.

108 Anderson, *Predicting the Weather*, 104.

109 James, "William Jerome Harrison, Sir Benjamin Stone and the Photographic Record and Survey Movement," 33; *British Journal Photographic Almanac* (1890): 610.

110 For a more detailed study of the relationship between the photographic survey movement and the BAAS, see Edwards, "Straightforward and Ordered." The BAAS provided a major site for the cultural reproduction of the values of professional science over a wide range of activities, networks of interest, and levels of engagement. See Morrell and Thackray, *Gentlemen of Science*.

111 Report of the BAAS, Leeds meeting, 1890, 429; Reid, "Geological Photography"; for a description of the Geological Photography Collection, see McKenna, "The Geological Photographs of the BAAS."

112 Report of the BAAS, Edinburgh meeting, 1892, 290. The increasing emphasis on this aspect parallels the gradual shift in organisational power-base of the geological photographs from amateurs to university departments by 1910.

113 "A Photographic Record and Survey," *BJP*, 13 May 1892, 306.

114 Report of the BAAS, Dover meeting, 1899, 592.

115 *Photography*, 31 October 1889, 615; Harrison, "Some Notes on a Proposed Photographic Survey of Warwickshire," 512.

116 Harrison, *A Proposal for a National Photographic Record and Survey*, 6.

117 Perkins, *Handbook of Gothic Architecture*, 9.

118 Sachse, "The Camera as Historian of the Future," 653.

119 Bothamley, "A Photographic Survey of Somerset,"169. The *BJPA* for 1899 lists two photographic societies in Somerset, at Bath and at Frome, although there was also a photographic society in Taunton, the county town.

120 *Photogram*, January 1907, 30–31.

121 For a full account, see Bailey, *Leisure and Class in Victorian England*, 36–37. See also Rose, *The Intellectual Life of the British Working Class*.

122 "Photographic Record Work: New Efforts," *Photogram*, October 1906, 307.

123 Perkins, "A Plea for Systematic and Associated Work in Photography," 132.

124 Talbot Archer [William Jerome Harrison], "English Notes," *Anthony's Photographic Bulletin*, 10 August 1888, 453; Perkins "A Plea for Systematic and Associated Work in Photography," 132; *AP*, 25 April 1890, 293; *CAH*, 5.

125 *AP*, 27 January 1899, 64. The reference is to sixteenth-century and seventeenth-century antiquaries John Stow (c. 1525–1605) and Sir William Dugdale (1605–1686). Stone owned books by both these writers.

126 Boyer, *The City of Collective Memory*, 12.

127 Captain William Abney (1843–1920) was one

of the major figures of scientific photography in the nineteenth century. He was also a distinguished astronomer, chemist, military man, and administrator. He developed photographic technologies for the military, to be used in applied survey and reconnaissance.

128 Harrison had called for a "state photographer" to create a national archive, and there were repeated appeals to various levels of government for support. Harrison, *A Proposal for a National Photographic Record and Surevy*, 5; *BJP*, 9 December 1898, 793.

129 Nora, "Between Memory and History," 15.

130 Harrison, *A Proposal for a National Photographic Record and Survey*, 3.

131 Report of the BAAS, 76th meeting, York, 1906, 646. The one-inch OS maps were also used as the basis for the work of the BAAS committee for the recording of "Localities in the British Islands in which evidences of the existence of Prehistoric Inhabitants of the country are found."

132 Edney, *Mapping an Empire*, 21.

133 In 1895–96 there was an abortive proposal for a complete geographical survey of the British Isles based on the OS maps. The proposal made direct reference to the photographic survey movement: "More facts and more surveys are ... required to perfect our knowledge." See Mill, "Proposed Geographical Description of the British Isles Based on the Ordinance Survey."

134 Gilbert, *Imagined Londons*, 11.

135 See Hauser, *Bloody Old Britain*.

136 *CAH*, 177.

137 *AP*, 1 June 1909, 512.

138 Harrison, "Some Notes on a Proposed Photographic Survey of Warwickshire," 512.

139 *Nottingham Daily Express*, 10 December 1901.

140 *BJP*, 17 October 1902, 836.

141 *Photographic News*, 21 March 1890, 219.

142 Crouch and Matless, "Refiguring Geography," 243; Crouch, "The Street in the Making of Popular Geographical Knowledge," 160, 170.

143 Ingold and Vergunst, *Ways of Walking*, 9.

144 *BJP*, 12 May 1899, 299.

145 Slater, "Notes of Photo-Cycling," 99.

146 See, for instance, Jones, "Cycling Records," 103–4; *AP*, 13 August 1907.

147 The photographs donated to Exeter were taken in 1893 and printed for the survey in 1911 (EPRS Schedule, vol. 1, items 17–27).

148 The Manchester and Liverpool amateur photographic societies tried to get for their members the reduced fares enjoyed by hobby anglers. MAPS Minutes, 8 September 1885.

149 Hansen, "Modern Mountains" 186–87. De Certeau, *The Practice of Everyday Life*, 97.

150 Crary, *Suspensions of Perception*; De Certeau, *The Practice of Everyday Life*, 100; Lee and Ingold, "Fieldwork on Foot," 78; Bann, *The Inventions of History*, 116; Edensor, "Walking in Rhythm," 69.

151 Trouillot, *Silencing the Past*, 29–30.

152 De Certeau, *The Practice of Everyday Life*, 98. Runia, "Presence," 13.

153 Creighton, "The Study of a Country," 297.

154 Harrison, "Some Notes on a Proposed Photographic Survey of Warwickshire," 513.

155 "Diary of A South Warwickshire Survey on Cycles with the Camera" (Ms. Birmingham Archives and Heritage, n.n., ff. 6).

156 *CAH*, 177–78, emphasis added.

157 De Certeau, *The Practice of Everyday Life*, 94.

158 *North Devon Journal*, 24 March 1892, 5.

159 Lee and Ingold, "Fieldwork on Foot," 67.

160 "Photographic and Pictorial Survey of Essex Annual Report," *Essex Naturalist* 14 (1906): 257. Dr. Laver was a noted local antiquarian.

161 Ingold and Vergunst, *Ways of Walking*.

162 Photographic and Pictorial Survey and Record of Essex, Essex County Archives, D/DGD Z59.

163 Woolwich Photographic Society Ledger, National Media Museum, Bradford, C6/53.

164 Manchester Amateur Photographic Society Minutes, M34/1/1/4, 12 December 1893.

165 Norfolk Archives, DD 1915/1/701–27.

166 Ingold, *Lines*, 88–89.

167 "Notes," *British Journal of Photography*, 25 May 1888, 333–34.

168 Ingold and Vergunst, *Ways of Walking*, 4. The sense of the embodied image-maker is central in recent analyses of observational cinema, moving analysis from a notion of disembodied gaze to embodied and subjective interaction. See, for example, Grimshaw and Ravetz, *Observational Cinema*, and McDougall, *The Corporeal Image*.

169 Middleton, "Photographic Survey Work," 112; Coulthurst, "Notes on a Photographic Survey," 116.

170 Anderson, *Predicting the Weather*, 95.

171 "Report of Council," *Transactions of the Bristol and Gloucestershire Archaeological Society* 21 (1898): 214.

172 Perkins, "Some Instruction in Photographic Survey Work," 344; A. Naylor to G. Scamell, 8 January 1898, LPS Secretary's Copy Books, West Yorkshire Archives, WYL2064/4/1.

173 Coulthurst, "Notes on a Photographic Survey," 115; *BJP*, 6 February 1892, 89; *PSRS Seventh Annual Report*, 1909, 11. *AP*, 28 February1908, 159–60.

174 Coulthurst, "Photographic Survey Work — A Plea."

175 Pollock, "Dislocated Narratives and Sites of Memory," 7.

176 Foucault, *The Archaeology of Knowledge*.

177 Pazderic, "Mysterious Photographs," 197.

178 *BJP*, 1 May 1892, 306.

179 Crary, *Suspensions of Perception*, 24.

180 Ibid., 47.

181 Norwich Public Library Minutes, MS21396, 25 April 1913.

182 *BJP*, 22 October 1909, 823.

183 Edwards and James, *A Record of England*, 9.

184 *Photography*, 10 September 1904, 228.

185 *Photography*, 19 November 1904, 427.

186 British Museum, Department of Prints and Drawings Papers, Reports to the Trustees, 6 June 1898.

187 Mandler, "Against 'Englishness,'" 168–69.

188 Readman, "Preserving the English Landscape," 198.

189 *AP*, 16 April 1897, 301.

NOTES TO CHAPTER 3: PRACTICES OF EVIDENCE, STYLE, AND ARCHIVE

1 "Record and Survey Photography," *BJP*, 14 August 1908, 616.

2 Domanska, "The Material Presence of the Past," 341.

3 MacDonagh, Introduction to *Sir Benjamin Stone's Pictures*, vii.

4 Daston and Galison, *Objectivity*, 139.

5 Daston and Galison, "The Image of Objectivity," 82.

6 Doane, *The Emergence of Cinematic Time*, 19.

7 The principle of entropy was developed in the mid-nineteenth century by the German physicist Rudolf Clausius. See Richards, *The Imperial Archive*.

8 Myers, "Popularizations of Thermodynamics," 308.

9 Balfour Stewart was one popular explicator of physics and wrote a key school text, *Lessons of Elementary Physics* (1870), that ran to many editions in the course of the latter part of the nineteenth century. He also wrote a standard textbook in the field, *The Conservation of Energy* (1873). Myers, "Popularizations of Thermodynamics," 308; Brush, "Thermodynamics and History."

10 Richards, *The Imperial Archive*, 75; Richards, "Archive and Utopia," 104.

11 Myers, "Popularizations of Thermodynamics," 309; Richards, *Imperial Archive*, 75. See also Arnheim, *Entropy and Art*, 7–12.

12 Richards, *Imperial Archive*, 75; Richards, "Archive and Utopia," 104.

13 *CAH*, 6.

14 In this vein, the *Photographic News* (reprinting an article from the American publication *Anthony's Photographic Bulletin*) suggested that amateur photographers had come of age and were now "fitted to accomplish work that shall tell in the development of photography." (James, "William Jerome Harrison, Sir Benjamin Stone and the Photographic Record and Survey Movement," 5.)

15 *AP*, 17 April 1896, 344.

16 *AP*, 7 October 1902, 101.

17 *CAH*, 160.

18 Watkins was active in photography, natural history, and local antiquarianism, writing extensively on all three subjects, as he did in his book *Photography: The Watkins Manual of Exposure and Development*, which ran to numerous editions. He is perhaps best remembered as the inventor of the Watkins Exposure Metre and the author of *The Old Straight Track*, which argued the existence of lay lines. See Daniels, "Lines of Sight." *AP*, 19 November 1897, 428.

19 Bridges-Lee, "Photographic Records," 7. Bridges-Lee invented a photograph theodolite that marked horizontals and verticals onto the negative. It was widely used in surveying mountainous regions. His work was exhibited at the Royal Photographic Society.

20 Middleton, "Photographic Survey Work," 122.

21 Tucker, *Nature Exposed*, 63–64.

22 Harrison, "The Desirability of an International Bureau," 548.

23 *BJP*, 15 October 1909, 801. The *BJP* reported the speech in full and the discussion. Conway believed firmly in the value of photographs and photographic collections to scholarship. His collection of reproductions of art and architectural historical subjects formed the basis of the Conway Art Library, Courtauld Institute of Art, University of London.

24 "A Photographic Record and Survey," *BJP*, 13 May 1892, 306.

25 Ibid.

26 Myers, "Popularizations of Thermodynamics," 321.

27 Daston and Galison, "The Image of Objectivity," 81.

28 Maver and Smiles, *Envisioning the Past*, 1; See also Kelsey, *Archive Style*.

29 Crabtree, "System in Record Work," 408.

30 Elkins, *The Domain of Images*, 52–53; Leith, "Amateurs, Antiquarians and Tradesmen."

31 Daston and Galison, *Objectivity*, 121. For further discussion of cultures of scientific self-restraint, see Porter, "The Objective Self."

32 Robinson's son, Ralph, was also a photographer and produced pictorialist work, some of which became absorbed into the Surrey survey, with which he was involved. His studio was managed by A. Horsley Hinton, who, as editor of *AP*, did much to encourage the survey movement.

33 There is an extensive literature on pictorialism, a literature which, of course, has its own dynamic history. See, for example, Bunnell, *Photographic Vision*; Lane, *Pictorial Photography in Britain*; Handy, *Pictorialist Effect/Naturalistic Vision*. For a discussion of a broader pictorialism and amateur practice, see Taylor, *A Dream of England*.

34 Green-Lewis, *Framing the Victorians*; Tucker, *Nature Exposed*; Taylor, *A Dream of England*; S. Edwards, *The Making of English Photography*.

35 Such class hierarchies are clearly implicated in the Somerset Archaeological and Natural History Society's resistance to extending membership to photographers who might help with their survey (SANHS Minute Book 10/12/1897. SCRO DD SAS.G733/1).

36 For instance, the work of Alfred Stieglitz by the second decade of the twentieth century, when he moved increasingly away from pictorialism and toward modernism, and the work of Paul Strand, to whom Stieglitz gave an early exhibition.

37 *Linked Ring Papers*, No Xa, 21 July 1899 (Bradford, RPS Collection).

38 Emerson's pictorial work of the Fens of East Anglia had a strong salvage ethnography element to it. Emerson himself saw his work as "ethnographic" and he was an active member of the Folklore Society, to whom he presented a copy of his book *Pictures of East Anglian Life* (1888). His photographs would probably have been familiar to all members of photographic clubs.

39 Smith, *Victorian Photography, Painting and Poetry*, 24.

40 There was some overlap between Morris's SPAB and the survey movement, particularly through architects involved in the latter: Philip Norman, secretary of the SPAB, was on the NPRA committee and Rev. Thomas Perkins of the Dorset survey was a local representative for the SPAB. See chapters 1 and 2.

41 There was of course a sense of the collective among pictorial photographers, such as those in the Linked Ring. However, while premised on commonly held interests the group focused on individual excellence and virtuosity to demonstrate and forward the project of art photography.

42 *AP*, 13 July 1909, 42.

43 Daston, "Objectivity and the Escape from Perspective," 603.

44 Stone addressing the AGM of the NPRA, *BJP*, 23 November 1906, 923.

45 "Record and Survey Photography," *BJP*, 14 August 1908, 615–16.

46 Harrison often referred to such photographs as "figures," as if to emphasise their scientific status. See Taylor, *A Dream of England*, 79.

47 Letter to the editor, *Photogram Magazine*, June 1900, 204.

48 The term was reputedly coined to describe an "acute form" of pictorialism among the salonists and the Linked Ring. By the late 1890s, it had become a term of ridicule applied to those who assumed "that the more fuzzy a photograph can be made the more it approaches 'art.'" (*BJP*, 28 January 1898, 50–51).

49 *AP*, 23 November 1900, 405.

50 Ibid.; Honorary Secretary's Report, 1911 Annual General Meeting, Norwich and District Photographic Society Minutes, vol. 2, October 1912, S0187/2.

51 *BJP*, 28 January 1898, 50–51. Baldock was also active in producing the BAAS Collection of geological photographs.

52 *AP*, 23 November 1900, 405.

53 *CAH*, 184.

54 *AP*, 21 May 1897, 413.

55 *AP*, 18 May 1909, 463.

56 *BJP*, 19 April 1907, 287.

57 *AP*, 10 May 1889, 302.

58 *CAH*, 35–36.

59 *Eastern Daily News*, 25 January 1913. Edward Peake was the master at a local elementary school. He was a keen amateur photographer and held office in the Norwich and District Photographic Society for many years. His wife, Elizabeth, was also a good amateur photographer who exhibited at the Royal Photographic Society in 1908. Correspondence, *Eastern Daily News*, 28 January 1913.

60 *BJP*, 21 May 1909, 396.

61 Ibid., 402. The amateur pictorial section was selected by E. O. Hoppé and included the work of Americans E. J. Steichen, Clarence H. White, Alfred Stieglitz, F. Holland Day, and A. L. Coburn, and three British representatives, J. Craig Annan, George Davison, and A. von Meyer. All were members of the International Union of Art Photographers. *BJP*, 18 June 1909, 474.

62 *AP*, 15 February 1902; Murchison, "Photography with an Object," 75.

63 Birmingham Photographic Society Council Minutes, 23 April 1897, CBA 266684; *AP*, 16 February 1900, 135.

64 Norwich and District Photographic Society Minutes, vol. 1, 13 November 1913, SO 187/1.

65 Leeds Photographic Society Minutes, 10 October 1889 (WAY 2064/2/2). The book under discussion is in all likelihood Emerson's *Naturalistic Photography for Students of the Art*, which was published that year.

66 Kelsey, *Archive Style*, 194.

67 Leicester and Leicestershire Photographic Society Records, General Meeting Minutes, Leicestershire, 9 April 1902, CRO, DE3868/2/.

68 Norwich and District Photographic Society Minutes, vol. 2, 31 March 1913, S0187/2; vol. 1, February 1904, S0187/1, NCRO.

69 Photographic Survey of Nottinghamshire Papers, DDM1 270/1.

70 The debate of course reflects a longer one in photography. The resistance to survey photography echoes Charles Baudelaire's well-known rant on the photography at the Paris salon of 1859, that photography in copying nature could have no claim to either imagination or individuality.

71 Green-Lewis, *Framing the Victorians*, 39.

72 Runia, "Presence," 22.

73 *The Photographic Record*, 9 (October 1889): 203.

74 Riegl, "The Modern Cult of Monuments," 23. See also Sweet, *Antiquaries*, 310–20.

75 See James, "William Jerome Harrison, Sir Benjamin Stone and the Photographic Record and Survey Movement"; Taylor, *A Dream of England*.

76 Photographic Survey of Nottingham, flyer, DDM1.270/1.

77 Exhibition Catalogue, BPS, 1893. On the relationship between caption and title, see Scott, *The Spoken Image*, 247.

78 *BJP*, 19 April 1907, 290; *BJP*, 14 August 1908, 616.

79 Crabtree, "System in Record Work," *AP*, 26 May 1904, 408.

80 Poole, "An Excess of Description," 168.

81 *AP*, 22 January 1897, 75.

82 James, "William Jerome Harrison, Sir Benjamin Stone and the Photographic Record and Survey Movement," 61.

83 Ibid., 51.

84 *BJP*, 14 August 1908, 616.

85 *AP*, 8 September 1908, 220.

86 *AP*, 22 January 1897, 75.

87 Richard Keene (1851–1894) was a photographer and stationer from Derby. A member of the Linked Ring, he specialised in romantic topographical views of the region. Two of his sons followed him into the photographic business.

88 Keene, "The Warwickshire Survey," 346.

89 Sekula, "Reading an Archive," 125.

90 Hamilton, "Living by Fluidity," 86–87.

91 Miller, *Material Culture*, 9.

92 For a detailed study of the latter, see Edwards and Hart, "Mixed Box," 47–61.

93 See, for instance, Gell, *Art and Agency*; Latour, "Technology Is Society Made Durable," 103–32; Dant, *Material Culture in the Social World*; Miller, *Materiality*.

94 Shapin and Schaffer, *Leviathan and the Air Pump*, 30; Daston and Galison, *Objectivity*. For a complication of this position that accords very much with the practices of the survey movement, see Porter, "The Objective Self," 644.

95 James, "William Jerome Harrison, Sir Benjamin Stone and the Photographic Record and Survey Movement"; Edwards, "Straightforward and Ordered," 183–208.

96 "Record and Survey Photography," *BJP*, 14 August, 1908, 616.

97 Crabtree, "System in Record Work," *AP*, 26 May 1904, 409.

98 *AP* and *PN*, 14 June 1910, 581.

99 *CAH*, 165–66. Perkins, "Some Instruction in Photographic Survey Work," 344.

100 Unidentified cutting reporting meeting on "Pictorial Historic Records," 16 March 1900. (JBS Cuttings, vol. 5). The speaker is possibly Stone.

101 Tucker, *Nature Exposed*. *Photography Quarterly* carried an article by Alfred Paterson on portrait photography entitled "Is Retouching Immoral?" (April 1890, 261–66).

102 Fowler, "Photographic Survey," *Photogram*, May 1900, 134.

103 These 1,222 negatives and prints were bequeathed to the NPRA in 1906 but they were never absorbed into the collection, probably because of the volume of undocumented material. (*BJP*, 16 November 1906, 912). They are now in the collections of the British Library (prints) and the Architectural Association (negatives). Brereton made a systematic study of Somerset church towers and produced a new taxonomy based on window number and position, which was published in the *Archaeological Journal* 62 (1905). He also exhibited his photographs at meetings of the Somerset Archaeological and Natural History Society (SANHS Minute Book, 1895–1908, 13/1/1905). He probably named the NPRA as recipient for his photographs because it was still active and had a high public profile. The Somerset survey had effectively collapsed by 1906.

104 This form of visual presentation can be traced back more generally to the visual arrays of herbals of the early modern period and the presentation of natural history specimens in the eighteenth century. See Edwards, *Raw Histories*, 58–62.

105 In platinum prints, the image-carrying chemicals are actually soaked into the paper fibre rather than held in an emulsion layer coating the paper fibres.

106 *AP*, 28 November 1901, 424. This was probably not solarization in the true sense but the effects of the self-conscious working of extreme contrasts.

107 Maidstone Museum, Photographic Survey of Kent files, no. 546. One is reminded here of Frederick Evans's comment on photographic paper: "The actual surface my be so artfully given, as to make the paper seem almost the actual thing itself." See Evans, "Glass versus Paper," *Camera Work*, April 1905, reprinted in Hammond, *Frederick Henry Evans*, 69.

108 *AP*, 13 July 1909, 41.

109 Bromoil was a pigment process that, through a chemical process, replaced the silver bromide with hardened gelatin, which can then selectively absorb oily printers inks. Hicks, "Bromoil."

110 "'Causerie' by 'The Magpie,'" *AP*, 21 March 1905, 222. These were silver gelatin-bromides, a silver-based chemistry. I am grateful to Nic Hale for his comments on historical processes.

111 Surrey History Centre, Survey photographs series, 7828/2/77/2–3.

112 Bristol Museums and Art Gallery, Photographic Survey of Bristol Albums, vol. 3.

113 *BJP*, editor's notes, 9 July 1897, 435.

114 Burton, "The Whole Duty of a Photographer," 682. Emphasis added.

115 For the same reasons of longevity, platinum printing was recommended for postmortem photography (P. Eland, "Photographing the Dead," *Practical Photographer*, September 1897, vol. 8, no. 93, 270).

116 *BJP*, 6 April 1900, 213–14.

117 The carbon process (also known as the carbon transfer print, or commercially as Autotype) produced pigmented gelatin layers on paper. The paper was sensitised with dichromate solution and contact printed (which insolublised the gelatin in proportion to the penetrating light). The hardened layer of gelatin was transferred to a second sheet of paper and washed with water to develop the image. A further transfer was necessary to rectify the reversal of the image. Carbon prints are rich in tonal range and extremely stable. Ware, "Carbon Process," 150. *CAH*, 70. The Exeter Pictorial Record Society was the only survey society to prefer carbon prints, "but platinotypes [were] accepted." Exeter had a rather different emphasis on acquiring photographs, buying, or even commissioning photographs from local commercial photographers. Many images from S. A. Chandler and Co., and from Heath and Bradnee, are carbon print enlargements.

118 Allen, "A Photographic Survey of Somerset," 100.

119 *PSRS, Eleventh Annual Report* 1912, 7. Emphasis added.

120 Ibid.; Sachse, "The Camera as Historian," 653.

121 *BKP*, 29 May 1914, 415.

122 *PSRS, Eighth Annual Report*, 1909, 6. When first introduced, Brown Japine papers were toned to give the look of the more familiar albumen prints.

123 For instance, the Manchester Amateur Photographic Society had a ten-by-eight-inch camera that could be hired for one shilling per day (MAPS Council Minutes, 24/3/1896, M34/1/2/1).

124 *AP*, Photographic Survey Notes, 24 April 1902, 328. Armytage also served briefly on the committee of the NPRA.

125 "The Photographic Survey of Essex," *BJP*, 9 September 1904, 791.

126 Kirkwood Hackett, "Photography as an Aid to the Antiquary," 32.

127 Ibid.

128 An Anglican clergyman of South Nutfield, near Redhill in Surrey, and keen amateur photographer and antiquarian.

129 Surrey Accessions Book, vol. 1, 163–65.

130 *PN*, 21 March 1890, 219.

131 *AP*, 17 April 1902, 313. Nonetheless, large-format stand cameras capable of long exposures remained almost essential for detailed architectural work, especially in the difficult lighting conditions of church interiors, where exposure times of fifteen minutes were not unusual.

132 Both were active archaeologists and antiquarians who also used their photographs to illustrate their papers in the publications of the Sussex and Surrey Archaeological Societies of which they were, respectively, members.

133 Sekula, "Reading an Archive,"115.

134 Osborne, "History, Theory, Disciplinarity," 189.

135 Edwards and Hart, "Mixed Box," 49.

136 There is a very substantial and wide-ranging literature on photography and archives that informs my argument here. Resonating throughout this literature are Foucault's classic works *The Order of Things* and *The Archaeology of Knowledge*. But see also, for instance, Smith, *American Archives*; Isles and Roberts, *In Visible Light*; Kelsey, *Archive Style*; Crimp, *On the Museum's Ruins*; Edwards, *Raw Histories*; Sekula, "The Body and the Archive." In relation to materiality specifically, see Rose, "Practicing Photography"; Edwards and Hart, *Photographs Objects Histories*; and Pinney, *The Coming of Photography in India*.

137 The occasional use of the word "archive" tends to be in connection with the long-term historical use of the photographs. "Collection," with connotations of the synthetic and the provisional, is used to refer to the flow of photographs into the survey archives. Sekula, "Reading an Archive," 117; Sekula, "The Body and the Archive," 352.

138 Derrida, *Archive Fever*, 3.

139 Sekula, "The Body and the Archive," 352.

140 Lynch, "Archives in Formation," 67.

141 *BJP*, 25 August 1893, 548.

142 Tagg, "The Pencil of History," 288.

143 Sekula, "The Body and the Archive," 352.

144 One, for instance, is devoted to the vernacular buildings of the city centre, another to the church of St. Mary Radcliffe.

145 Roth, "Photographic Ambivalence and Historical Consciousness," 93.

146 Rose, "Practicing Photography," 56.

147 Tagg, "The Pencil of History," 292.

148 Becker and Clark, *Little Tools of Knowledge*.

149 MAPS Council Minutes, 9 April 1901, M34/1/2/2.

150 The *CAH* gave a number of tests that could be used to detect impurities and aid record societies in their choice of paper and card.

151 *CAH*, 56.

152 Ibid., 60.

153 The most commonly adopted label was a five-by-three-inch card format used first by Surrey in 1903.

154 Tagg, "The Pencil of History," 293.

155 Riles, Introduction to *Documents*, 21

156 *CAH*, 77–78.

157 Rose, "Practicing Photography," 559–60. Referencing the archive of Lady Hawarden's photographs in the Victoria and Albert Museum in London, Rose discusses the ways in which archival practices, from mounting to description, and from numbering to boxing, focus the attention of users in certain ways.

158 *CAH*, 182. The day-books of Godfrey Bingley, an instigator of the Yorkshire survey, survive in the Brotherton Library, University of Leeds. They record all the technical information from his photographic survey activities, some of which is reproduced on the labels to his photographs.

159 *CAH*, 70.

160 Ibid., 107. There was even consciousness of the material qualities of ink as certain "engrossing inks" are recommended.

161 *CAH*, 70.

162 Ibid.

163 EPRS, 487–516.

164 Dixon was a clergyman from Ealing, West Lon-don. He won the *AP* survey competition in 1903 with this set of photographs (*AP*, 19 March 1903, 222). V. and A. E., 3135, 3148, 3180, 3265, 3231, 3282-2000.

165 Nottinghamshire Archives, DD 1915/1/131 rev.

166 This photograph is part of a set that won first prize in a competition for "Antiquarian 'Record' Photographs" in *Photogram* magazine in 1907 and was published in the journal (July 1907, 234). A print is in the NPRA collection V. and A. E.-3006–2000.

167 Young appears to have been a clerical officer in the Labour Exchange in Norwich.

168 Surrey History Centre, Surrey Survey files, 7828/2/101/47.

169 On the construction and management of facts, see Poovey, *A History of the Modern Fact*.

170 George Scamell (paper delivered at the Photographic Convention of the UK, Newcastle upon Tyne) *BJP*, 20 July 1900, 454.

171 It would appear that a lack of funds was the problem (*BJP*, 16 November 1906, 912).

172 *BJP*, 14 August 1908, 616.

173 *BJP*, 10 January 1902, 30

174 NPRA annual report, *BJP*, 16 November 1906, 912.

175 As librarian of Peterborough in the 1890s, Jast was one of the first librarians in Britain to develop the combination of Dewey classification and open access in public libraries. Fry and Munford, *Louis Stanley Jast*, 11–15, and throughout.

176 *CAH*, 126,127.

177 Boyer, *The City of Collective Memory*, 149.

178 *CAH*, 101.

179 Edwards, *The Making of English Photography*, 177.

180 Edwards and Hart, "Mixed Box," 49. This position would question Steedman's claim that archives are just "stuff" until narrativised by the reader ("The Space of Memory," 67). I would suggest that the process of archiving itself is a form of narrativising.

181 These original albums have since been disbound.

182 I am grateful to Miss Valerie Dicker, Dorset County Museum, for this information.

183 Each mounted photograph is stamped on the

reverse with the dated British Museum stamp, marking its date of acquisition. It is therefore possible to reconstruct the flow of material into the NPRA collection.

184 Sekula, "The Body and the Archive," 351.

185 Rose, "Practicing Photography," 560, 566.

186 Edwards and Hart, *Photographs Objects Histories*, 11.

187 Tagg, "The Pencil of History," 293; Blau, "Patterns of Fact," 56; Fyfe, *Art Power and Modernity*, 164; Crane, "*Museums and Memory*, 3–4.

188 Latour, "Drawing Things Together," 57.

189 Foucault, *The Archaeology of Knowledge*, 50–55.

190 Snyder, "Picturing Vision," 220.

191 Osborne, "History, Theory, Disciplinarity," 89.

192 Maynard, *The Engine of Visualisation*, 31–32.

193 Miller, *Material Culture*, 19.

194 Cadava, *Words of Light*, xviii.

NOTES TO CHAPTER 4: LOCAL HISTORIES AND NATIONAL IDENTITIES

1 *The Times* (London), 14 April 1897, 6.

2 Mandler, *The English National Character*, 6.

3 Matless, "Regional Surveys and Local Knowledges," 464.

4 There is a massive literature on national identity, the nation-state, and national character that reaches well back into the nineteenth century. In addition, there is the extensive literature on locality and community in social theory and anthropology. See, for example, Gellner, *Nations and Nationalism*; Giddens, *The Constitution of Society*; Cohen, *Belonging*; Cohen, *Self-Conscious*.

5 Jäger, "Picturing Nations"; Taylor, *A Dream of England*.

6 Readman, "The Place of the Past in English Culture," 160.

7 Naylor, "Collecting Quoits," 316; Snell, *Parish and Belonging*, 4; see also Levine, *The Amateur and the Professional*, 172–74.

8 Survey photographers participated in the visual economy of local history. For instance, Harold Baker wrote a guidebook on Stratford upon Avon, illustrated with his own photographs. The second edition of Tom Burgess's *Historic Warwickshire* (1893) included photographs by

members of the Warwickshire Photographic Survey—W. Greatbatch, A. J. Leeson, and E. C. Middleton—which were acknowledged as such.

9 Lefebvre, *The Production of Space*, 46.

10 Cohen, *Belonging*, 2. See also Cresswell, *Place*, 7.

11 Cooke, "Locality, Structure and Agency," 8; Frykman, "Between History and Material Culture," 171.

12 Cosgrove and Daniels, *The Iconography of Landscape*; Daniels, *Fields of Vision*.

13 Lefebvre, *The Production of Space*, 143.

14 Taylor, *A Dream of England*, 64–89; Jäger, "Picturing Nations," 117; Pollock, "Dislocated Narratives and Sites of Memory."

15 For a critique of this position, see, for example, Readman, "The Place of the Past in English Culture," 186.

16 Pinney, *Photos of the Gods*, 3.

17 Herzfeld, *Cultural Intimacy*, 11.

18 Appadurai, *Modernity at Large*.

19 "Photographic and Pictorial Survey and Record of Essex," 1906, ECRO D/DGd z59.

20 Schwartz and Ryan, Introduction to *Picturing Place*, 10.

21 *CAH*, 33–34, quoting *Library Association Record*, February 1912.

22 Harrison, *A Proposal for a National Photographic Record and Survey*, 8. When the Dorset survey started again after the Great War, it was still organised through "12 areas, corresponding to the 12 Poor Law Divisions" (Dorset Photographic Survey Proceedings, 1921).

23 *1st Annual Report of the Joint Committee for the Survey of Leicestershire*, March 1902, 9 (LCRO DE 600/1/1); Surrey Survey Minute Book, 16/10.1902, Croydon Local Studies and Archives.

24 Edwards and James, *A Record of England*.

25 Perkins, "Some Instruction in Photographic Survey Work."

26 "Proposal for a Photographic Record of King's Lynn," 1913, n.p., KLPL; Harrison, *A Proposal for a National Photographic Record and Survey*, 8; *Photographic Societies Recorder*, 20 April 1889; *Eastern Daily Mail*, 14 January 1913.

27 *PSRS*, Administrative Papers, Box 474 2/3/24. Thomas Francis kept an outfitter's shop. The

newspaper cutting of an account of the Surrey survey is pinned to his letter.

28 Taylor, *A Dream of England*, 66–68.

29 Anderson, *Imagined Communities*; Appadurai, *Modernity at Large*, 8.

30 *AP*, 25 April 1890, 29.

31 Howarth, "Suggestions for the Photographic Survey of the District of Sheffield," 186.

32 Brogdew, "Some Thoughts on Record Work," 390.

33 Nora, "Between Memory and History," 13.

34 Mitchell, *Picturing the Past*, 14.

35 *Eastern Daily Press*, 31 January 1913.

36 Stace, *The First 100 Years*, 8.

37 For instance, J. Kenrick, a prolific amateur photographer of the Bletchington and Nutfield Photographic Society and the Surrey survey donated material to the Dorset, and Godfrey Bingley of Yorkshire donated material to Exeter.

38 J. Edwards, "The Need for a 'Bit of History,'" 163.

39 Ford, *The Spirit of the People*, 43.

40 Howkins, "The Discovery of Rural England," 63.

41 See chapters 2 and 3. See also James, *Coming to Light*. Photographers such as William Greatbatch, P. J. Deakin, and Harold Baker were exhibiting in the pictorialist salons of the Royal Photographic Society as well as contributing to the surveys. Baker was also a member of the Linked Ring.

42 Harrison, "Photographic Record Work," 307.

43 Cohen, *Belonging*, 6

44 J. Edwards, "The Need for a 'Bit of History,'" 148.

45 Allen, "A Photographic Survey of Somerset," 101.

46 *Kent Messenger*, 20 May 1911, 8.

47 Readman, "The Place of the Past in English Culture,"164–66; Sayer, *Country Cottages*, 113–16. The black and white colouration and visible half-timbering, which works to a striking effect in photographs, was itself often the result of nineteenth-century restoration, which stripped off eighteenth-century plaster and accentuated the woodwork as, for example, in Chester.

48 Lynn and Norfolk Photographic Record, undated flyer [1911].

49 Howkins, "The Discovery of Rural England," 64.

50 Herzfield, *Cultural Intimacy*, 22, 90. See Brooks, *Signs for the Times*.

51 *AP*, 5 February 1907, 124.

52 Brace, "Finding England Everywhere," 90–94; J. Edwards, "The Need for a 'Bit of History,'" 161.

53 Oliver, *Old Houses and Village Buildings of East Anglia*, 1. Oliver was a London architect. A number of the people he acknowledges were involved with photographic survey, for instance, Miller Christie of the Essex Field Club. In turn, Oliver's book was acknowledged as an important source by the Norwich Survey (*Eastern Daily Press*, 14 January 1913). Batsford similarly published a series of illustrated volumes, "Old English Cottages and Farm Houses," by county groups to "illustrate minor Domestic Architecture" (Publicity Flyer, c. 1912). In an article in *AP*, architect G. A. T. Middleton reminded photographers of the importance of attending to the textures of building materials in their work. "Building Material and Architectural Photography," *AP*, 3 September 1897, 191.

54 Brace, "Finding England Everywhere," 90–94.

55 Taylor, *A Dream of England*, 49–50.

56 Harrison, "On the Work of a Local Photographic Society," 426.

57 WPS Image Files, WK/B11/191.

58 Sussex Survey Image Files, 1298.

59 It should be noted that 1904 predates much of the radical and violent suffragette activity.

60 Exeter Pictorial Record Society Image Files, 07265–9. The race offered a huge prize of £10,000.

61 NPRA, E-5128-2000.

62 "Memoirs from Midlands," *AP*, 5 July 1901,15. On the heroic status of James Watt, inventor of the steam engine, Matthew Boulton, and other early industrialists in nationalist discourse, see MacLeod, *Heroes of Invention*.

63 Changes in local government also shifted boundaries, destabilising historical delineations of place.

64 See Hauser, *Shadow Sites*, 35.

65 Briscoe, "Proposals for a Photographic and Pictorial Survey of Essex," 1.

66 Flora Russell to R. Meldola, Imperial College Archives, Meldola Papers, MDLA 918, 24 November 1908.

67 Edgar Scamell, son of the NPRA secretary George Scamell, was a professional photographer based in north London. AP, 30 May 1905, 428.

68 Coulthurst, "Photographic Survey Work—A Plea," 311.

69 Taylor, *A Dream of England*, 51.

70 Andrews, "The Metropolitan Picturesque," 283.

71 Wanlass, "Picturesque Slums," 353.

72 An album of Malby snapshots, many of which are also in the NPRA collection, has recently come to light in Tower Hamlets Library, in East London.

73 Driver, *Geography Militant*, 170–98.

74 Coulthurst, "Notes on a Photographic Survey," 116.

75 Also, of course, slums tend to be "old buildings." This was certainly the focus in Birkenhead and in Bristol.

76 Boyer, *The City of Collected Memory*, 9.

77 Wilcock, "Photographic Survey of Manchester and Salford," 257. Ancoats is an area to the east of Manchester city centre. It was a working-class industrial area in the late nineteenth century and the site of dreadful urban poverty. Much of the terraced housing disappeared in the slum clearance of the 1960s. MAPS specific agendas are possibly connected to the strong Unitarian-liberal tradition of the city.

78 Harrison, "Art and Philanthropy."

79 AP, 16 October 1896, 320.

80 Readman, "The Place of the Past in English Culture," 177.

81 Jäger, "Picturing Nations," 125.

82 Local collections grew following provisions made by the Public Libraries and Museums Act, 1850, and subsequent revisions.

83 Murray, *Museums, Their History and Their Use*, 269.

84 CAH, 40.

85 See, for instance, Duncan, *Civilizing Rituals*; Bennett, *The Birth of the Museum*; Coombes, *Reinventing Africa*. For a critique, see Fyfe, "A Trojan Horse at the Tate," and Hill, *Culture and Class in English Public Museums*.

86 Duncan, "Art Museums and the Ritual of Citizenship," 102.

87 Black, *The Public Library in Britain, 1914–2000*, 177.

88 Joyce, "The Politics of the Liberal Archive," 40.

89 *Exeter Echo and Express*, 18 March 1911.

90 G. Stephen (Norwich) to H. J. Rennie, 6 March 1913, King's Lynn Library.

91 Joyce, "The Politics of the Liberal Archive," 45.

92 Despite some amalgamations, between 1886 and 1918 the number of free public libraries increased from 125 to 566, serving two-thirds (as opposed to one-third) of the population, with an emphasis on popular educational needs. See Kelly, *A History of Public Libraries in Great Britain*, 171. This was seen as a matter of local pride and efficacy. For instance, in Norwich, local papers reported the breakdown of library loans each month.

93 Joyce, "The Politics of the Liberal Archive," 45.

94 Plomer, "Local Records and Free Public Libraries," 137.

95 Bennett, "Regulated Restlessness," 163.

96 *Photographic Record (MAPS)* 7, 1889, 172.

97 CAH, 4.

98 Mandler, *History and National Life*, 22.

99 Bennett, "Regulated Restlessness," 172.

100 See, for instance, Readman, *Land and Nation in England*, 64–65.

101 George Scamell, secretary of the NPRA, addressing the photographic convention, Newcastle-upon-Tyne, July 1900. BJP, 20 July 1900, 454.

102 Gomme, *Lectures on the Principles of Local Government*, vii.

103 Ibid., v.

104 MacDonagh, Introduction to *Sir Benjamin Stone's Pictures*, vol. 1, vii. See also the flyer for the volume (NPG Related Documents).

105 *Eastern Daily Press*, 21 February 1914.

106 For example, Ward's *Directory of Croydon*, 1907, 84. As Colls has argued, local commercial directories, published by town and county in the late nineteenth century, offered not only a digest of local topographies, but maps of progress and modernity "from schools to the police station" (Colls, *Identity of England*, 227).

107 PN, 13 September 1889, 603.

108 Langton, "The Industrial Revolution and the Regional Geography of England," 158.

109 *BJP*, 25 August 1893, 549.

110 Lund, "Photographic Clubs: The Formation and Management," 310.

111 *City News*, 13 February 1892, reviewing an exhibition of the Manchester Amateur Photographic Society.

112 The Leeds Photographic Society (1852) claims to be the oldest in the world. The Liverpool Amateur Photographic Society was founded in 1853 and the Manchester Photographic Society was founded in 1855. The Photographic Society was founded in 1853 and in 1894 became the Royal Photographic Society.

113 "Memos from the Midlands," *AP*, 23 April 1897, 345.

114 *AP*, 27 January 1899, 64.

115 *Eastern Daily Press*, 14 January 1913. Cotman had extensive antiquarian interests, producing watercolours of the antiquities of East Anglia and of Normandy, for example. See Bann, *Romanticism and the Rise of History*, 112–19.

116 "London Letter," *Birmingham Photographic Society Journal*, August 1911, 91.

117 Fowler, "Photographic Survey," 136.

118 "Notes and Comments," *AP*, 8 August 1904, 81. Similar "local themes" are found in the medals of other local societies, for example, in local horticultural societies. I am grateful to Nick Mayhew of the Ashmolean Museum for this information. Many such "local productions" point firmly to the colonial.

119 This design, especially that of the lettering, was also derived from the "logo" of the Surrey Archaeological Society, in use since 1854.

120 Cooke, "Locality, Structure and Agency," 4.

121 Haddon to J. Foster, 20 May 1907, CAS Papers. This was ultimately the cause of the failure of the Cambridgeshire survey to flourish before the First World War.

122 Leicester Literary and Philosophical Society Council Minutes, 7 December 1900, 300. It appears that in this period the National Trust was trying to establish a county-by-county register and record of ancient sites. Leicester and Leicestershire Photographic Society, Minute Book, 9 April 1902.

123 E. Beloe, King's Lynn antiquarian, in a letter to the *Eastern Daily Press*, 30 January 1913.

124 Their suggestion that duplicate sets from the Norwich survey be deposited locally at King's Lynn and Great Yarmouth was rejected by the Norwich librarian, George Stephen.

125 *BJP*, 5 June 1903, 457. This does not appear to have happened.

126 *CAH*, 51.

127 Langton, "The Industrial Revolution and the Regional Geography of England," 150.

128 Joyce, "The Politics of the Liberal Archive," 40; Joyce, *Visions of the People*, 148; Colls, *Identity of England*, 226–28.

129 *BJP*, 25 August 1893, 548; Harrison, *A Proposal for a National Photographic Record and Survey*, 5.

130 Bennett, "Regulated Restlessness," 164.

131 *BJP*, 9 December 1898, 793.

132 Thomas Harrison Cummings, *Photography: A Fine Art*. Boston: Photographers' Association of America, August 1905, 8 (RPS Collection, National Media Museum). Cummings was editor of *Photo Era* in the United States.

133 Cohen, *Belonging*, 13.

134 Brabrook, "On the Organization of Local Anthropological Research"; Urry, "Englishmen, Celts and Iberians," 89.

135 Cooke, "Locality, Structure and Agency," 11.

136 Lefebvre, *The Production of Space*, 46.

137 Herzfeld, *Cultural Intimacy*, 27–29; see also Brace, "Finding England Everywhere."

138 Daniels, *Fields of Vision*, 5.

139 For example, *BJP*, 15 December 1911, 954. However, the use of this term is ambiguous. At that date it could also have meant "having an agenda," which the NPRA undoubtedly did, but it did not necessarily carry sinister overtones.

140 "Afternoon Tea with Sir Benjamin Stone and the National Photographic Record Association," *AP*, 9 March 1900, 183.

141 *AP*, 7 June 7 1910, 556.

142 Brace, "Finding England Everywhere," 94.

143 *AP*, 26 July 1901, 62.

144 *Morning Post*, 17 April 1897 (JBS Cuttings, book 4).

145 JBS Cuttings book 5, 7. Unidentified press cutting c. 1900.

146 Lecture given to Birmingham Photographic So-

ciety, reported in the *Birmingham Daily Post*, 21 October 1896.

147 MacDonagh, Introduction to *Sir Benjamin Stone's Pictures*, iii.

148 "Notes from the Northwest," *AP*, 16 August 1901,136. *Yorkshire Post*, 26 October 1897.

149 *The Times* (London), 25 October 1897.

150 Norwich City Library Annual Report, 1915–1916, 9. This call was repeated in the local press.

151 Nottinghamshire survey photographs, 337, 341, NCRO.

152 *AP*, 23 March 1900, 235.

153 Billig, *Banal Nationalism*.

154 *AP*, 7 January 1898, 15.

155 PSRS, *Thirteenth Annual Report, 1914*, 9.

156 For an illuminating account of the tensions between local and scientifically produced knowledge, see Matless, "Original Theories."

157 Thoresby Society, Leeds, ms box V/11, Letters and Papers Related to the Archaeological Description of Kirkstall Abbey.

158 E. Clark to G. Lumb, 6 January 1907.

159 *BAAS Reports*, 1906, 58; Harrison, "The Desirability of an International Bureau," 548.

160 *BJP*, 28 November 1902, 953.

161 See Mackenzie, *Propaganda and Empire*, 19–22, 68–75; Mackenzie, *Imperialism and Popular Culture*; Ryan, *Picturing Empire*.

162 Daniels, *Fields of Vision*, 6.

163 Mackenzie, *Propaganda and Empire*, 2.

164 See, for example, Porter, *The Absent-Minded Imperialists*; Readman, "The Place of the Past in English Culture," 182–83.

165 *BJP*, 25 August 1893, 548; *BAAS Report*, 1906, 63.

166 Sargeant, "RCHME 1908–1998," 58. The Archaeological Survey of India was founded in 1862.

167 Middleton, *Architectural Photography*, 21.

168 Late Gothic Perpendicular is a uniquely English style. Middleton, *Architectural Photography*, 21.

169 Dellheim, *The Face of the Past*, 126.

170 Cannadine, *Ornamentalism*.

171 Baucom, *Out of Place*, 47. Astrid Swensen, University of Cambridge, personal communication with the author, November 2007.

172 The exception here is London, where the remit was not only photographic. The London survey involved Philip Norman and other members of the SPAB and the arts and crafts movement.

There was regional interest in the central preservation movement. Reverend Thomas Perkins of the Dorset survey acted as the local representative of the SPAB, but on the whole the two projects attracted very different demographics.

173 See Edney, *Mapping an Empire*, 21.

174 They discussed the provision for traditional lands that had been absorbed into the British Empire, and which were then threatened by South Africa's pending secession from the empire.

175 Joseph Chamberlain (1836–1914) was a distinguished politician and businessman based in Stone's home city of Birmingham. He held the posts of president of the Board of Trade and colonial secretary, holding the latter with particular distinction and efficacy.

176 See Edwards and James, *A Record of England*.

177 This group was toured as a music hall act and curiosity by army officer and big-game hunter James Jonathan Harrison. In addition to the Houses of Parliament, they visited Buckingham Palace. For an extended history of this group, see Green, *Black Edwardians*, 116–37.

178 Stone, *Sir Benjamin Stone's Pictures*, 36.

179 Call for submissions for the Festival of Empire, *Birmingham Photographic Society Journal* 7, no. 75 (January 1911): 32.

180 The Maidstone Photographic Society had a display in the photographic section; it may have been connected to that.

181 Letter from the organising committee to George Scamell, 10 March 1910, London Survey papers, A/LSC/2, Minutes 19/2/1907–26/2/1912, London Metropolitan Archives. The survey component would probably have been more prominent had the death of Edward VII not postponed the festival until 1911. In the interim, the NPRA had disbanded. However, there is a suggestion that the inclusion of survey photography at the Festival of Empire was possibly at the suggestion of the Surrey Survey Committee, rather than the NPRA.

182 Ryan, *Picturing Empire*, 187–89.

183 Ibid., 188.

184 It was precisely these values of governmental propriety, judicial process, economic development, and imperial content, which is expressed

through the imagery of a popular magazine for the jubilee year *The Queen's Empire: A Pictorial and Descriptive Record*. This publication cost 6 pence an issue and was in an album format. Like Stone's *National Pictures* of 1905/6, which cost 7 pence an issue, it was published by Cassells and aimed at a largely lower middle-class and prosperous artisanal readership.

185 Mackinder, *Seven Lectures on UK for Use in India*, 61.

186 Cannadine, *Ornamentalism*, 121.

187 Jameson, *The Political Unconscious*, 17.

188 Lefebvre, *The Production of Space*, 143.

189 Daniels, *Fields of Vision*, 6.

190 Frykman, "Between History and Material Culture," 171.

191 Langton, "The Industrial Revolution and the Regional Geography of England," 164.

192 Jast, one of the authors of *The Camera as Historian*, had suggested that librarians could help people understand "the present conflict, the meaning of civilization, the values of various ideas and conceptions of the human mind" (Jast, "Public Libraries and the War," 12).

193 *Norwich Mercury*, 28 December 1918; 1 March 1919.

NOTES TO CHAPTER 5: PHOTOGRAPHY, DISAPPEARANCE, AND SURVIVAL

1 Perkins, "On the Desirability of a Photographic Survey of the County," 20.

2 *The Standard* (London), 31 March 1913; Button, *When Found, Make a Note*, 25; M34/1/1, 12 May 1885.

3 *AP*, 7 November 1901, 375; *AP*, 16 January 1902, 57.

4 "National and Local Photographic Record," *BJP*, 19 April 1907, 287.

5 Mitchell, *Picturing the Past*, 16–17; Boyes, *The Imagined Village*, 7.

6 Barthes, *Camera Lucida*, 15.

7 McQuire, *Visions of Modernity*.

8 Seremetakis, *The Senses Still*, 7.

9 *CAH*, 39.

10 Goodall, *Performance and Evolution in the Age of Darwin*; Ankersmit, *Sublime Historical Experience*, 9.

11 Burchardt, *Paradise Lost*, 90–91.

12 Doane, *The Emergence of Cinematic Time*, 4; McQuire, *Visions of Modernity*, 113.

13 Strathern, *After Nature*, 1.

14 Doane, *The Emergence of Cinematic Time*, 11.

15 Bakhtin, *The Dialogic Imagination*, 250.

16 Barthes, *Image Music Text*, 44.

17 Connor, "Topologies," 110. Bakhtin, *The Dialogic Imagination*, 84.

18 *AP*, 19 March 1907, 259.

19 Bothamley, "Photographic Record and Survey Work."

20 Bowler, *Biology and Social Thought, 1850–1914*, 37.

21 For a detailed discussion, although he does not address either anthropology or archaeology at any length, see Bowler, *Science for All*; see also Broks, *Media Science before the Great War*.

22 "Report of Ethnographic Survey," *Reports of the BAAS 63rd Meeting*, Nottingham, 1893, 621.

23 Report of Lecture, "History in Stone," *BJP*, 29 April 1898, 283. Middleton was an architect who wrote extensively on architectural photography and architectural history in the photographic press. He was also on the committee of the NPRA.

24 "Photographic Record," *BJP*, 9 March 1900, 152.

25 Ibid., 152.

26 *BJP*, 31 October 1889, 422; *AP*, 6 July 1900, 4.

27 There was also a specific anthropometric committee under Francis Galton, which also came under the auspices of anthropology, that continued to work throughout this period. The ethnographic survey overlapped with this, being interested not only in culture and archaeology but physical anthropology.

28 Brabrook, "On the Organization of Local Anthropological Research."

29 Hartland, "Notes Explanatory of the Schedules," 513.

30 In fact, very little photography was forthcoming. Haddon's series in relation to his ethnography of the Aran Islands, off the coast of Ireland, were one of the few substantial sets. The instructions took the form of lists of significant subjects to be covered and questions to be asked. These instructions were brought together to form an integrated twelve-page pamphlet pub-

lished by the Ethnographic Survey Committee of the BAAS and circulated to the corresponding societies. It has much in common with their instructions issued to survey photographers (see Edwards, "Straightforward and Ordered," 196–97).

31 Secretary's Copy Books, 1895–1898, 470, 20 April 1898, LPS papers, Leeds Metropolitan Archives, WYL2064/4/1. Hartland, "Ethnographical Survey of the United Kingdom," 208.

32 *Lynn News*, 6 February 1914. "Oxfordshire Photographic Survey," *Photography*, 19 May 1898, 337. This was probably due at least in part to the influence of J. L. Myers, of Christ Church College, Oxford, who was on the committee and active in both the BAAS and the Anthropological Institute. He advocated the systematic registration of photographs of anthropological interest, lists of which were published in the *Journal of the Anthropological Institute* in the 1890s.

33 "Photographic Record Work: New Efforts," *Photogram*, October 1906, 307.

34 *Practical Photographer* 8, no. 94 (October 1897): 311. The subjects were popularly described in the journal as "South Sea Islands." Lawrie was a Presbyterian missionary who was based in Aneityum, New Hebrides, for over fifteen years.

35 Haddon, *The Study of Man*, xxiii.

36 Haddon, "The Saving of Vanishing Knowledge." He expressed a similar sentiment the next year in his popular book *The Study of Man* (1898), published for the general reader in Murray's Progressive Science series.

37 Brabrook, "On the Organisation of Local Anthropological Research," 274.

38 Nora, "Between Memory and History," 7.

39 Hartland, "Ethnographical Survey of the United Kingdom," 208.

40 *PSRS, Fourth Annual Report*, 1905, 6.

41 *BJP*, 14 July 1905, 559.

42 Fowler, "Photographic Surveys," 489.

43 Herbert, *Culture and Anomie*, 256.

44 Ibid., 299.

45 Clifford, "On Ethnographic Allegory," 113–16.

46 Pinney, *Camera Indica*, 45–46.

47 For example, MAPS Photograph Files, 6167, 6170.

48 NPS, DD, 1915/1/126.

49 JBS Cuttings, vol. 5, 16 (c. 1898); Harrison, "The Desirability of an International Bureau," 548.

50 Blanc, "Photographs as an Aid for the Architect," 295.

51 Merewether, "Traces of Loss."

52 Clifford, "On Ethnographic Allegory," 115.

53 Colls, *Identity of England*, 252.

54 Balfour Stewart, *Lessons in Elementary Practical Physics*, 3 vols. (London: Macmillan, 1885–97).

55 Tylor, *Anthropology*, 15.

56 Colls, *Identity of England*, 249. Stone had a substantial library of local antiquarian and historical literature; see Leeson, *Catalogue of the Extensive and Valuable Library of the Late Sir Benjamin Stone*. Leeson himself was a keen amateur photographer and contributed to the Warwickshire survey.

57 In contrast to other sciences, such as astronomy and biology, there is, as far as I am aware, no study of nineteenth-century popular coverage of anthropological science, especially in its cultural, rather than physical, varieties.

58 Lang, *Anthropological Essays Presented to E. B. Tylor on Honour of His 75th Birthday*, 7.

59 E. B. Tylor, "Anthropology. Part VI. Development of Civilization," *Encyclopaedia Britannica* 1902.

60 Colls, *Identity of England*, 248.

61 Gomme. *Ethnology in Folklore*, 1; Gomme, *Folklore as an Historical Science*, 319. Gomme was, with his wife Alice, an eminent folklorist and president of the Folklore Society. He was also active in anthropology.

62 *PSRS, First Annual Report*, 1903, 29.

63 Gomme, *Ethnology in Folklore*, 6.

64 Balfour, "Presidential Address—Call for a National Folk Museum," 15.

65 See Edwards and James, "Our Government as Nation."

66 Tylor, *Anthropology*, 15.

67 As Cannadine has noted, many of these ceremonies and spectacles of state emerged in relation to the practices of the constitutional monarchy in the course of the nineteenth century. Cannadine, "The Context, Performance and Meaning of Ritual."

68 Stocking, *After Tylor*, xiv.

69 "National and Local Photographic Record," *BJP*, 19 April 1907, 287.

70 Edwards, "Straightforward and Ordered."

71 Newspaper cutting, possibly the *Birmingham Gazette*, c. 1900. (JBS Cuttings, vol. 5).

72 *AP*, 18 August 1898, 649. This is most evident in the development of literary landscape. For example, the local topography delineated through George Scamell's photographs of London houses for the NPRA appears to be based on Henry B. Wheatley's three-volume *London Past and Present: Its History, Associations, and Traditions* (1891), which was a revision of Peter Cunningham's *The Handbook of London*, the one-volume edition of which appeared in 1850. Wheatley himself was a well-known London antiquarian, the editor of Pepys's diaries, and a member of the NPRA committee.

73 Hartland, "Ethnographical Survey of the United Kingdom," 212.

74 Gruber, "Ethnographic Salvage and the Shaping of Anthropology," 1297.

75 Gomme, *Folklore as an Historical Science*, 336.

76 Tilley, *The Materiality of Stone*, 25.

77 Ditchfield, *The Charm of the English Village*, 2. Emphasis added. In addition to being the author of popular sentimental and nostalgic books on the English landscape, Ditchfield was a noted scholar and edited the Berkshire volumes of *Victoria County Histories*.

78 Gough, *The History of Myddle*, 96.

79 Snell, *Parish and Belonging*, 13. The parish was also the focus of W. E. Tate's magisterial study, *The Parish Chest* (1946). Pevsner's county architectural guides still follow this format: the church is described first, followed by the large houses and then "other buildings."

80 Brooks, *Signs for the Times*, 150.

81 Middleton, "English Architecture," 8–9.

82 Riegl, "The Modern Cult of Monuments," 23.

83 Middleton, *Architectural Photography*, 20–22.

84 Ruskin, *The Seven Lamps of Architecture*, 186–87. Ruskin's sixth lamp of architecture was, of course, memory.

85 "Architectural Note with Special Reference to English Churches," *The Yearbook of Photography and Amateur's Holiday Guide* (1896), 265.

86 Pitt-Johnson, "A Plea for Our Village Churches."

87 *AP*, 30 October 1897, 346.

88 Norwood, "A Plea for the Protection of Ancient Buildings, for the Sake of History, Art and Religion," 83.

89 Perkins, *Handbook of Gothic Architecture*, 14.

90 NPRA, *Annual Report*, 1900, 6

91 *AP*, 30 October 1897, 346.

92 Bennett, "Architecture as a Subject for the Camera," 270.

93 Robinson and Herschman, *Architecture Transformed*, 51. They point out that this style was established in the 1870s. It is significant that the photographs made of the newly built south London churches in the 1860s and 1870s by William Strudwick and copied for the Surrey survey in 1912–13 uniformly follow this style.

94 Maleuvre, *Museum Memories*, 5. See also Blau, "Patterns of Fact," 45.

95 Boyes, *The Imagined Village*, 4. For an account of the struggle for and significance of Kirkstall Abbey, see Dellheim, *The Face of the Past*, 92–110. Industrial cities made much of their medieval roots, as exemplified by the eleven-volume series *Historic Towns*, edited by E. A. Freeman and W. Hun (Wiener, *English Culture and the Decline of the Industrial Spirit, 1850–1980*, 44) which first appeared in 1889, the date of Harrison's scheme for the Warwickshire Photographic Survey.

96 Perkins, *Handbook of Gothic Architecture*, 11.

97 Baker, "Restoration"; Tilt, "Restoration—A Reply"; Baker, "Restoration—A Rejoinder"; Perkins, "Restoration."

98 Baker, "Restoration" 329.

99 *PSRS* Papers, Croydon, B 474.3/3/62, Cuttings AGM, 1905.

100 See, for example, Perkins, "Restoration," 455–59.

101 Birmingham Photographic Society, monthly programmes, 1887–1904, L. F25.69, f.23.

102 SPAB, *Annual Report*, June 1885, 27

103 Norwood, "A Plea for the Protection of Ancient Buildings, for the Sake of History, Art and Religion," 81.

104 Perkins, "Restoration."

105 Bothamley, "Photographic Record and Survey Work," 581.

106 *AP*, 5 December 1901, 454–55.

107 "Pictures for Future Historians," *Brighton Herald*, 14 August 1909, 5.

108 Beloe, *Our Borough, Our Churches*, 139, 112–13.

109 Douglas, *Purity and Danger*.

110 Whyte, "How Do Buildings Mean?"

111 "A Competition for Survey and Record Workers," *AP*, 6 June 1905, 466. There were intermittent plans by the diocese of York to make redundant, or even demolish, a number of the city's many medieval parish churches. The plan announced in 1885 was strongly resisted by William Morris, among others, because it would wreck the visual identity of the city. See Dellheim, *The Face of the Past*, 113–26.

112 "On Architectural Photography," *Photogram*, June 1903, 182.

113 Middleton, "Architectural Ornament—Its Photographic Treatment," 27. This debate is not dissimilar to that around the photography of sculpture and the "point of view." See Johnson, *Sculpture and Photography*.

114 Evans produced many of his greatest architectural works as lantern slides because the form's particular luminosity and natural depth could capture the spirit of buildings. Evans, "Glass versus Paper."

115 Hammond, *Frederick Henry Evans*, 16.

116 Bennett, "Architecture as a Subject for the Camera," 271. WPS Box T3. A note on the mount of 1900 lists the changes to the door.

117 Middleton, "English Church Porches," 289.

118 Marriott Dodson, "Architectural Record Work—Wood Carving." 121.

119 Brooks, *Signs for the Times*, 160–61.

120 Fincham, a cardboard box manufacturer and keen photographer and antiquarian, was a member of the North Middlesex Photographic Society and lived at Hornsey. He donated some 170 photographs to the NPRA and was involved with the establishment of the North Middlesex survey in 1903.

121 *BJP*, 27 May 1892, 346.

122 Sayer, *Country Cottages*, 1.

123 "Village Photography," *BJP*, 7 November 1902, 882.

124 Huish, *Happy England*, 118.

125 Dellheim, *The Face of the Past*, 18; Mandler, *The English National Character*, 93.

126 Dr. J. C. Cox's popular *How to Write a Parish History*, first published in 1879, ran to four editions by 1909.

127 Zerubavel, *Time Maps*, 42.

128 Gomme, *The Village Community*,15.

129 *AP*, 18 October 1904, 307.

130 Sayer, *Country Cottages*, 115.

131 Blau, "Patterns of Fact," 45.

132 Report on the NPRA, *Photography*, 15 July 1897, 439.

133 *CAH*, 183.

134 Surrey Survey Collections, Woking, 7828/1/97/62. Stanley was a stained-glass designer based in Croydon. His father, a retired watchmaker, also photographed for the Surrey survey.

135 Snell, *Parish and Belonging*, 20.

136 Jäger, "Picturing Nations," 129. See also Howkins, "The Discovery of Rural England."

137 For a discussion of photographic books on the cult of Shakespeare, see Taylor, *A Dream of England*, 64–80. On 10 June 1889, for example, the Birmingham Photographic Society had a whole-day excursion to "Shakespearean villages" (Birmingham Photographic Society, monthly programmes, 1887–1904, 14).

138 A set of prints of the places associated with *The Pilgrim's Progress* is in the NPRA collection, E1702–3–2000, E1705–9.2000, E1718–2000.

139 Dinah Morris, the charismatic nonconformist preacher and redemptive character in *Adam Bede* elicited much admiration from contemporary readers. Queen Victoria was so taken with the description of Morris that she commissioned a watercolour of the scene from Edward Corbauld. See Witemeyer, *George Eliot and the Visual Arts*, 51.

140 *Nottingham Daily Express*, 10 December 1901.

141 Ibid.

142 "Record Work," *Photogram*, April 1908, 101.

143 *AP*, 15 January 1897, 42.

144 Bennett, "Architecture as a Subject for the Camera," 270.

145 Boyes, *The Imagined Village*, 18. There is a very substantial literature on the folk and revivalist movement, the position of which is well summarised in Boyes.

146 Sayer, *Country Cottages*, 131.

147 NPRA, *Annual Report*, 1899, 6.

148 "Recording History in Photographs," *Church Family Newspaper*, 20 October 1899, 606.

149 Bakhtin, *The Dialogic Imagination*, 84.

150 Boyes, *The Imagined Village*, 13–14.

151 Ibid., 7.

152 *AP*, 22 January 1897, 75.

153 "Photographic Record and Survey Notes," section *AP*, 4 June 1907, 500; "Local Customs and Photography," *BJP*, 26 May 1905, 401.

154 *The Times* (London), 3 March 1910.

155 Fowler, "Photographic Surveys," 489.

156 "Record Work," *Photogram*, April 1908, 101.

157 Summary of a lecture by A. C. Haddon, "Photography and Folklore," *Folklore* 6 (1895): 222.

158 Draft Report of Folklore and Anthropology Section for 1903, *PSRS* Croydon, Box 474 2/3/22.

159 *PSRS*, *3rd Annual Report*, 1904, 4.

160 Greatbatch et al., unpublished diary, "South Warwickshire Survey," 5 April 1896, Birmingham Archives and Heritage, WPS collection.

161 I am grateful to Ollie Douglas for this information.

162 Hobsbawm and Ranger, *The Invention of Tradition*.

163 *PSRS*, *Sixth Annual Report* 1907, 7.

164 Again, there are anthropological connections. Cambridge anthropologist A. C. Haddon showed ornaments from British New Guinea at the same meeting (JBS Invitations, Vol. 7, 1899–1903).

165 Parker, "History by Camera," 145.

166 Stone's library contained many such publications on the antiquities and customs of English counties in which he took his photographs. See Leeson, *Catalogue of the Extensive and Valuable Library of the Late Sir Benjamin Stone*.

167 Simpson, *The Collection of 'Wroth Silver*, 3, 7.

168 JBS Cutting Book, vol. 5, 1906, 29. Another inexplicable absence is the full range of Stone's "folk customs" photographs in the NPRA collection, the national collection. While Stone was the collection's main supporter and donor, many of his photographs of major folk customs, for instance the Abbots Bromley Horn Dance or the Baal Fire, Whatton, Northumberland, which are in his own collection in Birmingham, are not present in the NPRA collection.

169 Stone himself and his collecting activities became the focus of photographic recording. A correspondent to *AP* describes watching Stone at work photographing the Knutsford May Day Festival, his comments on and photographs of Stone were published as a full-page feature. *AP*, 22 May 1902, 417.

169 This was, however, a form of punishment used almost exclusively on women.

170 NPRA, *Annual Report*, 1900, 6.

171 S. J. Young appears to have been a clerk at the local employment office. NHC Box, Agriculture, 1. *Eastern Daily Press*, 21 February 1914.

172 *CAH*, 187.

173 *AP*, 18 October 1904, 307.

174 "Some Further Notes on Record and Survey Photography," *AP*, 6 March 1916, 183.

175 *AP*, 25 April 1890, 292; *AP*, 16 March 1900, 204.

176 Walter Ruck was a stationer and bookseller who sold photographs by a number of local photographers. Charles Ferneley was a professional photographer from Radcliffe on Trent.

177 Box WK/W4/200–249. Stone also photographed this event more formally in his style of theatre of tradition.

178 *AP*, 22 May 1902, 421.

179 Harrison, *A Proposal for a National Photographic Record and Survey*, 5

180 *AP*, 2 August 1901, 81.

181 Perkins, "On the Desirability of A Photographic Survey of the County," 20. The references to Hardy's novels are, respectively, to *Far from the Madding Crowd*, to *Under the Greenwood Tree*, and to *Tess of the d'Urbervilles*. Perkins's own parish of Turnworth took in some of those bleak hills of central Dorset.

182 Albums on this subject put together by Malby have recently come to light in Tower Hamlets Library, London. H. Malby was a professional technical photographer, but also produced artistic work as a hobby, although his contributions to the RPS exhibitions are largely in the technical classes. He was related to Reginald A. Malby and Son, specialists in botanical photography especially for the horticultural trade. In 1902 *Amateur Photographer* ran an article entitled "Picturesque Slums" (*AP*, 23 October 1902, 352).

183 Winter, *London's Teeming Streets*, 198.

184 Large numbers of photographs of stocks were also sent to the Photographic Record and Survey section of *AP*.

185 Im Thurn, "Anthropological Uses of the Camera"; Portman, "Photography for Anthropologists." Portman also railed against "fuzzigraphs." For an extended discussion of these statements in the context of anthropology, see Edwards, "Uncertain Knowledge."

186 George Wheeler was a Manchester stationer and printer. A. Corder, from Brighton, appears to have let out apartments for a living.

187 Im Thurn's paper at the Anthropological Institute was reported in the photographic press, but the reporter rather missed the point, suggesting that Im Thurn was "unworkmanlike" and should set up a studio. *BJP*, 14 April 1893, 227.

188 Winter, *London's Teeming Streets*, 198.

189 "Address to the Photographic Club," *BJP*, 9 March 1900, 152; *The Times* (London), 9 March 1900.

190 Riegl, "The Modern Cult of Monuments," 37–38.

191 Taussig, *Mimesis and Alterity*, 35; Benjamin, "The Work of Art in the Age of Mechanical Reproduction," 217.

192 Ankersmit, *Sublime Historical Experience*, 367.

193 Harrison, "The Desirability of an International Bureau," 548.

194 Two engravings of the church in Eccles appear in the revised and illustrated tenth edition of Lyell's *Principles of Geology* from 1867.

195 Letter to the *Eastern Daily Press*, 21 January 1913; *The Essex Naturalist* 14 (1906–1907): 70.

196 "The Lost Land of England," *Strand Magazine* 22 (1901): 398.

197 Ibid., 404. Similar concerns have been recently expressed in the contexts of global warming. See "Silent Victories of the Sea: Rising Tides Threaten Archaeological Sites," *Independent* (London), 1 October 2007. With climate change, the Norfolk coastline and its preservation has become a significant political and ecological debate in the twenty-first century.

1 Kansteiner, "Finding Meaning in Memory," 180.

2 Frisch, *A Shared Authority*, 16.

3 Fyfe, *Art, Power and Modernity*, 6; Naylor, "The Field, The Museum and the Lecture Hall," 495.

4 *Bromsgrove Messenger*, 3 December 1896 (JBS Cuttings, vol. 4).

5 *CAH*, 4.

6 *AP*, 12 November 1903, 382.

7 Bowler, *The Eclipse of Darwinism*, 80–81.

8 Barthes, *Camera Lucida*, 4.

9 *BJP*, 9 March 1900, 152.

10 The Education Act of 1870 established the framework for elementary school education and by 1880 all children passed through some form of compulsory education. The Balfour Education Act of 1902 opened opportunities for secondary education to all, at least theoretically. For the broad impact of these acts, see, for example, Rose, *The Intellectual Life of the British Working Class*.

11 Warner Marien, *Photography and Its Critics*, 112–14. The idea of formal visual education dates at least to a Lockean tradition: John Locke's *Some Thoughts Concerning Education* (1693) stressed the efficacy of pictorial teaching.

12 Warner Marien, *Photography and Its Critics*, 137.

13 Readman, "Landscape Preservation, Advertising Disfigurement," 73. See also Horn, *Education in Rural England, 1800–1914*, 258.

14 As Bowler has noted, popular science magazines were increasingly illustrated with photographs after 1900. Bowler, *Science for All*, 94.

15 Briscoe, "Proposals for a Photographic and Pictorial Survey of Essex," 1.

16 Nightingale, *Visual History* (original emphasis). This series covered a wide range of subjects, from geography to botany, and was published well into the 1950s. On history books, including illustrations, see Chancellor, *History for Their Masters*.

17 "School Board Lectures on Local History," *The Times* (London), 7 November 1901.

18 *BJP*, 28 November 1902, 953.

19 *PSRS, Ninth Annual Report*, 1910, 9.

20 *BJP*, 21 October 1904, 903.

21 Harrison, "On the Work of a Local Photographic Society," 426.

22 Ibid. The Kyrle Society, founded in 1875, was a philanthropic body concerned with the "diffusion of beauty." Through its local branches, it provided art, books, open spaces, and urban gardens, especially for the urban working class.

23 Report of the NPRA, *Photography*, 15 July 1897, 438.

24 Schwartz, "Objective Representation," 165.

25 Tucker, *Nature Exposed*, 111–13.

26 Creighton, "The Picturesque in History," 262. This was a lecture delivered before the Royal Institution of Great Britain on 5 February 1897.

27 *PSRS*, *Eighth Annual Report*, 1909, 9; *Eastern Daily Press*, 2 December 1913, NHC Stephen Scrapbook, 52.

28 *AP*, 15 September 1908, 259; *AP*, 25 August 1908, 186.

29 Norwich and District Photographic Society Minutes, vol. 1, 4 February 1907, NCRO S0187/1. Kimber gave a similar lecture to the Leicester Photographic Society.

30 Lecture flyer, n.d. Images from these projects were donated to the NPRA and to the Kent survey; MDPS Minutes, vol. 1 [SO 187/1], 4 February 1907.

31 Rüsen, "Historical Consciousness," 66.

32 See Pollock, "Dislocated Narratives and Sites of Memory," 1–2, concerning the early exchange of survey-type activity between photographic societies, notably those in Liverpool and Boston.

33 *AP*, 17 February 1899, 135.

34 *AP*, 12 January 1900, 35.

35 *AP*, 31 March 1899, 255. Chorley is a small town in Lancashire.

36 *AP*, 14 February 1916, 124; *BJP*, 30 July 1897, 489; MacDowel Cosgrave, "History in Stones," 193.

37 Harrison also wrote a number of books on the practice of photography for amateurs, for instance, *Photography for All* (1888) and *Chemistry for Photography* (1888).

38 *CAH*, 6.

39 Bingley Notebooks, Brotherton Library, University of Leeds.

40 James, "William Jerome Harrison, Sir Benjamin Stone and the Photographic Record and Survey Movement," 41.

41 Richardson, "Cycling as an Intellectual Pursuit."

42 Readman, "Preserving the English Landscape," 198, makes this point in relation to rural scenery.

43 For detailed studies of this phenomenon, see, for example, Shattock and Wolff, *The Victorian Periodical Press*; Altick, *The English Common Reader*, chapters 14–16; Rose, *The Intellectual Life of the British Working Class*. See also S. Edwards, *The Making of English Photography*.

44 Tucker, *Nature Exposed*, 51.

45 Anderson, *Imagined Communities*.

46 Tucker, *Nature Exposed*, 50–51; Daston, "Objectivity and the Escape from Perspective," 608.

47 See Readman, "Preserving the English Landscape," 201–2; *AP*, 3 May 1889, 283.

48 Bridges-Lee, "Photographic Records," 12.

49 *AP*, 26 February 1903, 163.

50 *AP*, Survey and Record Notes, 19 March 1907, 259.

51 *AP*, Survey and Record Notes, 12 November 1903, 382.

52 "The Guild Record," vol. 1, no. 9, 1; *Photogram*, December 1897.

53 *Photographic Gossip*, no. 26, 1 November 1902. Mary, Queen of Scots, was a major figure of the Victorian popular and romantic historical imagination.

54 *AP*, 19 March 1903, 222.

55 *AP*, 12 December 1901, 461.

56 *AP*, 29 June 1900, 502; *AP*, 25 July 1905, 62. In the mid-1890s, the popular journal *Practical Photographer* ran survey photography competitions that also included geological photographs.

57 *AP*, 3 August 1900, 81.

58 *AP*, 20 August 1901, 237.

59 *AP*, 28 November 1901, 424.

60 Gethin appears to have come from a middle-class family who ran a coal merchants' business. He was Secretary of Hereford Photographic Society for fourteen years and a member of the Architectural Detail Club. *Photographic News*, 27 August 1897, 551.

61 Dixon was vicar of Ealing, in West London, and a local antiquarian.

62 *AP*, 20 November 1902, 402.

63 *AP*, 19 March 1903, 222.

64 *AP*, 11 January 1910, 34.

65 Stewart, *On Longing*, 41, 64–65.

66 Publicity leaflet for *Sir Benjamin Stone's Pictures*, c. 1905, National Portrait Gallery, Stone Collection related documents file.

67 Ibid., 11.

68 Ibid., 18.

69 Ibid., 2.

70 Stone owned a set of *Cassell's History of England*, and copies were readily available in libraries and reading rooms. I have my great-grandmother's set. At the age of four, Cassell's history was my favourite book, and I spent hours looking through the pictures.

71 *Photographic News*, 23 January 1897, 258.

72 Altick, *The English Common Reader*, 302–4; Rose, *The Intellectual Life of the British Working Class*, 393; MacDonagh, Introduction to *Sir Benjamin Stone's Pictures*, vii.

73 Bennett, *The Birth of the Museum*, 59–88.

74 Bennett, "Difference and the Logic of Culture," 66.

75 George Stephan to H. Rennie, 6 March 1913, King's Lynn Public Library, Photographic Survey Files. Since the mid-1840s, local authorities had been empowered to raise funds for library and, a little later, museum provision from a percentage of the local tax revenue. By the late nineteenth century, all cities and most towns had a free library. The exact nature and regulation of free libraries changed and their provisioning was refined and strengthened in the second half of the nineteenth century, although the principle remained the same. While libraries were philanthropic, there was, in many places, and especially in the early days, staunch resistance from ratepayers who thought the local tax went toward a dubious cause.

76 Bieranki and Jordan, "The Place of Space in the Study of the Social," 141; Topley, "Photographic Surveys and Their Work," report from the *Transactions of the South East Union of Scientific Societies*, 1918, 64 (offprint, PSRS Papers, Croydon Local Studies and Archives).

77 Jast, *The Library and the Community*, 75.

78 Hill, *Culture and Class in English Public Museums*, 1.

79 Joyce, "The Politics of the Liberal Archive," 39; Bennett, "Difference and the Logic of Culture," 50–51.

80 Heathorn, *For Home, Country, and Race*, 4.

81 Joyce, "The Politics of the Liberal Archive," 45.

82 Heathorn, *For Home, Country, and Race*, 178.

83 Williams, *The Long Revolution*, 68.

84 Herzfield, *Cultural Intimacy*, 14.

85 De Certeau, *The Practice of Everyday Life*, xiv.

86 Hill, *Culture and Class in English Public Museums*, 4.

87 Joyce, "The Politics of the Liberal Archive," 37.

88 Warner Marien, *Photography and Its Critics*, 115.

89 South London Photographic Society address by Charles H. Oakden, BJP, 22 April 1898, 250.

90 Viscount Middleton, presidential address, PSRS, Second Annual Report, 1904, 7.

91 I am grateful to Katherine Dunhill for this information.

92 Jast, *The Library and the Community*, 62.

93 "Photography and History: Local Record Movement," *Eastern Daily Press*, 2 December 1913 (NHC Stephens Cutting Book, 52).

94 *PSRS, Tenth Annual Report*, 1910, 1.

95 "Photography and History: Local Record Movement," *Eastern Daily Press*, 2 December 1913 (NHC Stephens Cutting Book, 52).

96 *PSRS, Seventh Annual Report*, 1908, 4; CAH, 153–54.

97 Perkins, "A Plea for Systematic and Associated Work in Photography," 341.

98 "Pictures for Future Historians," *Brighton Herald*, 14 August 1909, 5.

99 Perkins, "A Plea for Systematic and Associated Work in Photography," 341.

100 BPS Council Minutes, 23 April 1897 (Birmingham City Archives, BPS 266684).

101 Birmingham Photographic Society monthly programmes, 1890 (Birmingham City Archives, BPS L.F25.69. f.24). Nottinghamshire survey flyer, 1897 (NCRO Mechanics Institute Minutes DDM1 270/1).

102 *AP*, 10 July 1896, 22.

103 *CAH*, 77–78.

104 *CAH*, 154–55, 157.

105 Palmer, "Philanthropic Photography," 206.

106 *South Western Star*, 5 October 1906, 7.

107 "Exhibition of Historical and Architectural Photographs," BJP, 26 July 1901, 47. For the full catalogue, see *Catalogue of Photographs Con-*

sisting of Historical and Architectural Subjects and Studies from Nature: Chiefly Contributed by Sir J. B. Stone. Over two-thirds of Stone's photographs in the exhibition were of sites of "national tradition," those from the National Art Library included commercially produced topographical and architectural studies from photographers such as S. B. Bolas and Co., who also donated images to the NPRA.

108 V. and A. Archives, Nominal File NA/1/S3594.

109 Borzello, *Civilising Caliban*, 5.

110 Borzello, "Pictures for the People"; see also Borzello, *Civilising Caliban*, 32–47.

111 *BJP*, 24 June 1898, 450.

112 Borzello, *Civilising Caliban*, 34.

113 Though sources are scant, by 1900, in the domestic sphere, owning at least a few photographs was within the financial grasp of all but the very poorest, especially in urban areas. See Linkman and Warhurst, *Family Albums*.

114 See, for example, Nead, *Victorian Babylon*, 153–54, 184–89.

115 Borzello, *Civilising Caliban*, 64–65.

116 Nickel, *Francis Frith in Egypt and Palestine*, 92.

117 Hill, *Culture and Class in English Public Museums*, 133; Flint, "Painting Memory," 536.

118 *AP*, 27 February 1902, 175. Menevia was probably William Mariott Dodson, an amateur photographer and antiquarian from Betws-y-Coed, Conwy, Wales.

119 Harrison, "On the Work of a Local Photographic Society," 425.

120 *PSRS, Sixth Annual Report*, 1907, 5. It would appear that the lecture that became *The Camera as Historian* was first developed by F. Wood, the society secretary, not by the eventual authors.

121 *AP*, 20 August 1903, 142.

122 Harrison, *A Proposal for a National Photographic Record and Survey*, 11.

123 Working-men's clubs were founded by Henry Solly in the 1860s to provide respectable working-class leisure.

124 *CAH*, 43.

125 Landau, "The Illumination of Christ in the Kalahari," 29–31. See also Schivelbusch, *Disenchanted Night*, 219–21.

126 Nead, *The Haunted Gallery*, 174–75; Hinton, *Pictorial Photography*, n.p.: Affiliation of Photographic Societies, 8 October 1896 (pamphlet, Bod 17091.e.107).

127 *Berrows Worcester Journal*, 23 January 1897, 2. This is probably Thomas James, a Kidderminster fellmonger (part of the tanning trade).

128 Croydon Library, *Annual Report*, 1906–1907, 26.

129 *PSRS, Ninth Annual Report*, 1910, 9. For an account of rural educational practices at the end of the nineteenth century, see Horn, *Education in Rural England*, 252–73.

130 Kansteiner, "Finding Meaning in Memory," 195.

131 Minute Book for the Committee, 1895–1908, 11 January 1901, 235 (SANHS, DD/SAS.G733 1/2). Up to twenty hours in any one year were permissible. See Horn, *Education in Rural England*, 255.

132 *PSRS, Seventh Annual Report*, 1908, 4. I am grateful to Keith Bonnick, of the Cuming Museum, Southwark, for information on the museum and its history. The museum regularly had an attendance of over 30,000 per year in the early twentieth century.

133 For a catalogue of the survey exhibits, see *Royal Photographic Society International Exhibition, Crystal Palace 1898: Catalogue* (n.p., 1898), 201–5.

134 *Croydon Library Annual Report, 1904–1905*, 9, 11 (Corydon Library Collection).

135 *Croydon Readers' Index* 15, no. 6 (1913): 142.

136 See S. Edwards, *The Making of English Photography*, 109.

137 Rose, *The Intellectual Life of the British Working Class*, 6.

138 See, for instance, Karp and Levine, *Museums and Communities*.

139 Hill, *Culture and Class in English Public Museums*, 138.

140 Readman, "Preserving the English Landscape," 202–3.

141 *Photographic Monthly*, vol. 14, May 1907, 157.

142 *PSRS, Seventh Annual Report*, 1908, 11.

143 *PSRS, Sixth Annual Report*, 1907, 9.

144 *PSRS, Twelfth Annual Report*, 1913, 9, which notes that local Croydon people in the library would look through the survey pictures.

145 Hepworth and Alexander, *Norwich Public Libraries*, 16.

146 *Croydon Library Annual Report*, 1901–1902,17; *Library Association Record* 4 (1892): 47. Cheap editions of the great Victorian historians, such as MacCauley and Carlyle, were available and read well into the twentieth century, by both working-class and middle-class readers. See Rose, *The Intellectual Life of the British Working Class*, 4, 52, 130–31.

147 Hill, *Culture and Class in English Public Museums*, 132.

148 Bann, "Photography and Genre: A Project for Cultural Studies," 4.

149 Lord, "From Document to the Monument," 361.

150 See Fyfe, *Art, Power and Modernity*, 176.

NOTES TO CHAPTER 7: AFTERLIVES AND LEGACIES

1 Anonymous, "Celebration for Images of England." *Heritage Today* is "the magazine for members of English Heritage," an organisation that works to protect Britain's "legacy of historic buildings, landscapes and archaeological sites."

2 English Heritage, "Images of England." http://www.imagesofengland.org.uk/faq/. The project is finished and the information cited is now included under the Frequently Asked Questions section of the website.

3 See Edwards and James, *A Record of England*.

4 "Photographic Survey Report," *Dorset Natural History and Antiquarian Field Club Proceedings*, 37 (1916): xxxvii.

5 Ellis, *Public Libraries and the First World War*, 46.

6 Ibid., 7.

7 See Hauser, *Shadow Sites*.

8 *CAH*, ix; *AP*, 27 November 1916, 437.

9 Mandler, "The Consciousness of Modernity," 119. See also Hall, *Cultures of Empire*, 9.

10 See James, "Birmingham, Photography and Change."

11 Matless, "Regional Surveys and Local Knowledges," 465. The Camera Obscura used by Geddes on Castle Hill, Edinburgh, is now an optical and quasiphotographic tourist attraction.

12 *CAH*, 40.

13 John Swarbrick to Alderman T. C. Abbott, 21 February 1921, Manchester Central Library, Local Studies, M34/5/1.

14 *Croydon Library Annual Report, 1913–14*, 8 (Croydon Library Records).

15 *Exeter Flying Post*, 8 April 1911, 5; Exeter Council Town Planning Minutes, 23 March 1911.

16 Meller, *European Cities, 1890–1930s*, 4.

17 Fagg, "The History of the Regional Survey Movement," 85. See also Matless, "Regional Surveys and Local Knowledges," 464–80.

18 James, "William Jerome Harrison, Sir Benjamin Stone and the Photographic Record and Survey Movement," 52; Shropshire Photographic Society, "A Short History of Our Society," 2007. http://www.shropshire-photographic.org.uk.

19 Hepworth and Alexander, *Norwich Public Libraries*, 22. Rushworth and Pickles, "The Cambridgeshire Local History Society Photographic Project, 1992–2000." This latter project is also in the spirit of the New Topographics movement in contemporary photography.

20 Fowler, "Photographic Surveys," 490.

21 *AP*, 22 November 1910, 513.

22 W. Foot-Walker (East Riding Antiquarian Society, Hull) to NBR, 20 May 1941, NMR File, Archaeological Societies (English Heritage). Holy Trinity Hull is the largest fifteenth-century parish church in the country. The photographs survive in the NPRA collection. For an account of NBR, see Hauser, *Shadow Sites*, 217–20.

23 Jay, *Customs and Faces*, 13.

24 Sekula, "Reading an Archive," 124.

25 Roberts, *Tony Ray Jones*, 16–17; Meadows, *The Bus*, 81. Tony Ray Jones himself was a major influence on Meadows.

26 Samuel, *Theatres of Memory*, 350–61.

27 Jay, "Sir Benjamin Stone," 2–10.

28 Ibid., 2. Edwards and James, *A Record of England*, 151.

29 Ford, *Sir Benjamin Stone, 1838–1914*.

30 Gloucestershire County Record Office, K989/4: 18 July 1974.

31 Arts Council of Great Britain, *The Real Thing*, 122.

32 Williams and Bright, *How We Are*.

33 Mellor, *No Such Thing as Society*, 32.

34 I am very grateful to Bernard Heathcote for

verifying this story, first recounted to me by the local studies librarian in Nottingham City Library. Heathcote and Heathcote, *Pioneers of Photography in Nottinghamshire*, 27.

35 *BJP*, 11 May 1906, 370.

36 I am grateful to the Norwich Heritage Centre staff for recounting this sad tale to me. There is an unfortunate irony that at the opening of the survey's first exhibition in December 1913, the speaker commented that ideally "the collection should be duplicated . . . in case one of the collections should unfortunately be destroyed by fire or through some other unforeseen calamity" (*Norwich Mercury*, 5 December 1913, reprint pamphlet, 4).

37 Schlak, "Framing Photographs, Denying Archives," 86.

38 Hayes, Silvester, and Hartmann, "Picturing the Past in Namibia," 115.

39 Samuel, *Theatres of Memory*, 337–47.

40 Collini, *English Pasts*, 95.

41 Schlak, "Framing Photographs, Denying Archives," 87.

42 Leith, "Amateurs, Antiquarians and Tradesmen."

43 Schlak, "Framing Photographs, Denying Archives," 94. See also Sassoon, "Photographic Materiality in the Age of Digital Reproduction"; Edwards, "Photographs and History."

44 Ricoeur, *Time and Narrative*, 118.

45 The advance of local history was also supported institutionally through the Standing Conference for Local History, which attempted to foster research standards and connect professional historians interested in local, regional, and small-scale histories, and in what was happening on the ground. See, for instance, the debate between J. D. Marshall and Alan Everitt in the pages of *Amateur Historian* in 1963–64.

46 Bernard Heathcote, personal communication with author, April 2010.

47 Nora, "Between Memory and History," 13.

48 Bradley, "The Seductions of the Archive," 108.

49 Devon Library and Information Services, "Exeter Pictorial Record Society," September 2007, http://www.devon.gov.uk/print/localstudies/.

50 See Ranahan, "Establishing the Case for Digitising the Warwickshire Photographic Survey."

51 Boston Public Library, "Old Boston Photo-graph Collection," 2008, http://wwww.flickr.com/photos/boston public library/sets/.

52 Manchester City Council, "Manchester Local Image Collection," 2011, http://images.manchester.gov.uk/index.php?session=pass/; Birmingham City Libraries, "Digital Handsworth," n.d., http://www.digitalhandsworth.org.uk/.

53 Norfolk County Council, "Picture Norfolk," http://www.picture.norfolk.gov.uk/.

54 Pollock, "Dislocated Narratives and Sites of Memory," 19.

55 Berger, *About Looking*, 57.

56 Helva, "The Photography Complex," 103.

57 Poole, *Vision, Race, and Modernity*, 8.

58 Ankersmit, *Sublime Historical Experience*, 1.

59 Garde-Hansen, Hoskins, and Reading, *Save As . . . Digital Memories*, 17; Jenkins, *Convergence Culture*, 209.

60 Van Dijck, "Digital photography," 62.

61 Macdonald, "Photos in Wiradjuri Biscuit Tins," 236.

62 Bradley, "The Seductions of the Archive," 107.

63 Didi-Huberman, *Images in Spite of All*, 33.

64 Tucker, "Entwined Practices," 5.

NOTES TO APPENDIX

1 Harrison, *Proposal for a National Photographic Record and Survey*, 9–10.

2 Photographic Survey and Record of Surrey, leaflet, *PSRS* Papers, Croydon Local Studies and Archives.

3 "Proposed Federation of Photographic Survey Societies," *BJP*, 18 February 1910, 128.

4 Record Office for Leicestershire, Leicester and Rutland, Papers of the Leicester Literary and Philosophical Society, DE600/1/3/2. Roechling was secretary of the revived Leicestershire survey and a local civil engineer, architect, and surveyor. (Reproduced by kind permission of Leicester Literary and Philosophical Society.)

5 Cambridge Survey Papers, Cambridge City Library, 1904, n.p.

ARCHIVAL SOURCES

Birkenhead Public Library (Cheshire and Wirral Survey Albums)

Birmingham City Archives (Birmingham Photographic Society Papers; Warwickshire Photographic Survey Papers and Photograph Files, Sir Benjamin Stone [JBS] Cuttings Volumes and Invitation Books)

Birmingham City Library (Warwickshire Photographic Survey Files)

Bodleian Library, Oxford (Oxford Architectural and Historical Society Committee Minute Book, 1893–1899 [Dep.d.524]; Ashmolean Natural History Society of Oxfordshire/Oxford and District Natural History Society. Minute Books, 1888–1910 [Dep.d.706–7])

Brighton Heritage Centre (Sussex Survey Photograph Files)

Bristol Museum and Art Gallery (Bristol and West of England Photographic Association: Survey and Record Albums). These albums have since been moved to Bristol City Record Office.

British Museum (Central Archive and Department of Prints and Drawings Papers)

Cambridge Antiquarian Society, Haddon Library, University of Cambridge. (Society Papers, Minute Books 3–5, 1899–1911; Congress of Archaeological Societies Volume, Miscellaneous Correspondence)

Cambridge Local Studies Library (Cambridgeshire Survey Photographs and CAS Photographic Record Committee Minute Book, 1904–1924 [C.65.5])

Cambridge University Library (Special Collections: Haddon Papers)

Croydon Local Studies and Archives (Photographic Survey and Record of Surrey [PSRS] Photographs and Papers; Croydon Library Records)

Devon Studies Library, Exeter (Exeter Pictorial Record Society

Schedule, Volumes 1–2; Town Planning Committee Minutes)

Dorset County Museum (Photographic Survey Files; Dorset County Museum Minute Books, 1890–1905)

English Heritage: National Buildings Record, Swindon (File: Photographic Societies and Camera Clubs)

Essex County Record Office (Papers of Essex Field Club, D/DGd Z59, Photographic and Pictorial Survey and Record of Essex; D/DU 2035/1 Essex Field Club Minutes; Photographs 6B 61 D/1)

Gloucester Archives (Photograph Files SR44/36297; Correspondence K989/4)

Hereford Public Library (Hereford Photographic Society Minute Book, 1906)

Huddersfield Local Studies Library (Photograph Collections)

King's Lynn Public Library, Local Collections (North Norfolk Survey Photographs and Papers)

Leeds City Library (Bingley Albums)

Leicestershire County Archives (Papers of the Leicester Photographic Society DE 600/1; Papers of Leicester Literary and Philosophical Society 14 D.55.10; Council Minutes, 1886–1902, 14.D.55/11; Council Minutes, 1902–1920, 14.D.55/7; General Meeting Minute Book, DE 1612.1; General Meeting Minute Book, 1909–1971; Museum Committee Minutes CM27/7)

London Metropolitan Archives (Papers of Photographic Survey of London, A/LSC/1, Minutes 25/6/1894–15/10/1907)

Maidstone Museum (Kent Survey Photographs; Museum Committee Minutes, 1904–1913)

Manchester City Library (Manchester Amateur Photographic Society Minutes M34/1/1/1–5; Council Minutes M34/1/2/1–2; Correspondence M18 9/2, M18 1/1, M33/1/1/5; Survey Photograph Files)

National Media Museum, Bradford (RPS Collection)

Norfolk County Record Office (S0187/1 Norwich and District Photographic Society Minute Volumes, S0187/1–3; Public Libraries Minutes, 1911–1918, MS21396; Correspondence MS 11322.652.314)

Norfolk Heritage Centre (Norfolk Survey Photographs and Papers. Miscellaneous Library Papers

Stephenson Cutting Books. See also www.picture.norfolk.org.uk)

Nottinghamshire Archives (Mechanics Institute Papers, DDMI 270/1; DD Nottingham Photograph Society DD 1915/5/9/DO 70-1; DD1915/6/12/H1/98, 110, 115, 210, 215, 233, 237; Nottinghamshire Survey Photographs DD 1915/1/101–727)

Sheffield City Archives (Sheffield Photographic Society Papers)

Society of Antiquaries, London (Congress of Archaeological Societies; Annual and Special Reports; Executive Committee Minutes, 12 December 1889 – 24 March 1904; Council Minute Books, Vols. 9–10)

Somerset County Record Office (Papers of Somerset Archaeological and Natural History Society Minute Books for the Committee DD/SAS.G733 1/1–2)

Somerset Local Studies Library (Somerset Survey Photographs)

Suffolk County Record Office, Ipswich (Ipswich Society Papers)

Surrey History Centre, Woking (Surrey Survey Photographs)

Thorsby Society, Leeds (General Papers, Kirkstall Abbey)

Victoria and Albert Museum (NPRA Collection Department of Photographs; Central Archives Nominal File NA/1/S3594)

West Yorkshire Archive, Leeds (Papers of the Leeds Photographic Society, Minute Books WYL2064/2/2–3; Secretary's Copy Books WYL2064/4/2; Scrapbooks WYL20-64/7/1-1)

Yorkshire Archaeological Society (Minute Books 1/1-1)

HISTORICAL PUBLISHED SOURCES

Only more substantial and "authored" pieces are listed here. The majority of the book's references are too short to be included here, or are untitled anonymous pieces in the contemporary press. These are referenced in full in the endnotes.

Allen, F. J. "A Photographic Survey of Somerset." *Somerset Archaeological and Natural History Society Proceedings*, n.s., 37, pt. 2 (1891): 100–105.

Arago, D. F. "Report of the Commission of the

Chamber of Deputies." 3 July 1839. In *Classic Essays on Photography*, edited by Alan Trachtenburg, 15–25. New Haven, Conn.: Leetes Island Books, 1980.

Baker, H. "Restoration." *AP*, 25 October 1901, 329.

———. "Restoration—A Rejoinder." *AP*, 5 December 1901, 454–55.

Balfour, H. "Presidential Address—Call for a National Folk Museum." *Museums Journal* 9 (1909): 5–18.

Beloe, E. *Our Borough, Our Churches*. Cambridge: MacMillan and Boures, 1899.

Bennett, H. W. "Architecture as a Subject for the Camera." *AP*, 6 April 1900, 270–73.

Blanc, H. J. "Photographs as an Aid for the Architect." *BJP*, 7 May 1897, 295–96.

Board of Education. *Catalogue of Photographs Consisting of Historical and Architectural Subjects and Studies from Nature: Chiefly Contributed by Sir J. B. Stone*. London: Victoria and Albert Museum, 1901.

Bothamley, C. H. "A Photographic Survey of Somerset." *Somerset Archaeological and Natural History Society Proceedings*, 3rd ser., 3 (1897): 166–71.

———. "Photographic Record and Survey Work: Some Practical Notes." *AP*, 14 June 1910, 582–83.

Brabrook, E. "On the Organization of Local Anthropological Research." *Journal of the Anthropological Institute* 22 (1893): 262–74.

Bridges-Lee, J. "Photographic Records." *AP*, 3 July 1902, 9–13.

Briscoe, A. E. "Proposals for a Photographic and Pictorial Survey of Essex." *Essex Naturalist* 13 (1903–1904): 1–5.

Brogdew, F. "Some Thoughts on Record Work." *AP*, 15 May 1902, 390–92.

Burton, C. "The Whole Duty of a Photographer." *BJP*, 18 October 1889, 682.

Conway, M. "On General and Local Photographs in Museums." *BJP*, 15 October 1909, 800–803; 22 October 1909, 821–22.

Coulthurst, S. "Notes on a Photographic Survey." *Practical Photographer*, April 1897, 115–18.

———. "Photographic Survey Work—A Plea." *AP*, 17 April 1902, 311.

Crabtree, J. "System in Record Work." *AP*, 26 May 1904, 408–9.

Creighton, M. "The Picturesque in History." In *Historical Lectures and Addresses*, edited by L. Creighton. London: Longmans, Green and Co., 1903.

———. "The Study of a Country." In *Historical Lectures and Addresses*, edited by L. Creighton. London: Longmans, Green and Co., 1903.

Ditchfield, P. H. *The Charm of the English Village*. London: Batsford, 1908.

Evans, F. "Glass versus Paper." In *Frederick Henry Evans: Selected Texts and Bibliography*, edited by A. Hammond. Oxford: Clio Press, 1992.

Fagg, C. C. "The History of the Regional Survey Movement." *S. E. Naturalist* 33 (1928): 71–94.

Ford, F. M. *The Spirit of the People: An Analysis of the English Mind*. London: Alston Rivers, 1907.

Fowler, C. J. "Photographic Surveys." *BJP*, 30 July 1897, 488–90.

———. "Photographic Survey." *Photogram Magazine*, May 1900.

Gomme, L. *The Village Community*. London: Walter Scott, 1890.

———. *Ethnology in Folklore*. London: Kegan Paul, Trench, Trübner and Co., 1892.

———. *Lectures on the Principles of Local Government*. Westminster: n.p.,1897.

———. *Folklore as an Historical Science*. London: Methuen, 1908.

Gough, R. *The History of Myddle*. Edited by David Hey. Harmondsworth: Penguin, 1981.

Gower, H. D. L., Stanley Jast, and W. W. Topley. *The Camera as Historian: A Handbook to Photographic Record Work for Those Who Use a Camera and for Survey or Record Societies*. London: Sampson Low, Marston and Co., 1916.

Haddon, A. C. "Photography and Folklore." *Folklore* 6 (1895): 222.

———. "The Saving of Vanishing Knowledge." *Nature* 55 (1897): 305–6.

———. *The Study of Man*. London: Murray, 1898.

Harrison, W. J. "On the Teaching of Science in Public Elementary Schools." *Proceedings of the Birmingham Philosophical Society* 2 (1882): 274–93.

———. "Work for Amateur Photographers." *AP*, 13 March 1885, 364.

———. "On the Work of a Local Photographic Society." *BJP*, 3 July 1885, 425–26.

———. "Light as a Recording Agent of the Past." *PN*, 8 January 1886, 23.

———. "Some Notes on a Proposed Photographic Survey of Warwickshire." *Photographic Societies Reporter*, 31 December 1889, 505–15.

———. *A Proposal for a National Photographic Record and Survey*. London: Harrison and Co., 1892.

———. "The Desirability of an International Bureau: Established (1) To Record; (2) To Exchange Photographic Negatives and Prints" *BJP*, 25 August 1893, 548–49.

———. "The Desirability of Promoting County Photographic Surveys." *Reports of the 76th BAAS York Meeting*, (1906): 58–67.

———. "Photographic Record Work: New Efforts." *Photogram*, October 1906.

Hartland, E. S. "Ethnographical Survey of the United Kingdom." *Transactions of the Bristol and Gloucestershire Archaeological Society* 18 (1893–94): 207–17.

———. "Notes Explanatory of the Schedules." *Report of BAAS Ipswich Meeting* (1895): 513–18.

Hinton, A. Horsley. *Pictorial Photography*. Affiliated Photographic Societies, 8 October 1896 (pamphlet, Bod 17091.e.107), n.p.

Howorth, E. "Suggestions for the Photographic Survey of the District of Sheffield." *Photographic Societies Reporter*, 30 April 1889, 186.

Huish, M. B. *Happy England: As Painted by Helen Allingham*. London: A. C. Black, 1903.

Im Thurn, E. "Anthropological Uses of the Camera." *Journal of the Anthropological Institute* 22 (1896): 184–203.

Jast, L. S. "Public Libraries and the War." *Library Association Record* 17 (January-February 1915): 10–17.

———. *The Library and the Community*. London: Thomas Nelson and Son, 1939.

Jeffs, O. W. "Geological Photography." *AP*, 4 June 1886, 271–73.

Jones, C. "Cycling Records." *AP*, 7 August 1902, 103–4.

Keene, R. "The Warwickshire Survey." *BJP*, 27 May 1892, 346.

Lang, A. *Anthropological Essays Presented to E. B. Tylor on Honour of His 75th Birthday*. Oxford: Clarendon Press, 1907.

Leeson, J. H. and Son. *Catalogue of the Extensive and Valuable Library of the Late Sir Benjamin Stone*. Birmingham: "Journal" Printing Office., July 1919.

Lockett, A. "Measuring and Surveying by Photography." *BJP*, 28 December 1906, 1024–27.

Lund, P. "Photographic Clubs: The Formation and Management." *AP*, 20 April 1902, 310–11.

MacDonagh, M. Introduction to *Sir Benjamin Stone's Pictures: Scenes from National Life*. Vol. 1. London: Cassell and Co., 1906, v–viii.

MacDowel Cosgrave, E. "History in Stones—Transferred to Lantern Slides." *Practical Photographer* 8, no. 91 (July 1897): 193–95.

Mackinder, H. *Seven Lectures on UK for Use in India*. 1909. Text to accompany lantern slides. London: Waterlow and Co., 1909.

Marriott Dodson, W. "Architectural Record Work—Wood Carving." *AP*, 6 February 1902, 236.

Marshall, F. A. S. *Photography: The Importance of Its Application in Preserving Pictorial Records of the National Monuments of History and Art*. London: Hering and Remington, 1855.

Middleton, E. C. "Photographic Survey Work." *Practical Photographer* 8, no. 85 (April 1897): 108–12.

Middleton, G. A. T. "Architectural Ornament—Its Photographic Treatment." *AP*, 9 July 1897, 27.

———. "Building Material and Architectural Photography." *AP*, 3 September 1897, 191–92.

———. *Architectural Photography*. London: Hazell, Watson and Viney, 1898.

———. "English Church Porches." *AP*, 13 April 1900, 289.

———. "English Architecture." *AP*, 2 January 1902, 8–9.

Mill, H. R. "Proposed Geographical Description of the British Isles Based on the Ordinance Survey." *Geographical Journal* 7, no. 4 (1896): 345–65.

Murchison, H. E. "Photography with an Object." *Photographic Quarterly* 1890.

Murray, D. *Museums, Their History and Their Use*. 3 vols. Glasgow: James MacLehose and Sons, 1904.

Nightingale, A. *Visual History: A Practical Method of Teaching Introductory History*. London: A. C. Black, 1915.

Norwood, T. W. "A Plea for the Protection of Ancient Buildings, for the Sake of History, Art and Religion." *SPAB 8th Annual Report*, June 1885.

Oliver, B. *Old Houses and Village Buildings of East*

Anglia: Norfolk, Suffolk & Essex. London: Batsford, 1912.

Palmer, Rev. H. J. "Philanthropic Photography." *Photographic Record* 9 (1889): 203–6.

Parker, G. F. "History by Camera." *Century Magazine* 68 (May 1904): 136–45.

Perkins, T. "A Plea for Systematic and Associated Work in Photography." *Photographic Quarterly* (July 1890): 337–44.

———. "On the Desirability of a Photographic Survey of the County." *Dorset Natural History and Antiquarian Field Club Proceedings* 15 (1896): 19–25.

———. "Some Instruction in Photographic Survey Work." *AP*, 17 April 1896, 344–45.

———. *Handbook of Gothic Architecture*. London: Hazell, Watson and Viney, 1897.

———. "Restoration." *AP*, 5 December 1901, 455.

Photographic Survey and Record of Surrey. Annual Reports, 1903–1918. Croydon: PSRS 1903–1918.

Pitt-Johnson, E. C. "A Plea for Our Village Churches." *AP*, 7 November 1901, 367.

Plomer, H. "Local Records and Free Public Libraries." *Library Association Record* 4 (1892): 137–38.

Portman, M. V. "Photography for Anthropologists." *Journal of the Anthropological Institute* 15 (1896): 75–87.

Reid, A. S. "Geological Photography." *Photographic Quarterly* (January 1891): 104–7.

Richardson, B. W. "Cycling as an Intellectual Pursuit." *Longmans Magazine* 2 (1883): 602–3.

Royal Photographic Society. *Royal Photographic Society International Exhibition, Crystal Palace, 1898: Catalogue*. London: Royal Photographic Society, 1898.

Ruskin, J. *The Seven Lamps of Architecture*. 1880. New York: Dover, 1989.

Sachse, J. "The Camera as Historian of the Future." *PN*, 22 August 1890, 653–54.

Simpson, R. T. *The Collection of Wroth Silver*. Rugby: Rugby Advertiser, 1910.

Slater, P. J. "Notes of Photo-Cycling." *BJPA*, 1900, 99.

Stone, J. B. *Sir Benjamin Stone's Pictures: Records of National Life and History*. 2 vols. London: Cassell, 1905–1906.

Tilt, W. "Restoration—A Reply." *AP*, 7 November 1901, 363.

Tylor, E. B. *Anthropology*. London: Macmillan, 1881.

Wanlass, H. "Picturesque Slums." *AP*, 23 October 1902, 352.

Wells, J. A. *A History of the Old Cambridge Photographic Club*. Boston: Alfred Mudge and Sons, 1905.

Wilcock, J. "Photographic Survey of Manchester and Salford." *Photographic Record* 11 (April 1890): 255–61.

SECONDARY PUBLISHED SOURCES

Altick, R. *The English Common Reader: A Social History of the Mass Reading Public, 1800–1900*. Chicago: Chicago University Press, 1957.

Anderson, B. *Imagined Communities: Reflections on the Origin and Spread of Nationalism*. London: Verso, 1983.

Anderson, K. *Predicting the Weather: Victorians and the Science of Meteorology*. Chicago: University of Chicago Press, 2005.

Andrews, M. "The Metropolitan Picturesque." In *The Politics of the Picturesque: Literature, Landscape and Aesthetics since 1770*, edited by S. Copley and P. Garside, 282–98. Cambridge: Cambridge University Press, 1994.

Ankersmit, F. *Sublime Historical Experience*. Stanford: Stanford University Press, 2005.

Anonymous. "Celebration for Images of England." *Heritage Today*, March 2006, 12.

Appadurai, A. *Modernity at Large: Cultural Dimensions of Globalization*. Minneapolis: University of Minnesota Press, 1996.

Armstrong, N. *Fiction in the Age of Photography: The Legacy of British Realism*. Cambridge: Harvard University Press, 1999.

Arnheim, R. *Entropy and Art: An Essay on Order and Disorder*. Berkeley: University of California Press, 1971.

Arts Council of Great Britain. *The Real Thing: An Anthology of British Photography, 1840–1950*. London: Arts Council of Great Britain, 1975.

Attridge, S. *Nationalism, Imperialism, and Identity in Late Victorian Culture: Civil and Military Worlds*. London: Palgrave Macmillan, 2003.

Baer, U. *Spectral Evidence: The Photography of Trauma*. Cambridge: MIT Press, 2005.

Bailey, P. *Leisure and Class in Victorian England:*

Rational Recreation and the Contest for Control, 1830–1885. London: Routledge and Kegan Paul, 1978.

Bakhtin, M. *The Dialogic Imagination: Four Essays*. Edited by Michael Holquist. Translated by C. Emerson and M. Holquist. Austin: University of Texas Press, 1981.

Bann, S. *The Inventions of History: Essays on the Representation of the Past*. Manchester: Manchester University Press, 1990.

———. "Photography and Genre: A Project for Cultural Studies." In *Images of England: The Photograph in Context*, edited by the University of Kent, Canterbury. Canterbury: Modern Cultural Studies, 1991.

———. *Romanticism and the Rise of History*. Oxford: Maxwell Macmillan, 1995.

Barthes, R. *Image Music Text*. Translated by S. Heath. London: Fontana, 1977.

———. *Camera Lucida*. Translated by R. Howard. London: Fontana, 1984.

Baucom, I. *Out of Place: Englishness, Empire, and the Locations of Identity*. Princeton: Princeton University Press, 1999.

Becker, C. "Everyman His Own Historian." *American Historical Review* 37, no. 2 (January 1932): 221–36.

Becker, K. "Picturing Our Past." *Journal of American Folklore* 105 (1992): 4–18.

Becker, P., and W. Clark, eds. *Little Tools of Knowledge: Historical Essays on Academic and Bureaucratic Practices*. Ann Arbor: University of Michigan Press, 2001.

Bell, D. "Mythscapes: Memory, Mythology and National Identity." *British Journal of Sociology* 54, no. 1 (2003): 63–81.

Bender, B. "Time and Landscape." *Current Anthropology* 43, supplement (2002): 103–12.

Benjamin, W. "The Work of Art in the Age of Mechanical Reproduction." In *Illuminations*, edited by H. Arendt. London: Fontana, 1973.

Bennett, T. *The Birth of the Museum: History, Theory, Politics*. London: Routledge, 1995.

———. "Regulated Restlessness: Museums, Liberal Government and the Historical Sciences." *Economy and Society* 26, no.2 (1997): 161–90.

———. "Difference and the Logic of Culture." In

Museum Frictions, edited by I. Karp et al., 46–69. Durham: Duke University Press, 2008.

Berger, J. *About Looking*. London: Writers and Readers Co-op, 1980.

Bieranki, R., and J. Jordan. "The Place of Space in the Study of the Social." In *The Social in Question: New Bearings in History and the Social Sciences*, edited by P. Joyce, 133–50. London: Routledge, 2002.

Billig, M. *Banal Nationalism*. London: Sage, 1995.

Black, A. *The Public Library in Britain, 1914–2000*. London: British Library, 2000.

Blau, E. "Patterns of Fact: Photography and the Transformation of the Early Industrial City." In *Architecture and Its Image: Four Centuries of Architectural Representation*, edited by E. Blau and E. Kaufman, 36–57. Montreal: CCA, 1989.

Borzello, F. "Pictures for the People." In *Victorian Artists and the City*, edited by J. Bruce-Nadel. New York: Pergamon, 1980.

———. *Civilising Caliban: The Misuse of Art, 1887–1980*. London: Routledge and Keegan Paul, 1987.

Bowler, P. *The Eclipse of Darwinism: Anti-Darwinian Evolution Theories around 1900*. Baltimore: Johns Hopkins University, 1983.

———. *Biology and Social Thought, 1850–1914*. Berkeley: University of California, Berkeley, Office for History of Science and Technology, 1993.

———. *Science for All: The Popularization of Science in Early Twentieth-Century Britain*. Chicago: University of Chicago Press, 2009.

Boyer, M. C *The City of Collective Memory: Its Historical Imagery and Architectural Entertainments*. Cambridge: MIT Press, 1994.

———. "*La Mission Héliographique*: Architectural Photography, Collective Memory and the Patrimony of France, 1851." In *Picturing Place: Photography and the Geographical Imagination*, edited by J. M. Schwartz and J. R. Ryan, 21–54. London: I. B. Tauris, 2003.

Boyes, G. *The Imagined Village: Culture, Ideology, and the English Folk Revival*. Manchester: Manchester University Press, 1993.

Brace, C. "Finding England Everywhere: Regional Identity and the Construction of National Identity, 1890–1940." *Ecumene* 6, no. 1 (1999): 90–109.

Bradley, H. "The Seductions of the Archive: Voices Lost and Found." *History of the Human Sciences* 12, no. 2 (1999): 107–22.

Broks, P. *Media Science before the Great War*. Basingstoke: Macmillan, 1996.

Brooks, C. *Signs for the Times: Symbolic Realism in the Mid-Victorian World*. London: George Allan and Unwin, 1984.

Brush, S. "Thermodynamics and History." *Graduate Journal* 7, no. 2 (1967): 477–566.

Bunnell, P., ed. *Photographic Vision: Pictorial Photography, 1889–1923*. Salt Lake City: Peregrine Smith, 1980.

Burchardt, J. *Paradise Lost: Rural Idyll and Social Change in England since 1800*. London: I. B. Tauris, 2002.

Button, D. D. *When Found, Make a Note: History of the Norwich and District Photographic Society, 1903–2003*. Norwich: Norwich Photographic Society, 2003.

Cadava, E. *Words of Light: Theses on the Photography of History*. Princeton: Princeton University Press, 1997.

Cannadine, D. "The Context, Performance and Meaning of Ritual: The British Monarchy and the Invention of Tradition, c. 1820–1977." In *The Invention of Tradition*, edited by E. Hobsbawm and T. Ranger, 101–64. Cambridge: Cambridge University Press, 1983.

———. *Ornamentalism: How the British Saw Their Empire*. London: Allen Lane, 2001.

Castel, R., and D. Schnapper. "Aesthetic Ambitions and Social Aspirations: The Camera Club as a Secondary Group." In *Photography: A Middle-Brow Art*, edited by P. Bourdieu and translated by S. Whiteside, 103–28. Cambridge: Polity Press, 1990.

Chancellor, V. *History for Their Masters: Opinion in the English Historical Textbook, 1800–1914*. Bath: Adams and Dart, 1970.

Clifford, J. "On Ethnographic Allegory." In *Writing Culture: The Poetics and Politics of Ethnography*, edited by J. Clifford and G. E. Marcus, 98–121. Berkeley: University of California Press, 1986.

Cohen, A. *Belonging: Identity and Social Organisation in British Rural Cultures*. Manchester: Manchester University Press, 1994.

———. *Self-Conscious: An Alternative Anthropology of Identity*. London: Routledge, 1994.

Colley, L. *The Britons: Forging the Nation, 1707–1837*. London: Pimlico, 1994.

Collini, S. *English Pasts: Essays in History and Culture*. Oxford: Oxford University Press, 1999.

Colls, R. *Identity of England*. Oxford: Oxford University Press, 2002.

Colls, R., and P. Dodd, eds. *Englishness: Politics and Culture, 1880–1920*. London: Croom Helm, 1986.

Connor, S. "Topologies: Michel Serres and the Shapes of Thought." *Anglistik* 15, no. 4 (2004): 105–17.

Cooke, P. "Locality, Structure and Agency: A Theoretical Analysis." *Cultural Anthropology* 5, no. 1 (1990): 3–15.

Coombes, A. *Reinventing Africa: Museums, Material Culture and Popular Imagination in Late Victorian and Edwardian England*. London: Yale University Press, 1994.

Cosgrove, D., and S. Daniels, eds. *The Iconography of Landscape*. Cambridge: Cambridge University Press, 1988.

Cousserier, A. "Archive to Educate." Paper presented at the Photography Next conference, Nordiska Museet, Stockholm, February 2010.

Crane, S. A., ed. *Museums and Memory*. Stanford: Stanford University Press, 2000.

Crary, J. *The Techniques of the Observer*. Cambridge: MIT Press, 1990.

———. *Suspensions of Perception: Attention, Spectacle, and Modern Culture*. Cambridge: MIT Press, 1999.

Cresswell, T. *Place: A Short Introduction*. Oxford: Blackwell, 2004.

Crimp, D. *On the Museum's Ruins*. Cambridge: MIT Press, 1995.

Crouch, D. "The Street in the Making of Popular Geographical Knowledge." In *Images of the Street*, edited by N. Fyfe, 160–75. London: Routledge, 1998.

Crouch, D., and D. Matless. "Refiguring Geography: Parish Maps of Common Ground." *Transactions of the Institute of British Geographers*, n.s., 21, no. 1 (1996): 236–55.

Daniels, S. *Fields of Vision*. Cambridge: Polity Press, 1993.

———. "Lines of Sight: Alfred Watkins; Photography and Topography in Early Twentieth Century Britain," http:www.tate.org.uk/research/tateresearch/tatepapers/06autumn/daniels.htm.

Dant, T. *Material Culture in the Social World: Values, Activities, Lifestyles.* Buckingham: Open University Press, 1999.

Daston, L. "Objectivity and the Escape from Perspective." *Social Studies in Science* 22 (1992): 597–618.

Daston, L., and P. Galison. "The Image of Objectivity." *Representations* 40 (fall 1992): 81–128.

———. *Objectivity.* New York: Zone Press, 2007.

De Certeau, M. *The Practice of Everyday Life.* Berkeley: University of California Press, 1984.

Dellheim, C. *The Face of the Past: The Preservation of the Medieval Inheritance in Victorian England.* Cambridge: Cambridge University Press, 1982.

Derrida, J. *Archive Fever.* Translated by E. Prenowitz. Chicago: University of Chicago Press, 1993.

Didi-Huberman, G. *Images in Spite of All: Four Photographs from Auschwitz.* Translated by S. B. Lillis. Chicago: University of Chicago Press, 2008.

Doane, M. A. *The Emergence of Cinematic Time.* Cambridge: Harvard University Press, 2002.

Domanska, E. "The Material Presence of the Past." *History and Theory* 45 (2006): 337–48.

Douglas, M. *Purity and Danger: An Analysis of the Concepts of Pollution and Taboo.* London: Routledge and Kegan Paul, 1966.

Driver, F. *Geography Militant: Cultures of Exploration and Empire.* Oxford: Blackwell, 2001.

Duncan, C. "Art Museums and the Ritual of Citizenship." In *Exhibiting Cultures*, edited by I. Karp and S. Levine, 88–103. Washington, D.C.: Smithsonian Institution Press, 1991.

———. *Civilizing Rituals: Inside Public Art Museums.* London: Routledge, 1995.

Edensor, T. "Walking in Rhythm: Place, Regulation, Style and the Flow of Experience." *Visual Studies* 25, no. 1 (2010): 69–79.

Edney, M. *Mapping an Empire: The Geographical Construction of British India, 1765–1843.* Chicago: University of Chicago Press, 1990.

Edwards, E. *Raw Histories: Photographs, Anthropology and Museums.* Oxford: Berg, 2001.

———. "Samuel Butler's Photography: Observation and the Dynamic Past." In *Samuel Butler: Victorian Against the Grain*, edited by J. Paradis, 251–86. Toronto: University of Toronto Press, 2007.

———. "Straightforward and Ordered: Amateur Photographic Surveys and Scientific Aspiration, 1885–1914." *Photography and Culture* 1, no. 2 (2007): 185–210.

———. "Photographs and History: Emotion and Materiality." In *Museum Materialities: Objects, Engagements, Interpretations*, edited by S. Dudley. London: Routledge, 2009.

———. "Photography and the Material Performance of the Past." *History and Theory* 48, no. 4 (2009): 130–50.

———. "Unblushing Realism and the Threat of the Pictorial." *History of Photography* 33, no. 1 (2009): 3–17.

———. "Uncertain Knowledge: Photography and the Late Nineteenth Century Anthropological Document." In *Documenting the World*, edited by G. Mittman and K. Wilder (forthcoming).

———. "Urban Survivals and Anticipated Futures: Photographic Survey in England, 1885–1918." In *Urban Photography and Cultural Ideas: Values and Norms in Nineteenth-Century Europe*, edited by T. Verschaffel. University of Leuven Press-Cornell University Press (forthcoming).

Edwards, E., and J. Hart. "Mixed Box: The Cultural Biography of a Box of 'Ethnographic' Photographs." In *Photographs Objects Histories: On the Materiality of Images*, edited by E. Edwards and J. Hart, 47–61. London: Routledge, 2004.

———, eds. *Photographs Objects Histories: On the Materiality of Images.* London: Routledge, 2004.

Edwards, E., and P. James. "'Our Government as Nation': Sir Benjamin Stone's Parliamentary Pictures." In *Making Things Public: Atmospheres of Democracy*, edited by B. Latour and P. Wiebel, 142–55. Cambridge: MIT Press, 2005.

Edwards, E., P. James, and M. Barnes. *A Record of England: Sir Benjamin Stone and the National Photographic Record Association, 1897–1910.* Manchester/London: Dewi Lewis/V&A Publications, 2006.

Edwards, J. "The Need for a 'Bit of History': Place and Past in English Identity." In *Locality and Belonging*, edited by N. Lovell, 147–67. London: Routledge, 1998.

Edwards, S. *The Making of English Photography: Allegories*. University Park: Pennsylvania State University, 2006.

Elkins, J. *The Domain of Images*. Ithaca: Cornell University Press, 1999.

Ellis, A. *Public Libraries and the First World War*. Denbigh: FFynnon Press, 1975.

Engelke, M. "The Objects of Evidence." *Journal of the Royal Anthropological Institute, Special Issue Series* 14, no. S1 (2008): S1–S21.

Fentress, J., and C. Wickham. *Social Memory*. Oxford: Blackwell, 1992.

Flint, K. *The Victorians and the Visual Imagination*. Cambridge: Cambridge University Press, 2000.

———. "Painting Memory." *Textual Practice* 17, no. 3 (2003): 527–42.

Foote, K. E. "Relics of London: Photographs of a Changing Victorian City." *History of Photography* 11, no. 2 (1987): 133–53.

Ford, C. *Sir Benjamin Stone, 1838–1914: Victorian People, Places and Things Surveyed by a Master Photographer*. London: National Portrait Gallery, 1974.

Foucault, M. *The Archaeology of Knowledge*. London: Routledge, 1974.

Frisch, M. *A Shared Authority: Essays on the Craft and Meaning of Oral and Public History*. New York: SUNY Press, 1990.

Fry, W. G., and W. A. Munford. *Louis Stanley Jast: A Biographical Sketch*. London: Library Association, 1966.

Frykman, J. "Between History and Material Culture: On European Regionalism and the Potentials of Poetic Analysis." In *Being There: New Perspectives on Phenomenology and the Analysis of Culture*, edited by J. Frykman and N. Gilje, 169–91. Lund: Nordic Academic Presses, 2003.

Fyfe, G. "A Trojan Horse at the Tate." In *Theorizing Museums*, edited by S. Macdonald and G. Fyfe, 203–36. Oxford: Blackwell, 1996.

———. *Art, Power and Modernity: English Art Institutions, 1750–1950*. Leicester: Leicester University Press, 2000.

Gaines, J. "Introduction: The Real Returns." In *Collecting Visible Evidence*, edited by J. M. Gaines and M. Renov. Minneapolis: University of Minnesota Press, 1999.

Garde-Hansen, J., A. Hoskins, and A. Reading, eds. *Save As . . . Digital Memories*. London: Palgrave Macmillan, 2009.

Gell, A. *Art and Agency: An Anthropological Theory*. Oxford: Oxford University Press, 1998.

Gellner, E. *Nations and Nationalism*. London: Weidenfeld and Nicholson, 1983.

Giddens, A. *The Constitution of Society*. Cambridge: Polity, 1984.

Gilbert, P., ed. *Imagined Londons*. New York: SUNY Press, 2002.

Gillis, J. R. *Commemorations: The Politics of National Identity*. Princeton: Princeton University Press 1994.

Goodall, J. *Performance and Evolution in the Age of Darwin: Out of the Natural Order*. London: Routledge, 2002.

Green, J. *Black Edwardians: Black People in Britain, 1901–14*. London: Frank Cass, 1998.

Green-Lewis, J. *Framing the Victorians: Photography and the Culture of Realism*. Ithaca: Cornell University Press, 1996.

Grimshaw, A., and A. Ravetz. *Observational Cinema: Anthropology, Film and the Exploration of Social Life*. Bloomington: Indiana University Press, 2009.

Gruber, J. W. "Ethnographic Salvage and the Shaping of Anthropology." *American Anthropologist* 72 (1970): 1289–99.

Gunn, S. "The Failure of the Victorian Middle Class." In *The Culture of Capital: Art, Power and the Nineteenth-Century Middle Class*, edited by J. Wolff and J. Seed, 17–43. Manchester: Manchester University Press, 1988.

———. *The Public Culture of the Victorian Middle Class: Ritual and Authority and the English Industrial City, 1840–1914*. Manchester: Manchester University Press, 2000.

Hackett, T. K. "Photography as an Aid to the Antiquary." *The Practical Photographer* 12 (September 1904): 32–35.

Halbwachs, M. *On Collective Memory*. Edited and translated by L. A. Coser. Chicago: University of Chicago Press, 1992.

Hall, C., ed. *Cultures of Empire: Colonizers in Britain and the Empire in the Nineteenth and Twentieth Centuries: A Reader*. Manchester: Manchester University Press, 2000.

Hamilton, C. "Living by Fluidity: Oral Histories,

Material Custodies and the Politics of Archiving." In *Refiguring the Archive*, edited by C. Hamilton et al., 209–27. Cape Town: David Philips, 2003.

Hammond, A. *Frederick Henry Evans: Selected Texts and Bibliography*. Oxford: Clio Press, 1992.

Handy, E., ed. *Pictorialist Effect/Naturalistic Vision: The Photographs and Theories of Henry Peach Robinson and Peter Henry Emerson*. Norfolk, Va.: Chrysler Museum, 1994.

Hansen, P. "Modern Mountains: The Performative Consciousness of Modernity in Britain, 1870–1940." In *Meanings of Modernity: Britain from the Late-Victorian Period to World War II*, edited by M. Daunton and B. Rieger, 57–72. Oxford: Berg, 2001.

Harris, J. *Private Lives, Public Spirit: A Social History of Britain, 1870–1914*. Oxford: Oxford University Press, 1993.

Harrison, M. "Art and Philanthropy: T. C. Horsfall and the Manchester Art Museum." In *City Class and Culture Manchester*, edited by A. J. Kidd and K. W. Roberts, 120–47. Manchester: Manchester University Press, 1985.

Haseler, S. *The English Tribe: Identity, Nation and Europe*. London: Macmillan, 1996.

Hauser, K. *Shadow Sites: Photography, Archaeology and the British Landscape, 1927–1955*. Oxford: Oxford University Press, 2007.

———. *Bloody Old Britain: O.G.S. Crawford and the Archaeology of Modern Life*. London: Granta, 2008.

Hayes, P., J. Silvester, and W. Hartmann. "Picturing the Past in Namibia." In *Refiguring the Archive*, edited by C. Hamilton et al., 103–33. Cape Town: David Philip, 2002.

Heathcote, B., and P. Heathcote. *Pioneers of Photography in Nottinghamshire*. Nottingham: Nottinghamshire County Council Community Services, n.d.

Heathorn, S. *For Home, Country, and Race: Constructing Gender, Class, and Englishness in the Elementary School, 1880–1914*. Toronto: University of Toronto Press, 2000.

Helva, J. L. "The Photography Complex: Exposing Boxer-Era China, 1900–1." In *Photographies East: The Camera and Its Histories in East and Southeast Asia*, edited by R. Morris, 79–199. Durham: Duke University Press, 2009.

Hepworth, P., and M. Alexander. *Norwich Public Libraries: Norfolk County Record Office*. Norwich: Libraries Committee, 1965.

Herbert, C. *Culture and Anomie: Ethnographic Imagination in the Nineteenth Century*. Chicago: University of Chicago Press, 1991.

Herzfield, M. *Cultural Intimacy*. London: Routledge, 1997.

Hicks, R. "Bromoil." In *The Oxford Companion to the Photograph*, edited by R.Lenman, 89. Oxford: Oxford University Press, 2005.

Hill, K. *Culture and Class in English Public Museums, 1850–1914*. Aldershot: Ashgate, 2005.

Hobsbawm, E. "The Social Functions of the Past." *Past and Present* 55 (1972): 3–17.

Hobsbawm, E., and T. Ranger, eds. *The Invention of Tradition*. Cambridge: Cambridge University Press, 1983.

Horn, P. *Education in Rural England, 1800–1914*. Dublin: Gill and Macmillan, 1978.

Howkins, A. "The Discovery of Rural England." In *Englishness, Politics and Culture, 1880–1920*, edited by R. Colls and R. Dodds, 62–88. London: Croom Helm, 1986.

Ingold, T. *Lines: A Brief History*. London: Routledge, 2007.

Ingold, T., and J. L. Vergunst. *Ways of Walking: Ethnography and Practice on Foot*. Aldershot: Ashgate, 2008.

Isles, C., and R. Roberts. *In Visible Light*. Oxford: Museum of Modern Art, 1996.

Jäger, J. "Picturing Nations: Landscape Photography and National Identity in Britain and Germany in the Mid-Nineteenth Century." In *Picturing Place: Photography and the Geographical Imagination*, edited by J. M. Schwartz and J. Ryan, 117–40. London: I. B. Tauris, 2003.

James, P. "The Evolution of the Photographic Record and Survey Movement." *History of Photography* 12, no. 3 (1988): 205–18.

———. "William Jerome Harrison, Sir Benjamin Stone and the Photographic Record and Survey Movement." Master's thesis, Birmingham Polytechnic, 1989.

———. *Coming to Light*. Birmingham: Birmingham Libraries, Museum and Art Gallery, 1998.

———. "Birmingham, Photography and Change." In *Remaking Birmingham: The Visual Culture*

of Urban Regeneration, edited by L. Kennedy, 99–112. London: Routledge, 2004.

Jameson, F. *The Political Unconscious*. London: Methuen, 1981.

Janowitz, A. *England's Ruins: Poetic Purpose and the National Landscape*. Oxford: Blackwell, 1990.

Jay, B. "Sir Benjamin Stone." *Album* 1 (1970): 2–10.

———. *Customs and Faces: The Photographs of Sir Benjamin Stone, 1838–1914*. London: Academy Editions, 1972.

———. *Cyanide and Spirits: An Inside-Out View of Early Photography*. Munich: Nazraeli Press, 1991.

Jenkins, H. *Convergence Culture: Where Old and New Media Collide*. New York: New York University Press, 2006.

Johnson, G., ed. *Sculpture and Photography: Envisioning the Third Dimension*. Cambridge: Cambridge University Press, 1998.

Joyce, P. *Visions of the People: Industrial England and the Question of Class, 1848–1914*. Cambridge: Cambridge University Press, 1991.

———. *Democratic Subjects: The Self and the Social in Nineteenth Century England*. Cambridge: Cambridge University Press, 1994.

———. "The Politics of the Liberal Archive." *History of the Human Sciences* 12, no. 2 (1999): 35–49.

Judge, Roy. "May Day and Merrie England." *Folklore* 102 (1991): 131–48.

Kansteiner, Wulf. "Finding Meaning in Memory: A Methodological Critique of Collective Memory Studies." *History and Theory* 41 (May 2002): 179–97.

Karp, I., and S. Levine, eds. *Museums and Communities: The Politics of Public Culture*. Washington, D.C.: Smithsonian Institution Press, 1992.

Kelly, T. *A History of Public Libraries in Great Britain*. London: Library Association, 1977.

Kelsey, R. *Archive Style: Photographs and Illustrations for U.S. Surveys, 1850–1890*. Berkeley: University of California Press, 2007.

Kumar, K. *The Making of English National Identity*. Cambridge: Cambridge University Press, 2003.

Landau, P. "The Illumination of Christ in the Kalahari." *Representations* 45 (winter 1994): 26–40.

Lane, B., ed. *Pictorial Photography in Britain, 1900–1920*. London: Arts Council, 1978.

Lang, T. *The Victorians and the Stuart Heritage: Interpretations of a Discordant Past*. Cambridge: Cambridge University Press, 1995.

Langton, J. "The Industrial Revolution and the Regional Geography of England." *Transactions of the Institute of British Geographers*, n.s., 9, no. 2 (1984): 145–67.

Latour, B. "Drawing Things Together." In *Representation in Scientific Practice*, edited by M. Lynch and S. Woolgar, 19–68. Cambridge: MIT Press, 1990.

———. "Technology Is Society Made Durable." In *A Sociology of Monsters: Essays on Power, Technology, and Domination*, edited by J. Law. New York: Routledge, 1991.

———. "The Berlin Key or How to Do Words with Things." In *Matter, Materiality and Modern Culture*, edited by P. M. Graves-Brown, 10–21. London: Routledge, 2000.

Lee, J., and T. Ingold. "Fieldwork on Foot: Perceiving, Routing, Socializing." In *Locating the Field: Space, Place and Context in Anthropology*, edited by S. Coleman and P. Collins, 67–85. Oxford: Berg, 2006.

Lefebvre, H. *The Production of Space*. Oxford: Blackwell, 1991.

Le Goff, J. *History and Memory*. Translated by S. Randall and E. Claman. New York: Columbia University Press, 1992.

Leith, I. "Amateurs, Antiquarians and Tradesmen: A Context for 'Photographic History in London.'" *London Topographic Record* 28 (2001): 91–118.

Levine, P. *The Amateur and the Professional: Antiquarians, Historians and Archaeologists in Victorian England, 1838–1886*. Cambridge: Cambridge University Press, 1986.

Linkman, A., and C. Warhurst. *Family Albums*. Manchester: Manchester Studies Series, 1982.

Lord, B. "From Document to the Monument: Museums and the Philosophy of History." In *Museum Revolutions*, edited by S. Knell et al. London: Routledge, 2007.

Luckhurst, R., and J. McDonagh, eds. *Transactions and Encounters: Science and Culture in the Nineteenth Century*. Manchester: Manchester University Press, 2002.

Lynch, M. "Archives in Formation: Privileged Spaces, Popular Archives and Paper Trails." *History of the Social Sciences* 12, no. 2 (1999): 65–87.

Macdonald, G. "Photos in Wiradjuri Biscuit Tins: Negotiating Relatedness and Validating Colonial Histories." *Oceania* 73, no. 4 (2003): 236.

MacDonald, R., ed. *The Language of Empire: Myths and Metaphors of Popular Colonialism*. Manchester: Manchester University Press, 1994.

Macdonald, S., ed. *The Politics of Display: Museums, Science, Culture*. London: Routledge, 1998.

Mackenzie, J. *Propaganda and Empire*. Manchester: Manchester University Press, 1984.

———. *Imperialism and Popular Culture*. Manchester: Manchester University Press, 1986.

MacLeod, C. *Heroes of Invention: Technology, Liberalism and British Identity, 1750–1914*. Cambridge: Cambridge University Press, 2007.

Maleuvre, D. *Museum Memories: History, Technology, Art*. Stanford: Stanford University Press, 1999.

Mandler, P. "'In the Olden Time': Romantic History and English National Identity, 1820–50." In *The Union of Multiple Identities, c. 1750–c. 1850*, edited by L. Brockliss and D. Eastwood, 78–92. Manchester: Manchester University Press, 1997.

———. "Against 'Englishness': English Culture and the Limits of Rural Nostalgia, 1850–1940." *Transactions of the Royal Historical Society*, 6th ser., 7 (1997): 155–75.

———. "The Consciousness of Modernity? Liberalism and the English National Character, 1870–1940." In *Meanings of Modernity: Britain from the Late Victorian Era to World War II*, edited by M. Daunton and B. Rieger, 119–44. Oxford: Berg, 2002.

———. *History and National Life*. London: Profile Books, 2002.

———. *The English National Character*. London: Yale University Press, 2006.

Manikowska, E. "Building the Cutural Heritage of a Nation: The Photographc Archive of the Polish Association for the Protection of the Monuments of the Past." Paper presented at Photo-Archives and the Photographic Memory of Art History-Part II, October 2009.

Martin, G. H., and D. Francis. "The Camera's Eye." In *The Victorian City: Images and Realities*, vol. 1, edited by H. Dyos and M. Wolff. London: Routledge and Kegan Paul, 1973.

Matless, D. "Regional Surveys and Local Knowledges: The Geographical Imagination in Britain, 1918–39." *Transactions of the Institute of British Geographers*, n.s., 17, no. 4 (1992): 464–80.

———. *Landscape and Englishness*. London: Reaktion, 1998.

———. "Original Theories: Science and the Currency of the Local." *Cultural Geographies* 10 (2003): 354–78.

Maynard, P. *The Engine of Visualisation: Thinking Through Photography*. Ithaca: Cornell University Press, 1997.

McDougall, D. *The Corporeal Image: Film, Ethnography, and the Senses*. Princeton: Princeton University Press, 2006.

McKenna, G. "The Geological Photographs of the BAAS." *Geology Today* 6, no. 5 (September–October 1990): 157–59.

McQuire, S. *Visions of Modernity: Representation, Memory, Time and Space in the Age of the Camera*. London: Sage, 1998.

Meadows, D. *The Bus: The Free Photographic Omnibus, 1973–2001*. London: Harvill Press, 2001.

Meller, H. *European Cities, 1890–1930s: History, Culture and the Built Environment*. London: John Wiley, 2001.

Mellor, D. A. *A Paradise Lost: The Neo-Romantic Imagination of Britain, 1935–55*. London: Lund Humphries, 1987.

———. *No Such Thing as Society: Photography in Britain, 1967–87*. London: Hayward Publishing, 2008.

Melman, Billie. *The Culture of History: English Uses of the Past, 1800–1953*. Oxford: Oxford University Press, 2006.

Merewether, C. "Traces of Loss." In *Irresistible Decay: Ruins Reclaimed*, edited by M. Roth. Los Angeles: Getty Research Institute, 1998.

Miller, D., ed. *Material Culture: Why Some Things Matter*. London: UCL Press, 1998.

———. *Materiality*. Durham: Duke University Press, 2005.

Mitchell, R. *Picturing the Past: English History in Text and Image, 1830–1870*. Oxford: Clarendon Press, 2000.

Mitchell, W. J. T., ed. *Landscape and Power*. Chicago: University of Chicago Press, 1994.

Moretti, F. *Graphs, Maps, Trees: Abstract Models for Literary History*. London: Verso, 2005.

Morrell, J., and A. Thackray. *Gentlemen of Science: The Early Years of the British Association for the*

Advancement of Science. Oxford: Clarendon Press, 1981.

Moser, S., and S. Smiles, eds. *Envisioning the Past: Archaeology and the Image*. Oxford: Blackwell, 2005.

Myers, G. "Popularizations of Thermodynamics and the Rhetoric of Social Prophecy." In *Energy and Entropy: Science and Culture in Victorian Britain*, edited by P. Brantlinger, 307–38. Bloomington: Indiana University Press, 1989.

Naylor, S. "The Field, the Museum and the Lecture Hall: The Spaces of Natural History in Victorian Cornwall." *Transactions of the Institute of British Geographers*, n.s., 27 (2002): 494–513.

———. "Collecting Quoits: Field Cultures in the History of Cornish Antiquarianism." *Cultural Geographies* 10, no. 3 (2003): 309–33.

Nead, L. *Victorian Babylon: People, Streets, and Images in Nineteenth-Century London*. London: Yale University Press, 2000.

———. *The Haunted Gallery: Painting, Photography, Film c. 1900*. London: Yale University Press, 2007.

Nickel, D. *Francis Frith in Egypt and Palestine*. Princeton: Princeton University Press, 2004.

Nora, P. "Between Memory and History." *Representations* 26 (1989): 7–24.

Osborne, T. "History, Theory, Disciplinarity." In *The Social in Question: New Bearings in History and the Social Sciences*, edited by P. Joyce, 175–90. London: Routledge, 2002.

Palmer, C. "From Theory to Practice: Experiencing the Nation in the Everyday." *Journal of Material Culture* 3 (1998): 175–99.

Palmquist, P. *Catherine Weed Barnes Ward: Pioneer Advocate for Women in Photography*. Arcata, California: P. E. Palmquist, 1992.

Pazderic, N. "Mysterious Photographs." In *Photographies East: The Camera and Its Histories in East and Southeast Asia*, edited by R. E. Morris, 83–206. Durham: Duke University Press, 2009.

Phythian Adams, C. *Re-thinking English Local History*. Occasional Papers. 4th series, no. 1. Leicester: Leicester University Press, 1987.

Pinney, C. *Camera Indica: The Social Life of Indian Photographs*. London: Reaktion, 1997.

———. Introduction to *Photography's Other Histories*, edited by C. Pinney and N. Peterson, 1–14. Durham: Duke University Press, 2003.

———. *Photos of the Gods*. London: Reaktion, 2004.

———. *The Coming of Photography in India*. London: British Library, 2008.

Pollock, V. L. "Dislocated Narratives and Sites of Memory: Amateur Photographic Surveys in Britain, 1889–1897." *Visual Culture in Britain* 10, no. 1 (2009): 1–26.

Poole, D. *Vision, Race, and Modernity: A Visual Economy of the Andean Image World*. Princeton: Princeton University Press, 1997.

———. "An Excess of Description: Ethnography, Race and Visual Technologies." *Annual Reviews in Anthropology* 24 (2005): 159–79.

Poovey, M. *A History of the Modern Fact*. Chicago: Chicago University Press, 1998.

Porter, B. *The Absent-Minded Imperialists*. Oxford: Oxford University Press, 2004.

Porter, T. M. "The Objective Self." *Victorian Studies* 50, no. 4 (2008): 641–47.

Price, M. "Town and Gown: Amateurs and Academics: The Discovery of British Prehistory, Oxford, 1850–1900: A Pastime Professionalised." D.Phil. thesis, University of Oxford, Institute of Archaeology, 2007.

Ranahan, T. P. "Establishing the Case for Digitising the Warwickshire Photographic Survey." Master's thesis, University of Northumbria, School of Computing, Engineering, and Information Sciences, 2010.

Readman, P. "Landscape Preservation, Advertising Disfigurement, and English National Identity c. 1890–1914." *Rural History* 12, no. 1 (2001): 61–83.

———. "The Place of the Past in English Culture." *Past and Present* 186 (2005): 147–99.

———. *Land and Nation in England: Patriotism, National Identity and the Politics of Land, 1880–1914*. Woodbridge: Bodley Head, 2008.

———. "Preserving the English Landscape." *Cultural and Social History* 5, no. 2 (2008): 197–218.

Richards, T. "Archive and Utopia." *Representations* 37 (winter 1992): 104–35.

———. *The Imperial Archive*. London: Verso, 1993.

Ricoeur, P. *Time and Narrative*. Vol. 3. Chicago: University of Chicago Press, 1988.

Rieger, B. *Technology and the Culture of Modernity in Britain and Germany, 1890–1945*. Cambridge: Cambridge University Press, 2005.

Riegl, A. "The Modern Cult of Monuments: Its Character and Its Origin." Translated by K. W. Forster and D. Ghirardo. *Oppositions* 25 (fall 1999): 21–51.

Riles, A., ed. Introduction to *Documents: Artifacts of Modern Knowledge*. Ann Arbor: University of Michigan Press, 2006.

Roberts, R. *Tony Ray Jones*. London: Chris Boot, 2004.

Robinson, C., and J. Herschman. *Architecture Transformed: A History of the Photography of Buildings from 1839 to the Present*. Cambridge: MIT Press, 1987.

Rollins, W. H. *A Greener Vision of Home: Cultural Politics and Environmental Reform in the German Heimatschutz Movement, 1904–1918*. Ann Arbor: University of Michigan Press, 1997.

Rose, G. "Practicing Photography: An archive, a Study, Some Photographs and a Researcher." *Journal of Historical Geography* 20, no. 4 (2000): 555–71.

Rose, J. *The Intellectual Life of the British Working Class*. London: Yale University Press, 2001.

Roth, M. "Photographic Ambivalences and Historical Consciousness." *History and Theory* 48 (December 2009): 82–94.

Runia, E. "Presence." *History and Theory* 45 (2006): 1–29.

Rüsen, J. "Historical Consciousness: Narrative Structure, Moral Function, and Ontogenic Development." In *Theorizing Historical Consciousness*, edited by P. Seixas, 63–85. Toronto: University of Toronto Press, 2004.

Rushworth, G., and J. Pickles. "The Cambridgeshire Local History Society Photographic Project, 1992–2000." *Proceedings of the Cambridge Antiquarian Society* 93 (2004): 159–60.

Ryan, J. *Picturing Empire: Photography and the Visualization of the British Empire*. London: Reaktion, 1997.

Samuel, R. *Theatres of Memory:Past and Present in Contemporary Culture* Vol 1. London: Verso, 1994.

Sargeant, A. "RCHME 1908-1998: A History of the Royal Commission of Historical Monuments of England." *Transactions of the Ancient Monuments Society* 45 (2001): 57–80.

Sassoon, J. "Photographic Materiality in the Age of Digital Reproduction." In *Photographs Objects Histories: On the Materiality of Images*, edited by E. Edwards and J. Hart, 186–202. London: Routledge, 2004.

Sayer, K. *Country Cottages: A Cultural History*. Manchester: Manchester University Press, 2000.

Schivelbusch, W. *Disenchanted Night: The Industrialization of Light in the Nineteenth Century*. Oxford: Berg, 1988.

Schlak, T. "Framing Photographs, Denying Archives: The Difficulty of Focusing on Archival Photographs." *Archival Science* 8 (2008): 85–101.

Schwartz, D. "Objective Representation: Photographs as Facts." In *Picturing the Past: Media History and Photography*, edited by B. Brennen and H. Hardt. Urbana: University of Illinois Press, 1999.

Schwartz, J. M., and J. Ryan, eds. Introduction to *Picturing Place: Photography and Geographical Imagination*, 1–18. London: I. B. Tauris, 2003.

Scott, C. *The Spoken Image: Photography and Language*. London: Reaktion, 1999.

Seixas, P., ed. *Theorizing Historical Consciousness*. Toronto: University of Toronto Press, 2004.

Sekula, A. "Reading an Archive." In *Blasted Allegories*, edited by B. Willis, 114–27. Cambridge: MIT Press, 1987.

———. "The Body and the Archive." In *The Contest of Meaning*, edited by R. Bolton, 343–89. Cambridge: MIT Press, 1992.

Seremetakis, C. N., ed. *The Senses Still: Perception and Memory as Material Culture*. Chicago: University of Chicago Press, 1996.

Shapin, S., and S. Schaffer. *Leviathan and the Air Pump*. Princeton: Princeton University Press, 1985.

Shattock, J., and M. Wolff, eds. *The Victorian Periodical Press: Samplings and Soundings*. Leicester: Leicester University Press, 1982.

Smith, L. *Victorian Photography, Painting and Poetry: The Enigma of Visibility in Ruskin, Morris and the Pre-Raphaelites*. Cambridge: Cambridge University Press, 1995.

Smith, S. M. *American Archives: Gender, Race, and Class in Visual Culture*. Princeton: Princeton University Press, 1999.

Snell, K. *Parish and Belonging*. Cambridge: Cambridge University Press, 2006.

Snyder, J. "Picturing Vision." In *The Language of Images*, edited by W. J. T. Mitchell, 219–46. Chicago: University of Chicago Press, 1974.

Solomon-Godeau, A. *Photography at the Dock*. Minneapolis: University of Minnesota Press, 1991.

Stace, A. G. *The First 100 Years: A Short History of the Royal Tunbridge Wells Photographic Society*. N.p.: [1986?].

Steedman, C. "The Space of Memory: in an Archive." *History of the Human Sciences*, 11 No. 4 (1998): 65–83.

Stewart, S. *On Longing: Narratives of the Miniature, the Gigantic, the Souvenir, and the Collection*. Durham: Duke University Press, 1993.

Stocking, G. *After Tylor: British Social Anthropology, 1888–1951*. Madison: University of Wisconsin Press, 1995.

Stoler, L. A. "Colonial Archives and the Art of Governance." In *Refiguring the Archive*, edited by C. Hamilton et al., 83–101. Cape Town: David Philip, 2002.

Strathern, M. *After Nature: English Kinship in the Late Twentieth Century*. New York: Cambridge University Press, 1992.

Sweet, R. *Antiquaries: The Discovery of the Past in Eighteenth-Century Britain*. London: Hambledon and London, 2004.

Tagg, J. *The Burden of Representation: Essays on Photographies and Histories*. Basingstoke: Macmillan, 1988.

———. "The Pencil of History." In *Fugitive Images: From Photography to Video*, edited by P. Pietro, 285–303. Bloomington: Indiana University Press, 1995.

———. *The Disciplinary Frame: Photographic Truths and the Capture of Meaning*. Minneapolis: University of Minnesota Press, 2009.

Taussig, M. *Mimesis and Alterity: A Particular History of the Senses*. New York: Routledge, 1993.

Taylor, J. *A Dream of England*. Manchester: Manchester University Press, 1994.

Tilley, C. *The Materiality of Stone*. Oxford: Berg, 2004.

Trouillot, M-R. *Silencing the Past: Power and the Production of History*. Boston: Beacon Press, 1995.

Tucker, J. *Nature Exposed: Photography as Eyewitness in Victorian Science*. Baltimore: Johns Hopkins University Press, 2005.

———. "Entwined Practices: Engagements with Photography in Historical Inquiry." *History and Theory* 48, no. 4 (2009): 1–8.

Urry, J. "*Notes and Queries on Anthropology* and the Development of Field Methods in British Anthropology, 1870–1920." *Journal of the Royal Anthropological Institute* (1972): 45–57.

———. "Englishmen, Celts and Iberians: The Ethnographic Survey of the UK, 1892–99." In *Functionalism Historicized: Essays on British Social Anthropology*, edited by G. Stocking Jr., 83–105. Madison: University of Wisconsin Press, 1984.

Van Dijck, J. "Digital Photography: Communication, Identity, Memory." *Visual Communication* 7, no. 1 (2008): 57–76.

Ware, M. "Carbon Process." In *The Oxford Companion to the Photograph*, edited by R.Lenman, 105. Oxford: Oxford University Press, 2005.

Warner Marien, M. *Photography and Its Critics*. Cambridge: Cambridge University Press, 1997.

Wertsch, J. V. *Voices of Collective Remembering*. Cambridge: Cambridge University Press, 2002.

Whyte, W. "How Do Buildings Mean? Some Issues of Interpretation in the History of Architecture." *History and Theory* 45 (2006): 153–77.

Wiener, M. *English Culture and the Decline of the Industrial Spirit, 1850–1980*. Harmondsworth: Pelican, 1985.

Williams, R. *The Long Revolution*. London: Chatto and Windus, 1961.

Williams, V., and S. Bright. *How We Are: Photographing Britain from the 1840s to the Present*. London: Tate, 2007.

Winter, J. *London's Teeming Streets, 1830–1918*. London: Routledge, 1993.

Witemeyer, H. *George Eliot and the Visual Arts*. New Haven: Yale University Press, 1979.

Young, R. J. C. *Colonial Desire: Hybridity in Theory, Culture and Race*. London: Routledge, 1995.

———. *The Idea of English Ethnicity*. Oxford: Blackwell, 2008.

Zerubavel, E. *Time Maps: Collective Memory and the Social Shape of the Past*. Chicago: University of Chicago Press, 2003.

ELIZABETH EDWARDS is Research Professor of Photographic History and Director of the Photographic History Research Centre, De Montfort University, Leicester. She is the author of *Raw Histories: Photographs, Anthropology and Museums* (2001) and the co-editor of *Photographs Objects Histories: On the Materiality of the Image* (2004) and *Photographs, Anthropology, and History: Expanding the Frame* (2009).

Library of Congress Cataloging-in-Publication Data

Edwards, Elizabeth, 1952–
The camera as historian : amateur photographers and historical imagination, 1885–1918 / Elizabeth Edwards.
p. cm. — (Objects/histories)
ISBN 978-0-8223-5090-3 (cloth : alk. paper)
ISBN 978-0-8223-5104-7 (pbk. : alk. paper)
1. Photography — Great Britain — History.
2. Great Britain — History — Victoria, 1837–1901.
I. Title. II. Series: Objects/histories.
TR57.E37 2012
770.9 — dc23 2011027454